ANSEL ADAMS

An Autobiography

ANSEL ADAMS
An Autobiography

WITH MARY STREET ALINDER

LITTLE, BROWN AND COMPANY *Boston New York Toronto London*

AUTHORIZED
EDITION

In 1976, Ansel Adams selected Little, Brown and Company as the sole authorized publisher of his books, calendars, posters, and CD-ROMs. At the same time, he established The Ansel Adams Publishing Rights Trust in order to ensure the continuity and quality of his legacy — both artistic and environmental.

As Ansel Adams himself wrote, "Perhaps the most important characteristic of my work is what may be called print quality. It is very important that the reproductions be as good as you can possibly get them." The authorized books, calendars, posters, and CD-ROMs published by Little, Brown have been rigorously supervised by the Trust to make certain that Adams' exacting standards of quality are maintained.

Only such works published by Little, Brown and Company can be considered authentic representations of the genius of Ansel Adams.

Acknowledgments of permission to quote from copyrighted material appear on pages 327–332.

First trade paperback edition, 1996
This new edition reproduces the entire text of the original book, as well as a small selection of the photographs.

Library of Congress Cataloging-in-Publication Data

Adams, Ansel, 1902–1984
Ansel Adams, an autobiography.
Includes index.
1. Adams, Ansel, 1902–1984. 2. Photographers — United States — Biography. I. Alinder, Mary Street, 1946– . II. Title.
TR140.A3A33 1985 770'.92'4 [B] 85-8135
ISBN 0-8212-1596-5 (cloth)
ISBN 0-8212-2241-4 (trade paperback)

Designed by Caroline Hagen

Published simultaneously in Canada by Little, Brown & Company (Canada) Limited
PRINTED IN THE UNITED STATES OF AMERICA

Contents

Preface

IF ONE FEELS INCLINED TO EMBARK ON A JOURNEY INTO MEM-
ory, after eighty-two years the experience promises to be kaleidoscopic
and, perhaps, willfully colored. I have attempted to remove the filter from
my memory lens, allowing more than my dreams to reach the page.
Many things are clarified only by the passage of time. I distrust any life-
long memory of facts, but not the lifelong glow of experience that de-
pends upon another form of reality. Possibly it would be too shattering to
recall everything exactly, not because it was necessarily bad, but because
it could reveal opportunities missed and errors made. Such might be best
unremembered.

I think I have something to give my readers of the flavor of a good part
of the twentieth century as seen through a life of creative experience. The
worlds of nature and of people have been closely involved; a fact not too
clear in the general opinion as I have chosen to stress the natural scene
above other directions in my photography.

I am not going to retrace my life from past to present on a one-lane
highway. I intend to recall varieties of experience, stretching tentacles of
memory to the earliest sources in such sequences as seem logical, but
without restrictions of time or place.

It is sometimes a desolate moment when one sees old photographs and
realizes that all the humanity represented is dead and forgotten. Painting
or sculpture of deceased persons, famous or not, does not evoke the same
response in me as do photographs; there is a reality in the camera re-
membrances that compels respectful consideration. Likewise, literary dis-
cussion of the departed holds a certain poignancy and euphoric assurance
of their continuing presence among us. As I write I find that while I use
words denoting past situations and long-dead persons, I continue to ac-

knowledge their living reality and their relationship to my life and work. It is my responsibility to recall them as essential spokes in the great wheel of life and to relate them to the conclusions I have drawn about my life and work.

Some of my friends were of tremendous importance in their time, yet what they accomplished was not the stuff of history books. Nevertheless, they continue in the lives of those influenced by their generosity and spirit. I have also known characters, both historical and famous, who were personally and immensely inspiring: Alfred Stieglitz, Paul Strand, Edward Weston, Charles Sheeler, Dorothea Lange, Minor White, Imogen Cunningham, Beaumont and Nancy Newhall, Edwin H. Land, David Hunter McAlpin, Georgia O'Keeffe, John Marin. Then the roster broadens; literally thousands of wonderful friends have accompanied me in life and many now await me in the secret eternity to come. I have enjoyed the long voyage and I thank all for their companionship and their affection.

I wish to express my deep appreciation:

To Mary Alinder, my dear friend and editor, whose devotion and love gave me the daily inspiration to continue writing this book, and whose editorial genius assembled it into a meaningful whole. She truly knows me better than I know myself —

To cherished Virginia, my wife of more than half a century, who gave excellent commentary on the text from the vantage point of remembering better than anyone both the joys and sorrows of my life in the world and in my art —

To James Alinder, who kindly read this tome as an historian, editor, photographer, and friend; his insights have served to clarify my chaos —

To Chris Rainier, Phyllis Donohue, and Rod Dresser for their continued and valued assistance —

And to my colleagues at Little, Brown: Janet Swan Bush, George Hall, John Maclaurin, Ray Roberts, and Arthur Thornhill, Jr., whom I have come to know over the past decade to represent the finest in publishing.

ANSEL ADAMS
Carmel, California
March 1984

Editor's Note

I BEGAN WORKING FOR ANSEL ADAMS AS HIS EXECUTIVE ASSIS-
tant in 1979. While I supervised his staff and his many projects, my prime
responsibility was to assist Ansel as he wrote his autobiography. We began
by taking long, daily walks — me with tape recorder in hand — asking
question upon question, jogging his memory, getting both of us excited
about the possibilities that lay ahead with this book. During the five years
we worked on this text, even during his increasingly frequent hospitaliza-
tions, we always continued in an established routine. We joked that the
hospital was the one place I could get him to concentrate fully on the
autobiography. Wherever we found ourselves, we worked well together,
writing and rewriting the chapters of this book through seven drafts.

Ansel died peacefully on the evening of Easter Sunday, April 22, 1984.
That day a concert by the great pianist Vladimir Ashkenazy, a close
friend, was given in Ansel and Virginia's home. Ansel had been hospital-
ized a couple of days before, but we thought until the last minute that he
would be able to attend. Although he was not physically there, everyone
in the audience felt that Ansel was listening with us as Ashkenazy per-
formed his inspired interpretation of music by Schubert, Schumann, and
Chopin. Following the concert, family and a few close friends came to
the hospital's intensive care unit and were greeted by Ansel's booming
words of welcome, wide grin, and outstretched arms. Just hours later he
quietly passed away. He had maintained his brilliance, vigor, humor, and
purpose right to the end.

It was a great honor as well as a formidable task to complete Ansel's
most personal book. I could not have done it without the selfless coop-
eration of our staff. Ansel had prepared us to continue without him
through his patient teaching and then bestowing of responsibility.

With Ansel's death I realized the absolute necessity to recheck facts, since he was not here to confirm them. Very helpful comments on the manuscript were given by Jeanne Adams, Michael Adams, Peter C. Bunnell, Anne Adams Helms, Ken Helms, George Kimball, Beaumont Newhall, Otto Meyer, Sue Meyer, Andrea Gray Stillman, McDonna Sitterle Street, David Vena, and most important, by Virginia Best Adams, a woman of great gifts who gave them unselfishly in support of the man she loved.

Ansel's death left a void in my life, but surrounding that emptiness is the love provided by my husband, Jim, who had read and commented on many drafts of this manuscript and whose photographic documentation of Ansel's last years enrich this book; and our three children, who helped magnificently while my life was dominated by this project.

I would like to add thanks to my colleagues at Little, Brown, particularly Janet Swan Bush, George Hall, Michael Mattil, Nancy Robins, Ray Roberts, John Maclaurin, and the designer Susan Marsh. I am appreciative of Polaroid Corporation for their generous contribution of necessary advice and materials. Special thanks also to Arthur Thornhill, Jr., William Turnage, and David Vena, Trustees of the Ansel Adams Publishing Rights Trust, for their counsel, support, and encouragement.

<div align="right">

MARY STREET ALINDER
Carmel, California
September 1984

</div>

ANSEL ADAMS

An Autobiography

I.

Beginnings

RECENTLY I MADE SOME NEW PHOTOGRAPHS, THE FIRST in several months. I had been occupied with printing, writing, workshops, and an accumulation of obligations that captured me. It was wonderful to set up the camera among the rocks at nearby Point Lobos and to work in the fresh sea air, experiencing again the empathies with scene and visualization and camera that every serious photographer comes to know. Just as a musician gets out of practice, I was slow with the mechanics involved in managing the equipment and even the exposure calculations. It took a little time to regain the facility I had when I was making new pictures every day. But all smoothed out and the miracle of the image on the ground glass revived me. I returned home to Carmel Highlands and a warming lunch and then spent a few hours working in the darkroom, processing the negatives I had made that morning.

People are surprised when I say that I never intentionally made a creative photograph that related directly to an environmental issue, though I am greatly pleased when a picture I have made becomes useful to an important cause. I cannot command the creative impulse on demand. I never know in advance precisely what I will photograph. I go out into the world and hope I will come across something that imperatively interests me. I am addicted to the found object. I have no doubt that I will continue to make photographs till my last breath.

Late that afternoon, as I do nearly every day, I sat by the living room window; the great Pacific Ocean stretched out before me, to the hazy line of the horizon, the borders gently interrupted by the silhouettes of pines, varied foliage, and the myriad colors of Virginia's flower garden. A small wind stirred. A bee explored the outer surface of the

window. From my chair I can see the many miracles of day and night. The external events of majesty and beauty are very clear and direct.

The ocean and its rich foreground compose a familiar view. Dusk is my favorite time, sometimes sparked by the gentle green flash as the ocean finally receives the sun. The sky darkened, holding no crescent moon or evening star to make the situation impossibly pictorial. An approaching band of fog suggested that the next day might be one of silver and cool gray. Robinson Jeffers wrote of the "vast shield of the ocean." I do not forget its presence even during those many hours I am in my darkroom or at my desk, both so detached from the direct light of sun or sky. Every so often I emerge, reaffirm the splendor of the world, and then return to the caverns of my particular creativity.

The next morning was, as expected, chilly and foggy. Cobwebs on the trees and bushes quietly sparkled with fog drops, minute star clusters that, when the sun broke through, slowly faded from their prismatic glitter. I decided to examine a box of old family photographs, some of which may accompany these recollections. I found one snapshot that is supposed to be me, an infant in an impossibly long white gown. My memory bank trembled a bit and I recalled lying in a perambulator on a warm afternoon looking up past its bonnet to the eaves of the house and beyond to a pastel blue sky with fingers of fog flowing east in silence. Soon the sky was fully gray and my nanny gathered me in her ample arms and put me in a crib indoors.

This memory faded into another of my mother and father having a party, probably in late 1903 or early 1904. My mother brought me downstairs to display me to an audience of black ties, white shirts, high-collared lace dresses, necklaces, rings, generous smiles, and strange sounds. There was much light — chandeliers, candles, and reflections — and I remember squeezing my eyes closed and gurgling in some form of primal protest. This ability to remember clearly even my earliest days has persisted over the decades.

Another fragment floated into memory: I was a child of about three. It was a winter morning; I stood at the window in my mother's room, looking over the dunes to the Marin hills rising in the misty rain over the waters of the Golden Gate. I can still see, these many years later, a fishing boat, with a pale gray, pointed sail, drifting eastward toward the bay, almost hidden in the delicate shrouds of rain. Quiet as the scene was, it was vibrant with light of a cool translucence and a great mystery of presence.

Memories come to me as if they are scenes revealed by the stately opening of a proscenium curtain. A spring morning in about 1910

came clearly to me. I was up early and out in the sand dunes near our home. A gale blew out of the northwest, difficult to stand against. It was cold and clear, and the grasses and flowers were shivering violently in their shallow little spaces above the ground. The brittle-blue distances, including the horizon of the sea, were of crystal incisiveness. The ocean was flecked with whitecaps that appeared as countless white threads in a blue tapestry. My experience that day was a form of revelation that in some way became part of my creative structure.

I constantly return to the elements of nature that surrounded me in my childhood, to both the vision and the mood. More than seventy years later I can visualize certain photographs I might make today as equivalents of those early experiences. My childhood was very much the father to the man I became.

The Adams family was from New England, having originally emigrated from Northern Ireland in the early 1700s. My paternal grandmother spent her last years striving to connect the confused family line to the Adams presidential dynasty. No luck. We could not trace any association. My father's father, William James Adams, traveled west as a young man in the early 1850s. He established profitable grocery businesses in Sacramento and San Francisco but then lost everything to fires. Returning home to Thomaston, Maine, in 1856, he wed a young widow, Cassandra Hills McIntyre, whom he brought to California in 1857. They settled in San Francisco, where my grandfather built a prosperous lumber business. It was called Adams & Blinn, and later, the Washington Mill Company. They eventually had their own lumber mills in Washington and Mississippi, as well as a large fleet of lumber ships.

My father, Charles Hitchcock Adams, was born to Cassandra and William in 1868; he was the youngest of five children. In the same year, my grandfather built the family home in Atherton, south of San Francisco.

My mother's family came from Baltimore. My grandfather, Charles E. Bray, married Nan Hiler and they, in the company of thousands of other pioneers, proceeded west by wagon train to make their fortune. My mother, Olive, was born in Iowa in 1862 and her sister Mary came into the world in Sacramento in 1864. The family next moved to Carson City, Nevada, where Charles Bray began a successful freight-hauling business, although I was told that as soon as he got financially ahead he plunged his resources into ill-considered mining or real estate ventures with repeatedly catastrophic results.

The Bray family home in Carson City was popular as a social and

cultural center. My mother was active in china painting, and we still have some of her handiwork. It always appeared to me to be of superior quality, but florid and decorative in the late Victorian manner. My Aunt Mary was a leader of the Browning Society, whose members spent frequent evenings reading the poems of the Brownings as well as less luminous local efforts at verse. These belles of Carson City, bustles and all, would attend glittering gatherings of San Francisco society, properly chaperoned, of course. At one such event Olive Bray met Charles Adams. He pursued his suit, traveling frequently to Nevada, and they were married there in 1896. After my Grandmother Nan Bray died in 1908, both Grandfather Bray and Aunt Mary came to live with us, and the family's Carson City era came to an end. Grandpa Bray and Aunt Mary had practically no resources and were additional financial burdens for my father until their deaths — Grandfather's in 1919 and Aunt Mary's in 1944.

I emerged into this world at about three in the morning on February 20, 1902, born in my parents' bed in their ample flat in the Western Addition of San Francisco. I was just a few hours into Pisces out of Aquarius: a fish out of water. So much for astrology. I was named for my uncle, Ansel Easton, a man of independent means who married one of my father's sisters, Louise.

At the time of my birth my father was building what was to be our family home on the dunes, out beyond the Golden Gate, the narrow passage from the bays of San Francisco and Oakland to the Pacific Ocean. This was thirty years before the famous bridge was built to connect San Francisco to Marin County, with its beautiful hills rising to the north. Our house was sturdily made; my Grandfather Adams, being a lumberman, gave my father the lumber in double the specification quality and quantity. A large brick chimney rose from the ground level and serviced the coal furnace and fireplaces in the living room and my parents' room on the second floor. The chimney continued upward through the eaves of the shingled roof to a noble height. A second, smaller chimney vented the kitchen stove.

My bedroom was on the second floor; it was about twelve feet square and situated in the northwest corner. I could see the Golden Gate from the north window and the cypress trees and rolling dunes around the old Chinese cemetery in what is now Lincoln Park to the west. I could also gaze well out to sea, beyond Point Bonita and the white glimmer of the Cabbage Patch, a dangerous shoal. I could watch ships of every description enter and leave the embrace of the Golden Gate.

There was always the distant bustle of the city, a deep and throbbing space-filling rumble of ironclad wagon wheels on cobbled streets and the grind of streetcars. It was almost like the sound of the ocean or the wind in the forest, yet deep with the brutality that only a city can offer in fact and spirit, no matter how glamorous the environment or euphoric the social veneer. This was a resonance we cannot experience today; rubber tires on smooth paved streets have muted the old, rough sounds of iron on stone and the clopping of thousands of horses' hooves, timing the slow progression of ponderous wagons and more sprightly buggies. It was a sound not to be forgotten: a pulse of life in vigorous physical contact with earth.

Returning from his downtown office, my father took a daily carriage from the end of the cable car line at Presidio Avenue to our home. I could see him coming for a mile over the sand dunes to the east, since hardly a structure interrupted the view over the dunes, from the Presidio to Lone Mountain. At Lake Street and 24th Avenue he would climb out of the "two-seater" and come down the boardwalk over the sand to our redwood gate between the two native laurel trees, carrying my milk and other groceries.

Though usually at home with us, April 17, 1906, found my father away on business in Washington, D.C. Mr. O'Connor, an old family friend, occupied the guest room. Our Chinese cook, Kong, slept in the basement. That evening all was quiet, except for the boom of the surf pounding on Baker Beach. I was tucked away in my child's bed. Nelly, my nanny, an elderly woman of expansive heart and frame, slept next to me in her bed.

At five-fifteen the next morning, we were awakened by a tremendous noise. Our beds were moving violently about. Nelly held frantically onto mine, as together we crashed back and forth against the walls. Our west window gave way in a shower of glass, and the handsome brick chimney passed by the north window, slicing through the greenhouse my father had just completed. The roaring, swaying, moving, and grinding continued for what seemed like a long time; it actually took less than a minute. Then, there was an eerie silence with only the surf sounds coming through the shattered window and an occasional crash of plaster and tinkle of glass from downstairs.

Nelly pulled me out of bed and quickly dressed me. My mother hastened into my room; I recall her as rather pale and dazed; the entire fireplace in her room had gone with the fallen chimney and she had awakened to a broad view of the Golden Gate and the cold morning breeze. She hugged me tightly and then we hesitantly went downstairs

to assay the damage. Mr. O'Connor was already about in his dressing gown, warning us not to step on the many shards of glass and china. The pantry, with its bountiful shelves of homemade preserves, was a shambles; everything movable seemed to be broken on the floor. The living room fireplace had fallen in; a treasured cut-glass vase from the mantel was buried in the bricks but was later miraculously retrieved in perfect condition. Plaster was cracked and detached everywhere, but fortunately the ceilings and walls solidly remained.

Mr. O'Connor had taken a quick look outside the house and knew that both chimneys had collapsed. I next heard the sounds of an altercation from the kitchen. Mr. O'Connor had forcibly to restrain Kong from building a fire in the stove; it would have been an added disaster. Kong appeared stunned. I later learned that he had suffered a concussion from being thrown against the wall by the quake.

Mr. O'Connor and Kong moved the stove outside, and by ten o'clock a breakfast was ready, although it took much foraging to find edible food in the appalling mess. I am sure my father, if present, would have recorded it all with his Brownie Bullseye box camera.

I was a little over four years of age and was very curious, wanting to be everywhere at once. There were many minor aftershocks, and I could hear them coming. It was fun for me, but not for anyone else. I was exploring in the garden when my mother called me to breakfast and I came trotting. At that moment a severe aftershock hit and threw me off balance. I tumbled against a low brick garden wall, my nose making violent contact with quite a bloody effect. The nosebleed stopped after an hour, but my beauty was marred forever — the septum was thoroughly broken. When the family doctor could be reached, he advised that my nose be left alone until I matured; it could then be repaired with greater aesthetic quality. Apparently I never matured, as I have yet to see a surgeon about it.

The impressions of confusion during the following days and, above all, the differences in daily life, are still very much with me. I recall a great to-do about cleaning up the house and a large and growing mound of broken glassware, crockery, bricks, and assorted rubble, piled in a far corner of the garden. Mr. O'Connor walked into town and secured food. Soldiers from the Presidio came by and gave us fresh water.

Kong returned to Chinatown to be with his family and friends. He came back a day later, looking grim, and stated that he had found no one and that fire was everywhere. He never discovered what happened to his family. It is probable that they were lost with the many

others in the fiery holocaust that consumed most of San Francisco east of Van Ness Avenue following the earthquake. Since the principal waterways and cisterns of the city were destroyed in the quake, there was no water with which to contest the fast-spreading flames. I have heard an estimate of four hundred lives lost; it was also said that the real total was closer to four thousand, as it is probable that the Chinese had never been counted. *All* personal and legal records in the city hall were lost: property records, birth certificates, recorded documents, all gone. The army moved in to maintain law and order. A meeting with the hangman or the firing squad was the assured fate of looters and other criminals; the word spread, and there was little crime.

From our house I saw vast curtains of smoke by day and walls of flame by night filling a good part of the eastern horizon. I remember the distant booms of dynamite as the program of blasting buildings to arrest the fire's progress continued. Refugees poured into our district, setting up their pitiful camps in the dunes with what they had carried from their burning or fire-threatened homes. We had several friends who had been burnt out of their dwellings sleeping on our floors.

I can understand now the intense anxiety my father must have felt, thousands of miles away, buffeted by outrageous telegraphed rumors of total disaster. It had been variously reported that all the city had burned, that San Francisco was slowly sinking into the sea, or that a huge tidal wave had wrecked the entire Bay area. My father left Washington as soon as he could find space on a train and arrived about six days later. Finally reaching the ferry docks, he was unable to get a horse and buggy, so he ran and walked five miles around the periphery of the fire to our home. Happily, he found all was well, with his family healthy and the house he had built largely intact.

An important family heirloom from New England, an 1812 grandfather clock with wooden works, had stood by the door in a corner of the living room. The shock transported it to a prone position, about twenty-five feet away in the opposite corner. The wooden gears and shafts were scattered about, and I am told that I exclaimed with glee, "Now I can play with the clockworks!" The parts were gathered up and within a year a clockmaker had put them all together. The old clock, serene in its antiquity, ticks on in our Carmel home today, still keeping astonishingly good time.

After the quake, field mice and sand fleas invaded the house. Our cat, Tommy, who had disappeared for two days after the quake, returned for a copious diet of mice, while fleas feasted on him and on us. Tommy did not get all the mice; some expired in the woodwork

and with that came the usual week of wrinkled noses and resigned expressions.

My closest experience with profound human suffering was that earthquake and fire. But we were not burned out, ruined, or bereft of family and friends. I never went to war, too young for the First and too old for the Second. The great events of the world have been tragic pageants, not personal involvements. My world has been a world too few people are lucky enough to live in — one of peace and beauty. I believe in beauty. I believe in stones and water, air and soil, people and their future and their fate.

2.

Childhood

D ESPITE A WIRY FRAME AND CONSIDERABLE STAMINA, as a child I was prone to frequent illness, with far too many colds and flu. I also had extremely poor teeth that plagued me later with diabolic toothaches, especially on cold mountain nights. I now realize that my diet as a child was atrocious: too many sweets and starches and not enough foods with the protein, mineral, and vitamin content I needed. I do not blame my parents for this; there was little knowledge of proper diet in the early 1900s.

My mental state was also precarious. At the age of ten I remember experiencing unsettled periods of weepiness. The doctor ordered me to bed in a darkened room every afternoon for two hours to calm me, but the effect was just the opposite. I remained alert, resistant and hostile to this routine. The sound of the surf from Baker Beach, of the gardener working outside my window, and of occasional children playing near the house created a yearning tension to get up and go that left me in much worse condition. I wanted to run down to the beach in sun, rain, or fog and expend the pent-up physical energy that simply fermented within me. Today I would be labeled hyperactive.

With a resolute whisper, Lobos Creek flowed past our home on its mile-long journey to the ocean. It was bordered, at times covered, with watercress and alive with minnows, tadpoles, and a variety of larvae. Water bugs skimmed the open surfaces and dragonflies darted above the stream bed. In spring, flowers were rampant and fragrant. In heavy fog the creek was eerie, rippling out of nowhere and vanishing into nothingness. I explored every foot, tunneling through the thick brush and following the last small canyons in the clay strata before it met the Pacific. The ocean was too cold for swimming, so I would

skirt the wave-foamed edge and follow the rocky shore to Fort Scott to the east or climb along the rugged cliffs to China Beach to the west. These cliffs were dangerous, but I was light and strong and could pull myself by my fingertips over minor chasms.

A beautiful stand of live oaks arched over the creek. In about 1910, the Army Corps of Engineers, for unimaginable reasons, decided to clear out the oaks and brush. My father was out of town when the crime was committed. One of his favorite walks was through these glades to Mountain Lake in the nearby San Francisco Presidio; on his return, he became physically ill when he witnessed the ruthless damage.

I must have been a juvenile problem of consequence, but I was limited by my very proper human surroundings. While my father was liberal in his politics, he was also shy and socially conventional. In the presence of all but close friends he addressed my mother as Mrs. Adams. I never saw him without a collar except on Sunday mornings. Attaching the collar to the shirt by front and back buttons was a major effort. He sometimes yanked the collar off the shirt while making a few pointed remarks about the fate of mankind that such gestures of convention should be so nasty. All his shirts were designed for stiff collars; collarless, he looked quite forlorn, showing a brass button and a long neck.

Certain matters of life were completely avoided or most daringly spoken of in whispers. That did not stop me from asking, "Does God go to the toilet?" Grandfather Bray would clearly enunciate, sometimes between clenched teeth, "Plague be gone, young'un!"

Inevitably, I pondered the beginnings: where from and how had I entered life? I asked these questions of my mother; she merely shook her head. I enjoyed a prepuberty erection in the bathtub and asked, "What is *that?*" Again my mother shook her head. I had heard or read mysterious words and would innocently ask neighbors questions such as "What does masturbate mean?" I never had an explanation, only queer looks and obvious evasions. One of the main city sewers drained about a thousand feet or so offshore at Baker Beach, and an array of objects would come ashore. Sanitation was a foreign word in those days and one had to walk carefully on Baker Beach! There also were interesting rubber objects that I first thought were jellyfish, or some other form of sealife. Bringing one home for questioning did not sit well with my mother, and I am confident now that Aunt Mary could not identify it.

I posed my questions to my father and he painfully explained —

after being sure we were alone and out of the house. I later learned that he did not have an accurate idea of the essential organs and their relationship. My friends and I, equally uninformed, conjectured the possibilities: never were there greater fantasies in all the paradises of fact or legend!

My favorite hobby was collecting insects. Various bugs filled the bottom drawer of the large bureau with phalanx after phalanx of tiny corpses displayed on pins. When my great-aunt, Mrs. Aurelia Hills Collamore, came from Thomaston, Maine, to visit us, she was given my room. She must have been eighty-five years old and was dressed like a Grant Wood woman on Sundays. I told her the bottom drawer of the bureau was full of bugs. Being slightly deaf she misunderstood me, thinking I had said, "Bed bugs!" There was a screech and a period of feminine demonstration. Even after my explanation, her visit was clouded with the faint possibility that the insects would crawl down from the pins and attack her. I had one huge African black beetle nearly three inches long with a horn like a rhinoceros. It always looked ready for takeoff, and she asked me to *please* put it somewhere else. I covered it with a little box and put a weight on it. That seemed to mollify her.

To continue my catalog of childhood leisuretime activities: I was quite a roller skater for a time until a number of hard falls and close calls with automobiles and horses convinced me I should stop that activity. Another sport I enjoyed for a while was golf. Once, at the old Lincoln Park Golf Links, I lofted a ball over a bunker in the general direction of the hidden green. My companion and I searched for the ball for half an hour (we had a very limited budget for golf balls) and then found it in the cup, an unanticipated hole in one! I played cribbage with my father and pinochle with my friend Billy Prince, and usually lost to both. I tried playing chess, without success, and bridge and poker were anathema. I just could not rouse the patience required to accomplish these games. I also had no interest in spectator sports.

When roaming our neighborhood and the city, I found there was only one rewarding way to get from place to place and that was to *run!* I was impatient at the tempo of walking and the slow sidewalk flow of pedestrians and I simply ran, doubtless an object of curiosity. Jogging was unheard of in those days, but a few athletes in training might be seen running in their white shoes, shorts, and sweaters. Darting about as I did in a conventional child's suit was out of order and conspicuous.

In the late afternoons I usually returned to Baker Beach to walk along the surf-edge across the dark, flamelike tongues of sand. I was

never able to find the source of the considerable amount of iron particles that caused this interesting effect. I would take cans of the sand home, dry it out and experiment, sprinkling the sand on a sheet of paper and moving magnets of different shapes underneath, producing wonderful patterns with the black iron particles against the white background.

Driftwood would come ashore in all shapes and sizes — large timbers, poles, wood fragments, and deeply worn parts of furniture. Some were very beautiful in their configurations. All had firewood potential. I carried as much as I could home each day to add to our supply.

The great sand dunes began stirring with developments. Contractors spawned houses on twenty-five-foot lots. Just east of our house, two blocks of sand and scrub were graded by scrapers powered by mules and sweating, yelling men. Baronial limestone gates were set up at 22nd and 24th Avenues. Twenty-third Avenue was cut off and a new street, paralleling Lake Street, was graded in, paved, with a strip of lawn and a sidewalk on each side and given the glamorous name of West Clay Street. The basic Clay Street ended more than a mile away to the east. The imagination is boggled by the lack of it at times.

Mr. S. A. Born was one of the more dependable and prosperous contractors and the one who developed the lands surrounding our home. His houses were contractor designed, put together without compromise, and have lasted with a stern dowager quality for many decades. He was very kind to me, allowing me to visit his field office and observe his draftsmen. His patience passeth understanding. From him I learned how to draw a straight line and a ninety-degree angle. I drew up some plans for houses, forgetting to provide for stairs and closets.

Words fail to convey my total experience in that office: the smell of pinewood, ink, and sweat, the all-pervading sand on tables, chairs, paper, and between teeth, the hot afternoon light coming through small, dusty, spider-hazed windows, and the sound of wind and surf invading the room every time the door was opened. There were rolls and rolls of plans, pale blue and frayed at the edges, stacked on frames and on the floor, bearing incomprehensible hieroglyphics of plumbing, wiring, and framing details. The master carpenter would come in, loudly arguing with gusty profanity some point, then exit in slam-the-door wrath only to reappear, sanguine, an hour later.

One day Mr. Born drove me into town and back in his two-cylinder Reo automobile. Proceeding home out Lake Street at eighteen mph with hands white-knuckled, grasping the jiggling steering

wheel, and the engine coughing and clattering under the seat, he yelled, "If a front wheel should come off, we would be crushed to jelly!"

Most of his houses were completed at close to the same time and they were quickly sold and inhabited. We became an instant neighborhood, a part of San Francisco, no longer loners on the sandy outskirts. Most thought it progress; I wistfully remembered the sand, sea grass, and lupines.

My parents enrolled me in a succession of schools. From that early period when I was battling institutional education, I too well remember the Rochambeau School. The architect of the school must have been a dull and primitive cubist. It was a dismal three-story building, dark brown on the outside, dark brown and tan on the inside; everything, including its atmosphere, grimly brown. The students acquired this pervading mood of depression from the teachers, and the teachers must have caught it from the building: big square rooms, wide noisy staircases, grimy windows, ink-stained desks, smudged blackboards, and crummy toilets. The janitor dour, the principal grim, and the playground dirty! Dogs would do and dump on the cement yard; evidences of trysts were occasionally found behind ashcans; the older boys-about-town would grin and wink knowingly.

The school bully, Beasley by name, picked on all the younger and more timid children. He always triumphed without doing too much physical damage. One day he encountered me in an isolated area of the schoolyard. He deftly punched me in the stomach, hard enough to make me gasp. I recall being completely furious. I knew nothing about boxing, but in my blind wrath I swung my fist like a pendulum and swatted him as hard as I could on the chin. To my amazement he toppled over and passed out cold. This was the first time I was personally taken home by the principal.

"Fighting is absolutely not permitted in my school!" the principal exclaimed to my mother.

"Beasley hit me first!" was my excuse.

The principal must have known about Beasley, but she kept silent, glared at me and left.

My mother asked, "Did he hurt you?"

"A little, I guess."

"Did you hurt him?"

"A little, I guess."

Case closed.

By the time I was twelve I had developed a behavior pattern that

if I became bored with anything I would drop it; hence my life was cluttered with incomplete expressions. One of my Rochambeau teachers was a Miss Oliver. She was a buxom Minerva with a steady, penetrating stare. Her voice oozed with unctuous certainty as she tried to bring order out of my chaos. Several times she asked me to come to her house for generalized lectures on behavior and responsibility. I did not comprehend most of what she was saying. We would sit in a stuffy little room in which a number of tired plants and an exhausted cat held forth. I remember that I could hear the ocean and yearned to escape the concerned stare and the flow of Truth that cascaded from her pursed lips. I am now sure that she was weaned on misunderstood Emerson.

Each day was a severe test for me, sitting in a dreadful classroom while the sun and fog played outside. Most of the information received meant absolutely nothing to me. For example, I was chastised for not being able to remember what states border Nebraska and what are the states of the Gulf Coast. It was simply a matter of memorizing the names, nothing about the *process* of memorizing or any *reason* to memorize. Education without either meaning or excitement is impossible. I longed for the outdoors, leaving only a small part of my conscious self to pay attention to schoolwork.

One day as I sat fidgeting in class the whole situation suddenly appeared very ridiculous to me. I burst into raucous peals of uncontrolled laughter; I could not stop. The class was first amused, then scared. I stood up, pointed at the teacher, and shrieked my scorn, hardly taking breath in between my howling paroxysms. To the dismay of my mother I was escorted home and remained under house arrest for a week until my patient father concluded that my entry into yet another school would be useless. Instead, I was to study at home under his guidance.

My father was quite good at French and also tutored me through the complexities of basic algebra. He insisted I read the English classics and provided me lessons in ancient Greek with an elderly minister, a Dr. Herriot, who taught me the complexities of that language and its aural magnificence.

Our conversations after the lesson would inevitably lead toward some matter of faith; Dr. Herriot assumed I went to church and he was very curious as to which one. It did no good to explain that I was an agnostic, to him a heathen. My disregard of conventional faith was incomprehensible to him.

One day Dr. Herriot asked what I was currently reading. I told him

I was immersed in Shelley's *Prometheus*. He was shocked, and said, "Shelley was a dastardly atheist." I could not understand Dr. Herriot any more than he could me.

Another conversation turned to evolution. "There is no such thing as evolution!" exclaimed Dr. Herriot. "There is only *de*volution from the year of the Creation!"

I appeared perplexed. He followed with, "We *know* God created the world in October, four thousand and four years before Christ; we are waiting for the Second Coming which will take place *soon!* Don't believe this evolution rubbish!"

Now I was stunned. I ventured, "Dr. Herriot, how do you explain the fossils in the rocks?"

The silver-maned Reverend Doctor looked at me with what would pass as theatrical compassion and said, "My dear boy, God put them there to tempt our faith."

After that revelation I could not return to him for further instruction. His cold blue eyes in the ruddy, white-whiskered face, his pronouncement of rigid faith, and his implications of what would happen to me on Judgment Day, all were at huge variance with the luminance of music, the revelations of philosophy and poetry, the freedom of the rolling hills and the ocean.

From my conversations with Dr. Herriot and others came my realization that intolerance, unreason, and exclusionism exist and that all three are blended in many manifestations of our society. This stimulated my intellectual and imaginative faculties, but also drew sharp lines of separation between myself and a good part of the society in which I lived. I believe religion to be deeply personal; I am a loner with my particular amorphous sense of deity.

Sometime in 1914, my father heard me trying to pick out notes on our old upright piano. He decided that his twelve-year-old son had talent! I soon began piano lessons, which were in addition to my other studies.

In 1915 my father gave me a year's pass to the Panama-Pacific International Exposition (celebrating the opening of the Panama Canal), which would be my school for that year. He insisted that I continue my piano and study literature and language at home, but I was to spend a good part of each day at the fair.

The exposition was large, complex, and astounding: a confusion of multitudes of people, more than I had ever encountered, with conversations at excitement levels and innumerable things to see. I visited every exhibit many times during that year.

In some respects it was a tawdry place, a glorious and obviously temporary stage set, a symbolic fantasy, and a dream world of color and style. The buildings, constructed expressly for the exposition, were huge and flamboyant, with great scale and spaciousness. They were to reflect the spirit of classicism, daringly transcribed by western architects and designers. Included were: the Campaniles, reminding me of Italian postcards, the Court of Ages with its infinity of finials, the rococo Hall of Horticulture, the glorious Palace of Fine Arts, and the improbable Tower of Jewels. There were acres of foreign pavilions as well as many from American states, some pleasing and instructive, some incredibly dull.

And then there was the Zone, the amusement area. In addition to the usual neck-breaking rides, tumblers, twisters, and tunnels of love, there were the seamy traps of girlie shows, curio shops, and freak displays. If the fronts of these establishments were bad, the backs were worse — plywood, tar paper, trash, as well as drunks and assorted strange fragments of humanity.

On occasion when I was late coming home, I would make for the exits through the backyards of the Zone to the nearest streetcars. On one such evening my path crossed a group of shabby men. One, with a hooked nose and sardonic grin, had rolled up his sleeve and was injecting himself with a huge syringe. I was badly frightened and I rushed through the nearest turnstile and jumped on the first streetcar I saw. It happened to be going in the wrong direction, but no matter; I felt I had escaped some awful, threatening situation. I got home quite late and very distressed. My father asked me what had happened. I blurted out the horror of the experience, but my father simply said, "He must have been a drug addict — you should feel very sorry for him." This clarifying charity eased my spirits.

I happily returned to my school, the exposition. The Festival Hall, a huge, domed building with excellent acoustics, contained an organ, a gargantuan instrument of some quality that now graces San Francisco's Civic Center. Daily at noon the exposition organist, Edwin Lamar, gave a concert that he closed with an improvisation on a theme submitted by someone in the audience. I was increasingly involved in my own music study and was impressed by his ability to create a prelude or a fugue on the spot with such inventiveness, musicianship, and authority. I always tried to attend his concerts, then scampered a mile to the YMCA cafeteria for a cheap lunch.

I made many visits to the painting and sculpture exhibits at the Palace of Fine Arts, where I saw work in the modern vein — Bon-

nard, Cézanne, Gauguin, Monet, Pissarro, Van Gogh. They had little effect on me at the time, though I remember viewing them repeatedly. I now wonder what subconscious effect they had in the years to follow.

My father often met me in the early afternoon and we visited exhibits together. He particularly enjoyed the science and machinery exhibits and also liked to sit in the courts and watch the fountains. Occasionally my mother and aunt would join us. We would have something to eat and stay for the fireworks; they were always spectacular. Arriving home late, the next day was usually a bit quiet for the ladies.

Although everyone at the exposition was kindly to me, I am sure I was a real pest. But patience is the keystone of salesmanship, and the intent of the exposition was to encourage interest in and purchase of the items displayed. It was much more sensible than ordinary advertising; everything was there to see and handle and try out if you wished. Exhibitors seemed interested in inquisitive children and went out of their way to explain things. They were anxious that word be spread at home and parents alerted to such things as new office or home equipment.

A friend of my father was managing the Dalton Adding Machine Company exhibit and he taught me how to use the machine. I enjoyed demonstrating it to spectators and often did so for an hour or two a day.

I also frequented the Underwood Typewriter exhibit that presented on a large movable stage dioramas of the history of office writing — from the eighteenth-century bookkeeper laboriously pushing a quill pen to the most modern typewriter of 1915. These scenes appeared in sequence, one dissolving into another with a smoothness that was truly remarkable. Real people were involved; each illusion was a beautifully arranged and illuminated stage set. How it was done baffled everyone.

I met Mr. Thomas Mooney, the technician of the display, and he revealed the secret, making me promise not to divulge it until the exposition was over. I was proud of this confidential information and carefully guarded the secret. It is hard to describe my astonishment and disbelief a few days after the shocking 1917 Preparedness Day bombing on Market Street to see a photograph of Thomas J. Mooney, charged with major complicity in this terrible crime. I found it difficult to believe he was guilty, but he was so charged and sentenced to many years in prison. In my memory he is a kind and gentle man.

On the closing day of the exposition, I arrived early and visited my

old haunts. Many displays were already packed up, leaving a sad, abandoned look. I had saved up some cash for a few rides on the roller coaster, then had a double-rich dinner at the YMCA cafeteria. Piles of turkey and dressing and ice cream went the way of my innards. I had one last ride on the roller coaster with disastrous gastronomic results and ended my activities at the infirmary.

I left the infirmary at nine in the evening and wandered off to the east gate. The crowd was huge, filling the large open areas from rim to rim. I was trapped in the center of a vast surge of people who swayed en masse as if under the spell of a choreographer. It was terrifying; several women fainted but were kept upright by the close-pressing bodies. We slowly reached the exit and poured into the street. The streetcars were jammed; there was little use waiting, so I started to walk home through the Presidio. I found that I was quite weak, the combination of illness and the long, frightening experience in that mindless throng had their effect. I needed to rest frequently and simply sat down on the roadside. I straggled home at two A.M. to find my family anxiously awaiting me, fearing the worst.

After the exposition, my education continued along its individual course. In and out of several schools in search of a legitimizing diploma, I finally ended up at the Wilkins School. Mrs. Kate Wilkins was a stout, motherly character; she read the lessons out loud to me and gave me an A. Graduating from the eighth grade at the Wilkins School signaled the end of my formal academic career.

I often wonder at the strength and courage my father had in taking me out of the traditional school situation and providing me with these extraordinary learning experiences. I am certain he established the positive direction of my life that otherwise, given my native hyperactivity, could have been confused and catastrophic. I trace who I am and the direction of my development to those years of growing up in our house on the dunes, propelled especially by an internal spark tenderly kept alive and glowing by my father.

3.

Music

M
Y THIRTEENTH YEAR WAS DOMINATED BY TWO SUB-
jects: the Panama–Pacific International Exposition and the
beginning of serious study of the piano. The world of mu-
sic was an immediate contrast to my undisciplined life and unsuccess-
ful performance in school. Within a block from our house lived an
extraordinary, elderly maiden lady of very definite Yankee determi-
nation. Miss Marie Butler, my first piano teacher, was a graduate of
the New England Conservatory of Music and had taught piano for
many years. Her technical competence was bewildering, her knowl-
edge of music — harmony, theory, and history — tremendous, and
her perseverance remarkable.

My father must have explained my undisciplined character to her.
She was very proper with a soft voice and manner, but she showed me
no mercy whatsoever. There was no adaptation to my usual scattered
approach to life. She insisted on week after week of grueling exercises
and repetitious scales that I felt to be purposeless. Then one autumn
day I suddenly realized what was happening. The perfection was be-
ginning to *mean* something to me! Miss Butler seemed to recognize
my awareness and said, "It's time for a little phrasing." My scatter-
brained existence was gradually being tuned to accuracy and musical
expression.

The change from a hyperactive Sloppy Joe was not overnight, but
was sufficiently abrupt to make some startled people ask, "What hap-
pened?" I still recall that the Bach Inventions taxed my concentration,
especially when a sunny breeze carrying the sound of the ocean stole
through the open window. I worked for a month getting the Bach

Invention No. 1 note-perfect. "Now," said Miss Butler, "we may be-
gin to *play* it!" Then began the wondrous putting-together of the
simple phrases in all their independence. Her approach to teaching was
"if it's not right in every way, it's wrong," and that was that. "Bring it
back *right* next lesson." She was very patient with problems of inter-
pretation, but to not have the correct notes or rhythms was unfor-
givable. She never played or demonstrated music that I was working
on. I had to express the music myself. Her teaching still remains
impressive.

BUTLER: "Look at this phrase; see the five rising and falling
notes?"
ADAMS: "What do you mean 'rising and falling'?"
BUTLER: "Isn't it on the page: a hill to climb and descend? Some-
thing to lift and let fall?"
ADAMS: "Oh! I think I see."
BUTLER: "Try it."

Shape was born! If the notes were accurate, their volume should be
in relation to their "lift." What had been an uneven plateau of notes
took on the aspect of a range of hills.

BUTLER: "Do you think you got an agreeable 'bell' quality with
the top note of this phrase?"
ADAMS: "Show me what you mean."
BUTLER: "No, it's *your* phrase. You have to sculpt it."
ADAMS: "Where is the accent? If I stress the top of the phrase,
am I not losing the prime accent?"
BUTLER: "Not at all. The *time* accent is the ground plan, the
phrase crest is the architecture."

Conversations such as these opened new worlds of thought and
feeling. Gaining the techniques to produce beautiful and precise
sounds, I began to express my emotions through music. I am con-
vinced that explanation of emotion in art is accomplished only in the
medium in which it is created. This came to me powerfully years later
when I turned to photography.

From the beginning I was trained to play a simple five-note exer-
cise, note by note, with a metronome set at sixty-nine beats a minute.
I do not know why sixty-nine and not seventy-two or sixty-five, but
sixty-nine it was.

Each note struck required the following:

1. Hand level, fingers lightly resting on the keyboard.
2. Lift the finger as high as the joints will allow.
3. Strike with finger impact only.
4. Relax finger just enough to prevent the damper dropping on strings.
5. Strike next note, releasing the first note as the next sounds.

This is a relaxed procedure and the basis of a true legato: each note a pure, balanced entity, most to be connected to other notes with a consistent smoothness and equality of tone. When all notes were even in sound and accurate in strike, the metronome speed would slowly be increased and the hand would remain relaxed. Later on, hand and arm energies would be used. It was a monotonous, but rewarding procedure.

The subject of legato is more than just the conventional smooth progression of one note to another. It is agreed that no matter how a single piano key is struck, a closely similar sound will be heard, more loudly as the impact force increases and impossible to control once struck. It is the relationship of volume and the interval of pitch and time between two or more notes that defines "touch," the sense of relative tonal quality, and suggests the shape of phrases. The retinal-cortex performance in the achievement of vision is not dissimilar to the aural-cortex phenemenon in hearing, in that the mind not only receives values, but creates their enhancement.

Consider a struck note; the first impact sound is followed by a complex series of harmonics. In this chain of harmonics there are links and profiles of completion, suggesting the ideal moment for the impact of the next note. However, the miracle dwells in the anticipation of the correct moment of impact of the following note; if we acted on perception of this moment, we would, because of the brain-nerve-muscle lag, be late in action and the theory of legato blasted.

With Miss Butler I progressed from Bach — all the Inventions, all the *Well-Tempered Clavier,* the Italian Concerto, etc. — to early Italian composers and Mozart. After several Mozart sonatas, I was allowed to play Beethoven, then the logical step to Chopin, playing most of the preludes and nocturnes and then the Fantasy C-sharp Minor Scherzo and the B-flat Minor Sonata. Then more Bach — the Partitas and the English Suites — and a balanced injection of Schumann and Schubert.

One day, after playing an assignment for her, she said, in a quiet and unemotional voice, "I have done all I can for you. It is time you went on to larger worlds. I think you should study with Frederick Zech for

a while, simply to get the feel of the great musicians of the middle and late nineteenth century."

My fairly placid world was abruptly changed in 1918 by the formidable character of Frederick Zech. He was at least eighty years old and possessed an impressive mustache and a strong German accent. He had been an assistant to Von Bulow in Potsdam. Zech played for me but once. Because I did not do very well with some double sixths, he pushed me aside and proceeded to cover the keyboard with a chromatic double-sixths scale with both hands at a dazzling tempo.

At my first session, Zech simply asked me to play for him. After a short survey of my repertoire, he said, "You have been very well trained. If you work hard you will play good. We shall now give you more heroic position! You will spend one hour on finger work, one hour on Bach, one hour on Beethoven, then two hours on something else that I shall give you. First we will try a little Schubert and a little Liszt and then we shall see."

Frederick Zech kept me in line with wry comments such as — this in regard to a Schubert Impromptu — "You must play it like making love, but you should not breathe so fast near the end." Once I was working on Liszt's *Saint Francis of Paulus Walking on the Waves*. I thought I had it fairly well in hand, but he was obviously distressed. "Mr. Adams, please — first you must know the notes, then you can bellow like Chaliapin." I fear that my performance had paraphrased an old homily, "You could not see the rocks for the avalanche." There was no way to put anything over on Frederick Zech.

By 1923 I was a budding professional pianist without a decent piano. I was still practicing on our old upright that was falling apart. My mother's family were old friends of Governor Jewett Adams (no relation) and his wife, in Carson City, Nevada. Mrs. Adams was a good pianist and took a friendly interest in my musical progress. When the governor passed on to the Higher Authority, she moved to San Francisco and had a fine, though small, apartment in the Stanford Court. Mrs. Adams had a huge German piano, an Ermler, nine feet long, that had been manufactured in about 1857. She kindly gave me her piano, which I felt to be a godsend. The keyboard was several notes shorter than modern pianos, the action was simple and not too subtle, but the tone was quite fine.

There was a quality about the Ermler that was unforgettable. Its case was of rosewood, with a marvelous, dark luminosity. The music rack was carved in East Indian style. The end was squared off, slightly coffinlike. In fact, with two candles set on either side of the music rack,

it had a truly funereal mood and reeked of the qualities quite different from those of fresh air and green hills in sunlight.

While the Ermler was a definite improvement, I longed for a more sympathetic piano and would visit the Wiley B. Allen store in San Francisco. They were agents for the Mason and Hamlin piano and were very kind to me, letting me come in to practice on whatever instruments were on the floor. One day in 1925 I arrived and the salesman said that two beautiful Double-B's had just come in. I played for a little while on one of them; it was superb. Then I sat down at the other one and within one minute I knew this was the piano for me! Love at first sound! It had an incredible tone and action; it was right, inevitable, and, of course, expensive! I reluctantly departed that afternoon. On the way home in the streetcar I accumulated gloom; here was the most wonderful piano I had ever touched and there could be no way I could afford it. Struggling to become a concert pianist, I now taught piano lessons, bringing home only a small income. I talked with my father and he said, "Maybe we can do something about it. Let me think."

The next morning my father reminded me that I had been given a lot in Atherton by my Uncle Ansel. We immediately sold it, receiving twenty-two hundred dollars. I used this as the down payment on the sales price of sixty-seven hundred dollars with interest. My father and I paid it off at seventy-five dollars a month for five years.

I will never forget the great anxiety of waiting for the new piano and the terror of seeing it carried up the twisting path to our house, teetering from side to side. The Mason and Hamlin was installed as though a queen in residence in a simple cottage. It gleamed in the morning light coming through the living room window as I cautiously sat before it, struck a few random notes, then tried a simple Chopin nocturne. With those first few notes, a new experience of beauty blossomed: the sound was so lovely, the dynamics so extended. There was a limpid excellence over the entire scale; the notes seemed willing to live as long as I wished them to. Sixty years later it still retains its beautiful tone; a few things of the world are of enduring quality, and this piano is one of them.

With continued hope for a future in music and with Zech's blessing, I moved on to another teacher, Benjamin Moore, an extraordinary and tranquil personality, who taught by indirection, requesting me to comment on my own playing in the analytical, rather than critical sense.

Benjamin Moore created thought-trains that I have retained over

the years. He was a master of the "as if" method of communication. I will never forget how difficult it was to create any impression of legato with widely separated notes or chords without the sustaining pedal. Getting from one to another position as quickly as possible might give a very short time lag, but the note or notes sounded would be heard as a "slap." Ben Moore would say quietly, "Why not think of the 'up' from the first position as part of the 'down' of the second position?" Immediately I was able to achieve the elusive legato, even over a space of several octaves. This was another example of anticipation: achieving the unique moment when the input of a new sound into the receding harmonics of the previous sound is at the optimal moment.

Of course, music is not simply putting one note after another; a tremendous variety of physical, aesthetic, and emotional situations are brought under control over the years by arduous practice. All falls together in a grand, yet apparently simple creative pattern that reveals high levels of memory, comprehension, and sensitivity.

Not made for the piano, my hands were rather small, with a span that barely managed a tenth on the keyboard, and fingerpads that would not tolerate much bravura playing; bone-bruise occurred frequently. I was told I had ideal violin hands — probably also good for flute, piccolo, and harmonica! My style and repertoire were therefore constrained by my physical limits. I did develop an unusually beautiful touch and musical quality. I do not think I could have achieved much notice as a concert pianist, but I could produce effective sounds, phrasing, and a style of unusual quality. I could have become a performer of a limited repertoire, an accompanist, and teacher.

My first meeting with a celebrated musician was when I was fifteen years old. Paula Humphries, a neighbor, was dedicated to the musical life of San Francisco and frequently entertained visiting greats. She kindly asked me to an afternoon tea with Johanna Gadski, the Wagnerian singer. I approached the event with terror. When I rang the doorbell, I was ushered into a large living room and a chattering flood of voices. For a few moments I was dismally alone in a very strange world. Then Paula rushed up to greet me (one would think I was her son, the mayor, or the symphony conductor) and introduced me to the crowd upon a gathering tide of welcome and hospitality. I was led to the Presence: a mountain of a woman, radiant with health, creative aura, and sheer physical power. She gripped my hands, drew me toward her, clasped me to her expansive bosom adorned with a shimmering emerald, and said, "I am *so* glad to meet you. Any friend of Paula's is a friend of mine!" I received an additional bear hug, almost

swallowing the emerald, and was passed on so that the next guest could receive the appropriate greeting.

The euphoria of this contact with greatness lasted quite a while. When I heard Gadski sing *The Valkyrie,* I had that smug satisfaction of saying to myself, "I know her. She hugged me. She's glorious!" In fact, she was.

Mischa Elman, an extraordinary violinist, was just the opposite. I recall a day in the early 1930s when Kathleen Parlow, a fine violinist who lived next door, invited us to lunch with Elman. He talked incessantly about himself and the dastardly character of most musicians and critics. After lunch, Kathleen suggested we all go to our house. She was sure he would like our big, white living room. He entered, took one look about him, and said, "Kathleen, get your fiddle." She brought it, whereupon he spent almost two hours striding up and down the room, playing Bach for the unaccompanied violin. I shall never forget the enormous tone he evoked from the instrument and the complete absorption of the man in his music. He asked me to play some accompaniment for him; I tried, scared to death. It was a score for violin and piano by Dvořák that I happened to have. He was a completely commanding musician, and all I could do was timorously follow him.

At the close he said, "Thank you. I want your piano, how much?"

I replied that my pride and joy was not for sale, but he simply would not listen.

He said, "I will pay you five thousand dollars."

"I do not want to sell it."

"I will pay you seven thousand dollars!"

"I won't sell it for anything!"

"Ten thousand dollars?"

"NO!"

He then said, "Kathleen, I want to go back to your house," and departed forthwith.

I saw him again several years later and he asked, "Will you NOW sell your piano?"

I said, with a certain asperity, "NO, I will NOT sell it to you or anyone."

He turned away, insulted. I have wondered how a great artist could be so opaque: possessing extraordinary musicianship, incredible tone, and authority, but ruthless and self-centered. I have never been able to reconcile all these qualities in one personality.

One of my oldest friends, Ernst Bacon, represents a creative-

intellectual balance I have found rare in artists. He is a gifted pianist, a superior composer, and a perceptive commentator on the human-political scene. In his eighties he still exudes a marvelous youthfulness. He does not find all the notes these days, but his piano playing is strong, solid, and compassionate.

It was always an exciting indulgence to attend a symphony rehearsal, and I went to quite a few in the 1920s. The conductor of the San Francisco Symphony was Alfred Hertz, a full-bearded, totally bald man. Though lame from childhood polio, he had vast energy, excellent musicianship, and a wry, Teutonic sense of humor. He was a perfectionist in the very precise German fashion. He loved a lot of brass and maximum decibel climaxes. He built our orchestra from poor to acceptable.

I recall a Danish violist, who, at least, tried hard. While I never heard him slip in concert, he made some extraordinary mistakes in rehearsal. Hertz was quick to isolate and humorize them if possible. At one point in a rehearsal of a Strauss tone poem, the violas were to enter in unison. Our Danish friend produced a slightly wan, but audible, note, one beat ahead of the score. Hertz tapped vigorously on the music desk, bringing the entire orchestra to silence. He looked around the hushed group and said, in measured, sepulchral tones, "There is something rotten in Denmark!" Everyone roared, including the hapless violist. He would tell this story on himself with glee for the rest of his life.

On one occasion I heard a harpist of undoubted ability who could sometimes be vague and forgetful. He arrived at one of those occasional symphonic opportunities where the harp has a glittering and prolonged cadenza. With handsome head thrown back, eyes closed, and hands rotating like spikey cartwheels across the strings, he completely neglected the score and enjoyed repeating this particular virtuosic display. Hertz let him get through two repetitions, but when he began the third, Hertz banged on the desk and yelled, "STOP, mein Gott, you have passed the station!"

Ridiculous moments, such as these, endure, while many of the fine performances I heard were forgotten. Perhaps if it were not for the persistent underlying humor of musicians, the rigors of the profession would unbalance them. My own highest inane musical achievement was at a VERY liquid party where people were doing extraordinary things. They begged me to play. I felt capable and proved it in a unique and unrepeatable way. I chose the Chopin F Major Nocturne with

confidence. In some strange way my right hand started off in F-sharp major while my left hand behaved well in F major. I could not bring them together. I went through the entire nocturne with the hands separated by half a step. No one said anything; the cacophony must have been horrendous. A musician I had just met looked at me with bleary eyes and slowly shook his head. The party moved on to fresh excitements. For me, and I think for most nonvaudevillian pianists, this performance would have been an impossible feat had I not been under the influence of Demon Bourbon. I still cannot figure out what strange perversion of the imagination induced such a schizoid performance. I was told the next day that I was surprisingly accurate throughout, with both hands behaving well in their chosen keys: "You never missed a wrong note!"

During my youth, most of my friendships came from musical associations, including my best friend for many years, Cedric Wright. When I was about eight years old, my father, mother, and I spent a few weeks with Cedric's family, the George Wrights, at their country home in the Santa Cruz Mountains. George Wright was my father's attorney, and he and his wife were also part of my parents' social life in San Francisco.

The Wrights' country house was built on a steep, forested bank at least fifty feet above the San Lorenzo River. From the main porch the view was directly into the high branches of the trees and down to the pure and rippling stream. It was all very idyllic and clean: bird chirps, river sounds, and the fresh forest fragrance of the air.

Dinner, which I dreaded, was conducted under very proper conditions of stuffy furniture and stuffier food with table talk either above or below me but certainly inconsequential. One afternoon I was swinging rather violently in the porch hammock, expending all the energy I could before my enforced dinner with the adults. I overdid it and fell backwards, hitting my head on the very hard floor. I was out for an hour or so and awoke in bed with a concerned doctor, worried hosts, and frantic parents hovering above me. Any damage, for good or bad, remains undetermined.

That country near Santa Cruz was a strange complex of lush riverbanks, canyon forests, and high, brushy, arid areas. It was always hot in summer — too far inland for the cool benediction of the sea fog. When the wind was right, fragrant smoke from the sawdust burners drifted down the canyon. Seventy years ago the forests seemed inexhaustible and few were concerned over their depletion.

Cedric Wright was a bit of a rebel; the very conventional Wright home in Alameda would have been a difficult environment for any free spirit in which to flower. I will never forget Cedric's debut violin recital in San Francisco that I attended when I was about twelve and he was about twenty-five. Cedric appeared in knickers, an affectation that persisted throughout his life. He started with the Bach Chaconne for Unaccompanied Violin in D Minor, playing it forthrightly, though with a nervous intonation. When he reached the first repeat, he returned to the beginning and played an interesting and properly enhanced variation. When he came to the repeat again, he forgot the second ending and had to start over. He played courageously, only to forget the second ending once more. He then flourished the violin from under his chin and said to the audience, "Well, I guess you have had enough of that," and walked off the stage. He returned unperturbed for the rest of the program, which he performed very well indeed, and received a hearty round of applause. For many musicians, especially at their debut, such a lapse of memory would have been catastrophic, but not for Cedric. He was able to put his rather extraordinary personality above such minor disasters; in fact, he would extract all possible humor from them.

I did not see Cedric again until the summer of 1923 in Yosemite. The Sierra Club enjoyed an annual outing, during which many members would camp and climb together. In 1923 the outing group, including Cedric, came to Yosemite and started their trek to the northern areas of the park. I was invited to join them for the first few days. On this short excursion Cedric and I became warm friends. We found we had many mutual interests, especially music (we both preferred Bach and Beethoven), the mountains, and our budding awareness of photography.

Many of Cedric's photographic portraits were very fine, and a good portion of his prints were excellent. Somewhat like Edward Weston, he had a specifically personal technique, hence a disregard for many of the basic technical principles of photography. However, in his continuous search for artistic identity, Cedric often came under the influence of admiring flatterers and would be swayed in his approach to photography with unpredictable results. A noted pictorialist, Nicholas Haz, admired Cedric's work and convinced him that the formula for creativity was freedom from rules and technique. Cedric's photography never entirely recovered from the self-indulgence this fostered.

Cedric was greatly influenced by Elbert Hubbard's doctrines of

naturalistic simplicity, and I am sure William Morris would have accepted him in his circle. Walt Whitman, Havelock Ellis, and Edward Carpenter were Cedric's saints, and Fritz Kreisler, the great violinist, his prophet.

I became a regular at the frequent, happy, and informal evenings at Cedric's Berkeley home, where I met many of the people who were to become so important to me in future years. The route to Berkeley by ferryboat, train, and streetcar was long and circuitous, taking nearly four hours round trip, but the journey was always worth it.

I was beguiled by the unique architecture and spirit of Cedric's Bernard Maybeck–designed studio home. Maybeck was a magnificent architect, with an incredible wealth of imagination and taste. He had created a marvelous home for Cedric out of an old barn tucked away in redwoods and lush foliage on Etna Street, a few blocks from the University of California. One of the most remarkable buildings I have ever seen is the still amazingly contemporary Christian Science Church in Berkeley that Maybeck created and built in 1911. He also designed the one building from the 1915 Panama-Pacific Exposition in San Francisco that still stands — the Palace of Fine Arts, now sheltering the Exploratorium, a "hands on" science museum. The functional design of his elegant structures was, in my opinion, far more humane and workable than were those of Frank Lloyd Wright. And, Maybeck's roofs seldom leaked, a common complaint of the occupants of Wright's masterpieces.

Despite the fact that his first wife, Mildred, and daughter Alberta were both intelligent and charming, Cedric was a victim of an unrequited desire for the ideal woman. He had a stunning affair, which I am sure was unrealized, with an impossibly perfect creature, who quite unexpectedly married a motorcycle racing star! I had Cedric's case of hysterics on my hands for a week. He smothered his woes with marriage to Rhea Ufford, a pianist. They had a reasonably happy life together and produced two children, David and Joanne.

What was both a curse and a blessing for Cedric was that he was always comfortable financially and had absolutely no concept of what the average material condition of most people might be. I have found this true of many idealists and have wondered what restricted funds might have done to Cedric's continual devotion to the unrealities of life. I believe he would have overcome any misfortune because he had such faith in beauty and the human potential. So confident was Cedric of the humanizing powers of the mountains that he wanted to invite

Joseph Stalin on a Sierra Club outing! As an old mutual friend said of his intention, "Well, you never can tell, he just might have pulled it off!"

There was never anyone more at home in the mountains than Cedric, though he seldom scaled peaks and heartily disliked what he called "display climbing" — chalking off fourteen-thousand-foot crags as trophies. We joined in a disregard for the naming of things and were skeptical of those nonprofessionals who go through the wilderness classifying and labeling everything in sight. We both agreed that mountains and places probably should have names, but that a simple flower gains little (except to botanists) by carrying a ponderous Latin classification.

My involvement with the Sierra Club was a basic introduction to the concepts of wilderness and conservation. Cedric was never directly involved with the conservation-environmental aspects of the Sierra Club activities, but he was devoted to the Sierra at a very human and creative level and made impressive contributions through the pairing of personally written associations with his photographs. We all have our ways in which we serve best; some work independently in the world at large, some work within the structure of organizations, and others create personal prompts and messages in various art forms which support the dominant theme: protection of the environment for those qualities and benefits only the earth can provide for now and for the future.

In 1960 the Sierra Club published *Cedric Wright: Words of the Earth*, a beautiful posthumous book of his photographs and writings edited by Nancy Newhall. In this book Cedric wrote:

> *Out of the vast process of evolution through need,*
> *out of the cycle of passing forms,*
> *arises eternal, elemental beauty.*
> *Intense beauty is liberation.*

For a while, all seemed well with Cedric until he suffered a stroke. His last years were complex and difficult. He dedicated himself to writing and mimeographing hundreds of pages against all educational systems in general. His daughter fell in love and married a teacher. This was the last straw; nothing could have been more destructive to Cedric's intensified ego. Sadly we observed another personality, rigid and dictatorial, emerging in this later part of Cedric's life; a painful experience for all his friends.

I remember well the younger Cedric as almost an occupant of another world and a creator and messenger of beauty and mysteries. Perhaps his greatest gift was that of imparting confidence to those who were wavering on the edge of fear and indecision; often it was me. We shared much, playing music together, hiking together, writing letters with our deepest feelings, bolstering each other through topsy-turvy romances with dream girls and real girls. In 1937 I wrote:

Dear Cedric,

A strange thing happened to me today. I saw a big thundercloud move down over Half Dome, and it was so big and clear and brilliant that it made me see many things that were drifting around inside of me; things that related to those who are loved and those who are real friends.

For the first time I know what love is; what friends are; and what art should be.

Love is a seeking for a way of life; the way that cannot be followed alone; the resonance of all spiritual and physical things. Children are not only of flesh and blood — children may be ideas, thoughts, emotions. The person of the one who is loved is a form composed of a myriad mirrors reflecting and illuminating the powers and thoughts and the emotions that are within you, and flashing another kind of light from within. No words or deeds may encompass it.

Friendship is another form of love — more passive perhaps, but full of the transmitting and acceptances of things like thunderclouds and grass and the clean reality of granite.

Art is both love and friendship and understanding: the desire to give. It is not charity, which is the giving of things. It is more than kindness, which is the giving of self. It is both the taking and giving of beauty, the turning out to the light the inner folds of the awareness of the spirit. It is the recreation on another plane of the realities of the world; the tragic and wonderful realities of earth and men, and of all the interrelations of these.

Ansel

4.

Family

WHEN I WAS A YOUNG CHILD, THE ADAMS FAMILY was prosperous. We frequently visited my grandparents' residence, "Unadilla," in Atherton. It was a stately old home with extensive grounds, typical of a wealthy family of the times. I recall the spacious rooms, the heavy furniture, period oil paintings, and several servants, including two gardeners. The great oaks stood at discrete distances from one another with skirts of English ivy that climbed far up the large trunks. A wide and generous staircase led from the lawns to the broad porch with rocking chairs and awnings. The first floor had a parlor, a sitting room, a dining room, a smoking room, and a very ample kitchen and pantry. The second floor had numerous bedrooms, all furnished with mahogany beds, tables, and chests, marble wherever there was a flat surface, and large windows with double curtains. There was also a tower with a curving staircase where I could sit and read while looking over the oak groves and mountains in the west or the marshes leading to San Francisco Bay to the east. The tower was a wonderful place to be in a storm and there I could be found, gloating at the wind and rain from my lofty, secure perch.

The mournful whistle and roar of the trains, passing night and day, became part of the total experience. Many a night I lay in my comfortable bed and waited for the Doppler-distorted whistle with its swelling, then subsiding rumble as the trains plowed through the dark countryside south to San Jose or north to San Francisco.

Grandfather Adams died in 1907 when I was five years old and "Unadilla" burned to the ground the next year. I remember my father receiving the news about "Unadilla" over the telephone. He hung up the phone and, with a sad and pale manner, went upstairs and closed

the door. My grandfather's business had failed during this same period: three depressions, the loss of twenty-seven lumber ships and three mills all within a decade.

My father bravely attacked the problems of regaining the family fortunes, but there was not much money and we literally went on rations. The only other member of the family interested in sorting out the financial mess was my wealthy Uncle Ansel Easton. My father, Uncle Ansel, and Cedric's father, George Wright, incorporated the Classen Chemical Company, a handsome factory at the site of one of my grandfather's lumber mills at Hadlock, Washington. They had acquired the rights to a process that produced two-hundred-proof industrial alcohol from sawdust. Its location in the heart of the lumber country was ideal; huge quantities of sawdust and chips were free for the asking. Barges were acquired for transportation of this material from all parts of Puget Sound. The first alcohol produced met the highest quality tests.

In the meantime, what was known as the Hawaii Sugar Trust woke up to the fact that Classen was to be a prime competitor. The Hawaiian firm used sugarcane for the production of alcohol through a somewhat different process. The Hawaii Sugar Trust put the Classen Chemical Company out of business by buying up the stock, discharging the directors and executives, and operating the plant in a thoroughly destructive way.

It was a terrible blow to my father to learn that his trusted brother-in-law — my Uncle Ansel — and George Wright — his good friend and attorney — had each secretly sold their one-third interest to the Hawaiian group for a handsome sum, knowingly providing the controlling interest. It was one more financial calamity, made all the more difficult to endure because of the betrayals. It ensured near-poverty for my father for the rest of his life.

Named after Uncle Ansel Easton, I ceased using Easton in my name when twenty years later I realized the enormity of what he had done. My photographs from this time can be dated because of this decision. Through 1932 I signed Ansel Easton Adams, then Ansel E. Adams in 1933, and finally Ansel Adams from 1934 to the present day.

The Bank of California and my grandfather and father had always worked in close collaboration. There was mutual trust; loans were made with the assurance they would be repaid. The bank financed my father as he attempted to use the Classen property to launch a process related to the mineral antimony. His head chemist was not a bright individual, and the result was another debacle. My father simply was

not a good businessman and he could not cope with the deviousness that confronted him at most every turn. The bank took over the property, but they went beyond the call of duty in supporting my father over a number of years of hopeful exploration of enterprises that could be developed at this location. Years later I photographed the remains of the old factory and thought of it as a haunted shell of true disaster. Lumbering in the area had diminished to the vanishing point, and the entire region was quite depressed.

My father struggled to make a good life for me. I did not realize until many years had passed how tough it really was; the family fortune had diminished to a memory and my father was desperately seeking a position. It was very difficult for this formerly affluent man to find an appropriate job.

I recall the great psychological depression my mother suffered through these years. I could not understand it, but I was quite aware that something was wrong. My mother simply gave up in the face of continuing misfortune and spent much time staring at the floor and brooding over fate and circumstance. She could speak of little else but the crooks who did my father in. It was a time when my father desperately needed support and cheer and these were sadly lacking. Aunt Mary did little to help the situation, moaning and groaning along with my mother and blaming my father for "not using his brains." He finally got a job selling insurance for the West Coast Life Insurance Company and had to spend several months in Salinas. It was a lonesome period for me.

I think often of one bleak evening with a strong and bitter wind and no rain to console the tumult. My father returned home to the usual lack of sympathy, taking recourse in some bourbon, which he richly deserved. Mother was aloofly critical. Aunt Mary was quite impossible, sniffing with disdain and saying Father should not appear in such a condition before his son. I could never recall him exceeding the limits of genteel tottering and could not grasp why he should not have a drink if he wanted. I remember the last, slightly warm rays of the sun, shredded by the clouds, and the strange noises of the wind as it whistled about the house. My father went upstairs to bed, holding firmly to the banister. I went to my room and played with my Anchor Blocks. I started to build a powerhouse, German-style, but my set of blocks was not large enough to manage it. I loved building with those blocks, seeing a structure take form in the earthy reds, yellows, and blues of various shapes and dimensions. I had started music lessons at this time and sensed a relationship of precision between the abstract

notes and the creation of structures with my blocks. My supreme achievement was a Gothic cathedral that the family cat demolished by smoothing against it.

The delicacy of chance and the uncertainty of fate grow upon me as I come to the last act of my personal performance. I can still see my father with slight instability navigating the stairs, my mother's ill-concealed embarrassment, and Aunt Mary's stern displeasure. What impresses me now, nearly seventy-five years later, was the total integration of my family, the wind, the last sun rays, and the consolation of playing with my blocks.

Sharp visions of childhood remain engraved in memory with an intensity far beyond their factual experience. Re-created in later years, they sometimes serve as catalysts for a better understanding of many occurrences. I recall one precious moment of an early summer. The persistent fog had lifted and the warm sun streamed into the dining room through the west-facing windows. I was setting the table for our supper. The light was unforgettable. Fog was still pouring through the Golden Gate and the foghorns could be heard. Why should a situation such as this create a lasting revelation? Some might say that such memories are déjà vu, that we are building castles of imagination and nostalgic affirmations. I do not believe this. I feel that such events as this and the night I realized my parents' unhappiness offer a glimpse into a world-pattern beyond our conscious awareness.

After failing at a series of jobs, in the early 1920s my father became the secretary of the Merchant's Exchange Association. He managed their office building on California Street. On its ground floor there was Maritime Hall, the center of the shipping business in San Francisco. The fourteenth floor was occupied by the Commercial Club, a businessmen's lunch club. The floors in between were leased as offices. Each month my father would make out the rent bills and I would take them around the building to all the tenants. Every two weeks there was payday for the building's employees. The wages were put, as cash, into little, sealed envelopes with the name of the recipient and the amount typed across the top. The janitors, engineers, and elevator operators came to the office for their pay, where I doled out the envelopes. I tried to help my father whenever I could spare the time from my music. Each employee counted his pay carefully, smiled, and then signed that it had been received if they could write or placed an X if they could not.

When the crash of 1929 came and things went sour for business in general, my father tried to hold the Merchant's Exchange together.

The board of directors, quite scared, were insistent that all tenants in arrears be evicted with dispatch. My father argued that many of them had occupied their space for years; he felt sure they would pay up when they could, "For God's sake, give them a chance!" The board refused, whereupon my father said he would leave if they insisted upon the evictions. He would have been fired except that one member of the board, Mr. Henry Wangenheim, stoutly stood up for my father and persuaded the board to admit that a tenant removed would merely leave unoccupied space, but if retained might, when recovery came about, pay up the rent past due. By the late 1930s, when the Depression had eased, over ninety percent of the tenants had paid their rent debt in full.

Through these years my mother continued to fail, first in her lack of support for my father and then in her own stamina and health. Arthritis struck before the age of sixty. After two severe falls, she was eventually confined to a wheelchair. My father blamed himself for her long, slow descent into despair.

Finally, in 1950, at the age of eighty-seven, my mother went into a coma. My father was bewildered, for now there was truly nothing to be done. We stood around her in a vague state of dread of the inevitable, mixed with hopes that her ending would not be further prolonged. She died quite peacefully of pneumonia, simply ceasing to breathe. I had heard the death rattle before. With my mother it was a long rustling sound combined with an inexpressibly sad sigh. Her eyes were open, of startling clarity and stillness, staring beyond us and beyond the world. The doctor came and signed the death certificate. The undertaker arrived with cool professionalism, moving the wrapped remains to a gurney. My mother was wheeled out of the house and down the walk, through the gate to the awaiting hearse. My father insisted upon following and he stood bareheaded in the drizzle while her body was rolled into the vehicle and the doors closed.

We returned to the house and I fixed hot toddies, which we drank by the fire. My father was dazed, but I am sure he was also relieved. I had a peculiar sad joyousness that I could not share with anyone. For many years my mother had lived but half a life, mentally and socially, a life that brought little pleasure to her or to anyone.

I went the next day to finalize the funeral arrangements. I was welcomed with a hushed bow and, "We are, of course, here to serve you in all possible ways. Please be seated." In proper time a portly character in semiformal clothes, face molded in unction, entered the waiting

parlor and asked, "Now, Mr. Adams, what may we do for you and your family?" I explained the desire of my father and myself for the most simple service and accessories. He asked me to come to the casket room and pick out what my mother would have wanted. I told him I desired the simplest and cheapest box in the room. Cremation was to follow; why burn up furniture? I passed by the samples he showed me, beginning with the eight-thousand-dollar model and selected a two-hundred-sixty-dollar affair that seemed the least I could purchase without doing the job myself (gruesome thought).

The undertaker appeared to be shocked and said, with an arched expression, "Have you no respect for the dead?"

I was, for one of the few times in my life, furious. I said, "One more crack like that and I will take Mama elsewhere." She was already embalmed in icy grayness upstairs.

"Very well," he replied, "Mr. Adams, please pick the casket easiest for you and we shall proceed." Icicles draped the establishment, its people, and me.

It was like buying an automobile. The accessories inflated my mother's final splurge in which I was trapped. Credit was discreetly arranged. The butler of death gave me a scornfully hostile adieu, and I went to greet some friends and distant relatives who had come to pay last respects to an effigy that was definitely not my mother. The distressingly mannered "slumber room" made me want to grab what was left of her and escape to any place where there was some life and fresh air. The assembled group talked in conspiratorial whispers, attempting a mood of awe, but there was nothing to feel awed about.

The funeral took place two days later: a depressing event with a poor organist and a nitwit minister. A large number attended the affair; people came out of the social woodwork for the occasion. After the remains were viewed, those who were to go to Cypress Lawn Cemetery for the "fireside" services assembled and two limousines followed the hearse in a slow and stately processional, commanding the flow of traffic as is the privilege of the dead. In the chapel adjacent to the crematory, the casket, smothered with flowers, was mumbo-jumboed over and then, with surprising efficiency, wheeled through the open doors into the blazing furnace. The doors closed.

We rejoined the cars and were returned home at almost illegal speed. Our driver said goodbye in the first normal-toned voice we had heard that day. The house was not really lonely, only different. We went for a drive to Land's End where we could see and feel the healing

beauty and power of the sun and sea and the distant hills. It took me much longer to get over the affront of the Death Business than the death itself.

One of the bright moments of my father's life was the award of the Bruce Medal by the Astronomical Society of the Pacific. It was totally unexpected; my father was not an astronomer but was devoted to the subject and this prestigious society to which he gave so much of his time. I wish my father could have lived several decades more to observe the vast expansion of cosmic knowledge and the discovery of billions of galaxies, worlds without end. I remember him explaining to me the LaPlace theory of the spiral nebulae, which were supposed to be solar systems in formation, huge configurations of gas condensing into a sun and attendant planets. So obvious and so clean cut! And so wrong, for spectroscopic research revealed these spiral forms as vast masses and eddies of billions of stars at incomprehensible distances.

My father survived for little over a year after my mother's death. He made a good adjustment to the loss but suffered disintegrating health. His infirmity was old age. He became weaker and was finally unable to leave his bed. I rented a TV set in an attempt to interest and orient him. One day he called me into his room. He was watching a bevy of smiling chorines toothfully singing while looking directly at the viewer. My usually immaculate father was unshaven, sitting up in an old robe. He asked me in all embarrassed seriousness, "Ansel, can they see *me?*"

Harry Oye had worked for us for many years as gardener and cook. He gave warm support to everyone. A devout Nicheran Buddhist, Harry put on his religious robes, set up a little altar, lit some candles, and silently sat by my father throughout his last hours. As Harry silently prayed, I held my father's hand. My father's breathing became more rapid and shallow and then he trembled with the slight shiver of death. The room was silent and his face peaceful. He died on August 9, 1951.

We held a simple service at home with soft choral music by Frescobaldi and a minister who was human and wise. My father's ashes rest in the family plot at Cypress Lawn, as do Harry Oye's. While far more bearable than my mother's funeral, such ceremonies are completely inadequate in relation to the significance of the person. The most moving event of my father's death was the presence of Harry Oye in his beautiful ceremonial robe, the symbol of the lighted candles, the ever-present wisdom of Buddha, and his quiet benediction.

5.

Yosemite

WHEN I WAS TWELVE, I CONTRACTED MEASLES AND was put to bed for two weeks with the shades drawn to protect my eyes. My father read to me when he came home from the office. My mother and Aunt Mary fluttered around, commiserating and annoying, though with the best of intentions.

The spaces between the shade and the top of the windows in my bedroom served as crude pinholes, and vague images of the outer world were projected on the ceiling. When anyone moved outside to the east, the highly diffuse image would move along to the west above me. It took me quite a time to understand this phenomenon; it was my first inquiry into the complex structure of image formation. My father explained it and I then grasped the theory of the camera lens and why the picture was upside-down on the film. He opened his Kodak Bullseye camera, placed a piece of semitransparent paper where the film usually resides, set the shutter on open, pressed the button, and voilà — a camera obscura! This effect had been observed for thousands of years, yet it was not until 1826 that photography began with an image that was actually preserved by the Frenchman Nicéphore Niepce.

My Uncle Will brought me his old microscope, a dignified contraption of brass with a few accessories. My father gave me some slides, slide covers, and a tube of balsam. I made a lot of microscope slides, including one of a flea that I photographed several years later. I had great pleasure and successful therapy in this exploration.

In 1915, the family began planning a vacation for the early summer of 1916, destination uncertain. My Aunt Mary flatly declined to come with us, wherever we went, because there would be no one to care

for the cat. This was a sore point with my father, who felt she was a bit irrational about the animal, as a neighbor had offered to care for it. This particular cat was a suave, black individual who took every arrogant opportunity to be lord of the house.

In April 1916, I was in bed again, this time with a cold. Aunt Mary gave me her copy of *In the Heart of the Sierras* by J. M. Hutchings, published in 1886. I became hopelessly enthralled with the descriptions and illustrations of Yosemite and the romance and adventure of the cowboys and Indians. The text is florid, commonplace, and not too accurate, but I did not know that — I devoured every word and pored over the pages many times. The following quote from *In the Heart of the Sierras* was written by Dr. Lafayette Bunnell in 1851, who was a member of the first expedition of "white men" to "discover" Yosemite.

> It has been said that "it is not easy to describe in words the precise impressions which great objects make upon us." I cannot describe how completely I realized this truth. None but those who have visited this most wonderful valley, can even imagine the feelings with which I looked upon the view that was there presented. The grandeur of the scene was but softened by the haze that hung over the valley — light as gossamer — and by the clouds which partially dimmed the higher cliffs and mountains. This obscurity of vision but increased the awe with which I beheld it, and as I looked, a peculiarly exalted sensation seemed to fill my whole being, and I found my eyes in tears of emotion.
>
> To obtain a more distinct and quiet view, I had left the trail and my horse and wallowed through the snow alone to a projecting granite rock. So interested was I in the scene before me, that I did not observe that my comrades had all moved on, and that I would soon be left indeed alone. My situation attracted the attention of Major Savage — who was riding in the rear of the column — who hailed me from the trail below with, "You had better wake up from that dream up there, or you may lose your hair; I have no faith in Ten-ie-ya's statement that there are no Indians about here. We had better be moving; some of the murdering devils may be lurking along this trail to pick up stragglers." I hurried joined the Major on the descent, and as other views presented themselves, I said with some enthusiasm: "If my hair is now required, I can depart in peace, for I have here seen

the power and glory of a Supreme Being; the majesty of His handy-work is in that 'Testimony of the Rocks.'"

The promised vacation MUST be in this incredible place: Yosemite! Neither of my parents had been there. Their thoughts were of Santa Cruz or Puget Sound, but my insistent pleadings finally brought them around to Yosemite. June was a month away and it was hard to concentrate on anything except the coming trip, but I endured the agonies of impatience and on June 1, 1916, we boarded the early morning train in Oakland, bound for Merced and El Portal. The car was full of people — fanning elders, active and inquisitive children —shepherded by a disdainful conductor. The air was clean as we traveled through the San Joaquin Valley; pollution had not taken its toll and we could see the distant Sierra Nevada, more than a hundred miles away, as we emerged from the Altamont Pass.

Our railroad car was transferred from the Southern Pacific to the Yosemite Valley Railroad in Merced, then a sleepy little agricultural town in a flat and very hot plain. After we lunched in the local hotel, the train chugged out of the station, passing pastures and fields on its way to the mountains.

As we entered the foothills, the heat became severe; the train windows were open, in spite of the dust, ash, and smoke, and we were grateful for the breeze. All the hills were covered with dry, golden grass; this parched color seemed to accentuate the heat. California loses its green mantle at low altitudes in April and May. My mother suggested I take off my fairly heavy jacket so that my perspiration could evaporate. At one hundred degrees in the shade, anything more than a shirt was drenching. My father did likewise, but my mother lived in an age when she could not take anything off; she was very moist and uncomfortable. She wore bloomers, a long khaki skirt, a closely buttoned blouse, wide-brimmed khaki hat, and high boots and carried a warm khaki coat.

Roaring and belching smoke, the train passed through hills of increasing height to the Merced Canyon. To our right was the foaming Merced River, and far above us the bleached hills rose loftily, dotted with pine and oak. The echoes of the locomotive on the canyon walls were shattering. Blasts of hot air buffeted through the windows, and the steam whistle sent chills up my spine; anticipation mounted with every new vision.

There was a fresh fragrance from the Digger pines sparsely gathered

on the hills, the sunlit gray-green whispers of forest that cast little shadow. The steep slopes dropped to the river with outcroppings of lichened rock and slanting gullies. There was evidence of small creeks, dry since late spring, and mossy alcoves and grottoes.

Toward the cooling end of the afternoon, thickly forested mountains rose higher above us. We arrived at El Portal at about six P.M. and departed the still radiating coach for the Hotel Del Portal, registered, and were shown to our rooms. I threw open the windows to let out the stifling air, only to find the air that came in even hotter. But the open window also admitted the insistent roar of the Merced River; it was a different sound from that of the ocean and reverberated from the surrounding mountains — new sights, new sounds, new fragrances!

Under protest I took a bath after dinner. I surely needed one, but at fourteen who cares? The river sounds seemed to swell during the night. I was up at dawn, hours before breakfast, ran down to the river, explored its rocky shoulders, and investigated the train being put together for its departure back to Merced later that morning. I was tardy for breakfast, of course.

After an ample meal we were called to the huge, open bus that provided gales of fresh air, mixed with dust, fumes, and wonderful views. The road from El Portal to Yosemite climbs two thousand feet in ten miles. It skirts the north and west cliffs along the river; in 1916 it was a rough gravel road with thrilling drop-offs and towering vistas. Some of the passengers kept their eyes closed most of the time; my father called them flatland people. We passed Cascade Fall, the first waterfall I had seen. The guide kept yammering names and heights and fake Indian lore, but the river drowned him out.

We finally emerged at Valley View — the splendor of Yosemite burst upon us and it *was* glorious. Little clouds were gathering in the sky above the granite cliffs, and the mists of Bridal Veil Fall shimmered in the sun. We trailed a drogue of dust as we gathered speed on the level valley floor. One wonder after another descended upon us; I recall not only the colossal but the little things: the grasses and ferns, cool atriums of the forest. The river was mostly quiet and greenish-deep; Sentinel Fall and Yosemite Falls were booming in early summer flood, and many small shining cascades threaded the cliffs. There was light everywhere!

Dazzled, we arrived at Camp Curry and were met by that odd character, David Curry, the Stentor of Yosemite. After dark each night he would bellow for the "Fire to Fall" from the great cliff of Glacier

Point, thirty-two hundred and fifty vertical feet above the camp. Whereupon someone up there would push the glowing embers of a pine-bark fire over the cliff while a soprano sang a "thrilling" song. Even at that age I knew it was an insult to Yosemite.

I do not recall the rest of that incredible day; I had had enough. How we got to tent number 305, what we had for dinner, and how I stayed awake through my first campfire are mysteries to me now. I do recall the shivering night and the unbelievable glow of a Sierra dawn. A new era began for me.

One morning shortly after our arrival in Yosemite, my parents presented me with my first camera, a Kodak Box Brownie. After a few minutes of simple instructions, my camera and I went off to explore. A few days later, with my usual hyperactive enthusiasm, I climbed an old and crumbling stump near our tent to get a picture of Half Dome. I perched on the top of this relic of arboreal grandeur with my camera and was about to snap the shutter when the stump gave way and I plummeted to the ground. On the way down, headfirst, I inadvertently pushed the shutter. I landed in a cascade of rotten wood on a soft bed of pine needles. Undaunted, I wound the film to the next number visible through the little red window in the camera back and finished the remainder of the film.

The roll was developed at Pillsbury's Pictures, Inc. at the old Yosemite Village. I remember that it was Mr. Pillsbury himself, commercially successful in photographing Yosemite, who presented me with my developed film. He had not cut it apart, as he wanted to inquire how this picture had come to be upside down in reference to the others on the roll. He asked, "Did you hold the camera over your head to avoid close foliage?" After I explained to him about my accident, he gave me a strange look and I do not think he was ever certain of my normalcy from then on. The negative is reasonably sharp and one of my favorites from this, my first year of photography.

Financial troubles weighed heavily upon my father in 1917, but he insisted that my mother, aunt, and I visit Yosemite that summer. I returned by myself in the summer of 1918. I hiked and photographed, concentrating on making pictures of wildflowers that I sent to my father, an avid amateur botanist. They were very poor photographs indeed, but the subjects were identifiable. That summer interlude ended all too soon, and I returned home to my music, general studies, and a part-time job in a photo-finishing business.

In the early spring of 1919 I came down with a cold that turned into the classic flu of the year. This flu was a very serious matter;

people were dying everywhere. I was miserable, weak, and just lay in bed, a very sick seventeen-year-old. The doctor examined me and said there was nothing to do. He was bone weary and grim.

I fully recuperated, though it took several weeks. When I could read, I was given some books; one was about the life of Father Damien, the saintly priest who cared for the lepers of Molokai. The description of leprosy and the lepers had a profound effect on me. In my weakened state the psychological fixation grew into a compulsion. For months afterward I feared to touch anything such as doorknobs, streetcar railings, or people. If contact was made, I would rush posthaste to some washbasin and I would be agonized if I could not immediately find one. I remained physically weak and mentally disturbed.

I wanted to go back to Yosemite — I was certain there was no leprosy there! The doctor doubted the wisdom of exposing me to altitude and exhaustion. My father thought it a good idea; he knew that I was not progressing in my home environment. He arranged for the old tent at Camp Curry for a couple of weeks and wrote to Mrs. Curry and Mr. Francis Holman, whom we had met in Yosemite in 1917, explaining my condition and asking them to watch over me.

I will never forget my arrival in Yosemite on that mid-June day. The journey by train and bus had been exhausting. I could hardly walk to the Camp Curry office to register, and the further walk to my tent was an ordeal. The next morning I awakened to the sound of Yosemite Falls and the human chatter and bustle of the camp. I made it to breakfast. Afterward I found that I could walk around a bit. Mrs. Curry was very kind, and I think she knew that I needed anything but coddling. She saw to it that I had lunch and dinner and then hustled me off to bed.

The following day I walked the two miles to Happy Isles and back and another mile to see Mr. Holman at his riverside camp. Within the week I was able to walk to the top of Nevada Fall, and the following week I climbed Half Dome. Yosemite had cured me! I was never again bothered by such irrational fears and fixations.

Francis Holman (I called him Uncle Frank) talked little about himself, though I discovered he had graduated from the Massachusetts Institute of Technology in 1877 and had worked as a mining engineer in South America; he apparently had done well enough to retire with austere limitations. His face was chiseled and sad, his mustache drooped. He had lost one eye in a firecracker accident when a child; the other eye was as sharp as an eagle's.

Uncle Frank knew the Yosemite Sierra well and was a genius of

minimal-equipment camping. He was a cautious climber, a productive fisherman, and a well-trained ornithologist, who collected for the San Francisco Academy of Sciences. With full credentials, he occasionally fired a pellet gun at a specimen-to-be and then wept when the bird fell to earth and science. I shared his conscience about killing things. He was a rigorous Puritan, kind, intelligent, though noncommunicative in ordinary things of the world. By the close of his life I had learned nothing more about him. I have conjectured all kinds of careers. Did he have a "past"? Was he fleeing some great and shattering disappointment of life? I was never to know.

Uncle Frank and I had many marvelous and sometimes perilous experiences together in the Sierra. I have thought that we anticipated the Outward Bound spartan-style schools of wilderness adventure. We rose from our sleeping bags at dawn and alternated the chores of our camp: preparing breakfast or going out into the frosty meadow and untying the burro. The ropes would be ice-hard, the knots congealed, and fingers aching and sore. In time I would get them loose and hear Uncle Frank yell, "For God's sake, the mush is ready!" I would slowly struggle back, dragging one or two burros as the case might be, chilled to the bone, my legs wet and very cold, my nose runny, and my spirit dejected. I would soon revive, standing so close to the fire I could smell scorch.

Under the opposite situation I would prepare breakfast: oatmeal (if any), bacon and eggs (if any), and flapjacks (always). Occasional trout brightened any cooked meal. We did not starve, but we would brush close to malnutrition. We never stopped to unpack for lunch, which usually consisted of dried fruit or whatever could be reached through the burro-pack covers. Dinner would be tinned meats and vegetables, sometimes canned soup, raisins or dates for dessert, and maybe tea, especially if it was nippy (which it usually was above six thousand feet elevation).

The only thing I remember with distaste is that Uncle Frank was always determined to keep on the trail until it was practically dark. Then we would fumble for a campsite and a reasonably rockless or pineconeless stretch of flat earth. There was no way of knowing if we had put our bags on an ant nest; we found out in good time after retiring. I recall some dismal nights, awakening, crawling with ants — the nice, black half-inch-long wood ants that could bite, and often did. I would crawl out of my bag into frigid air, take the bag apart, and shake and pick off the ants from both the bag and myself as well. If there was no moon, I would stir up the fire to see the critters as best

I could. If I felt any on return to the bag, I would roll on them and often get a bite of appreciation in return. I remember dreadful nights when I had my fights with the ants and a toothache; it was almost too much.

For our more hazardous mountain ascents, Uncle Frank and I tied ourselves together with a fifteen-foot length of windowsash cord about an eighth of an inch in diameter. We climbed without thought of a belay. Had one of us fallen, the other would either have been pulled along or cut in two by the cord. Technical rope climbing was not introduced to the Sierra Club until 1931 by the eminent British climber Robert Underhill. With the advent of skilled rope climbing, formerly frightening situations became child's play.

Today the history of climbing recounts spectacular conquests in Yosemite; the Cathedral Spires, then the sheer faces of El Capitan and Half Dome were scaled by techniques of engineering that I find difficult to accept. A mountain can be climbed with delight and otherwise perilous slopes can be ascended with the use of ropes. I abhor the drilling of expansion-bolt holes in the pristine flanks of El Capitan and Half Dome; it is a desecration. Ego seems to vie with the respect I feel should be expressed in the presence of mountains. How can we define the delicate borders between ambition and the search for perfection and identity?

Francis Holman gave more to the mountains than he ever took. For several years he served as the custodian of the LeConte Memorial, the Sierra Club's headquarters in Yosemite. The Sierra Club Board of Directors had funded and authorized its structure, designating it as a memorial to Joseph LeConte, the eminent geologist and early conservationist who died in Yosemite Valley in 1901.

In 1918, the custodian was a mousy girl from Berkeley, majoring in botany. She treated me with great patience. I would often visit and read from the meager collection of books and pore over the snapshot albums of assorted mountain travels and climbs. The botany collection consisted of a number of pressed wildflowers in scratched cellophane covers; they were disintegrating and colorless mummies of the glorious lanterns of the world that blossomed progressively from early spring in the foothills to September on the highest summits. Perhaps the principal service of the Memorial was to mountaineers: there were maps, well worn and marked, and Park Service and Sierra Club bulletins.

In 1919 I had learned that the custodian was not to return the coming year so I joined the Sierra Club and applied to its great leader, Mr.

William E. Colby, for the job. Colby, an attorney who specialized in mining law, was the chairman of the California State Parks Commission. He had led the Sierra Club since the death of John Muir in 1914. Fortunately, Mr. Colby was understanding of my enthusiasm and, in spite of my callow youthfulness, I was hired as the custodian.

I arrived in Yosemite on April 17, 1920. The LeConte Memorial is a lovely, though simple, stone cottage, designed by an associate of Bernard Maybeck. It is on the south side of the valley, in the long shadow of Glacier Point, and when I arrived to begin my duties, it was damp, chilly, and dirty. Someone had broken in during the winter, made a general mess of things, and burned all the fireplace wood. The water and lights were shut off. I slept on an army cot with one thin blanket. The ten days required to clean the building and its surrounding area were grim indeed. In addition, it rained part of the time, the roof leaked, the waterfalls thundered out of the persistent cloud cover, the oaks were bare of leaves, the rocks and ground were wet and clammy, and the mice ran wild. Early spring in Yosemite is not always a joyous place of white water and light. In any event, I got the place clean and tidy and set up my little camp. In good time, the leaves burst out on the oaks, the ground dried, the skies cleared, and the waterfalls roared down their granite walls in sunlight. People would visit and ask questions, many that I could not answer that first year.

One day a week I led a small party somewhere about the valley or its rims. The routine was always the same: we would have breakfast together at Camp Curry, I would report where we were going, and then we would go out into the wilds. A trip I enjoyed repeating was a talus-top tour of the valley, starting at the base of the Royal Arches and working our way west. Sometimes we were hundreds of feet above the valley, then we descended to where the cliffs projected onto the valley floor. It was a real adventure, and the intimate situations of clean rock and flowers, tangles of brush and fallen trees, and the glorious views were exciting, especially to first-comers to Yosemite.

One occasion was not so sublime; at Camp Curry my party of eight and I had breakfast in which some ingredient was less than digestible. All but two of us became ill on the cliffs east of Indian Canyon. Retracing the steep slopes could not be considered in their condition, so we crawled on to the top, only to meet an expanse of snow on the forest floor. We found a clear space with some sheltering rocks, gathered wood, and built a large campfire, cheered by the excellent performance of an amateur ventriloquist. With nothing to eat and falling temperatures, we endured a long and uncomfortable night. At dawn

we continued across Indian Creek, threaded the icy ridge above Yosemite Creek, and hurried as fast as we could down the trail by Yosemite Falls to the valley. Rangers were out in force to rescue us. I was relieved to be told that I had done the correct thing in settling the group down for the night rather than retracing a dangerous route or proceeding onward after dark.

That summer of 1920 I was also preparing for my first lengthy trip with Uncle Frank into the High Sierra. Our itinerary would include Merced Lake, Mount Clark, and the beautiful wilderness east of the Merced Range, and I would have to buy my own burro to help carry our camping gear and food. I anxiously wired my father:

CAN BUY BURRO FOR TWENTY INCLUDING OUTFIT. CAN SELL AT END OF SEASON FOR TEN. FINE INVESTMENT AND USEFUL. WIRE IMMEDIATELY AS OFFER IS FOR TODAY ONLY.

My father replied positively and Mistletoe, the burro, was mine.

I knew little about burros and asked Chief Ranger Townsley how to feed it. His reply, "Stake it out in the meadow, lead it to water daily, and give it some barley every other day."

I bought a box of pearl barley at the village grocery store. It did not look like convincing food to Mistletoe, so I took it to the Ranger's Office and confronted Townsley at a staff meeting. "Is this what you said I should get for the burro?" I asked. There was an immediate howl of laughter. I was advised to go to the stables and get a huge sack of regular, rough barley, which cost about the same as the box of delicate breakfast food. For years I was known as "Pearl Barley" Adams.

This first High Sierra trip was my introduction to true wilderness. The Sierra Nevada, the dominant mountain range of California, may be roughly divided into three areas: the foothills, the middle elevations of four thousand to eight thousand feet where the finest forests are found, and the high country from eight thousand to fourteen thousand feet. Properly, Yosemite Valley is a national shrine, with millions of people each year coming under its spell. The High Sierra is also an environment of majesty, but it has, in addition, isolation, where one can come to terms with solitude.

The excitement of departure from Yosemite for this trip remains clear in my mind. Uncle Frank's burro and Mistletoe were properly outfitted and the packs carefully equalized. Each animal carried nearly a hundred pounds. Uncle Frank and I carried packs weighing thirty

pounds, my load being primarily photographic equipment. We were accompanied by Admiral Pond, his daughter Bessie, and a delightful Scottish lady, Miss Smith, who spoke with a burr as rugged as a juniper tree. The Admiral was a charming character, quite short and stout, but a tremendous walker. He and his daughter had walked the entire length of the California coast.

With compassion for our animals we had a moderate first day's climb to the Little Yosemite Valley. The penance paid for equine assistance was the sufferance of thwarted speed and inhalation of clouds of swirling dust. The animals must be in the lead: walking ahead of them can cause trouble because at every opportunity they will stop to browse or wander off the trail. I learned how to stake them out to feed, how to persuade, rather than browbeat, these determined animals, and how to attach the saddles and lash on the packs with the sleeping bags on top. Good balance and tight ropes were the essentials; there is nothing more distressing than to see a pack topple off a burro when negotiating a steep and narrow trail.

I had already grasped many of the rituals of camping on our earlier trips: finding a proper bit of smooth ground for the sleeping bag — being sure not to place the open end of the bag facing into the night wind — and how and where to build a campfire. In 1920 there were no worries about pure water, ample firewood, and pasturage for burros. Now the water, even at the highest elevations, is suspect, grazing animals and using dead wood for firewood are not allowed. The resources are too fragile to support the demands of the growing number of people who seek a wilderness experience.

The old Sunrise Trail to Merced Lake was varied and beautiful. We climbed out of the Little Yosemite through verdant forests of pine and fir with marvelous vistas of the Merced Range and then descended to the Merced River near Echo Creek Junction. Every moment was exhilarating. Even the animals were frisky, and Uncle Frank addressed them with choice Spanish expletives. Ever the gentleman, he first checked that the ladies did not understand Spanish.

The first dinner at our campsite two miles east of Merced Lake was an adventure. The voracious mosquitoes vanished with the chill of twilight. There was no moon and the stars were bigger and brighter than I had ever seen them. The sounds of the river and of the cascades of Gray Peak Creek above us were enhanced in the granite canyon: a sustained pedal point of throbbing, continuous tone.

At dawn I crept from my bag into the cold Sierra air at seventy-five hundred feet elevation. A broad spur of granite touched the river

nearby, and I decided to climb it, beckoned by the sunrise light on the sparse and rugged trees more than a thousand feet above me. As I ascended, the vistas of the Merced Canyon opened and I soon saw the crags below Mount Clark shining in the early light, their spires dominating all I could see. I returned to camp and found Uncle Frank busy with breakfast. He gave me a knowing smile and said, "Pretty fine, my boy, isn't it?" The mood of that moment was continued for many years and for many miles together on the trails and it was always pretty fine in every way.

We moved on to Washburn Lake and toiled up Fletcher Creek to Babcock Lake. Miss Smith proceeded farther and returned, extolling her discoveries in her broad Scotch burr, "Emerick Lake is like a Scotch loch." She sounded as if she was tearing apart a piece of plywood.

We returned to Yosemite Valley, arriving at the LeConte Memorial late in the day, begrimed and weary but celestially happy at the splendors we had experienced.

That summer also brought me friendship with William Zorach and his wife, Marguerite, who had come to Yosemite to sketch and paint. Both were excellent artists in the modern mode and I found their paintings inspiring. One hot day in July, Bill and I went on a hike. We climbed the trail to the base of Nevada Fall, then explored the gorge between Mount Broderick and Liberty Cap. Surviving this without harm, we ambitiously proceeded west to Grizzly Peak. Bill sketched madly whenever we stopped for a breath.

Rather than return the long way round via Nevada Fall, I decided to climb down the LeConte Gully just north of Grizzly Peak. It is very rough and steep, difficult enough to climb up, which I had done a number of times, but this was my first descent. I soon became aware that such precipitous terrain looks very different on the way down.

Bill was impatient to get back to camp. He was carrying a large portfolio, now filled with beautiful sketches. I kept to the north side of the gully, but he thought he saw a better route across a steep, polished slope of rock that broke off into a near-vertical precipice of several hundred feet. I yelled at him not to try to cross the rock; the dangerous combination of loose gravel and smooth, leather-soled boots was obvious to me. But he was determined to get to the other side, and I watched in dismay. Suddenly his feet slipped out from under him, his portfolio flew into the air, all his sketches fluttered out, lost over the cliff below, and he started sliding to the brink. He kept sliding with increasing speed, but with great fortune was able to grasp

a small, gnarled tree growing in a tiny cleft. With great difficulty he got to his feet and was able to stand on the steep slope against the little tree. He was frightened and bewildered. I was really scared and begged him just to stay where he was.

I climbed down to a point opposite him, about thirty-five feet away over a distressingly oblique and smooth rock surface. I told him to take off his shoes and socks, and I did the same. We tied the shoes together, stuffed them with our socks and hung them around our necks. I started out over the slick rock in bare feet that made good contact. When I reached him, we took off our belts and fitted them together. I led the way back, very slowly and carefully, each of us grasping the belt ends with one hand and holding up our pants with the other. We made it — the longest thirty-five feet I can remember. I have two handsome watercolors by Marguerite and Bill Zorach that hang in my bedroom. His is inscribed, "In memory of a wonderful summer in Yosemite."

There seems always to be some person, or persons, that will inadvertently shape a life, give it direction — for good or ill. Bill and Marguerite Zorach showed me their full and happy lives as creative artists. And I shall ever be indebted to Uncle Frank for his model of discipline and integrity. He taught me to keep cool and work hard under even extremely adverse conditions.

In the early 1920s Uncle Frank, his friend Mr. Schuh, and I camped at Young Lakes, north of Tuolumne Meadows in mid October. It was late in the season for nine-thousand-foot camping and it was very cold. We had a splendid climb on Mount Conness and planned to take two days to return to Yosemite Valley.

We all got quickly into our sleeping bags after supper. I crawled into my bag with all of my clothes on, including my coat, using my boots as my pillow. On awakening, I found about eight inches of fresh snow piled on my bag. Mr. Schuh was up ahead of me and had built a roaring fire. I knocked off the snow; my boots were quite dry but it was chilling putting them on as the snow kept falling.

Unfortunately, Uncle Frank had decided to be civilized. The previous night he had fully undressed and put on a nightgown, hanging his clothes on the willows about him. The morning presented a ghostly array of pants, shirt, shorts, socks, and jacket, thoroughly whitened with snow, while a snowy mound on the ground indicated the presence of Uncle Frank, with his boots, filled with snow, by his head.

He awoke and was appalled by the situation. We kept him in his bag until the various garments had been dried over the fire. Finally, he

was damply dressed and steaming before the fire. We took stock of our situation; it was twenty-four long miles to Yosemite. The snow at the present depth would be hard on our burros. We had to cross an exposed pass seven hundred feet higher, and the snow would be deeper as it continued to fall. We knew we must pack up and get over that pass without delay. Breakfast must wait.

At times the trail was impossible to see. The burros slipped and stumbled on the snow-covered rocks. At Tuolumne Meadows the snow abated but we pressed on, arriving in the valley at seven P.M., very weary and finally having our first meal of the day. We were lucky: four or five inches more snow and we would have had to reluctantly abandon the animals to save ourselves.

Such frightening experiences did not deter my explorations. I often hiked alone for days, an unsafe practice that is not to be condoned. I am sure that I found myself in many situations of uncommon danger because of my own ignorance and stupidity. However, I continued to treasure my solitary excursions into the Sierra; they gave me many unforgettable days and nights and constant opportunities for photo-graphing.

In the early spring of 1923, I decided to see the Merced Lake area under snow. It had been a severe winter and there was snow consis-tently above sixty-five hundred feet. I started out with my sleeping bag, food, and camera. Cooking utensils were stashed at a permanent lean-to campsite near the lake. I was wearing my favorite basketball shoes and two pairs of socks, which I found a favorable combination for hiking, though not exactly appropriate for snow.

I stopped near the base of Nevada Fall, hid my backpack under some rocks, and scrambled up the gorge between Mount Broderick and Liberty Cap. I climbed each of them, having some little trouble with the snow. It would be a bit hairy returning the way I came, so I went around Liberty Cap and ran down the zigzag Nevada Falls trail, an early masterpiece of trail construction. As I approached my hidden backpack, I alarmed a bear who apparently had designs on my food. He was dispersed by yells and a few well-placed rocks.

I started off again, complete with backpack, and when I reached Little Yosemite Valley I was feeling super-enthusiastic. I met two men coming down from Merced Lake and asked them to leave word at the LeConte Memorial for Uncle Frank that I would stay two days longer than expected. I had designs on Mount Clark.

The snow was soft in the afternoon and the going was not easy. I arrived at camp rather late, fixed a supper, and went to bed. I was up

at a very cold four-thirty A.M., had a good breakfast, fixed something for lunch, and suspended the remaining food from a high branch. I took my sleeping bag just in case I was forced to stay out overnight. I traveled up the canyon and soon realized the Mount Clark idea was quite impossible as it was a climb of another forty-five hundred feet.

I continued on to Washburn Lake and up the canyon beyond. Some clouds covered the sun, which kept the air cool and the snow firm. I climbed up into Triple Peak Canyon, still feeling full of exuberance and anticipation. Why not Isberg Pass? I proceeded to climb; the snow was in good shape but it took longer than expected. The late afternoon view was wonderful. I realized I could not get back to camp that day, so why not stay the night on Isberg Pass? It was only ten thousand feet. I had nothing to eat, but the magnificence of the scene compensated for food.

I dug a hole in the snow on the lee of a large rock ledge, crawled into my waterproof sleeping bag, and covered it with snow, still the best way to contend with subfreezing air. It was getting *very* cold; that night was the coldest I have ever experienced. A full moon illuminated the Ritter Range, and a vast view of the southern Sierra stretched southeast, while the Mount Clark Range and the Merced River basin glistened in the west under moonlit snow and ice.

The sunrise was glorious, but I remained in my bag until there was sufficient heat for me to crawl out, coat, shoes, and all, to face nothing to eat and many miles to camp. I finished off a roll of film with shivering hands and started down the precipitous, snowy slopes. The snow was frozen hard and the going was precarious in my rubber-soled basketball shoes. By the time I got to the lip of the five-hundred-foot shelf above the Merced Canyon, the snow had softened and the going was tough in another way: I was breaking through the snow, sometimes to a depth of several feet, and the effort of clambering out and venturing through more snow was exhausting.

I finally reached Washburn Lake at five that afternoon and Merced Lake one and one half hours later. I built a fire that, psychologically, at least, warmed my frozen body. A wind came up, which further accentuated the temperature. I took a pail to the river to get water for my projected cooking and as I stooped down to fill it I was struck in the abdomen with excruciating pain. I had never experienced anything like it. Doubled up, I nearly lost the pail to the swift water. I knew something was wrong as the pain persisted and then increased. I felt hot, in spite of my near-frozen condition. Without really knowing what I was doing, I managed to bring a full pail of water to the lean-

to, climb into my bag, and drink a large quantity of water over the several hours to midnight. My fever broke and I slept fitfully while it rained and thundered for hours, not adding to my peace of mind. The next day I attempted to leave but was too weak and disorganized. I finished my remaining food and kept as warm as I could. The following morning I started out for Yosemite Valley, about thirteen miles away. I picked up strength and spirit and arrived at the LeConte Memorial at sundown with no symptoms, though weak and tired.

It was not until May of 1929 that I found out what the illness at Merced Lake had been. I awoke one morning in Mabel Dodge Luhan's guest house in Taos, and as I got out of bed I felt the same fierce abdominal pain. It was diagnosed as appendicitis, and I was rushed to Albuquerque where the famed surgeon Dr. Charles Lovelace promptly operated. Had I known what it was on the frozen night years before in the Sierra, I would probably have died of fright on the spot.

How different my life would have been if it were not for these early hikes in the Sierra — if I had not experienced that memorable first trip to Yosemite — if I had not been raised by the ocean — if, if, if! Everything I have done or felt has been in some way influenced by the impact of the Natural Scene.

It is easy to recount that I camped many times at Merced Lake, but it is difficult to explain the magic: to lie in a small recess of the granite matrix of the Sierra and watch the progress of dusk to night, the incredible brilliance of the stars, the waning of the glittering sky into dawn, and the following sunrise on the peaks and domes around me. And always that cool dawn wind that I believe to be the prime benediction of the Sierra. These qualities to which I still deeply respond were distilled into my pictures over the decades. I *knew* my destiny when I first experienced Yosemite.

6.

Monolith

THE SNAPSHOTS THAT I MADE ON MY EARLY YOSEMITE excursions were studied at other times of the year with unflagging interest. My purpose, during those first years of photography, was to make a visual diary of my mountain trips. "That one is of Mount Clark. Here is Uncle Frank fishing near Merced Lake. This shows my campsite near Echo Creek."

The snapshot is not as simple a statement as some may believe. It represents something that each of us has seen — more as human beings than photographers — and wants to keep as a memento, a special thing encountered. The little icons that return from the photo-finisher provide recollections of events, people, and places; they stir memories and create fantasies. Through the billions of snapshots made each year a visual history of our times is recorded in enormous detail.

As I made more and more snapshots, I became interested in the photographic process and decided to learn how to make my own prints. Frank Dittman, a San Francisco neighbor, operated a photo-finishing business in the basement of his house. I forget who introduced us, saying, "You can learn a lot of nuts and bolts from Frank." Mr. Dittman offered me a job as a "darkroom monkey," and I began part-time work in 1917 and continued through the next year. I received two dollars a day and my first darkroom instruction, uninspiring as it was.

I arose early so that I could leave Dittman's place a little after seven A.M., fully loaded with yesterday's photographs and statements, delivering them by streetcar to a number of drugstores while collecting the work to be processed. Usually back at the shop around ten-thirty, I either developed the new rolls of film or made prints from

the preceding day's collections. I learned his photographic routines quickly.

As the films of the era were orthochromatic (only sensitive to blue and green light), I opened them in red light and marked the end of each roll with the job number, using a grease pencil. The films were hung from a wooden rod and weighted by clamps placed at the base of each film. Six rods at a time, with a total of thirty-six rolls of film, were grasped and lowered into the deep, twenty-five-gallon developer tank. A clock timer was set for five to seven minutes (the longer time if the developer was cold), and the rods moved up and down every half-minute in the tank for agitation. They were then lifted out of the developer and into the short-stop tank, jiggled a bit, and then placed in the fixing bath tank and further jiggled every minute or so. Each full batch of film was washed for about twenty minutes. When the developer solution dropped two inches it would be "freshened" with replenisher. One tank would last for several months, changed only when the solution looked like a thick broth.

After washing, each rod was hung on brackets and the film wiped with a small rubber squeegee. They were then moved to an electrically heated drying cabinet where they dried in less than half an hour. After noting the roll numbers, we then cut the films into separate frames and assembled them in their original envelopes.

To make the prints, I exposed the negatives with a rudimentary contact printing machine while another employee developed them. Print exposure time was experience-based guesswork, as was the selection of the contrast grade of paper. The negatives varied in density and contrast to a discouraging degree, but fortunately, the paper had a lot of exposure latitude. After only a week on the job, my judgment improved enough to make a large number of successful prints on the first try. But all too often the person developing the prints would howl, "Do number twelve over again!"

The prints were developed in a very dilute developer with a long developing time, allowing processing of thirty or more small prints at a time. A bunch of prints were dropped into the developer, separated swiftly, and poked around at random. After about three minutes they would be gathered and dumped into a fairly strong acid stop bath, separated, moved around a minute, and then put into a large tray holding the fixing bath. In three minutes they were placed in a drum washer; when all two hundred to three hundred prints of a set were in the drum, the water would be turned on and the prints spun around,

some sticking together, some sticking to the inside surface of the drum, and some getting cornered and folded in the turmoil.

Thirty minutes later the prints were removed to a drain board and then put through a ferrotyping solution, drained again, and fed to a heated drum dryer. The prints were placed face up on the canvas apron; there were eight prints to a row and we were hard pressed to complete laying out a row before it crept out of sight against the drum. With the proper amount of heat and speed, the prints dried upon completing one rotation and dropped off into a basket. Occasionally a print stuck to the drum; pulling it off would ruin it, so it was allowed to pass through again. If it remained stuck, it would cause a lot of trouble.

About once a season Dittman took off the dryer's cloth apron and had it laundered. I shudder now to think of the chemical contamination transferred from the inadequately washed prints to the apron. We did not realize at the time how important fresh solutions, proper processing times, and thorough washing were to image-permanence. These, my first lessons in darkroom technique, were decidedly archaic, not archival.

At this point I was not a professional or creative photographer, but an ardent hobbyist, if that term can be applied to a curious youth who wanted to try everything within reach. Though I was still deeply immersed in music, during the decade of the twenties, photography and hiking were my beloved diversions. From my music studies, I applied the axiom of "practice makes perfect" to my photography. Mastering the craft of photography came through years of continued work, as did the ability to make images of personal expression. Step by inevitable step, the intuitive process slowly became part of my picture making.

I remember seeing, in about 1919, an exciting vista from Baker Beach: a mass of dark cliffs gathering above the shore with a small segment of the ocean horizon beyond. The cliffs were clearly segmented into strong planar areas of light. I had no camera but my eye, and no reference to time but the slow passage of the sun. The scene has remained brilliantly fixed in my mind. I often returned with my camera in a futile search for that elusive experience with hopes for a moment that would justify a photograph. It has taken me a lifetime to recognize when I should *not* feel obligated to make a photograph. If I do not "see" an image in terms of the subject and its creative potential at the time, I no longer contest my instincts. I am certain that an-

other photographer's eye might perceive wonders in the scenes that evaded me.

In these early years there were glimmers in my mind, such as that experience at Baker Beach, of what a photograph could be. On June 8, 1920, I wrote my father from Yosemite about a photograph I had made of a little cascade in Tenaya Canyon. I had begun the study of aesthetics and applied what little I knew of the formal rules of art: design, symmetry, form, texture, tonality.

> . . . I am more than ever convinced that the only possible way to interpret the scenes hereabout is through an impressionistic vision. A cold material representation gives one no conception whatever of the great size and distances of these mountains. Even in portraying the character and spirit of a little cascade one must rely solely upon line and tone. I have taken such a photograph . . . and am enclosing it in this letter.
>
> It is a delicate subject to use and I want to explain the print and my object in taking it thus. . . . I had the idea all framed several days before undertaking the picture. The idea is as follows; in some way to interpret the power of falling water, the light and airy manner of the spray particles and the glimmer of sunlit water. Very easy to think about but not so simple to do. The representation of detail and texture here gives the impression of fineness and lightness. As to the portrayal of sunlight on water I have managed that by the lighting — a deep somber background upon which the extreme opposite tone of the water is exaggerated so as to appear almost luminous. Can you see now what I mean when I say the tone and texture of a print has much to do with character and condition? Also the placement of the principal parts are such that the eye cannot follow them without slight Effort, adding more to the dynamical portrayal of the scene. . . . The reason for this lengthy explanation is that I want you to see what I am trying to do in pictorial photography — suggestive and impressionistic you may call it, — either, — it is the representation of material things in the abstract or purely imaginative way. I feel quite happy over this picture, to my mind it is the most satisfactory composition I have yet done. Hope you like it. . . .

I can recall achieving another layer of meaning in only a few of the photographs taken before 1927. In 1923 I was on a long pack trip with my friend Harold Saville in the regions south of Mount Lyell, carrying a 6½x8½-inch Korona view camera, six double plate holders, and six boxes of Wratten Panchromatic glass plates. I had only one lens, and since it was fairly wide-field, my landscape pictures were

quite inclusive. I made many drab shots and suffered some embarrassing failures.

There was one exceptional photograph of Banner Peak and Thousand Island Lake with a glowing evening cloud. I can recall the excitement of the scene, though at the time I had no precise idea of the image I was to make. It seemed that everything fell into place in the most agreeable way: rock, cloud, mountain, and exposure. I am sure things were going on in my mind: associations, memories, relative structuring of experiences and ideas, and the flowering of intuition. This picture still has a certain unity and magic that very few others suggested in those early years.

One bright spring Yosemite day in 1927 I made a photograph that was to change my understanding of the medium. My soon-to-be wife, Virginia, our friends Cedric Wright, Arnold Williams, and Charlie Michael, and I started out quite early that morning on a hike to the Diving Board. A magnificent slab of granite on the west shoulder of Half Dome, the Diving Board overlooks Mirror Lake thousands of feet below. Several years before I had climbed to the Diving Board with Francis Holman, and since then I had thought of that staggering view of Half Dome and knew it would make a good photograph.

We decided to climb via the LeConte Gully, just north of Grizzly Peak. This route would be relatively free from snow though it is very steep and rough, and much easier to ascend than to descend, as I had discovered with Bill Zorach in 1920. My camera pack alone weighed some forty pounds, as I was carrying my Korona view camera, several lenses, two filters, six holders containing twelve glass plates, and a heavy wooden tripod.

At the top of the gully, we removed our packs for the difficult final climb of several hundred feet to the summit of Grizzly Peak. This craggy rock tower gave us a rather startling panorama: four waterfalls, the great mass of Glacier Point, Half Dome rising thousands of feet higher, and the many peaks of the Sierra, dominated by Mount Florence and Mount Clark. Everything above seven thousand feet was covered with snow. I regretted leaving my camera below the summit.

We returned to the intermediate base, took up our packs and proceeded up the long, partially snowy rise of Half Dome's shoulder. I stopped often to set up and compose pictures. I had several failures, but did get one rather handsome telephoto image of Mount Galen Clark. By the time I had finished that picture, which took two exposures, added to the six errors I had already made, I had only four plates left for my prime objective of the trip.

We reached the Diving Board at about noon, tired and hungry. It was beautiful, but the enormous face of Half Dome was entirely in shade, and I felt I must wait a few hours until the sun revealed the monolith. It was one of those rare occasions when waiting was justified.

Following lunch washed down with water from melting snowbanks, I made a picture of Virginia standing on one of the thrusts of the Diving Board. The camera was pointed to the west, and with the first plate I forgot to shield the lens from the direct sun. I made a second plate to be sure. I now had only two plates left for one of the grandest view-experiences of the Sierra, the face of Half Dome itself.

At about two-thirty I set up the camera at what seemed to be the best spot and composed the image. My 8½-inch Zeiss Tessar lens was very sharp but, as usual with lenses of this design, did not have much covering power; the image formed by the lens was just large enough to cover my glass plate when centered thereon. I had to use the rising-front of the camera, as tilting the camera up more than a small amount would create the unwanted effect of convergence of the trees. Over the lens I placed a conventional K2 yellow filter, to slightly darken the sky. I finally had everything ready to go. The shadow effect on Half Dome seemed right, and I made the exposure.

As I replaced the slide, I began to think about how the print was to appear, and if it would transmit any of the feeling of the monumental shape before me in terms of its expressive-emotional quality. I began to see in my mind's eye the finished print I desired: the brooding cliff with a dark sky and the sharp rendition of distant, snowy Tenaya Peak. I realized that only a deep red filter would give me anything approaching the effect I felt emotionally.

I had only *one* plate left. I attached my other filter, a Wratten #29(F), increased the exposure by the sixteen-times factor required, and released the shutter. I felt I had accomplished something, but did not realize its significance until I developed the plate that evening. I had achieved my first true visualization! I had been able to realize a desired image: not the way the subject appeared in reality but how it *felt* to me and how it must appear in the finished print. The sky had actually been a light, slightly hazy blue and the sunlit areas of Half Dome were moderately dark gray in value. The red filter dramatically darkened the sky and the shadows on the great cliff. Luckily I had with me the filter that made my visualized image possible.

The date was April 17, 1927, and the results of this excursion were
✹ three very good plates: *Monolith, The Face of Half Dome, Mount Galen*

Clark, and the one of Virginia on the edge of the Diving Board, *On the Heights.*

Monolith has led a charmed life. It survived my darkroom fire in 1937 with only charred edges that are cropped from the final print anyway. I have not dropped the glass plate nor sat on it. It rests in my vault, still printable, and represents a personally historic moment in my photographic career.

Visualization is not simply choosing the best filter. To be fully achieved it does require a good understanding of both the craft and aesthetics of photography. I was asked by *Modern Photography* to write an article about creative photography for their 1934–5 annual. This was my definition of visualization.

> The camera makes an image-record of the object before it. It records the subject in terms of the optical properties of the lens, and the chemical and physical properties of the negative and print. The control of that record lies in the selection by the photographer and in his understanding of the photographic processes at his command. The photographer visualizes his conception of the subject as *presented in the final print.* He achieves the expression of his visualization through his technique — aesthetic, intellectual, and mechanical.

The visualization of a photograph involves the intuitive search for meaning, shape, form, texture, and the projection of the image-format on the subject. The image forms in the mind — is visualized — and another part of the mind calculates the physical processes involved in determining the exposure and development of the image of the negative and anticipates the qualities of the final print. The creative artist is constantly roving the worlds without, and creating new worlds within.

When I met Alfred Stieglitz in 1933, I told him of my concept of visualization, and he responded with his explanation of creative photography.

Once he had been querulously asked, "Stieglitz, what *is* a creative photograph, and what is this creative photography you are talking about and how do you go about making a machine be creative?"

Stieglitz replied, "I have the desire to photograph. I go out with my camera. I come across something that excites me emotionally, spiritually, aesthetically. I see the photograph in my mind's eye and I compose and expose the negative. I give you the print as the *equivalent* of

what I saw and felt." I think that his explanation is the most valid statement extant on the genesis of a creative photograph.

Anticipation is another prime element of creative art and essential to visualization. Some years ago I was talking with Edwin Land, a brilliant scientist and close friend. We talked about the remarkable photographs of Henri Cartier-Bresson, with his images of people in motion arrested at precisely the optimum expressive moment of time and place.

Land pointed out that the moment captured on film was realized through anticipation. Had Cartier-Bresson released the shutter at the "decisive moment" as revealed in his pictures, the psycho-physical lag would have resulted in capturing the moment *after* the ideal position in the composition.

Anticipation is one of the most perplexing capabilities of the mind: projection into future time. Impressive with a single moving object, it is overwhelming when several such objects are considered together and in relation to their environment. I believe that the mind, working at incredible speeds, is able to probe into the future as well as recall the past. Our explorations of the past support the present, and our aware-ness of the present will clarify the future.

As with all art, the photographer's objective is not the duplication of visual reality. Photographic images cannot avoid being accurate op-tically, as lenses are used. However, they depart from reality in direct relation to the placement of the camera before the subject, the lens chosen, the film and filters, the exposure indicated, the related devel-opment and printing; all, of course, relating to what the photographer visualizes.

The exhilaration, when anticipation, visualization, mind, equip-ment, and subject are all behaving, is fantastic. Sometimes disaster breaks the chain: a light-leak in the film holder, the omission of a filter-factor or a lens-extension factor, a sharpness-spoiling gust of wind at the moment of exposure, the frustrations of the shutter that sticks, the cable-release that develops a kink, the slow collapse of the tripod leg (unnoticed until the exposure has been made), and the glo-rious pageantry of a great cloudscape just after the last negative has been exposed. When one of these things happened to me in Beau-mont Newhall's presence, he would blandly quote:

"A blank he lived and a blank he died;

"He never remembered to pull the slide!"

I do not know any photographer who was not thrilled over his first exposures and who does not continue to be excited as his pictures

evolve and his craft improves. With all of my analysis of photography, there is still something quite incomprehensible to me about the photographic process. A friend once said to me, "The two most beautiful sounds in the world are the opening and closing clicks of the camera shutter." How clearly I recall the stately sound of my old Compur shutter, carving one second out of time in which the measured throng of photons poured through the focused lens and agitated the myriad halide crystals of the negative emulsion. The physics of the situation are fearfully complex, but the miracle of the image is a triumph of imagination. The most miraculous ritual of all is the combination of machine, mind, and spirit that brings forth images of great power and beauty.

Photography is an investigation of both the outer and the inner worlds. One might consider that if one is born an explorer he will never find existence dull. The first experiences with the camera involve looking at the world beyond the lens, trusting the instrument will "capture" something "seen." The terms _shoot_ and _take_ are not accidental; they represent an attitude of conquest and appropriation. Only when the photographer grows into perception and creative impulse does the term *make* define a condition of empathy between the external and the internal events. Stieglitz told me, "When I make a photograph, I make love!"

7.

Albert Bender

ONE EARLY SPRING DAY IN 1926 CEDRIC WRIGHT TELE-
phoned to say, "Come over tonight and bring your earth-
quake nose, music fingers, and some prints to show." When
I arrived in Berkeley at that evening's impromptu party, Cedric's home
was already awash with musicians, artists, professors, the rich, the
poor: a typical cross section of Bay Area intelligentsia.

The food served was identical to that of a Sierra Club outing into
the High Sierra: big bowls of spaghetti with meat balls, green salad,
baskets of French bread, a gelatin dessert, and cookies. The rich,
strong coffee, poured from a huge pot, tasted almost as good as it did
in the mountains.

After dinner, Cedric picked up my box of prints and led me to a
smiling little man sitting on a couch. "Here's Ansel Adams. He plays
pretty good piano and takes damn good photographs." Then to me,
"This is Albert Bender. He lives in San Francisco, too, and he likes
art." I had heard of Albert Bender's reputation as a serious patron of
the arts.

Albert stood, shook my hand, and said, "Let's find some brighter
light. I want to see your pictures." Apprehensively, I followed him to
a well-lit corner and watched as he carefully examined about forty of
my photographs of Yosemite and the High Sierra.

He finished, smiled, and said, "Fine! Come and see me at my office
tomorrow morning about ten. I want to look at these again." I floated
through the remainder of the evening — this was the first important
interest in my photographs from someone outside my musical and
mountaineering circles.

The next morning, promptly at ten o'clock, I was ushered into Albert's office at 311 California Street. He was a partner in a leading insurance firm in the city, not large, but possessed of a remarkable clientele. His desk was a chaotic mass of letters, envelopes, postcards, books, and pamphlets: an ever-accumulating mound of memorabilia into which he could delve and immediately find whatever he sought. He greeted me warmly, talked a minute with his staff, made a phone call, then took me to a small table, pushed aside some books and periodicals, and said, "Let's look at them again." During his thorough inspection of my photographs he received at least two visitors and six phone calls, but nothing disturbed the intensity of his concentration on my work. After he finished, he looked me squarely in the eye and said, "We must do something with these photographs. How many of each can you print?"

I replied, "An unlimited number, unless I drop one of the glass plates."

He then said, "Let's do a portfolio." I remained outwardly calm, but was electrified by his decision.

We quickly established the probable costs and the time required to do the job. He called Jean Chambers Moore, a respected publisher and dealer in fine books, and arranged for her to publish the portfolio and the Grabhorn Press to do the typography as well as the announcement. Edwin and Robert Grabhorn had developed a worldwide reputation for their incredibly beautiful typographic design and printing. Having decided upon an edition of one hundred portfolios (and ten artist's copies) of eighteen prints each, Albert suggested a retail price of fifty dollars for each portfolio. It was a whirlwind morning. This was my first experience with such decisive organization; red tape was not a part of Albert's world.

Albert was a true philanthropist. He never requested money from his friends for any purpose unless he had first contributed. When he had concluded the arrangements for the portfolio, he said to me, "Of course, I'll take ten copies. Here is my check for five hundred dollars." He later bought ten more. He was back on the phone and, before lunchtime, with a magnificent job of promotion, he had sold more than half the portfolios, assuring the project's financial success.

His first call was to Mrs. Sigmund Stern, who was kindly, wealthy, and always supportive of the arts. "Top o' the morning to you, Rosalie! I have a young friend here who has done some fine photographs. We are going to make some portfolios and I have taken ten." She said she

would take ten, too, and asked Albert to bring me to dinner. The same approach was used for several other benefactors of the arts, with considerable success. San Francisco has had a great tradition of support for its arts and artists, with Mrs. Stern one of the brightest lights. That tradition has continued with her remarkable daughter, Elise, and her husband, Walter Haas, and through them to their children. The Sterns, Haases, and Goldmans feel that great responsibility accompanies wealth. This one family has proven vital in establishing northern California as an area of enlightenment, bringing the creative works of man to all citizens.

Jean Chambers Moore decided she dare not publish the portfolio if it had the term *photographs* in the title. She was adamant against my objections; she was the experienced publisher, not I. We needed to sell the remaining half of the portfolios, and at that time creative photography was not considered commercially viable, as hardly anyone considered it to be a fine art. Hence, we coined a bastard word to take the place of photograph — *Parmelian Prints*. I am not proud at allowing this breach of faith in my medium. And then, to add to my chagrin, when I saw the finished title page I found an error, *Parmelian Prints of the High Sierras*. The name *Sierra* is already a plural. To add an *s* is a linguistic, Californian, and mountaineering sin.

Albert's nickname was Mickey, from his Irish ancestry. He was born in 1866 in Dublin, Ireland, the son of a rabbi and a Catholic mother. Albert came to San Francisco at the age of seventeen, penniless. First employed in a relative's insurance office, Albert later went into business for himself and his firm was one of the most respected in San Francisco.

Albert was in many ways an extraordinary person, and his acquaintances and admirers were legion. However, his circle of truly close friends was small, and I always felt him to be a lonely spirit.

His apartment was a splendid clutter of meaningful things: a small but marvelously kept library with most volumes inscribed to Albert, signed portraits, a few paintings by his late cousin, Anne Bremer, and a comfortable collection of elegant furniture. Most of the important art objects he acquired over the years were passed on to museums almost as fast as he received them. He had very special interests in fine printing and rare books and gave numerous examples of these to the libraries of San Francisco, the University of California, Mills College, Stanford University, and as far away as Dublin, Ireland, where he established Bender Collections in memory of his parents.

Albert's housekeeper, an elderly woman without culinary imagi-

nation, provided him with scrambled eggs for almost every meal, year after year. He did not drink anything stronger than soda pop but nevertheless kept a bar for his friends, though he had no conception of the amenities of wine and liquor. He would have the housekeeper set out Scotch, ginger ale, and paper cups. I am glad to report that several of us arranged for a better display of potables, furnished ice, and saw to it that he had sufficient bar glasses so that paper cups were finally abandoned.

Every St. Patrick's Day Albert gave a great party, claiming it was also his birthday. For this occasion he wore an authentic cardinal's robe and looked extremely ecclesiastical. It was safe to assume that every person of regional consequence would be there. Catholics, Jews, Blacks, Orientals, Hillsborough Caucasians, beautiful women and once-beautiful women, artists, writers, stage people, book people, printers, musicians, characters, and crashers — all were welcome and made very merry.

Albert did not drive but relied on his friends, including me, to pilot him around in his 1926 Buick Coach. He made frequent grand tours to libraries, museums, and to the studios and homes of many artists and writers. As we drove, he recited quantities of Shakespeare, delivered with histrionic gestures and facial expressions as required. He could quote the poetry of Robert Burns with a marvelous burr.

Albert would telephone and ask me, "What are you doing today?"

Except under extraordinary work deadlines I would reply, "When do you want to leave, Albert?" Practically every excursion was an important event to me, for these were my introductions to a new world of creative people.

One of our regular treks was to visit the revered California poet Ina Coolbrith. When I met her, she was in her eighties and lived in a stuffy, little apartment with two elderly female companions. Albert kept her in cash and on each visit brought her a bottle of fine port.

After my first visit, one of Ina's companions phoned me and asked for a medical prescription for port wine, saying, "You know, the bottle that dear Albert brings does not last very long!" Albert had jokingly introduced me as "Doctor" (he had granted me his Ph.D. — Doctor of Photography) and they had taken it literally. I was helpless! I told an amused Albert about this call, and we soon presented Ina and her friends with an ample supply. The consumed a considerable quantity of port, which probably kept them in stable health throughout Prohibition.

One Friday morning in June 1926, a few months after we had first

met, Albert telephoned and said, "How about the weekend? We can go to Carmel and see the poet Robinson Jeffers and others. Can you get away this afternoon and we will come home late Saturday?"

Naturally I could get away! I had never visited Carmel. Our route led south through the late, lamented orchards of the Santa Clara Valley; the groves became factories as the land was transformed into Silicon Valley, the heartland of computer technology. After a lunch stop at Gilroy, we drove over a winding grade to Salinas, west to the ocean at Monterey, over Carmel Hill to Carmel, and a final five miles south to the Carmel Highlands and its Peter Pan Lodge, a charming little place, with a number of tiny rooms attached like barnacles to its squarish hull. The lady hosts were effusive, the view of the sun setting over the Pacific remarkable, and the dinner tasty.

I shall never forget the events of the next day. We were up early and drove along the foggy Highlands coast to call on Johnny and Molly O'Shea. They lived in a massive home built of local stone and huge timbers. Johnny and Molly greeted us at the entrance, and Albert was warmly embraced. I remember the paintings by Johnny that I saw as being very strong in form and color, with semiabstract respect for the scene. The rocks were huge, the waves tumultuous, the trees incredibly gnarled and agonized: nothing soft about O'Shea's paintings.

The lunch was ample and delicious. Out came the whiskey; the O'Sheas and Adams paid due honor to some fine old Irish booze, and Albert drank coffee. As the fog lifted, windows were opened and the sound of the sea flooded the room. The ocean magic of Carmel came over me, different from the mountain magic of the Sierra, but unforgettable.

After stops for several other short visits, we arrived at the Robinson Jefferses' just before four o'clock. I knew and admired Jeffers's poetry and was aware of his celebrity status. I was nervous. We walked up to the gate beyond which the stone house and tower loomed in the returning Carmel fog. Across the entrance a chain supported a little wooden sign with the words, "Not at home before four o'clock." The message on the other side of the sign was even more terse, "Not at Home." Neither of them were to be disregarded. All but their intimates wrote for appointments or waited in the road until the little sign and chain were removed. Sometimes the "Not at Home" sign was displayed for days at a time as they lived a quiet life on their own terms. Jeffers's chosen daily routine was spent in intense writing and strenuous labor personally building their home, Tor House and the Hawk Tower. Constructed of native shore granite, it took him years to finish.

In "To the Rock That Will Be a Cornerstone of the House," he wrote:

> Lend me the stone strength of the past and
> I will lend you
> The wings of the future, for I have them.

Promptly at four, Una Jeffers appeared, removed the sign and chain, and greeted us. She was a slight though striking woman of great poise and charm. She led us into the house where Jeffers was awaiting us — a tall man with a hard face and a bold shock of hair. He was wearing an open shirt and knickers. Quiet and shy in manner and voice, he possessed a strange presence with his rugged features and relentless glance. He grasped Albert's hand in welcome and turned to me. Albert introduced us and, with a faint suggestion of relaxed eyes and lips, Jeffers murmured, "Glad you could come." I sensed a power of personality that I have rarely felt. We had nothing important to say to each other at the time, so we said nothing. One did not make small talk with Robinson Jeffers.

Una brought out wine for us and fruit juice for Albert. We were made to feel very much at home, and Albert held forth with torrents of discussion on books and libraries, writers and literary gossip. The vivacity of both Albert and Una was balanced by Jeffers's quiet tranquility. Una was always in tune with this genius who, in my opinion, produced much of America's greatest poetry. The writer Mary Austin categorically praised Jeffers as "the greatest poet since the Greeks."

I passed time by absorbing the conversation and inspecting the beautiful, simple furnishings of the room, including a fine Steinway grand piano. Later Albert asked me to play for the Jefferses. I was tense, but I knew my notes. I played a section of a Bach Partita, then a Mozart sonata, and I recall the performance as creditable. Una was touchingly appreciative and Albert was beaming. Jeffers said, "Good." The glacier began to melt; Jeffers brought out a copy of *Roan Stallion* and inscribed it to me, June 26, 1926. The fog thickened and Una set out candles. Jeffers thawed a little more. When we departed for San Francisco at dusk, I felt I was leaving new and truly warm friends.

Jeffers's poetry deeply affected me, not so much because of the narrative complexities of the epic poems, or the stern messages involved in many of them, but the extraordinary grandeur of the images invoked and the profound music of his lines. In addition to the great themes of tragedy and symbolic experience, his poetry contains

musical word-sounds and relationships. The surge of the ocean lives in the flow of phrase and imagery; the brilliant shafts of sheer beauty that illuminate so many passages in his work give an added dimension to the harsh bones of his creative vision, expressed in lines such as these from "Night."

> *The deep dark-shining*
> *Pacific leans on the land,*
> *Feeling his cold strength*
> *To the outermost margins.*

Jeffers was a dramatist, deeply concerned with the ebb and flow of humanity in the chaos of an inhuman cosmos, writing of the eternal realities of the natural world where man is but an accidental phenomenon. He promised a future when man will go the way of all species and the eternal domains of nature will persist magnificently without him. There are sheep by the billion, but the shepherds are few. And the shepherds in the modern capitals of the world may lead us either to pasture or to slaughterhouse. Jeffers saw man as inseparable from nature; thus man must conduct himself accordingly or he is doomed. Jeffers was a prophet of our age.

That first trip to Carmel was but one of a number of trips that Albert and I made together. A most memorable one was in 1927 to Santa Fe, my first trip to our American Southwest: twelve hundred long miles, mostly on washboard roads.

Our entrance into Santa Fe was greeted by a dust storm. I went to bed depressed; the bad weather destroying my hopes for a land that had promised many new photographs. The next morning all was diamond bright and clear, and I fell quickly under the spell of the astonishing New Mexican light. The magical transference from dusty wind and heat to sparkling vistas and translucent air was unexpected and felicitous. Summer thunderstorms create the dominant symbolic power of the land: huge ranges of flashing and grumbling clouds with gray curtains of rain clearing both the air and the spirit while nourishing the earth.

Those who have not visited the Southwest will not discover its true qualities in texts or illustrations. Very few artists have caught its spirit; the siren-calls of the theatrical are not favorable to aesthetic integrity. Color photography usually takes advantage of the obvious. Black and white photography fares better, as its inherent abstraction takes the viewer out of the morass of manifest appearance and encourages in-

spection of the shapes, textures, and the qualities of light characteristic of the region.

Traveling with Albert and me on that first Southwest trip was Bertha Pope, a wealthy, intelligent woman who could not abstain from buying Indian pots, blankets, and other objects to decorate her several houses in the Berkeley area. The three of us spent many wonderful days sightseeing about Santa Fe and meeting many of its exciting citizenry, including the writers Mary Austin and Witter Bynner. The native peoples had responded over the ages to the stark benedictions of earth, water, sky, and sun, giving testament to those four elements in an architecture of noble style and service: the Santuario de Chimayo, the wonderful St. Francis Church of Ranchos de Taos, and the Penitente moradas.

While the Southwest natural scene has always seemed beautiful and inviting, the human experience has often been otherwise as I glimpsed vistas of the surge of its history. What I experienced in the 1927–1946 years was a time of pause between two periods of exploitation — the Spanish Conquest of the past and the Anglo conquest of the future — when the human pageant was in quiet suspense and the natural character and integrity of the land was temporally secure.

We finally made our way home, stopping at Zuni and Laguna Pueblos and the South Rim of the Grand Canyon. At each of these places Bertha added to her purchases, while insisting on sitting in the front seat. I shall never forget Albert, squeezed in the back, draped with rugs and adorned with pots, literally covered with Bertha's collection. There was no air conditioning, of course, and if the backseat windows were opened, the blast of air would damage the feathers of the Hopi Kachina dolls. Red as a beet and dripping with perspiration, Albert manfully endured the three-day ordeal of the hot return trip. Bertha and I thought the trip had been wonderful. Albert was less impressed with the wild west but enjoyed the human contacts and the sophisticated life of Santa Fe.

My wife, Virginia, and I traveled to Santa Fe for an extended visit in 1929 to photograph the marvelous people and landscape. I loved northern New Mexico, and in the back of my mind was thinking of moving there. To balance income with expenses, I planned to seek out portrait commissions and what other work came my way.

On this trip we were accompanied by a friend of Albert's, Ella Young. Ella was an event! Superficially an eccentric, she was a brilliant and sensitive woman with an imposing career in law and politics and had been dangerously active in the Irish Revolution. Feeling that she

had fulfilled her obligation to society, she turned to poetry and Irish myths. Ella believed in the Little People and said that she communicated with them often, especially her own indentured pixie, Gilpin.

She was also a great ceremonialist. On this trip whenever we reached a state border she asked me to stop and would get out of the car, stand in silence for a few moments, and then pour a little wine and crumble a little bread on the new soil, chanting a few words in Gaelic. At first this seemed odd to us but her sincerity dominated the ritual.

On April 4, 1929, I wrote to my father from Santa Fe:

Today there is a thick black sky and snow is falling in the hills. Tomorrow it may be a crystal clear day; the changes of the weather are always startling. The night we went hunting the Penitentes the stars were more brilliant than I have ever seen them — I could really see the shape of the Orion nebula. And the sunrise over the Sangre de Cristo mountains was most extraordinary.

Mary Austin invited Virginia and me to stay with her in Santa Fe. We accepted and our friendship quickly grew. Its natural progression produced our enthusiastic decision to collaborate on a book of words and pictures on a New Mexican subject. As I wrote to Albert that spring:

We have finally decided on the subject of the portfolio. It will be the Pueblo of Taos. Through Tony Lujan, the Governor of Taos was approached "with velvet" — a council meeting was held, and the next morning I was granted permission to photograph the Pueblo. It is a stunning thing — the great pile of adobe, five stories high with the Taos Peaks rising in a tremendous way behind. And the Indians are really majestic, wearing, as they do, their blankets like Arabs. I think it will be the most effective subject to work with — and I have every hope of creating something really fine. With Mary Austin writing the text . . . , I have a grand task to come up to it with the pictures. But I am sure I can do it. Dear Albert — look what you started when you brought me to Santa Fe!

The conditions of the pueblo council included a fee of twenty-five dollars and a copy of the finished book. The pueblo was opened to me for as long as I needed to work, and I was permitted to return until I

was finished with the project. The book I presented to the pueblo was, I am told, carefully wrapped in deerskin and installed in one of the kivas.

Albert took great interest in *Taos Pueblo* and offered to sponsor it. Valenti Angelo was employed to design the thunderbird insignia for the book. Albert again suggested we have the Grabhorn Press produce the typography and printing. Rather than use regular half-tone photomechanical reproductions, I decided to make original photographic prints that were then bound directly into each book. Many weeks were required in the darkroom to make the nearly thirteen hundred prints.

Will Dassonville was commissioned to make the printing paper for me. Will was an excellent technician and a remarkably consistent local manufacturer of photographic papers, though it was impossible for him to compete nationally with the large manufacturers. After the specially ordered, rag-base paper had arrived from a New England mill, Dassonville delivered half the paper to the Grabhorns for the text pages and coated the other half with a rich silver-bromide emulsion, a variation of his standard paper, Dassonville Charcoal Black. It had an exceptional tonal range and depth with a matte surface. By 1933 I ceased using it only because of my growing preference for smooth, glossy papers.

Taos Pueblo was published in 1930, a final edition number of one hundred beautiful books (plus eight artist's copies) with twelve original prints. Albert set the price at seventy-five dollars each and, of course, took ten copies. Several friends said I would never sell the books at that price, but they were all gone within two years. In a recent book auction I was astounded to learn that a single copy brought twelve thousand dollars.

From Mary Austin's text:

Every house is a Mother Hive, to which the daughters bring home husbands, on terms of good behavior; or dismiss them with the simple ceremony of setting the man's private possessions — his gun, his saddle, his other pair of moccasins — outside the door. To the wife — the soft voiced matron who trips about on small, white shod feet in fashions of three hundred years ago, — belongs the house, the furniture, the garnered grain, the marriage rights of her children. Peace and stability, these are the first fruits of Mother-rule. It is this peace and stability which

makes in so large a part the charm of Taos for the restless Americano, all the more because it lies so deep, secret without being hidden, secure because undefended, loved,

"As a woman with children is loved for her power
Of keeping unbroken the life of peoples,"

says the Creation epic. Tap-rooted, the charm of Taos should endure for another hundred years, even against the modern American obsession for destructive change. But before that it will have fulfilled the prayer of the Rain Song of the Rio Grande pueblos,

"All your people and your thoughts, come to me,
Earth Horizon!"

Mabel Dodge Luhan, never a victim of convention, chose to spell her married name differently from her husband Tony Lujan. They were both legendary characters in the Southwest fantasy. Mabel's cultural education had been her association with the movers and shakers of her time in Europe and America. She played out her life on a stage, illuminated by her great wealth and the sycophantic bees that flocked to her hive. She did bring great artists into her fold and aided them, but I always felt it was a demonstration of the enticements of the huntress rather than a determined contribution to culture.

Tony, a stolid and burly Taos Indian, had married Mabel after a period of serving as her chauffeur. Tony was a pleasant and theatrical character — his black hair in long braids, his red, black, or white blanket, and his haughty, Indian demeanor. He had abandoned his Indian wife for Mabel, and the Pueblo was angered. Mary Austin, always a proponent of human rights, notified Mabel that if she did not do right by Tony's former wife, Mary would bring the weight and wrath of the Bureau of Indian Affairs upon Mabel's head. Mabel provided alimony for life for the displaced wife, and the pueblo returned to peace.

My introduction to Mabel was arranged by Mary. Mabel's home, Los Gallos, was beautiful, and the surrounding country, magnificent. Georgia O'Keeffe, Paul Strand, John Marin, and D. H. Lawrence were among her many guests. All were free to go about their creative business. Some left feeling that they had experienced a new Athens; others found Mabel's strong personality an unbearable strain. My relationships with Mabel and Tony were most agreeable, and *Taos Pueblo* might have been impossible were it not for Mabel's hospitality and Tony's assistance in obtaining the permission of his pueblo to make the photographs.

One night at a large party at Los Gallos, Mabel decided to hold dinner until Tony returned from Denver with the new LaSalle car she had given him for his birthday. Seven o'clock had been the anticipated arrival time. We waited until ten-thirty, imbibing the best "Taos lightning," as the local hootch was called, until few cared if there would be dinner. Tony finally arrived, looking quite disheveled.

Mabel asked, "Tony! What happened?"

Tony said slowly and convincingly, "I hit cow. She right there. So was me. Boom!"

After Tony had changed blankets, we went out to inspect the new car: a ruined front end and cracked windshield, covered with blood and cow fragments.

In 1930 the Luhan/Lujans visited us in San Francisco for a few days. Tony loved nothing better than to perform on his drum, repeating the Taos tribal songs ad nauseam. Shortly after arriving, wrapped in his blanket he seated himself on the curb in front of our house and began singing and loudly beating his resonant drum. In no time at all neighbors and children living blocks away were drawn by the insistent throb and the guttural chants he rumbled forth. It was an extraordinary experience: an incongruous happening in a conventional setting.

Theirs was a strange, but apparently happy, marital situation. The last time I saw them was after they had given up Los Gallos for reasons of advancing years and bought a little cottage in the Rio Grande Canyon, halfway between Taos and Santa Fe. The house was very plain, and there were only a few valuable objects of art in sight. From a glamorous, almost opulent, environment and life-style, they had changed into that of a staid, elderly couple: Mabel retaining her intense conversational style and Tony his drum and blankets.

While the center for the gatherings of the creative in Taos was Mabel's, in Santa Fe it was the home of the poet Witter Bynner. Hal, as he was generally called, invited us often to his typically riotous parties. In those euphoric and bibulous days, the entire Santa Fe intelligentsia, a mélange of strange life-styles, would attend Bynner's bashes. His friends affectionately called him "America's greatest minor poet." I rank him among our best lyricists. He introduced Virginia and me to many people in the world of letters.

I drove Virginia and Mary Austin to one such party. Entering the fray with too much enthusiasm, the potent bootleg liquor worked its charms early. I grandly played the piano, including my spoofs of a Chopin etude with benefit of an orange in my right hand and Strauss's

Blue Danube waltz, performed both with my fingers and, for the emphatic chords, with my derriere.

The next morning at breakfast I said to Mary, "That was quite a party! I guess I lost my reputation last night."

She replied, "You certainly did, but you lost it so quickly nobody missed it!"

Hal marked the occasion in poetry:

To a Guest Named Ansel

Wherever a bird lands he sings
And brings
A bit of heaven down or preens
His wings like little evergreens
Of upward earth, combing so
The light that shines and things that grow
And all the best of all the weathers
Into a single ball of feathers.

You, sir, are personal and long
Far too large to make a song.
Combining rightly like a bird
Only the things good to be heard —
And yet you touch a floor or a chair
Or the indoors or the outdoors air
With just the presence that can float
Away upon a perfect note.

Whether in New Mexico, Carmel, or San Francisco, Albert Bender opened many doors for me throughout the years of our friendship. Although I was aware of his advancing age, I guess I took for granted that he would always be with us. Virginia and I were shocked to receive an emotional telegram on March 4, 1941, from an old friend telling us that Albert had passed away after a short illness. We were living in Yosemite and I did not even know he had been ill. We immediately left for San Francisco and inquired what we could do to help. I was told Albert had requested an Irish wake to be attended by his friends and that I would take charge the final day from midnight till the morning funeral at Temple Emmanuel.

I thought of all Albert had been to me as I parked my car on Post Street and walked through the entrance garden and on to his door. I arrived promptly at midnight and was briefed by a friend who turned

over authority to me for the shift. Sandwiches, cookies, soft and hard drinks, and cheerful reminiscences softened an otherwise sorrowful occasion. Several people were there, some standing at the casket and others talking softly in the dining room. All during the small hours men and women, singly or in couples, would enter the apartment quietly, many obviously stricken with grief. Some talked about Albert and what kindnesses he had done for them; one elderly man whispered to me, "Albert helped put our son through college. We shall never forget him." Practically all of these people were unknown to me. Most were relatively obscure: clerks, garage men, nurses, gardeners, mailmen, garbage collectors, janitors from his office building on California Street, and others who sought a last communion with their friend. These people of the night and dawn revealed to me the scope of Albert's life. I looked for the last time upon him, seemingly comfortable in his casket and serene as if he were dreaming of his good works. His example of nobility and generosity bore fruit in many orchards of the human spirit.

8.

Virginia

A S AN ENTHUSIASTIC YOUNG MUSICIAN, MY FIRST SUM-
mers in Yosemite posed one dilemma: where to practice? Any-
one attempting to become a concert pianist cannot take a
three-month hiatus every summer. In 1921 I was introduced to Harry
Best, the owner of Best's Studio, who kindly allowed me to practice
on his old Chickering square piano. I was first attracted to Mr. Best's
piano and soon thereafter to his seventeen-year-old daughter. Virginia
Best was housekeeping for her father because her mother had passed
away the year before. Virginia had a beautiful contralto voice and
planned a career as a classical singer. We found considerable mutual
interests in music, in Yosemite, and, it turned out, in each other.

Later that summer on a hike with Uncle Frank, I wrote to her for
the first time:

> *Lake Merced, Yosemite National Park*
> *September 5th, 1921*

Dear Virginia,

*You cannot imagine what a really delightful time we are having up here in
the wilderness. Excepting a rather severe thunderstorm, the weather has
been perfect, and we have done nothing but "loaf" the last three days away.*

*Tomorrow we start for the Lyell Fork Canyon (of the Merced) and
will spend perhaps five days thereabouts. This lofty valley is one of the
most remarkable regions of the park, and the grandeur of Rogers Peak,
the ascent of which is our main objective, cannot be described. . . .*

If I only had a piano along! The absurdity of the idea does not prevent me from wishing, however. I certainly do miss the keyboard; as soon as I am back in Yosemite, I shall make a beeline for Best's Studio, and bother your good father with uproarious scales and Debussian dissonances. I certainly appreciate the opportunity offered me this summer to keep up my practice, and I am very grateful to you all indeed. I shall go back to the city feeling that I have lost little in music during the summer. A month, I'll wager, will find me completely caught up.

Cordially,
Ansel

Best's Studio, which Harry began in Yosemite in 1902, sold his paintings of Yosemite, wood carvings, and fine books, as well as a variety of more mundane souvenirs. Harry, his brother Arthur, and Arthur's wife, Alice, were self-taught painters of western scenery. Their romantically stylized paintings seemed far away from the qualities I responded to in the Sierra landscape — the hard, yet subtle granite with clean edges and compelling structure, the sharp delineation of waterfalls and forests, and the clean and crisp air and horizons.

The tradition of concessions in our National Parks had begun before the founding of the National Park Service in 1916. The parks had previously been supervised by the U.S. Army, and the new Park Service continued to allow concessionaires to operate their businesses (rooms, tents, meals, studios — such as Best's — a general store, and the stables) for an annual operating fee. For the dullards who did not know what to do in Yosemite there were pool rooms, bowling alleys, and dance halls. The general level of taste in Yosemite Valley in the 1920s was about that of a bustling frontier mining town.

Harry Best retained a photographer of small talent but huge energy, whose name has long been forgotten. He joined the photographers from the other studios who arrived for sunrise at Mirror Lake each summer day to photograph the tourists who flocked there to be photographed. There was great competition among the photographers for the ideal location for the cameras, and altercations were common.

A stone walkway had been built out into the lake, and families would be induced to walk out, turn around, and stand facing the camera. In the still air of early morning, with Mount Watkins beyond, they would be recorded along with their mirrorlike reflection in the lake. Within an hour many pictures were made, deposits collected,

and receipts given. The quiet beauty of the scene itself faded as the gathering morning wind broke up the "mirror" of Mirror Lake for the day. The tourists would come to the studios in the afternoon and see the proofs. Their final prints would be ready the next day. The logistics of this enterprise were frantic and complicated, and the quality of the work was definitely mediocre.

I trusted the development of my own films to the workers in Yosemite's darkrooms for only a very short time. The darkrooms were damp, stinking caves with stalactites of hypo hanging down from the bottom of the leaking sinks. The large tray for the fixing bath was a wooden box about 2x3x1 feet, lined with white oilcloth that was attached by numerous rusting carpet tacks. The fixer was mixed when the concessions opened in the spring and discarded in the fall when they closed. The prints fixed after June in this overtaxed bath would not last the year, and some of my friends suffered confirmation of this inevitable fact.

Virginia shared with me a feeling of revulsion at the commercialization of Yosemite. From our first years of friendship, I felt a rightness about the two of us. We were comfortable together. My letters of the period express a calflike wonder and an introspective analysis at a simple, but deeply felt level.

I wrote in Victorian mode to my father about my first love.

Yosemite, July 7th, 1922

Dear Pa,

I am sure you will not mind — I know you will not — when I tell you I have met someone, whom I have grown very fond of indeed. A very lovely character — one whose affection is a privilege to possess. . . . Pa, I have been hit very hard, and I make no pretense of denying it — for I am proud of it — but I do not want you to worry about it — I shall always be prudent and rest upon your advice. . . .

The world seems fuller, more beautiful, — there is something in it now that was not there before, something I did not dream would come so soon. I am beginning to realize what real life is — life of the loftiest kind.

Well, I have told you everything — you know who it is — I do not think you will worry about me. I shall not mar this letter with everyday facts and conventional phrases, so I will close what seems to me to be a

very important communication. I will write you and Ma soon again. Keep well.

My love to you and Ma — this is addressed to both of you.

Ansel

Virginia and I were serious for some six years before we were finally married in 1928. Engaged-disengaged-reengaged would be a more accurate description. A year after our first engagement, I realized how far I had to go with music before I would amount to anything, and I wrote her a letter of painful decision. Virginia took it wonderfully well, although I came to know later it was a most distressing event in her life. Between our engagements I considered the future with other young ladies. Once or twice I became quasi-serious, but fortunately, nothing came of these short-lived relationships.

I arrived in Yosemite to celebrate the New Year of 1928 with Virginia, and after the years of procrastination I formally proposed and she accepted. On January 2, just three days later, we were married at Best's Studio with my parents, her father, and a few friends in attendance. Virginia did not have time to buy a wedding dress and so wore her best dress, which happened to be black. With perhaps a trace of scorn for tradition, along with a coat and tie, I wore knickers and my trusty basketball shoes. Happily, Cedric Wright and another good friend, Ernst Bacon, were in Yosemite. Ernst played an Austrian wedding march on the Chickering. Before the ceremony my best man, Cedric, was putting chains on Harry Best's Dodge loaned to us for the honeymoon. Not only was Cedric thoroughly soaked from the fast-falling snow, but he had lost the ring my parents had brought and had entrusted to his care. He found it in the slush under the car just in time and, though soaking wet, performed his duties as best man with aplomb.

Virginia and I finally left Yosemite at six P.M. on our wedding day, with Cedric and Ernst joining us for the ride to Berkeley. Beyond Merced we had a flat tire. The jack would not fit under the car, and we had to uproot a nearby mailbox post to use as a lever. The tire was exchanged, the mailbox post set back in its hole, and we continued on to Berkeley, arriving at Cedric's unheated home at midnight. Our bed was a roll-away, but we were so weary that it made no difference to us that night.

In the early winter of 1932 Virginia became pregnant. I was in the

throes of my first full years in photography and was gingerly balancing commercial with creative work, much of the latter in Yosemite and the Sierra. I was on the staff of the Sierra Club outing for 1933 that was to be a month-long excursion into the Kings River High Sierra. The baby was due in early August, and I expected to be back in Yosemite in good time for the arrival of another world citizen. During the trip I heard nothing from the outside world; the last letter brought in by packtrain gave no indication of impending events. Intuitively, I left the last outing camp a day early. It was an arduous hike over Bishop Pass, down to the Owens Valley, and then by car to Yosemite. I arrived in the late evening at Best's Studio and rushed in to ask how things were with Virginia. Her father succinctly said, "They was."

I dashed to the local hospital to find mother and child doing exceedingly well. Michael had arrived two days before. A message had been sent but I did not receive it, since being in the High Sierra was literally being out of this world. Michael was a handsome baby and in perfect health, as was Virginia.

When our daughter was born two years later, we were living in San Francisco, but I was back in Yosemite on an assignment. The indications of our baby's debut were not pressing, and I arrived a day late. Virginia had known it was time, called a taxi to be taken to the hospital, and welcomed Anne a few minutes after arrival.

I telegrammed:

MARCH 9, 1935

VIRGINIA ADAMS
ANNE PUT ONE OVER ON ME AFTER ALL STOP I EXPECTED IT WOULD BE SIMPLE AS USUAL BUT I WAS WAITING FOR A WIRE OR CARD AND WAS ALL READY TO RUSH DOWN STOP EVERYONE SENDS LOVE AND CONGRATULATIONS STOP ARE YOU ALL RIGHT STOP SHALL I COME RIGHT DOWN OR SHALL I STAY HERE UNTIL MONDAY AND FINISH IMPORTANT WINTER PICTURES STOP WHATEVER YOU WANT ME TO DO I WILL GLADLY STOP LET ME KNOW HOW YOU ARE AT ANY EVENT STOP LOVE TO ALL AND AN ESPECIAL LOT FOR YOU AND ANNE

ANSEL ADAMS

Virginia was a wonderful mother. My parents were, of course, ecstatic over the children and would have welcomed a dozen of them;

we considered two to be sufficient. More would have taxed our ability to give them the opportunities and constructive attention we felt important.

Harry Best died suddenly in 1936 as he was saying good-night to our year-old baby, Anne. After his death, Virginia became the owner of Best's Studio. When we opened the studio in the spring of 1937, the first thing we did was to stock it with quality books, photographic supplies, and the finest American Indian crafts we could find.

I wrote to the National Park Service in 1938, outlining my concern about the sale of souvenirs in our National Parks.

> *The individual derives experiences from the parks while he is in them; he also desires to take something tangible from them as a memento of his experiences. He buys a painting, a photograph, a book, or a curio. These curios are significant to him; it serves to remind him of his experience in the National Park in which he purchased it. . . .*
>
> *It seems that in an earlier day, authentic relics of Indian culture, real pieces of stone and petrified wood, samples of rocks, bark, foliage, were sought by an interested public. These things were real — they were an actual minute fraction of the environment. As time progressed, the supply of naturally occurring objects was reduced in relation to the demand and subsequent governmental restrictions — and the commercial souvenir appeared. Now here in Yosemite we have many forms of souvenirs that have no justification for sale in National Parks. Factories churn out pennants, pillow cases, purses, book markers, paper knives, paper weights, dolls, even hip flasks — all inscribed with the words "Yosemite National Park."*
>
> *The shops selling such curios cannot be blamed for depreciating the public taste and exploiting the parks. Nothing else exists for them to sell and few of the dealers have the taste, knowledge, or capital necessary to enter a special manufacturing field.*

Virginia and I decided that for us to be able to keep Best's Studio open we would have to produce some of the needed high-quality items ourselves, but the National Park Service balked and would not allow Best's Studio to act also as a publisher. Along with three friends, we formed the small, separate firm of Five Associates, to publish fine color and black and white photographic postcards and notecards, as well as both serious picture books and guide books to Yosemite and the Sierra.

I hit upon an idea that provided the Yosemite visitor with another

type of souvenir. I selected a few of my Yosemite negatives that could be printed in large quantities as 8x10-inch photographs by an assistant, and sold for a nominal sum. My practice has been to sign only the photographs that I, myself, print, since the making of the print can be as important as the making of the negative. Though I do not print the Special Edition photographs, I did sign them during their first years, then initialed them for one year. But in 1974 I stopped, as I realized that signing or initialing would mislead people into thinking the Special Editions were my fine photographs. From their beginning, Special Edition Prints have been stamped and labeled as such, so they can be clearly differentiated from my fully original work. They have proved very popular and are still being made under my supervision and sold only in Yosemite.

The success of these prints depends on their consistently high print quality, and that hinges upon the assistant I choose to print them. Recently we have truly hit our stride and, though still carefully watched by my eagle eyes, the past couple of assistants have been ideal: first, during the early 1970s, Ted Orland and then Alan Ross. Alan was my photographic assistant from 1974 until 1979, and he continues to make the Special Edition Prints with sensitivity. He knows those negatives thoroughly and interprets them as closely as possible to my original fine prints of those images.

When our children were young it occurred to Virginia and me to do a children's book, titled *Michael and Anne in Yosemite Valley*. It was published and distributed by Studio Publications of New York in 1941. We should have published it ourselves as we did with our later books. The reproductions were terrible and the editor ruined the simplicity of Virginia's text by making it conventionally inane at every opportunity. Despite these problems, the book was a considerable success. To this day, parents of grown children bring the book to us, tattered and torn from much use, and request our signatures, saying their children were brought up on it.

The Yosemite grammar school was excellent and a short walk from our home. Our children grew up in the idyllic environment of Yosemite, but when high school was considered we realized we had a problem. The Mariposa High School was less than ideal academically and involved a daily ninety miles of busing, a bit worrisome for us in poor weather. After much thought, we sent Mike to Wasatch Academy in Utah, a favorite high school for children of National Park Service employees.

Anne was an appealing child, very intelligent, feminine, and be-

guiling. She attended the rather posh Hamlin School in San Francisco for a time. I well recall one rainy day when, dressed in my usual Levi's, black darkroom apron, old hat, and formidably bushy beard, I escorted an embarrassed Anne to the school pickup car. Anne told me that later one of the other girls asked, "Is *that* your father?" Anne went on to Dominican High School in San Rafael, a most excellent institution, graduating with highest honors, and later attended Barnard College and Stanford University.

After Anne's first husband, Charles Mayhew, lost his life in an unfortunate accident, she bravely faced parenting their three little girls. In 1971 Anne married Ken Helms, then a Unitarian minister, now a research psychologist. Ken helped tremendously in bringing up the girls.

Anne's eldest daughter, Virginia, is a professional musician, who on her happy and frequent visits to us practices her instruments, the clarinet, flute, and saxophone, with a discipline that reminds me of myself. Alison has graduated from college, and we are very proud that she is now independent and successful in the business world. Anne's youngest daughter, the lovely and exuberant Sylvia, is presently attending college.

Virginia turned over Five Associates to Anne, who has through brains and very hard work, built it into a fine business now called Museum Graphics. Anne produces cards and notes of most excellent quality that carry handsome reproductions of my photographs as well as those by Edward Weston, Imogen Cunningham, and others.

Our son, Michael, attended Stanford. Unknown to us at the time, he applied some of his allowance money to flying lessons. During the Korean conflict Mike enlisted in the air force and became a fighter pilot. After his tour of duty, he continued flying with the California Air National Guard in Fresno, where he completed his undergraduate and then his premedical studies.

Michael and the vivacious Jeanne Victoria Falk were married in Yosemite in 1962. After receiving his degree from Washington University School of Medicine in St. Louis, during which time their two children, Sarah and Matthew, were born, Michael began another tour of duty with the Air Force, this time as an intern in Washington, D.C., and as a flight surgeon and pilot-physician in Germany. In 1971 their family returned to Fresno, where Michael served his internal medicine residency and now practices as an internist, while continuing to fly jet trainers for the California Air Guard. Jeanne and Mike direct the former Best's Studio, renamed the Ansel Adams Gallery in 1972,

and when time permits enjoy the summer mountains and the winter skiing.

We were all immensely proud when Sarah earned her pilot's license at eighteen. She is now in the midst of her years as a college student. Matthew is a very bright high school student with a love for books and reading as well as possessing a healthy athleticism.

So much for the family history. All goes well.

People often ask, "Why did your children (and now grandchildren) not take up serious photography?" If they had indicated such an interest, I would indeed have been pleased, but I consider it basically wrong to impose your career on your children. Both Anne and Michael followed rewarding directions and have imparted concepts of individualistic excellence to their children. I believe children must be treated as individuals from the start, not bound to their parents by bonds other than affection.

Most of us struggle throughout life to find ourselves and our appropriate channel. The finding depends as much upon good fortune as upon any quality of character or ability. Virginia was my good fortune. I could not have achieved what I have without her sublime understanding and tolerance over these many decades. Shortly after our marriage I wrote:

> To Virginia
>
> *I would write you my love in a myriad shining lines,*
> *Verse upon verse as fresh as swaying pines*
> *Upon a snowy hill. And yet I know*
> *I have no power to sound the deeps below*
> *The world of vision and of flesh and voice*
> *Wherein we wander. You, my heart's first choice,*
> *Are as the flowing winds upon the lea,*
> *And as the ageless earth and shimmering sea.*
>
> *So I shall sing with silence and will gaze*
> *Through all the beauty of the gathering days*
> *To the dim mountain and the quiet haze*
> *Marking the final hour.*
> *And you shall guess*
> *That all our years have only served to bless*
> *The wind and earth and sea.*
> *All words are less.*

9.

Straight Photography

URING THE FIRST TWO YEARS OF OUR MARRIAGE I juggled two professions: music and photography. By 1930 I was wracked by indecision because I could not afford either emotionally or financially to continue splitting my time between them. I decided to return to New Mexico to complete the Taos book, hoping the Southwest summer sunlight and towering thunderclouds would inspire a decision.

Arriving unannounced at Los Gallos, I found it so crowded that Mabel had not one guest room left. I was introduced to Paul and Becky Strand, who invited me to stay with them in the extra bedroom of the small adobe guest house that Mabel had given them for the summer. I knew photographer Paul Strand by creative reputation, and I had seen his photographs in handsome photogravure reproductions in Stieglitz's great photographic journal, *Camera Work*. Paul was a buoyant spirit and Becky a serene and beautiful woman.

That first evening I dined with the Strands and Georgia O'Keeffe. Strand inquired politely about my Taos Pueblo project, then I inquired if he had any prints to share. He asked if I would like to see his negatives, since he had made no prints that summer nor had he brought prints from New York. Of course I would!

The next afternoon Paul took a white sheet of paper and set it in the sunlight streaming through a south window. He placed me squarely in front of the paper and opened a box of 4x5-inch negatives. He handed them to me, admonishing, "Hold them *only* by the edges."

They were glorious negatives: full, luminous shadows and strong

high values in which subtle passages of tone were preserved. The compositions were extraordinary: perfect, uncluttered edges and beautifully distributed shapes that he had carefully selected and interpreted as forms — simple, yet of great power. I would have preferred to see prints, but the negatives clearly communicated Strand's vision.

My understanding of photography was crystalized that afternoon as I realized the great potential of the medium as an expressive art. I returned to San Francisco resolved that the camera, not the piano, would shape my destiny. Virginia was very supportive of my decision; my mother and aunt reacted differently, pleading, "Do not give up the piano! The camera cannot express the human soul!"

I replied, "Perhaps the camera cannot, but the photographer can."

Though committed, I was uncertain what Ansel Adams's direction in photography should be. Increasingly, I detested the common pictorial photography that was then in vogue and also questioned the more sophisticated work of some San Francisco photographers because it clung to those pictorial skirts. There was nothing I responded to in this mannered style of photography. In fact I had seen little photography that I felt was art. My knowledge of the important people in the history of photography and the work of other creative photographers was abysmal.

With high energy I began to explore a personal photographic direction based on the inherent qualities of the photographic process itself. I abandoned my textured photographic papers and began using the same smooth, glossy-surfaced papers used by Paul Strand and Edward Weston to reveal every possible detail of the negative. I am unsure how much this change in paper affected my photographic "seeing," but I suddenly could achieve a greater feeling of light and range of tones in my prints. I felt liberated; I could secure a good negative born from visualization and now consistently progress to a fine print on glossy paper.

One evening in 1932 there was a remarkable collection of sympaticos gathered at the Berkeley home of Willard Van Dyke, a University of California student and photographer: Van Dyke, Imogen Cunningham, Edward Weston, Henry Swift, Sonya Noskowiak, John Paul Edwards, and myself. I presented, with extroverted enthusiasm, my new sense of direction in photography. The response was immediate, striking powerful sparks of accord from the others, some of whom had already embarked on the same journey.

We agreed with missionary zeal to a group effort to stem the tides of oppressive pictorialism and to define what we felt creative photog-

raphy to be. Perhaps most importantly, our efforts provided moral support for each other. Though we actually met together very few times as a group, I have found records that show that we paid dues, at least once, of ten dollars each.

On another evening at Willard's, we bantered about what we should call ourselves. The young photographer Preston Holder was present that night, and he suggested we call ourselves "US 256," the designation of a very small lens aperture many of us used to achieve greater sharpness and depth. Afraid that people would confuse us with a highway, I followed his line of thought, picked up a pencil, and drew a curving $f/64$. The graphics were beautiful and the symbol was apt — $f/64$ was the new aperture marking system identical to the old system number US 256.

Group $f/64$ became synonymous with the renewed interest in the philosophy of straight photography: that is, photographs that looked like photographs, not imitations of other art forms. The simple, straight print is a fact of life — the natural and predominant style for most of photography's history — but in 1932 it had few active proponents.

The members of Group $f/64$ decided that our first goal would be to prepare a visual manifesto. Our work was varied but shared a fresh approach that stirred the wrath of the salonists, perplexed many in our local art world, and delighted a few pioneers including Lloyd Rollins, director of the M. H. de Young Memorial Museum in San Francisco. Lloyd had come to one of our gatherings at Willard's where we had a small display of the group's work. After looking at our photographs, he immediately offered us an exhibition. This was an important event for each of us; for me it was my third major museum exhibition. I had had a solo show in 1931 at the Smithsonian Institution, and both Edward and I had already had exhibits at the de Young earlier in 1932. For this exhibition the seven members of Group $f/64$ invited four others to show with us: Preston Holder, Consuela Kanaga, Alma Lavenson, and Brett Weston, knowing that they represented the same photographic philosophy. The exhibition dates were November 15 through December 31, 1932. There were a total of eighty photographs in the show, from four to ten prints per photographer, with prices that now seem ridiculous: Edward charged fifteen dollars per print and the rest of us charged ten.

At the exhibit we handed out a written manifesto to accompany the visual one. I was one of the authors and feel that it explains quite clearly what we were about.

GROUP $f/64$ MANIFESTO

The name of this Group is derived from a diaphragm number of the photographic lens. It signifies to a large extent the qualities of clearness and definition of the photographic image which is an important element in the work of members of this Group.

The chief object of the Group is to present in frequent shows what it considers the best contemporary photography of the West; in addition to the showing of the work of its members, it will include prints from other photographers who evidence tendencies in their work similar to that of the Group.

Group $f/64$ is not pretending to cover the entire field of photography or to indicate through its selection of members any deprecating opinion of the photographers who are not included in its shows. There are a great number of serious workers in photography whose style and technique does not relate to the metier of the Group.

Group $f/64$ limits its members and invitational names to those workers who are striving to define photography as an art form by a simple and direct presentation through purely photographic methods. The Group will show no work at any time that does not conform to its standards of pure photography. Pure photography is defined as possessing no qualities of technique, composition or idea, derivative of any other art form. The production of the "Pictorialist," on the other hand, indicates a devotion to principles of art which are directly related to painting and the graphic arts.

The members of Group $f/64$ believe that photography, as an art form, must develop along lines defined by the actualities and limitations of the photographic medium, and must always remain independent of ideological conventions of art and aesthetics that are reminiscent of a period and culture antedating the growth of the medium itself.

Our exhibition and accompanying statement created considerable attention and invigorating discussion, much of it negative. The de Young Museum received many letters of protest, mostly from artists and gallery people, complaining that valuable space at a public museum had been given to photography *which was not Art!* Concerned, Rollins requested the opinion of the board of trustees of the

museum, who supported him by saying, "You are our director; if you think exhibits of photography are appropriate for the museum, by all means present them." Rollins telephoned me to describe the meeting and his great relief at its outcome. I have wondered what might have been the effect on the progress of West Coast photography if the Group $f/64$ exhibit had been rejected by the de Young.

Who were these pictorialists (we called them the fuzzy-wuzzies) that Group $f/64$ so strongly reacted against? At this time their champion was a Los Angeles photographer, William Mortensen. His photographs were of models suggesting classic and Renaissance characters in historical and allegorical situations while in various stages of nakedness and period costume. They were just plain awful. He wrote in the respected photographic journal *Camera Craft,* promoting his "inventive" approach to photographic art and attacking straight photography with articles such as "The Fallacies of Pure Photography." I answered his charges in what became one of the fiercest verbal battles in photographic history. He was and has remained synonymous with the opposite of everything I believe in and stand for in photography. A few years ago I was not overjoyed to find an important museum showing a major retrospective of my work in their main gallery simultaneously with a Mortensen retrospective on an upper floor. Caveat emptor!

One of my rebuttals to Mortensen was this letter I wrote to him in 1933:

Dear Mr. Mortensen:

The photographic Realists have in no way "self-defined" photography, especially in the contemporary aspects. The basic aspects of photography are so clearly defined in themselves that I am astonished you have so completely missed them. The Realists recognize and respect the merits of a sincere and fully realized Pictorial photograph when we find one. The early work of Stieglitz, Clarence White, Steichen, and others, and of the exponents of the gum process in Europe over thirty years ago — sincere and sensitive productions — are veritable milestones of photographic progress. The art and craft of photography has advanced since those earlier days, and the leader has unquestionably been Alfred Stieglitz, who, for forty years, has anticipated its trends and achievements.

When you say the Purist work consciously avoids any subjective interest you are making a grievous error. The Purist shuns sentimental-

subjective connotations that undermine the power and clarity of the real photographic expression. All great art in any medium avoids weak sentimental-subjective conceptions. The objective attitude in no way implies that photography is not emotional. I am surprised that you are not aware that objectivity is only the tool of intense expression.

In photography, I would say that the sincere realist is the creative artist; the non-realist is vague and muddling in his synthetic manipulation of the camera and the subsequent processes. He is guilty of the major crime of Art — bad taste.

Mr. Mortensen, there will be salons of Pure Photography long after your creations are to be found only in collections of Photographia Curiosa. There will be legions of photographers working long after you are forgotten — working to catch such "meaningless" things as the glint of sunlight on stone, the crisp inevitability of machines, the dignity of the human form and face, the grand pageant of the world in intense and infinite aspects. There will be fearless photography of humanity in social change and in heroic adventure. There will be infinitely tender photography of the most intimate aspects of the world — grass covered with dew (as Stieglitz has done), the sea-drift of Gaspé (Paul Strand), the resonance of pure light in shells (Edward Weston), documents of human derelicts (Walker Evans). New horizons will always open before us. How soon photography achieves the position of a great social and aesthetic instrument of expression depends on how soon you and your co-workers of shallow vision negotiate oblivion.

Group *f*/64 held only one other exhibition. In 1933, after my momentous meetings with Stieglitz, I returned to San Francisco determined to create a small gallery that would reflect the aesthetic stance of An American Place and Group *f*/64 as well. I opened the Ansel Adams Gallery at 166 Geary Street with the first exhibit photographs from Group *f*/64. I presented shows of superior photographs as well as paintings, sculpture, and prints. After nearly a year, I decided that my added job as gallery director was too exhausting, severely limiting the time I had for my own work. I acquired a partner, Joseph Danysh, and it became the Adams-Danysh Gallery and eventually just the Danysh Gallery.

I recognized Paul Strand as the catalyst who had challenged me to fully commit myself to photography. In three short years, I had progressed far thanks to hard work and the stimuli from my Group *f*/64 colleagues. After Willard moved to New York to begin a career as

a documentary cinematographer, Group ƒ/64 seldom met. Even though we did not continue in any formal sense, the flame lived. I wrote to Strand:

September 12th, 1933

Dear Paul Strand,

You may remember me and you may not. I had a few days with you and your wife and O'Keeffe at Mabel's in Taos. We motored down to Santa Fe together and shot at tin cans with a revolver on the way. If the last mentioned event has slipped your mind, perhaps you will recall that we had a wonderful morning with Marin at Taos.

I have been working hard with the camera since that time.

. . . I have opened a small gallery. . . . I would like to have a show of your photographs — 25 to 40 things, I do not know your attitude towards exhibits, but I can assure you there is enough interest in photography in San Francisco to provide a large and grateful attendance to a Strand show. Within eight days about 500 people have come to the ƒ/64 show and I am gratified that most of them evidenced a real interest and understanding in what the group is trying to do. A show of your things in the spring would be an event of major importance here.

Yours,
Ansel Adams

I was surprised when he refused me, stating:

October 14, 1933

. . . Your new venture of a gallery in San Francisco does interest me for I feel whatever you try to do will be in an honest and unarty way. Nevertheless I cannot say yes to an exhibition of my things at the present time. Actually I have little interest in exhibitions because at the basis they . . . exploit the artist to entertain the public free of charge. I can never get used to the idea that pictures are free entertainment in the U.S., elsewhere too, that the people who claim to enjoy a thing never support the individual who makes what gives them pleasure. . . . But in addition I don't like to let these prints go out of my hands. (They exist for the most part in only one example.) . . . to be handled by express or mail carriers — custom inspectors etc. They are not the usual tough gaslight

prints and a scratch means ruination. . . . Perhaps some day I will get to Frisco again and that would be different. All this I hope you understand and not feel me to be merely uncooperative.

I replied:

<div align="right">

October 31, 1933

</div>

I understand perfectly your refusal to send an exhibit to me. You have many good and sufficient reasons. I must admit that I do not fully understand your attitude about exhibitions in general. I think there are always a few people in any part of the land that would react completely to truly fine things — that would make those things functional in a social sense. After all, should we not be resigned to the naked fact that there is only a very, very small real audience for anything worthwhile? And should we not trust that in almost any group there will be a few — perhaps only one — who will perceive the significance of a great expression? And if there is only one, wouldn't that justify an exhibit?

I have always had things happen to me — psychologically, even physically — when I have seen your things. I believe you have made the one perfect and complete definition of photography. . . .

Strand and I remained friends, corresponding and visiting each other when possible. One March day in Yosemite in 1944 I received a phone call from a secretary at Selznick Productions in Hollywood asking if I could talk with Mr. Selznick about a very important matter; if so, please hang on. After a long wait, a tight, strained voice came on the other end. "Mr. Adams, we are in a crisis! This is Selznick speaking!" Pause. "Mr. Adams, our still photographer for the great film I have been working on, *Since You Went Away,* was drunk all the time and we have no production publicity pictures." Pause. "Mr. Paul Strand and Mr. Leo Hurwitz, who are working with me on this film, say you can make prints of *anything* — so I am calling you. Please come down right away and help me out."

I checked to see if it was Mr. Selznick and then drove to Los Angeles the next day. Nobody at Selznick headquarters had heard about me. I finally found Paul, and he confirmed he had recommended me. Confused, I finally arrived in the inner chambers of David O. Selznick. He explained again how and why he did not have any black and white publicity prints and how vital it was that he possess them. With rising

emphasis he said, "Mr. Adams, you and I can revolutionize the still photography part of the industry!" He then got out of his chair and started to pace around the room while he expounded the great future of our new approach.

I was bewildered and stood up, thinking he might be leading me on a visit to another office. He gestured to me and said, "Of course, you can pace too!" We then both paced the room while he talked on about this coming miracle in the movie business.

Finally he picked up the phone and told someone, "Mr. Adams will be over to select the frames from the master film negative to make prints from. This is very important. I am going to New York tomorrow for a week and I want to be sure Mr. Adams has everything, note *everything,* he needs." He hung up briskly, shook hands, and darted out the door.

I finally found the master cutting room and immediately observed that the editor there was seething. "What in hell does he think he's doing — letting you cut up the master negative to print frames that will be no good anyway? IMPOSSIBLE!!!"

I could hear the wisdom in what he was saying. What to do? It was decided to go through acceptable outtakes — many of them paralleled the frames in the master reel. First I had to sit in a small theater and go through the entire film, asking them to mark selected frames. This took a full day. Since they would not cut out individual frames, I had to take a suitcase full of footage to Yosemite for printing. It took another week of selection to find the exact frames before I was ready to print. I made about twenty final prints and, if I do say so myself, they were pretty good. I sent off two sets to Selznick who telegraphed, "MARVELOUS, WONDERFUL, A NEW ERA, ETC., ETC."

A week later I received a letter from Selznick's publicity department:

Dear Mr. Adams:

The prints are very beautiful. Unfortunately we cannot use them for publicity as none of the scenes have light backgrounds.

Finis to my role in the revolutionary concept of still photographs taken from the original negative film. All was not for naught, however, as I received seven hundred and fifty dollars for the job, and that financed several months of my own creative work in Yosemite!

Following our Hollywood adventure, Strand came to visit us in late May 1944. As luck would have it, during his week-long first visit to Yosemite, the cloud cover never lifted more than a thousand feet above the valley floor. Only the lower third of the cliffs was visible. In the constant mist or rain, Lower Yosemite Fall thundered out of the clouds.

Strand enjoyed the mood but was photographically inactive. He appeared depressed. He took a walk in the morning, returned for lunch, rested an hour or so, and had another walk in late afternoon. He would bundle up, secure from the chilly air and penetrating drizzle, and walk several miles on the valley roads and trails, all on level ground. He seemed appreciative, but remote. I offered him any camera I had, but he declined, saying, "I must get used to the place first." At the end of his visit he remarked, "I saw a stump I want to photograph sometime."

The next year I found him back in New York preparing a major exhibit for the Museum of Modern Art. He was given work space in the subbasement for mounting his photographs. I was occupied on the fourth floor with Department of Photography affairs. Over several days Strand frequently called me, asking that I come down and help him with a print mounting decision. I was flattered.

When I arrived Strand would say, "Good of you to come. I have another problem." Placing a print, already accurately trimmed and mounted on a thin card, on a larger mount board, he would say, "Do you like it here?" Then, moving it up or down a scant eighth of an inch, he would ask, "Or here?" For the life of me I could not feel any real difference, but I would take a careful stance, look, and reply, "I *think* I like the last [or first] position." He would then lightly define the corners of the print on the mount with a very sharp, hard pencil, then set the print and mount on the shelf and say, "I will make my final decision tomorrow." This extreme precision both interested and irritated me, but all was forgiven because the images were so beautiful.

Strand took active interest in the American Communist movement during the 1930s. His teacher at New York's Ethical Culture School had been Lewis Hine, the great photographer who documented America's new immigrants earlier in the century. Paul, following the lead of Hine and many other New York artists, was what is termed "leftist-leaning." Paul fervently believed that pure socialism was the best hope for mankind.

Most creative people are strongly humanistic. Artists must be free to create and offer the products of their imagination and emotion to

the world. They resent the restrictions of the unimaginative — the impulse to take, consume, and produce little except material things, and to profit thereby. Stieglitz was independently a rebel; Weston remained aloof to political involvement, but was a devout liberal in spirit; Strand required the support of group political activity to affirm his stand.

The happy and optimistic Paul that I first knew in the 1930s became morose. Because he no longer believed in a healthy future for America, Strand moved to France in 1949. He chose not to live and work under the impending fascism toward which he believed America was headed. Luckily, he escaped the witch trials led by Joseph McCarthy that horribly scarred the lives of many American artists.

I am glad that my dedication to him in my book *Photographs of the Southwest* came to his attention shortly before he died in 1976. It was a small tribute to a man who was a very important influence on my creative life.

10.

Stieglitz & O'Keeffe

W ITH VIRGINIA'S FIRST PREGNANCY IN THE WINTER of 1932 came the realization that our lives were soon to change. Virginia's father generously gave us a gift of one thousand dollars to take a trip to the East Coast and to see a bit of America before our family life began. We left San Francisco by train in early March 1933 with almost all of our money safely in traveler's checks. As the Great Depression was flourishing, our Pullman car was practically empty. To save money, we were tucked away in a single upper berth, much to the consternation of the conductor and porter.

Our first stop was Santa Fe, where we found that President Roosevelt had closed the banks and our traveler's checks were temporarily worthless. We stayed with friends, and the anticipated few days turned into two weeks. After an extended series of telegrams between us, Harry Best, and Albert Bender, Albert, in some miraculous way, manipulated our checks into cash and we were back on our way.

Armed with letters of introduction from Mrs. Sigmund Stern and Albert, we arrived in a freezing Chicago and were invited to an elaborate dinner at a sedate home in Winnetka. I was seated next to a very gushy lady, who cooed comments and questions.

"Mr. Adams, I *know* you have been *all over* Europe. What are your favorite places?"

I said, "No, I have never been to Europe."

She cooed again, "If you *did* go, what would your favorite places be?"

I replied, "I guess I would be most enthralled with the Gothic cathedrals."

And then she asked me, "And what would interest you *most* about the cathedrals?"

I said, "I guess it would be the flying buttocks."

End of conversation. I noted one guest practically choking to death while a general stony silence prevailed until someone spoke of a *divine* Cézanne just given to the Chicago Art Institute.

We went on to Detroit. The full effects of the Depression hit us there. It was such a sad city; the stores were open but empty. As I finished reading the nickel newspaper in the lobby of our hotel and put it down, a well-dressed man sitting near me got up and snatched it. We went to see Diego Rivera's newly completed frescoes at the Detroit Institute of Art and thought they were grand. The people of Detroit were already arguing over whether to have them painted over, with opinion divided among whether they were true art, Communist propaganda, or just plain ugly.

Then it was on to Buffalo, Niagara Falls, and Rochester to visit the Eastman Kodak factory. Visiting Kodak was a remarkable experience — from the laboratories with their complex equipment to the final shipping stations. Materials were moved about the extensive factory by little steam locomotives that puffed about with dispatch. I recall the large piles of silver ingots waiting to be dissolved into the emulsion compounds and the impressive ranks of huge rolls of paper awaiting coating. In those days photographic film had a nitrate base and was highly flammable and potentially explosive. Accordingly, the danger was clearly proclaimed throughout the factory.

Our most important destination was New York City, where we arrived on March 28. We were recommended a hotel, the Pickwick Arms on East 51st Street. It was the last resting place of the "denizens of the inferior stage" (quoting Lawrence). In the depths of the Depression, its dismality was exponential. While in New York we planned to visit the museums and attend plays and concerts, but my prime goal was to show my photographs to the greatest photographic leader in the world, Alfred Stieglitz.

Within hours of our arrival in New York, I sallied forth with my photographs under my arm to visit Stieglitz at his gallery, An American Place. I threaded my way through multitudes of garbage cans soaked with cold drizzle and shuddered at what I saw as the typical New York sidewalk scene, only later to realize that it was garbage collection day in that part of town. The buildings towered around me, soaring to oppressive heights. The traffic groaned, honked, sputtered,

and roared. I brushed another pedestrian and said, "Excuse me." He glowered in return. I moved on to Madison Avenue and turned right, passing interminable shops of infinite variety until I found 509 Madison Avenue.

Elevated to the seventeenth floor, with trepidation I pushed open the door of An American Place and found no one in sight. It was a beautifully barren room filled with expectant space, enclosed by walls of an indescribable tone on which a few paintings were hung, thrusting like jewels into the cool light. Four doorless apertures led to other spaces. Light came from windows looking west and north, and ceiling troughs emitted a blue-white glow. The radiators were knocking, and I could hear a crisp rustle of papers through one of the doorways.

I walked through that doorway and entered a small room filled with paintings, photographs, books, papers, frames, letters, pens, blotters, gum drops, leaflets, and a telephone. At its center was a small elderly man, enrobed in a large black cape, with silver hair and mustache and tufts of hair bristling out of his ears, his full attention on a book open before him on the desk. Stieglitz looked up at me with a glower.

"What do you want?"

"I came to meet you, Mr. Stieglitz, and show you my work. I'm a California photographer."

I presented him with my letter of introduction from Mrs. Stern.

He opened it and said, "All this person's got is money, and if this Depression keeps on much longer she's not going to have that. What do you want?"

My sense of chivalry toward my dear friend, the enlightened and generous Mrs. Stern, was bruised. "I just would like to show you my prints," I sputtered, hardly able to conceal my anger.

"Come back at two-thirty."

I stormed out of An American Place and pounded up and down Madison Avenue. I met Virginia for lunch and told her I wanted to go back to California. "Why should I take this kind of treatment?" I had found this first meeting very distasteful, and the ambience of New York, dreadful. Virginia calmed me down and convinced me to return, stating, "After all, what did you come all this way for?"

So I straggled back to 509 Madison, and as I entered Stieglitz said, "Come in, come in. Now, let's see what you've got." I gave him my portfolio and he opened it. It contained a number of small photographs, all recent contact prints that I felt were my best.

He sat on the one and only chair so I sat on the radiator. He looked at each print with the greatest care. Each time I started to say some-

thing he would imperatively gesture for silence. He put the prints back in the portfolio, tied up one end, tied up the other end, tied up the front, then looked at me. Then he opened the portfolio again and studied them as carefully as he had the first time. By now the steam heat was pouring out of the radiator and I could not sit there anymore; my bottom had baked into corrugation. I was extremely nervous, but Stieglitz finally spoke, "You are always welcome here." He liked my work. He felt my photographs were what he called "straight" and seen with "sensitivity."

Jubilantly, I returned to Virginia at the Pickwick Arms. I decided I now had the courage to also show my work to Alma Reed, who owned the respected Delphic Studios, one of the very few art galleries that dared to show photographs at the time. She expressed interest in my work and promised me my first one-man show in New York later that year.

Alma Reed represented the great Mexican painter Orozco, to whom she introduced me. Orozco was a very intense man who affected large dark eyeglasses, thereby creating the impression of some slightly wrathful Mayan god. Behind this fierce exterior he was gentle and sympathetic. Her permitted me to photograph him on Alma's back porch, glasses and all. I caught some of his intensity. Unknown to me at that time, in 1930 Edward Weston had made an excellent portrait of Orozco, glasses and all, that provided one of those occasions for historians to assume plagiarism, amusing both Edward and me.

My exhibition of fifty photographs opened at the Delphic Studio in November of 1933. I paid for the announcements and the shipment of my prints. A few were sold, for which I received nothing; the times were tough for all galleries and artists. It did receive a favorable paragraph written by Howard Devree in the November 19, 1933, *New York Times,* which was cheering.

Three shows are on at the Delphic Studios. Photography by Ansel Adams, a Californian, strikingly captures a world of poetic form. His lens has caught snow-laden branches in their delicate tracery; shells embedded in sandstone; great trees and cumulus clouds. It is masterly stuff.

I returned annually to New York to visit Stieglitz, and show him my latest photographs. In January of 1936 he told me he would give me a show. I was totally elated and worked for months to make just the right prints.

My exhibition at An American Place was mounted in November of 1936. I wrote to Virginia from New York:

November 16, 1936

. . . The show at Stieglitz is extraordinary — not only are they hung with the utmost style and selection, but the relation of prints to room, and the combination in relation to Stieglitz himself, are things which only happen once in a lifetime.

Afterwards, to Stieglitz I wrote:

November 29, 1936

. . . My work has become new and exciting to me as never before. The praise you give never nourishes conceit — it reveals too much of the future for that. And your criticism is never disintegrating. The entire experience evaluates much more than it defines, and the joy with which I will attack my problems from now on will be a joy that has nothing to do with conquest, superior accomplishment, fashionable fame and all the other transparent gew-gaws that ornament the garment of social intercourse. I can see only one thing to do — make the photography as clean, as decisive, and as honest as possible. It will find its own level.

Rather than say Stieglitz influenced me in my work, I would say that he revealed me to myself. Paul Strand's work showed me the potential of photography as an art form; Stieglitz gave me the confidence that I could express myself through that art form.

Stieglitz sometimes brought ideas to people that they did not want to understand; he possessed the very rare quality of spiritual independence. He was an enigma, a crank, an artist, a genius, an editor, a publisher, a dealer in art, a tastemaker, an influence. He believed that the artist has a right to work with dignity, thinking and doing as he desires.

I remember a brisk, cool spring day; leaves were appearing and the Manhattan towers stood sharply before huge, rolling clouds as seen through the windows of the Place. Stieglitz was positively gay in spirit. Marin watercolors were on the walls, and people had been coming and going most of the morning. After lunch (Stieglitz had his out of a bag, and I think I went to a French restaurant with friends), I returned and prepared to make some photographs of the Place with my 35mm

Zeiss Contax. Stieglitz was appreciative of my doing this, and he walked toward me, wearing his black cape and smiling. I took advantage of the moment and made a few portraits. Stieglitz said to me, "If I were younger and had one of those little cameras, I would lock the Place up for half the time and go out on the streets to catch the life of the city."

As I finished photographing, a regal woman entered, decked with glamorous furs and jewels. She quickly glanced at the walls and then accosted Stieglitz. "Mr. Stieglitz, my daughter is studying art. She simply *loves* art and she *adores* John Marin. Can I borrow the new Marin book for a week or so for her?" This charming and inexpensive little book, a collection of letters in conversational essay form, was quite revealing of Marin's personality.

Stieglitz peered at her over his glasses for a moment and then said, "My dear woman, Marin's book is for sale for two dollars and fifty cents. Please make out the check to the artist."

As he turned away she said, rather complainingly, "Mr. Stieglitz, she only wants it for a tiny bit of time; she will bring it back to you as soon as she has finished it."

Stieglitz turned to her and let forth a stern lecture on art and the responsibility to keep it alive. "The artist lives to create and contribute to the spirit; he is not interested in jewels except to possibly paint them; he must work for a living!"

The woman, abashed, perplexed, perhaps frightened, backed to the door while Stieglitz slowly advanced, talking continuously. She opened the door and fled. Stieglitz turned to me and said, "*THAT* should give her something to think about when she takes off those damned furs!"

Another time the telephone rang, Stieglitz picked it up, listened a few moments, and then barked, "Come here at two o'clock tomorrow!" He said to me, "Some man wants to show me his paintings; please come at that time, too." I was concerned because I felt Stieglitz was in a black mood.

At the appointed time the man arrived. He was uncertainly young and looked positively ill: white-faced, woebegone, and scared. Stieglitz said, rather brusquely, "How do you do. Let me see your work." The ragged portfolio was opened and the man took out his watercolors and put them on the desk. Stieglitz looked at each one, not saying a word, as he had treated me when I first met him — only this man had a chair to sit on.

After twenty-odd paintings had been viewed, Stieglitz turned to

him and said, gently, "These are very fine." I thought the man was going to faint.

Stieglitz then said to him, "You look like you have not had much to eat lately." The man agreed.

Stieglitz continued, "I wish to purchase one of these. What do you charge?" The man simply shrugged.

Stieglitz said, "How about one hundred and fifty dollars?" All the man could say was a whispered thank you.

Stieglitz wrote the check and gave him a five-dollar bill, saying, "You go and get a *good* lunch. Come back later and we will talk about your work." The man returned in a few hours, looking almost healthy. Stieglitz offered to hold his work for him ("I am sure I can sell some for you"). I never learned the painter's name nor do I know what happened to him and his work.

Stieglitz always showed great interest in new ideas and visions. He seemed grimly selective at times, but that was because of the very high expressive and craft standards he demanded of everyone, certainly including himself. He would often say, "It's too bad I didn't have your film when I was working thirty years ago!" He used a rather rickety camera with only two different focal length lenses. Like Edward Weston, he favored the doctrine "less is more" but he had the good sense to eat fairly balanced meals while Edward did not. Stieglitz made hundreds, rather than thousands, of prints and never showed those he felt were less than perfect.

In many ways Stieglitz did not act like an art dealer. He never gave a consignment slip for any print or painting and he never took a regular commission from a sale. His dealings were secured by his word, and he did more for his group of artists than any conventional dealer could have done, establishing unbelievable price levels. In a sense he was a dictator and his decisions were final as to price and to whom he would sell. He was criticized because he charged rich people what he thought they could and should afford to pay for a work of genius. When a purchase was made, he would say, "Make out the check to the artist for a certain amount and another check [usually for about twenty percent of the sale] for the rent fund." He had a small income that gave him precarious independence.

An American Place was there for anyone to come to; Stieglitz took nothing from it, it took everything from him. He told other artists what their work meant to him to their gain if they were big enough to accept the truth of his sincere opinion. He believed that art was one way of saying the essential things about life — what an individual feels

about the world and his relationship to it and to his fellow human beings.

However, the hours and days I spent with Stieglitz were often arduous in many ways. He would come forth with wise observations and then continue with a torrent of rhetoric on the difficulties that confronted him: inferior equipment, hostile camera club people, the lack of beautiful printing papers now that platinum paper was no longer made, the general perversity of museums and dealers, the proliferation of unneeded articles and ideas, and the insensitivity of both the public and the government to art. The repetitive insistence of his thoughts and opinions could wear the patience of angels. There was deep truth in many of his statements, but some merely indicated pique and disappointment over situations he might have managed better.

Nancy Newhall had a fine relationship with Stieglitz. Beaumont suffered because he was "that man from the museum." Museums were not in Stieglitz's favor and he cast a cold eye on the policies, programs, and people of the museum world. Stieglitz's security tower was so lofty and constraining that he resented practically everything that did not conform to his very rigid demands. His negative attitude toward museums was based in their failure, as perceived by him, in the adoration of the human spirit. Nancy contemplated a biography of Stieglitz, but his complex, mercurial character baffled her. He spoke in symbols and concepts, and it was difficult to hold him to a tangible statement.

One day in 1946, Nancy arrived at An American Place and found him alone and quite ill; he had suffered a heart attack. She sent for an ambulance and he died in the hospital a few days later, July 13. When more than a year had passed since his death, I received a marvelous Stieglitz photograph from O'Keeffe, *The City at Night,* in its original delicate, white metal frame. I kept it in my studio for a while, then loaned it to the Museum of Modern Art for a traveling show of photography. I eventually gave it to the Art Museum at Princeton University in honor of David McAlpin. I felt it would do far more public good there than in my vault in Carmel.

Following the usual procedure with gifts to not-for-profit public institutions, I had *The City at Night* evaluated for tax deduction purposes. To my surprise the valuation was $15,500! A few months after I filed my income tax I received a call from the IRS. The conversation was roughly as follows.

IRS: "Mr. Adams, I have been assigned to your account and everything looks fine, *except* for one item. I think there is a

typographical error. I think you intended perhaps $155, instead of $15,500 for the gift of a photograph to Princeton."

ADAMS: "No, the larger figure is correct."

IRS: "But for a *photograph?*"

ADAMS: "It was so evaluated by a licensed appraiser."

IRS: "Well, what is the photograph *of,* Mr. Adams?"

ADAMS: "It is of New York City at night by Alfred Stieglitz."

IRS: "I have not heard of the painter Alfred Stieglitz; is he recognized as a great artist?"

ADAMS: "Yes, he was one of the great photographers in history."

IRS: "You mean it isn't a photograph of an important painting?"

ADAMS: "It is a direct photograph of New York City taken at night."

IRS: "Well, Mr. Adams, I do not think we can accept such a value for just a *photograph!*"

ADAMS: "May I suggest you write Professor Peter Bunnell of the Art Museum at Princeton University for a description of the artist and the value of a Stieglitz print? He is an expert in the field of photography as an art form. I am sure he can properly explain the importance of this print."

IRS: "I shall be glad to do this, Mr. Adams, but I am sure he will consider it a typographical error. Thank you. Good day."

Bunnell wrote a scholarly letter that was an excellent dissertation on Stieglitz, his importance in American art, and the scarcity and value of his photographs. A few days after I received my carbon copy, the IRS telephoned. "Mr. Adams, we have received an enlightening letter from Professor Bunnell, and we wish to inform you that the valuation of your gift is accepted."

This event reminded me of the conversation I had with Dean Meeks of the Art Department of Yale University in 1933. I was urged to visit him and show him my work — the same group of prints I had shown Stieglitz. The dean was a most gracious and kindly person but had never seen my type of photographs.

He was taken with *Leaves, Mills College Campus* and asked, "Just what *is* this?"

I said, "It is a picture of foliage."

"Yes, I understand that, but what is the subject?"

I said, "What do you mean?"

He replied (just a bit testily), "What is the medium — is it an etching, a lithograph, or a detailed painting?"

I said, "It's a photograph!"

I was finally able to convince him that it was a direct photograph from nature. He became quite excited and arranged an exhibit of my work at Yale in 1934. I did not expect him to know anything about me, but it was hard for me to believe that a leading art historian did not know of the work of the great contemporary photographers. He had "heard of Stieglitz, he's a dealer in New York, I believe?" The names of Paul Strand and Arnold Genthe were unknown to him. Such was the awareness of photography in the halls of academia in the 1930s!

I had met Stieglitz's wife, the great painter Georgia O'Keeffe, in 1929 at Mabel Dodge Luhan's and again saw her there in 1930. Stieglitz had discovered O'Keeffe's extraordinary abilities as an artist, championed her painting, obsessively photographed her, and, despite an extreme difference in their ages, married her. By the time that I met Stieglitz, O'Keeffe had decided to reside and work in New Mexico, not as a separation from Stieglitz, but because of her determination to continue her work in a less distracting place than New York City. Stieglitz was forever set in the New York milieu, and in fact never traveled further west than Chicago, but he was impressed with the remarkable paintings she was making in the far-off and legendary New Mexico. There was a profound admiration and love between them, and their marriage survived in its unique way.

I recall one wintry morning; it was sleeting outside and chilly within An American Place. Stieglitz was grim and of waxy complexion and did not want to talk. A little man, bespectacled and timid, with briefcase and rubbers, entered the Place and asked for Mr. O'Keeffe.

Stieglitz glared at him and said with measured diction, "My name is Alfred Stieglitz, my wife, Georgia O'Keeffe, is in New Mexico. What do you want?"

Undaunted, he replied, "I have some papers for you to sign, Mr. O'Keeffe, that relate to community investments."

Equally undaunted, Stieglitz drew himself up and repeated, "My name is Alfred Stieglitz, my wife, Georgia O'Keeffe, is now in New Mexico!"

"Please, Mr. O'Keeffe." Stieglitz gave up and signed the papers. The little man stuffed them back in his briefcase, walked to the door, opened it and turned to Stieglitz, saying, "Thank you very much, Mr. O'Keeffe," and slammed the door as he left.

Stieglitz slowly turned to me and said, "My name is Alfred Stieglitz,

my wife, Georgia O'Keeffe, lives in New Mexico . . ." then turned and disappeared into the back room. I did not see him again that day.

Another cold and gray day, O'Keeffe was in town and asked me for dinner at their apartment near the East River. I picked up a depressed Stieglitz at the gallery and we hailed a cab; the radio was blaring at an irritating decibel level.

The driver asked, "Where to, gents?"

Stieglitz replied, "Four-o-five East Fifty-fourth Street. Stop first at a liquor store. Turn off that goddamn radio!"

"Yessir," said the cabbie with a disconsolate expression. We stopped at a store, and I suggested that I purchase a bottle of bourbon.

"Be sure it's the best," said Stieglitz.

We proceeded to the apartment. He gave the cabbie a very generous tip and said, "Thank you! Now you can turn on that goddamn radio!"

The cabbie smiled broadly and, as an aside to me, whispered, "Not such a bum geezer after all, huh?"

We entered the apartment. I was the only one of the three of us to have a drink. After we had begun a sparse but tasty dinner, Stieglitz recalled to O'Keeffe that he and I had had a discussion that day during which I had daringly suggested that perhaps the great man was too removed from the world and that the wonderful paintings he showed should reach a larger audience.

He said to O'Keeffe, "Adams thinks I should go public."

"Oh," said O'Keeffe.

Stieglitz continued, "He says I am esoteric."

"Oh?" said O'Keeffe with rising inflection.

"What are we going to do about that, O'Keeffe?"

"Well," said O'Keeffe, "I am shocked! Have some more veal, Adams?"

Stieglitz continued, "I thought he understood me."

I was getting very nervous but made no comment.

O'Keeffe said, "He will learn, I hope."

Silence.

Stieglitz said in a quiet voice, "I hope so, too."

O'Keeffe said, "More coffee, Adams?"

No further comment on the subject. I had been properly chastised. What I had thought of as an objective discussion seemed to Stieglitz a questioning of his most basic principles that he felt were absolutes of uncompromising excellence for the benefit of the human spirit. It did

become a happy evening as I was shown many beautiful drawings, paintings, and photographs.

My friendship with O'Keeffe continues to this day. She is not a recluse but her daily program is full and intense and she greatly dislikes casual conversation; hence, one manages an appointment with great difficulty and proof of serious intention. When she does greet you, she goes all out with generosity of time and hospitality, never elaborate but always in exquisite taste.

O'Keeffe wears black on most occasions, with enormous distinction. The only jewelry I remember her wearing is a simple, silver pin made for her by Alexander Calder. She has the most impressive physical presence of anyone I have ever met.

I have made a number of portraits of her over these past fifty years. On one of her visits with us in Carmel, I saw her in the very revealing light from my tall northwest-facing window and, rather catlike, I got out my Hasselblad, placed it on a tripod, put on the 120mm Distagon lens, and selected a back loaded with Tri-X film. She was sitting and enjoying the ocean, which was very lively that day.

I busied myself, focusing on a neat assembly of coral and shells that Virginia had arranged, and then asked O'Keeffe, with perhaps forced casualness, "Would you mind if I tried to make a picture of you?"

She replied, "Of course not, you were intending to do it all along."

I wanted her hands and face together, so I asked her to turn and rest her arms and place her face on her hands. What appeared was marvelous, though posed.

She remarked, "Just like Stieglitz; he always posed me but he said it was natural." A generous smile indicated she was not negative to the project. I think that the photograph I made was splendid, but she told me later, "I didn't like that picture at all. You made me look so grim. I am not grim." I admit that it is a strong picture, but I did not think it grim.

In November 1981 she visited us again, and I was able to ask for the opportunity to photograph her with a straightforward approach. She agreed and, with my old and still excellent 35mm Zeiss Contarex Professional, I made a few images of her seated in our garden, backed with ferns and other greenery, in a soft, generous light. I am very happy with this picture. Her sight is now limited but her friend and assistant, the excellent sculptor Juan Hamilton, described it to her in great detail and assured her she would like it if she could see it clearly.

In 1980, my former assistant Andrea Gray took the initiative and

coordinated an hour-long film on my life, *Ansel Adams: Photographer.* With the backing of San Francisco's public television station KQED and sponsors such as the Shaklee Corporation and the National Endowment for the Arts, the success of the project was assured. Andrea co-produced the movie with the very fine director John Huszar of FilmAmerica. We began filming in my darkroom and home in Carmel, and then traveled to my birthplace in San Francisco, to Yosemite Valley, and to New Mexico, where two sequences were scheduled — one with Beaumont Newhall and the other with O'Keeffe.

With ample prior notice, we arrived at O'Keeffe's house in Abiquiu. She gave close attention and all the time we required to film our episode. O'Keeffe and I decided to recollect our earlier days while walking around the interior court of her adobe home. We strolled about while talking informally, sat on a bench for more close-up conversations, passed through a hallway leading to the north garden, and walked together over the hilly grounds near the house. Several takes were made of each situation, and for each we had a flow of spontaneous talk. We were all astounded at her acuteness and strength at ninety-four. The movie turned out exceedingly well, and O'Keeffe much enjoyed the participation.

It is a moving experience simply to witness O'Keeffe's excitement with life. Her incisive rejoinders in conversation are never forgotten. One recent morning at breakfast in our Carmel home she spoke of the problem of being taken for other people wherever she is. I asked, wickedly, "Have you ever been taken for Grandma Moses?" With a deep "ARRRRRAGH!" she arose and encircled my throat with surprisingly strong fingers, clearly indicating she was not at all pleased with the idea.

In January 1982, she telephoned from New Mexico to compliment me on my eightieth birthday. I thanked her and said, "But you are a month early; it's not until February. I have still one more month of youth!"

She replied, "That makes no difference at your age. But remember, I shall always upstage you by fifteen years!" Her genius will always be in flower, no matter what age or events come upon her.

In the presence of O'Keeffe paintings, I cannot claim to fully understand them; I accept their power and dignity and the assurance that there is a tremendous reserve of beauty that fine artists, in all media, can give us. They may deny it vociferously, but artists burn with a need to convey by implication their personal conception of life and potential beauty, transcending all the laws, dogmas, practical aspirations, and

the instincts of self-preservation. They, along with the scientists, poets, and philosophers, illuminate the world rather than exploit it. Anyone who has viewed a Stieglitz, a Moore, a Strand, or an O'Keeffe must be excited by such vision and execution; their messages stand as beacons.

I believe that the artist and his art are only a part of the total human experience; the viewer in the world at large is the essential other part. I feel that a true work of art is like nothing else in the world. It is not essential to know how the artist thinks or how he believes he relates to his profession or his society. What he creates is his message. For me a work of art does not cry for comprehension, only for reaction at the level of art itself.

Stieglitz taught me what became my first commandment: "Art is the affirmation of life."

II.

The Sierra

Eastward, beyond the surf of the Pacific, beyond the tawny rolling Coast Range and the wide central valley of California, rises the great wall of the Sierra Nevada. Four hundred miles long, seventy-five miles wide, ten to more than fourteen thousand feet in height, it ranks with the major mountain ranges of the world. Certainly it is one of the most beautiful. Geologically, it is a tilted block of the earth's crust — a long, continuous slope fronting the west, and a short, breath-taking decline to the eastern deserts.

Truly the "Range of Light," as John Muir defined it, the Sierra Nevada rises to the sun as a vast shining world of stone and snow and foaming waters, mellowed by the forests growing upon it and the clouds and storms that flow over it.

THIS IS HOW I DESCRIBED THE SIERRA IN 1938 IN THE foreword to my book *Sierra Nevada: The John Muir Trail.* When I was young I could not imagine that the resources of the earth were anything but inexhaustible. When it was built in 1903, our family home was surrounded by sand dunes; they soon disappeared completely under housing developments. From our house I looked toward the pristine Marin hills that seemed eternal; suddenly in 1934, there was the Golden Gate Bridge with its steady stream of automobiles into and out of the city. My placid environment was forever changed. Was this to be the inevitable reality for twentieth-century man? Perhaps the introduction to astronomy by my father did much to open the awareness of universal beauty and order for me, for

even as a child I felt certain that the world around me was something more than an arena for exploitation or mere enjoyment.

The Sierra built and modulated my environmental concepts. It joined the wondrous visions of astronomical reality with the dynamics of nature all about me. And I did meet with people in the mountains who matched their power and dignity, not because they could conquer the peaks, but because they seemed to understand and become part of the mystery.

For the first three years that I visited Yosemite, the surrounding Sierra seemed inviolate. But in 1919, as I joined the Sierra Club and began work as the custodian of the LeConte Memorial, the Sierra took on a new meaning, and I looked more sensitively on the fragile qualities of the land around me.

Founded in 1892, the Sierra Club was actually a club — a group of University of California faculty and students and other San Francisco Bay Area lovers of the outdoors. John Muir, a great American environmentalist well before we had defined the meaning of that term, was the first president. He was the pathfinder as the club led the fight for the protection and preservation of American wilderness.

The purpose of the early Sierra Club was:

To explore, enjoy and render accessible the mountain regions of the Pacific Coast; to publish authentic information concerning them; to enlist the support and cooperation of the people and the government in preserving the forests and other natural features of the Sierra Nevada.

At the time, the members of the club considered themselves a mountaineering elite, for there were few people, other than hunters, prospectors, timber and sheep men, who ventured into the mountain vastness. Under Muir's brilliant leadership the club grew in size and clout until its influence was felt in the highest reaches of government and we all benefited: the establishment of the National Park Service and the creation of new national parks and monuments, including Sequoia, Mount Rainier, and Glacier National Parks. There were also the grave losses, such as Hetch Hetchy: a valley of beauty nearly equal to Yosemite's, drowned to become a vast reservoir.

My involvement with the Sierra Club revolved about my summer job as custodian, until 1927, when Cedric, Virginia, and I took part in that year's Sierra Club outing to Sequoia National Park. The outing

had been begun by Muir and William Colby in 1901. I wrote enthu-
siastically to Albert Bender:

July 25, 1927
Sierra Club Camp, Junction Meadow, Kern River Canyon

Dear Albert,

*I wish I could set out to tell you of this marvelous summer — but I shall
have to let my pictures do that. If nothing unfavorable happens to the
plates — and I hope nothing does — I will have to show you the best
set of mountain pictures I have ever had. But the pressure of my work
has allowed me little time for rest and writing. Up at four or five in the
morning — rushed breakfast — then off on the trail with 30 pounds on
my back and a tripod in my hand — and by the time I return I feel like
doing just nothing until the next morning.*

*Yesterday I climbed Milestone Mountain — 13,600 feet and hauled
my camera to the craggy top. The peak is about the most majestic I have
ever seen — and the view incomprehensible. We have been favored with
wonderful rolling clouds that have blanketed the entire Sierra.*

*I have been reading a good deal of Jeffers whenever I have the chance,
and he grows on me constantly. The power and vitality of his verse blends
so perfectly with the rugged mountains. I think he is great.*

*I will be home somewhere around the tenth of August — and wish I
could tell you how glad I will be to see you again. I have missed you a
very great deal. As I said, I regretted leaving the city for the first time on
account of the new lease on life your interest and friendship have given
me. I shall return with unbounded enthusiasm for work.*

Cedric Wright sends his best wishes.
Virginia Best " her " "
*and I send my " " and lots of affection besides
 — just oodles of it.*

*Remember me to all my friends and take care of yourself. Don't eat
from cans. That's what I have been doing for four weeks.*

Yours always
Ansel

(p.s.) Sold a portfolio to the President of the Sierra Club.

On returning to San Francisco in the fall, I began visiting the club's
offices and became active in its efforts and objectives. William Colby

telephoned me one day in early 1928 and advised me that the next summer's twenty-ninth annual outing would be in the Canadian Rockies. He asked me to come this time as their official photographer: all expenses paid but at no fee as the budget was very tight. There was only one possible reply to that invitation!

A friendly and excited group left by special train for Canada. I carried with me both my 6½x8½-inch and 4x5-inch Korona View cameras and lots of film. The Canadian Rockies are another world: spectacular and difficult. The rock is metamorphic, not as firm and bright as the granites of the Sierra. Timberline is lower, and the forests are sparse, though wild and green. It is gorgeous country, with unpredictable weather: a glorious sunset can resolve into a sudden rainstorm, changing into sleet by the early morning hours. The abundant mosquitoes were beautiful, large, and had padded feet; they could alight so gently you could not feel them land, and their excavation of epidermis began without delay! As in the Sierra I would unload exposed film and load fresh film with my film holders in a changing bag at dusk, while a friend kept the mosquitoes at bay.

Daylight lingered long and dawn came in the small hours. On a climbing day our Swiss guides would call us at two-thirty A.M., breakfast at three, and we were on the trail shortly thereafter. I remember on several occasions wading a stream in the gray dawn and finding the same stream waist-high in the late afternoon, flowing from the sun-warmed ice fields above and milky with glacier scoured rock particles.

We camped near the south base of Mount Robson, where we spent a day of revival and contemplation of the remarkable mountain rising about ten thousand feet above us. Robson is one of those big mountains that does not seem less distant as one plods toward it. We then moved around the west shoulder of the Robson Massif, past Robson Fall, and camped by beautiful Amethyst Lake, close to the several glaciers tumbling down from the summits of the Robson group.

The most spectacular day of the trip involved the ascent of Mount Resplendent. The guides took several large parties to its summit. The glacier we traversed was shattered with crevices, and the guides were in a frenzy to keep us in safe areas. The main groups were tied together with ropes, but I was on the loose with my camera. I had the tripod set up and ready to make a picture of Robson when I noticed some dirt on the lens. I took off the lens board and carefully cleaned the lens surfaces, then held it up to the sun to see if it needed any internal cleaning. To my dismay I noted several pinholes in the lens board. This implied that all the pictures taken with it to date were fogged. As

it turned out, most of them showed multiple faint pinhole images and, of course, were ruined. Fortunately I had some opaque black tape with me and all the negatives made after this repair were undamaged.

Seldom did I take specifically assigned pictures while serving as Official Photographer — even then, the greater part of my work was entirely self-motivated. I reveled in the limitless image resources of the world around me. To commemorate the outing, I made a portfolio of photographs that I sold at cost, thirty dollars, to other members of the trip. Its success was such that I also made Sierra Club outing portfolios for the 1929, 1930, and 1932 High Sierra trips. Few of these photographs were of vast landscapes, most were details, minutiae of nature, and the moods of light and weather on a single mountain or valley. The portfolios were not intended to be great creative efforts, but fine mementos.

The Canadian trip established me as a leader of the Sierra Club outings, and in 1930 I assumed the duties of Assistant Manager; I selected the next day's campsite, the route and the possible climbs on the way, arranged for the evening entertainment around the campfire, and cared for the lost and found. Each travel day I would arrive at our destination usually before the first packtrain, designate the men's camp, the women's camp, and the married camp. Location of the commissary and that of the two latrines was fairly easy. I would then vanish into the wilderness with my camera. Dinner was usually served at the most magical time of day for photography, and I often returned to camp too late for anything but a few desolate snacks and cold tea.

I wrote an enthusiastic description of the 1931 outing in an article for the *Sierra Club Bulletin* of February 1932.

Mid-afternoon . . . a brisk wind breathed silver on the willows bordering the Tuolumne and hustled some scattered clouds beyond Kuna Crest. It was the first day of the outing — you were a little tired and dusty, but quite excited in spite of yourself. You were already aware that contact with fundamental earthy things gave a startling perspective on the high-spun unrealities of modern life. No matter how sophisticated you may be, a large granite mountain cannot be denied — it speaks in silence to the very core of your being. There are some that care not to listen but the disciples are drawn to the high altars with magnetic certainty, knowing that a great Presence hovers over the ranges. You felt all this the very first day, for you were within the portals of the temple. You were conscious of the jubilant lift of the Cathedral

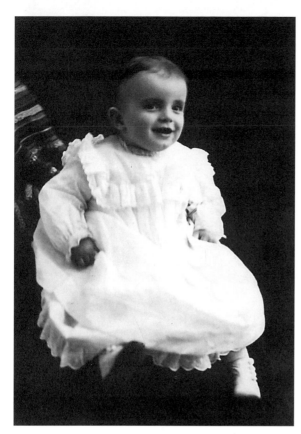

At eight months, 1902

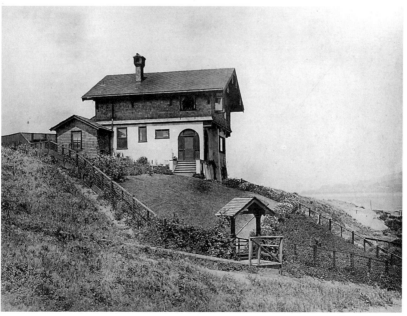

Adams family house, San Francisco, 1903 (by C. H. Adams)

With Father, Mother, and a friend, Yosemite National Park, 1916

Grandfather Bray, Mother, Aunt Mary,
and Father in our living room, c. 1918

Playing the piano, c. 1922

*Hiking the trails, Yosemite
National Park, c. 1925*

Our wedding day,
January 2, 1928, in front
of Harry Cassie Best
painting

Working in my dark-
room, San Francisco,
c. 1930
(copyright © 1985
by Virginia Adams)

Albert Bender, c. 1930

Portrait, 1930s (by Cedric Wright)

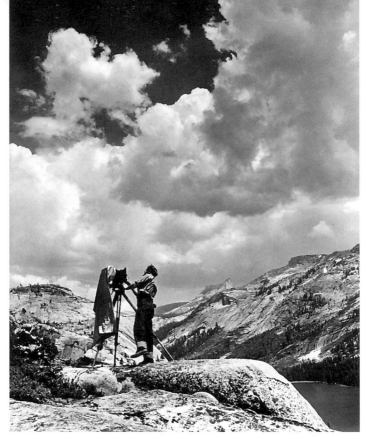

*Edward Weston, Tenaya Lake, Yosemite
National Park, 1937*

*Beaumont and Nancy Newhall, New York
City, c. 1939*

Alfred Stieglitz, c. 1945

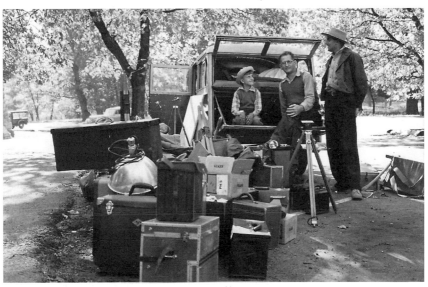

*Packing the car before our Southwest trip, with
my son Michael and Cedric Wright in Yosemite,
1941 (copyright © 1985 by Virginia Adams)*

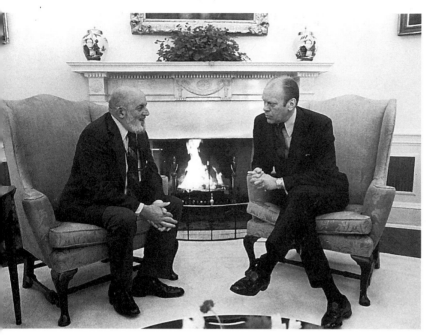

Lobbying President Ford at the White
House, 1975 (by Ricardo Thomas,
courtesy the Gerald R. Ford Library)

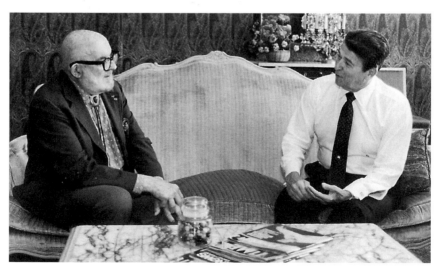

Remonstrating with President Reagan,
Los Angeles, June 30, 1983 (by Michael
Evans, courtesy the White House)

range, of the great choral curves of ruddy Dana, of the proces-
sional summits of Kuna Crest. You were aware of Sierra sky and
stone, and of the emerald splendor of Sierra forests. Yet, at the
beginning of your mountain experience, you were not impa-
tient, for the spirit was gently all about you as some rare incense
in a Gothic void. Furthermore, you were mindful of the urge of
two hundred people toward fulfillment of identical experience —
to enter the wilderness and seek, in the primal patterns of nature,
a magical union with beauty. The secret of the strength and con-
tinuance of the Sierra Club is the unification of intricate personal
differences as the foundation of composite intention and desire.

Upon the arrival of the packtrain of fifty or more mules, a quasi-
military organization would be set in motion: two men would be
directed to cut dead wood for the stoves; the kitchen group of four
would set up the equipment and get clean water from a nearby lake
or stream. Dan Tachet, the chef, would start the evening meal with
the conscription of general help and a flood of French-accented
instructions. The food was magnificent and varied; to feed nearly
two hundred people in the wilds properly for a month was no
mean achievement. As I described it in the February 1932 *Sierra Club
Bulletin:*

The first dinner in camp is a great occasion, especially for the
initiates, who receive illustrated instruction in the ethics of our
primitive cafeteria. It is then you get your spoon, a sort of visa to
all subsequent meals. If you lose it, you are in for diplomatic
difficulties of no mean degree. The spoon is the insignia of the
order; without it you are disenfranchised and helpless. It usually
reposes between the sock and boot-top, but some are drilled and
hang on the bearers' bosoms like medals. Literally, you are born
into the Sierra Club with a steel spoon in your mouth.
 At dusk we gathered at the rim of the world and watched the
last fires of sun-flare on the summits, and the valleys fill with cool
rivers of night. Stone and hoary trees and the bodies of our com-
panions merged in translucent unity with the world of mountain
and sky; our fire leaped and writhed into the night, and clouds
of querulous sparks soared high among the stars. A spirit of un-
earthly beauty moved in the darkness and spoke in terms of song
and the frail music of violins. You were aware of the almost
mystic peace that came over us all; the faces of those about us

reflected the experience of calm revelation. There was the face of the great scientist dreaming of a beauty beyond all formula — the face of the artist gazing with unseeing eyes into the abyss of stone, yet seeing an infinitude of things — the face of the man of affairs, quiet and eager, confronted with new and exquisite experience — the face of adolescence, hushed and surprised at this promise of the world's sharp beauty. At the close of the music we went quietly through the darkness to our beds, swaying and twinkling our lights among the trees and listening to the choir of golden bells from our animals at pasture.

Arranging entertainment about the campfire each evening was not difficult. Often Cedric and his best violin pupil, Dorothy Minty, would perform such charmers as Bach's Double Violin Concerto. Sometimes a good singer or lecturer would be extracted from the group. Over a number of rainy days in camp during the 1932 outing, I prepared a series of pseudo-Greek tragedies, *Exhaustos, The Trudgin' Women,* and *The Oxides.* (I never finished a fourth, titled *The Mules* by Oresturphannies.) The group entered into rehearsals and performances with great gusto. The cast of characters included such exalted roles as King Dehydros of Exhaustos; Commissaros, Prince of Indigestion; Clymenextra, daughter of King Dehydros, Rhykrispos of Poucha; Ogotellone, a fisherman; and the Chorus of Weary Men and Sunburnt Women. I was the Spirit of the Itinerary with a harp of bent wood and fishing line, greeting the assembled with such unforgettable lines as:

Hellenic splendor meets Sierra dusts
And javelins confront mosquito thrusts.

Cedric and his violin, hidden in the bushes, would produce the pizzicato effects with eerie timbre. How funny these plays were in situ and how dismal when given anywhere else!

In addition to making photographs and playing the violin at the evening campfires, with his usual dichotomy of effort Cedric designed and installed the first collapsible and portable latrines for the outings. He called them his "Straddlevariouses." Being highly inventive, he also made astonishingly solid camera and violin cases of varnished plywood with leather thongs, which would tolerate the rigors of being packed for a month on muleback.

While on that 1932 outing, we hiked over Kaweah Gap, where I was struck by the still, icy beauty of partially frozen Precipice Lake and its background, the black base of Eagle Scout Peak. I saw several images quite clearly in my mind and made five variations. The best of the resultant photographs, *Frozen Lake and Cliffs,* is still very satisfying to me. It has been termed "abstract," but I do not think any photograph can really be abstract. I prefer the term *extract* for I cannot change the optical realities, but only manage them in relation to themselves and the format.

By the late 1930s, the rigorous ecological requirements dictated that large groups of two- and four-footed creatures were no longer feasible. Today the Sierra Club schedules trips all over the world as well as in the Sierra, but the groups are small and propane is now packed into the mountains for cooking. There is no longer the bountiful provision of dead wood, and campfires with their cheer and fragrance are taboo.

In 1931, Francis Farquhar, then president of the Sierra Club, suggested that more women should be on its board of directors and promptly nominated Virginia. She was elected and served with distinction, paving the way to a less chauvinistic Sierra Club leadership. When Michael was born in 1933, Virginia decided she preferred to concentrate on home and family. The 1934 election was the beginning of my thirty-seven-year tenure as a board member, which proved to be one of the most important activities of my life. The change of stewardship was reported thus in the *San Francisco Chronicle:*

SHE WON — OR MAYBE HE DID; ANYWAY, HE GOT THE JOB

Black-bearded Ansel Adams, photographer, and his blonde wife are friendly enemies, Mrs. Adams disclosed today.

Both are members of the Sierra Club. For two years Mrs. Adams has been a member of the board of directors. This year, both were nominated for that position.

Ever since the nominations there have been Gaston–Alphonse scenes between them — "Now Ansel, you've been so active in club organization, I think you should be elected," and, "You've been a director for two years, my dear, and you ought to be re-elected."

Thus they campaigned, she for him and he for her.

Today results of the election were made public. Mr. Adams had beaten his wife to the job — or, if you look at it the other way, Mrs. Adams had beaten her husband in campaigning.

"I'm very glad he got it," Mrs. Adams insisted. She was busy with their baby, Michael, she said, and hadn't much time for directors' meetings anyhow.

"It's nice, but I wish she had been re-elected," maintained the tall, mountaineering photographer.

Francis Farquhar, in addition to being president of the club, was editor of the *Sierra Club Bulletin* and was also an assistant to Stephen Mather, the first director of the National Park Service. The National Park Act of 1916 is a strong and clear document, and Francis gave much time and energy ferociously protecting its structure and objectives.

Francis and I appeared to be quite dissimilar. He was a proper Bostonian, a Harvard man, and a staunch Republican. However, we shared a great love for the Sierra, hiking together for many years, and we were both active at the same time in the leadership of the Sierra Club. We put up with each other's politics: my liberal logic would contrast with his conservative one. He was a loyal member of the Bohemian Club and could never understand my refusal to join. The Bohemian Club, one of the most famous clubs in the world, began in the late 1880s as a group of artists but was taken over by their patrons and soon became the center of WASP culture. Since club membership was blatantly restricted, I persistently declined invitations of membership.

The fact remains that many of my friends did belong to the Bohemian Club, and many artists and musicians were members because of the prestige and fellowship involved. At their two-week-long Summer Encampment, the great of the world are invited: presidents, generals, scientists, and artists. I agreed to accompany Francis once, but could only stand it for four days before I escaped. I had seen only very white skin and could not help thinking of the other great people of color I had known who would have graced this club by their presence.

Francis was most supportive of my landscape photography. He would see a great vision in a photograph of a mountain or a pine tree but not in a close-up composition of a pinecone. To him my *Pinecone and Eucalyptus Leaves* represented a small fragment of nature that simply was not as important as an entire tree. I found his attitude disturbing, but in time I realized that for many viewers subject mat-

ter alone may dominate any photograph. The successful expression and transmission of creative concepts depends upon the sensitivity of the viewer. Again, quoting from my article in the 1932 *Sierra Club Bulletin:*

> It is a typical modern conceit to demand the maximum dimension and the maximum power in any aspect of the world — whether of men or mountains. It is better to accept the continuous beauty of the things that are, and forget comparisons of effects utterly beyond our control. An Oriental aesthete would never question the exquisite charm of those pale threads of water patterned on shining stone. The American mode of appreciation is dominantly theatrical — often oblivious of the subtle beauty in quiet, simple things. One can never assert the superiority of the vast decorations of the Sistine Chapel over some pure experience in line by Picasso, or of torrents swollen by the floods of spring against the quiescent scintillations of an autumn stream.

> *These with the rest, one and all, are to me miracles,*
> *The whole referring, yet each distant and in its place.*
> — from "Miracles," by Walt Whitman

Soon after my election the Sierra Club began the battle to establish the Kings River area as a national park. The middle and south forks of the Kings River rise in the craggy High Sierra, north of the borders of Sequoia National Park; the combined areas comprise some of the most rugged and beautiful country in America. In 1924 and 1925 I had traveled and photographed throughout the Kings River country with Professor Joseph LeConte II, his son Joe, and daughter Helen. During the 1930s, several of the Sierra Club outings were to the Kern and Kings River areas of the Sierra Nevada. My collection of good negatives from this area had become quite extensive. Francis published many of these pictures in the club bulletin, often as handsome gravure frontispieces, which enabled me to become generally known among the membership.

An important conference was called in 1936 in Washington, D.C., to discuss the future of both our national and state parks. The Sierra Club board of directors asked me to travel to Washington and lobby for the establishment of Kings Canyon National Park. They suggested that my photographs of this region would prove to our legislators the unique beauty of the area. Using photographs as a lobbying tool had

proven helpful in the past. Carleton Watkins's photographs of Yosemite had great positive effect on the efforts that made Yosemite Valley a state park in 1864, and William Henry Jackson's photographs of Yellowstone had been a deciding factor in the establishment of our first national park in 1872.

With total naïveté, I ventured into the strange wilderness of our nation's capitol with a portfolio of photographs under my arm, visiting congressmen and senators in their lairs. I boldly proclaimed the glories of the High Sierra and showed my pictures with the unabashed confidence that they would prove our contention. I was asked to address the conference and thereby became acquainted with Secretary of the Interior Harold Ickes. My unsophisticated presentation of photographs, coupled with appropriately righteous rhetoric, stirred considerable attention in Congress for our cause — although I returned home with no firm commitments on behalf of Kings Canyon National Park.

A young Sierra Club member, Peter Starr, had been killed in 1933 in a mountaineering accident in the Minaret region southeast of Yosemite. He had a passion for risky, solo wilderness climbing and the inevitable tragedy had occurred. Peter's death was a great shock to his father, Walter Starr, a successful lumberman, supporter of conservation, and a fellow director of the Sierra Club. Walter asked me to prepare a book with my photographs of the Sierra Nevada in memory of his son, which he would finance on the condition it be a production of the highest quality with the finest reproductions possible. Accordingly, Wilder Bentley of the Archetype Press in Berkeley served as designer, typographer, and text printer, and the Lakeside Press in Chicago made the 175-line-screen letterpress engraving plates and carefully printed them. The reproductions were of extraordinary quality and were trimmed and individually glued onto the large-format pages. They have often been mistaken for original photographic prints.

Shortly before my final deadline for *The Sierra Nevada and the John Muir Trail,* as the book was to be called, I joined Walter Starr and Rondal Partridge on a hike into the Minaret area, southeast of Yosemite. Ron, then my photographic assistant, was one of three sons of Imogen Cunningham and Roi Partridge, and was a fine photographer. An energetic redhead, Ron was more nutty than I and scrambled about the rocks with the abandon of a chipmunk.

I have never approached mountains with an attitude of conquest. The experience of being on and in the rocks, the marvelous sense of substance and scale, are more exciting for me than the panorama from

the highest peaks. Of course, it is fun to be on top and to identify
landmarks, but I have always enjoyed the climb and the descent more
than the summit pause.

One afternoon on this particular trip a storm gathered while we
were on Volcanic Ridge. Great thunderclouds enhance any landscape,
and a summer storm from the crest of Half Dome or Mount Clark is
unforgettable. But when the storms approach too closely I become
anxious; I have seen too much lightning dance on the crags to enjoy
posing as a lightning rod.

I was photographing Iceberg Lake and the central Minarets, poised
for a few moments with cable release in hand, waiting for a cloud
shadow to clear the Minaret Glacier. The thunder began as I made my
exposure, and I quickly gathered my things for a fast descent. Walter
was extremely agile and preceded me.

Ron said, "Give me the tripod," which he waved over his head,
yelling, "I am *not* afraid of lightning!" whereupon a rather strong jolt
of electricity caught him with tripod high in the air, freezing his arm
in a defiant position. He leaped down the jagged rocks with the tripod
held on high, yelling his defiance of lightning, but was petrified when
it was over. We all agreed he had had a close call and should not tempt
Zeus's aim again.

I was finally satisfied with the images for the book and it was pub-
lished. I immediately sent Stieglitz a copy and to my great delight he
praised it.

An American Place
Dec. 21, 1938

My Dear Adams:

*You have literally taken my breath away. The book arrived an hour ago.
Such a grand surprise. O'Keeffe rushed over to see it. I had phoned her
at once. Congratulations is a dumb word on an occasion like this. What
perfect photography. Yours. And how perfectly preserved in the reprod-
uctions. I'm glad to have lived to see this happen. And here in America.
All American. And I'm not a nationalist. I am an idolator of perfect
workmanship of any kind. And this is truly perfect workmanship. I am
elated. So is O'Keeffe. Many many thanks from both of us for the
magnificent gift and the thought of us.*

Our deepfelt affection,
Stieglitz

Victory for Kings Canyon National Park, however, had still not been won. Many of the images in *The Sierra Nevada and the John Muir Trail* had been made in the proposed park area. I sent a copy to Secretary Ickes, who was proving himself a great friend of the environment. I received a warm letter of thanks from him in which he expressed his hope that this book would encourage others to appreciate and interpret the national parks. This pleased me very much as it confirmed my desire that the book stimulate thought and action in others.

Ickes showed the book to President Franklin D. Roosevelt, who promptly commandeered it for the White House. Upon learning this, I arranged for a second copy to be sent to the secretary. President Roosevelt later joined with Ickes and pressured a stagnant Congress to pass the Kings River National Park bill in 1940.

Even today Harold Ickes continues to be respected as the most effective secretary of the interior in our history. Feisty, outspoken, fearless, a curmudgeon dedicated to high social objectives, he understood the importance of national parks and wilderness to the world and its future. When World War II began there were strong pressures in many circles to close the national parks for the duration, with the thought that no one needs a vacation in wartime. Ickes disagreed with this, stating that in times of national stress and sorrow the people needed precisely what the national parks could offer.

In the 1940s David Brower appeared on the Sierra Club scene. We had met during the 1930s when he was the publicity manager of Yosemite Park and Curry Company as well as an eager Sierra Clubber of boundless energy. Dave's devotion to the Sierra and the Sierra Club and his extraordinary record of rock climbing increasingly led him into organized conservation activities. I proposed Dave to the board as a salaried assistant to the president of the Sierra Club. With some budgetary opposition he was appointed at a salary of six thousand dollars a year. He did a magnificent job and rapidly ascended the ladder of authority, becoming the Sierra Club's first executive director in 1952. He led the club into an era of undreamed-of recognition and effectiveness.

Unfortunately, power and success often breed ego and arrogance, and Brower assumed an imperial stance that by 1969 threatened to shatter the club's organization and resources. The dispute arose because he continuously usurped the authority of the board of directors and proceeded unilaterally with various costly projects. It must be made clear that there was no charge whatever of dishonest use of

funds. He intensely believed in what he did, but he acted with complete disregard for financial realities — the bottom line had become unimportant. Though the publishing program had begun in a profitable way with *This Is the American Earth* in 1960, he brought the Sierra Club to the brink of disaster by producing a series of expensive coffee-table books — books with little relevance to the board's understanding of the American conservation movement.

Brower also was an overzealous crusader, an approach that alienated most of the government agencies with whom the club must work. He and his young knights indulged in tactics that irritated friend and foe alike. I admired Brower, but I could not overlook the escalating dangerous aspects of his management.

I had tried to maintain a balanced view of the important disputes that were rapidly growing in number as the Sierra Club flexed its increasing muscle. In the early 1960s, Pacific Gas and Electric Company announced the development of a nuclear power plant on the Nipomo Dunes, south of Pismo Beach, California. This was an exceptionally beautiful area and had been designated a future state park. The board of the Sierra Club felt that another site in the general area must be substituted, and we waged a battle royal on behalf of the dunes. We were relieved when PG&E gave up their claim and chose an alternative site to the north, Diablo Canyon. As are most areas of the California Coast, Diablo Canyon is an attractive place, but not unique. Fellow Sierra Club board member William Siri and I described our position in a 1967 *Sierra Club Bulletin*.

> Four mile long Diablo Canyon has many beautiful natural features including a grove of large, old oaks. Part of the grove would be sacrificed for power distribution equipment on fill in the lower end of the canyon. Much of the canyon will be left undisturbed. The impairment of the canyon, we believe, must be balanced against the greater values in the Nipomo Dunes.

Diablo Canyon made better sense as an alternate coastal power plant site with the attendant need for a constant source of cooling water. The club publicly expressed appreciation to PG&E for its willingness to change locations, though Brower and a minority of directors disagreed.

All hell broke loose. The next Sierra Club board elections resulted in a change in the balance of power, and the new majority, led by Brower, demanded another vote. Now the majority declared Diablo

Canyon to be a prime scenic treasure that must not be violated by any development. I thought the protest was unreasonable. I believed that if we strongly opposed a project we should make an effort to propose an alternative. We had made the decision and we should abide by it. I am certainly biased to the natural scene, but I also recognized the need for electrical power. The problem as I saw it was to maintain a balance of use, thereby assuring that the truly important areas would stand a better chance of protection. I became, in the minds of some, a reactionary, an Uncle Tom.

Diablo Canyon Nuclear Power Plant was built, but with continuing opposition to this day. And tragically, questions concerning the plant seem to mount with time, not about the location being a prime scenic area, but about the plant's position on a previously unknown earthquake faultline and charges of inferior construction.

The vehemence, anger, and accusations on both sides of the argument were beyond anything I had previously experienced. This fight did immense harm to the credibility of the Sierra Club and tore the leadership apart. I came to realize that the collective intelligence of boards and committees can be much less than that of the individuals composing them.

The elections of 1969 loudly expressed support for me and the minority position, and we again became the majority. Brower resigned immediately to form what he felt would be a more activist group, Friends of the Earth. But I was left depressed and without enthusiasm for this cause that had absorbed so much of my energies. I felt too many in the club had grown unreasonable. My concern grew and finally prompted me to resign as a director in 1971 at the age of sixty-nine. I firmly believed that new blood would be of greater benefit to the cause.

Diablo Canyon cost me some friends but strengthened my convictions. The human condition is part of the world's structure, and a balanced approach to the environment and its significance to humanity is essential. I did not then, and do not now, believe in big stick tactics; our reason for being is not to destroy civilization but to assist in guiding it to constructive attitudes. With the perspective of time I feel that education of the public in the vast, inclusive problems of the environment will have the most rewarding effects.

Dave Brower has continued to lead many important fights on behalf of our environment. As someone said of him, "Difficult as he may be, he is of the kind that moves the world." The smoke of conflict has

disappeared over the years. The earth is a better place because of this resolute crusader for the environment.

I had tried to resign from the Sierra Club board once before. In 1958 the National Park Service was under great pressure from tourist and business interests to make travel easier between Yosemite and the Owens Valley by widening, leveling, and straightening the Tioga Road. This road crossing the Sierra is the only one in the entire range that cuts directly through true high country. While safety dictated many of these "improvements" in view of the increasing visitation, the one truly sore spot for me was the proposed route of the new road in the Tenaya Lake area. I felt strongly that the lake should not be violated. A better alternative was to go up Magee Creek and eastward to a junction with the old road at the west end of Tuolumne Meadows. This would have reduced the pressures on Tenaya Lake and the beautiful granite dome region to the east, perhaps the finest landscape of its kind in the Sierra. Wilderness with a slick highway through it is no longer wild.

The Sierra Club board refused to take action on my plea, although quite a few members of the board supported me. I was dismayed; I felt immediate action must be taken. I first sent my resignation to the board of directors and then sent a hot telegram to Washington, D.C.

My telegram apparently alarmed a few politicians: five rushed out from Washington and five more from the San Francisco regional office of the Park Service, accompanied by the superintendent and chief ranger of Yosemite. I escorted them to Tenaya Lake and pointed out the causes of my concern. After much discussion, it was my understanding that they agreed to a proposed route that would sweep under the present Olmstead Point and follow a gentle canyon down to the lake level, leaving the vast granite domes unscarred.

I returned to San Francisco and found the board had refused to accept my resignation. I had caused a minor earthquake and escaped the falling debris. Several months later, to my horror, I discovered that the route had not been altered, my solution denied, and an incredible assault on the integrity of the area had been perpetrated by cutting a nearly mile-long road across one of the largest unbroken granite slopes of the Sierra. The excuse was, "The visitor will have a beautiful view of the lake as he drives!" The damage done is truly permanent.

The Sierra Club today, with a membership of about four hundred thousand and with more than fifty regional chapters, has great political impact. It is also a major publishing house, a travel agency, and a

producer of resolutions. Its emphasis has changed from a direct American conservation outlook to an inclusive sweep of environmental problems. It is difficult to imagine what the conservation movement would have been without its presence. The good that it has done can never be fully measured.

I cannot mention each of my good Sierra Club friends, and there were many, but I cannot neglect Dick and Doris Leonard, stalwart environmentalists and friends for more than fifty years. A successful lawyer, as was Colby, Dick possessed an enormous amount of energy and dedication. He is noted for his calm, measured approach to the feisty problems of the environment. People such as myself are far more explosive in expressing our convictions and in our actions, but Dick is always there to catch the ashes, so to speak. The environmental movement in America would not have advanced as far as it has, had he and Doris not been on the scene.

Another great team, Dr. Edgar and Peggy Wayburn, have made environmental history in many fields. Ed, currently the president of the Sierra Club, was the spark behind the Golden Gate Recreational Area concept, and Congressman Philip Burton, who used his great political talent to create it, was the flame. This extraordinary park is but one mile from the San Francisco shore: a unique juxtaposition. The Wayburns have also been closely associated with the Alaskan national parks and wildlife preserves. Peggy and Ed have fought a great and decisive battle on behalf of Alaska, our last frontier of wilderness. The goal is to achieve a balance of wise use and preservation of its marvelous lands and impressive resources for the future. There should be special medals cast for such heroes of the environmental movement.

Since resigning from the Sierra Club, The Wilderness Society has claimed my strongest allegiance for two reasons: its strong and specific concept of the importance of wilderness and the appointment of William A. Turnage as its executive director. In 1971 I was appointed a Chubb Fellow at Yale University. I met with many dedicated and challenging students there, but was immediately struck by a brilliant young man at the Yale School of Forestry. Bill Turnage had a degree from Yale, had studied at Oxford, and had worked for our State Department in Washington for three years before his passion for the American wilderness completely captured him. Bill has a grand love of hiking, climbing, and skiing and a great sensitivity to wilderness concerns.

Returning home to California, I suggested to Virginia that Bill would be perfect to manage Best's Studio, a task she had magnificently

performed for too many years. Bill left New Haven and moved to Yosemite, where he effectively, with the determination and energy of the young, reorganized and prioritized the business to the benefit of all concerned.

A close working relationship developed between Bill and me, as it became apparent that we shared the same heartfelt concerns about the fate of man and earth. I was fortunate to have Bill manage my business affairs and advise on the escalating demands that the decade of the seventies brought my way. During those critical years, Bill revealed a high order of intelligence and imagination.

Feeling he had accomplished what he could, Bill left Carmel at the end of 1977 to embrace the solitude that only a wilderness experience can provide — his choice, Wyoming. After a few, short months I learned that The Wilderness Society was considering him for its Executive Director. I knew Bill would be the propitious choice and was very proud when indeed he was the person selected.

Bill has no qualms in contesting ideas and opinions of the potent antagonists in Washington. Importantly, he has the determination and energy to follow through with the programs he has set in the political arena. It takes courage to face staunch opposition to the gargantuan environmental situations and, at the same time, raise funds for their solution.

I have come to the conclusion that to be complacent is to be ineffective, and to be tolerant of obvious error or injustice is unforgivable. Perhaps there is something amiss with the genes of Homo sapiens that does not innately command us to protect our home, Earth, as we instinctively protect ourselves. I am thankful for such fierce warriors as Bill Turnage and Dave Brower. I have come to think of them as the Saint Georges of the environmental movement; unfortunately, the dragon might have four more years.

12.

Commercial Photography

THE DECISION TO DEVOTE MY LIFE TO PHOTOGRAPHY brought with it the problem of how I was to earn a living. The solution was to work as a commercial photographer, not only to support my family but to allow time for my creative work. In 1930, Virginia and I built a home with a studio in the garden next to my parents' house and I hung out my shingle: Ansel Easton Adams, Photographer.

I found myself unusually fortunate in being able to accomplish, with balance of time and energy, my creative and commercial work. Over the lean years of the Great Depression, I did everything from catalogs to industrial reports, architecture to portraiture. Our bank account would dwindle to a distressing level and I would grow deeply concerned, then, usually at the financial brink, with creditors gathering, the phone would ring and an assignment would present itself. This would carry us for another month or so, when another crisis would appear and be solved in a similar way. Luckily, Virginia had independent spunk and was able to provide us with a small but reliable income by working at Best's Studio during the Yosemite tourist season. Finances necessitated my continued commercial work until the 1970s. There were exceptional years, of course, such as my Guggenheim Fellowships with grants of money that allowed large blocks of time to devote exclusively to my creative photography.

Before 1930 I was offered only an occasional photographic job. So that I could professionally handle interior photographs, I decided that I must master the technology of artificial lighting. I acquired the necessary equipment: a flash gun, black powder cap detonators, and a

supply of magnesium flash powder, because this was before the era of flash bulbs, much less the electronic flash. The flash powder came in little cardboard capsules marked small, medium, and large. It was reasonably safe, providing the ignition was at a good distance from one's eyes.

With the spring trigger-plunger set on safety, the black powder cap was inserted in the gun. The flash powder, in required amounts, was shaken onto the foot-long receptacle, covering the black powder cap. The gun was held aloft, the camera shutter opened, and the trigger released. There was a firm *pffuff!* and a small kick accompanying a brilliant flash of light, lasting for about one-tenth second or less. Exposure was determined by an instruction card.

I was offered my first professional assignment in about 1920. Our next-door neighbor, Miss Lavolier, taught at the Baptist Chinese Grammar School in downtown San Francisco. She asked if I would take a picture of her class. As the pupils were very active six-year-olds, she warned me it would not be easy either to get them to stand still or to have them all with eyes open.

Arriving at the school with my view camera and accompanying flash equipment, I thought I was perfectly prepared. I got the camera set up, the picture composed, and the flash equipment organized. Instructions indicated that one medium and one small capsule of flash powder should be used. I made an amateur's mistake and spread out three large capsules that were equal to twelve of the small ones. As the room had fairly dark walls, I added another large capsule, thus compounding the error. Without realizing it, I now had the equivalent of sixteen small capsules of flash powder. I thought the heap of gray stuff looked adequate, but that was my naïve estimate of the amount of powder I should use.

All seemed ready; I pulled the slide and raised the flash gun on high. To get the children's attention I made sounds that might pass for a Chinese mockingbird and then simultaneously fired the shutter and the charge. The light was apocalyptic. There was a thunderous PPFFFUFFF!! and my arm was firmly knocked down. I nervously reinserted the slide and looked out on my subjects. No one was in sight. There was dead silence, then a chorus of terrified wails arose from under the desks. The considerable cloud of smoke prompted Miss Lavolier to open the windows, and it billowed over the schoolyard and quickly alerted the fire department, who arrived with sirens screaming. Reassuring words from the office turned them back. Pupils

and desks were streaked with a fine, powdery fallout, but no damage
had been done. After we all calmed down I took the class outdoors
and photographed them using natural light and all was forgiven.

My confidence unshaken, I began to do portraits and weddings. For
one wedding I again used flash powder, this time in a small room with
very light walls. I moved the camera under a doorway while the bridal
party assembled before me. When I fired the gun — *pffuff!* — there
was a really bright light, and clouds of smoke rolled along the ceiling.
The people moved out of the room until the dust had settled. I felt
very sure of myself until I saw the door lintel. I had held the gun too
close to the freshly painted door frame; it was hopelessly scorched. I
paid for the repainting, and that totaled much more than what I got
for the pictures (which, by the way, turned out really quite well). How
much better it was when flash bulbs became available.

Ensconced in my studio in 1930, one of my first commissions was
to photograph the British novelist Phyllis Bottome. Miss Bottome
showed me some soupy portraits by English photographers, remark-
ing, "I really don't want anything like these, you know." I assured her
my pictures would be sharp and direct, nothing fuzzy.

I positioned her, using two metal light-box reflectors with brushed
aluminum interior panels; each held a regular tungsten lamp on a
separate circuit to illuminate her face. Flash bulbs were inserted; the
shutter was set at one-tenth second and synchronized with the flash.
The bulbs at that early state of the art were not dipped in the now-
obligatory plastic safety coating and often they would explode and
scatter pieces of glass and filament far and wide.

I made one exposure and realized I had a problem with my sitter
— the dear lady was like a flaccid, graven image. As I made the next
exposure, one of the flash bulbs exploded, scattering little pieces of
glass in her white hair and giving her a considerable scare. After clean-
ing up, I continued; the subject had now assumed a certain dignity
and poise, with a definite aspect of expectancy. While I do not rec-
ommend such fear tactics, the resulting portraits were very fine.

I found that, in addition to new techniques, there were business
skills to learn to be able to succeed as a professional photographer. An
old friend and Sierra Clubber, Dr. Walter Alvarez, gave me good ad-
vice that has been very helpful, especially during those years of com-
mercial work: "When anything goes amiss, establish a clinical attitude
and remain as objective as possible." To this day, when under stress I
find myself rather dispassionately observing people and their reactions
as well as my own.

Albert Bender gave me important financial advice. He also recommended me as a professional photographer to many of his friends. He taught me from the beginning that everything should be clearly expressed in writing between the client and myself; it is easy to overlook some apparently inconsequential detail only to find it can become a major point of dispute when work is in progress or the statement presented. I also learned to insist on what I believe my work is worth, not more or less. I am convinced that favorable progression in the profession depends upon three chief factors: basic capabilities, an attitude of inventiveness, and cooperation.

The professional photographer takes assignments from "without," injects what imagination he can apply, and does the best he can with the problems presented. The creative photographer, on the other hand, takes assignments from "within" and, if truly dedicated, may find that the client is tough and uncompromising! The conflict of the assignments from "without" versus those from "within" often perplexes the serious photographer.

It is also important to recognize the difference between the found situation and the contrived subjects in the studio. I am not denying that many professional studio photographs are quite beautiful, and entirely justified if they fulfill their function, but we should realize that the aesthetic qualities they possess are inherent in the organized compositions that the camera may elegantly record. The professional can build with light and color, shapes and textures, visualizing the final image as does the photographer working in natural light in the field.

I learned a lot from Anton Bruehl. He was a superb craftsman and a pioneering artist in the production of the finest professional color work of the 1930s found in *Vanity Fair* and other publications. During a New York trip at that time, Bruehl invited me to visit his studio; it was quite an experience. He was using a one-shot, three-color camera that produced, through a system of mirrors and filters, three black and white negatives; each made with a red, green, or blue filter; each exposed at the same instant through one lens. These separation negatives were transferred to screened engraving plates and the three colors printed in sequence, usually with an added black plate (made from the red negative) to reinforce the depth of color and tonal solidity of the printed image.

Bruehl used several large diffusing reflectors, each containing one or more modeling lights and sockets for up to about fifteen large flash bulbs. Four of these were fired from the shutter contact; the others were fired by induction.

The assignment I observed was that of a young woman in a striking bouffant dress of gorgeous but subtle color. She was gracefully holding a white and gold china teacup; a well-known tea company was the client. This was the first professional model I had seen in action, and I was impressed with her patience and Bruehl's masterful direction. When his technical crew had everything ready for the picture, Bruehl became alert, the model came to life and lifted the teacup with her appealing eyes fixed on the camera lens. The bulbs fired with a *swap!* sound, and a wave of heat flared over all. Immediately a pair of youths rushed to the set with ladders and shoulder bags full of fresh bulbs. They removed the fired ones and replaced them, with astonishing dexterity. Bruehl did not stint on supplies, equipment, nor staff. I recall he made at least six exposures of this subject. He had devoted more than three days to the construction of the set and the making of black and white test photographs. Bruehl was a perfectionist.

Even with great effort on my part, my studio experiences were not always as smooth as Bruehl's appeared to be. As I began in business I was not offered any jobs photographing lovely ladies, but more mundane subject matter. In 1940, to drum up business I ran advertisements such as this one in *U.S. Camera:*

ANSEL ADAMS
Photographs for publicity, advertising, and editorial use.
Available for private instruction.
Best's Studio, Yosemite National Park, California

I accepted one assignment that was so phony it was funny. A large dried-fruit company desired a compelling photograph of raisin bread. I prepared for the experience by clearing a space, getting out the lights and putting on a stern, professional appearance. The client's delegation arrived: an account executive of the advertising company, a head of the advertising department of the fruit company, a home economist, an art director of the agency, and a man carrying a large box of bread.

We discussed the layout at great length: a loaf of bread on a breadboard with several slices cut and a shining knife laying across the board. The background was to be high gray, with a tablecloth of dark gray, both provided by the client.

The assembly process began. The raisin bread was placed on the board and sliced, with all the crumbs carefully removed. The compo-

sition was approved on the camera's ground glass. Then, the raisin bread was replaced by a loaf of sandwich bread with its white, smooth, minimal-textured facade. This surprising situation was explained when I observed the home economist and the art director carefully poking little holes with tweezers into the sandwich bread face and slices, extracting raisins from the raisin bread one by one and, with surgical precision, inserting them into the sandwich bread. When this arduous task was accomplished, the sandwich bread surfaces were carefully painted with a brownish liquid. Voilà! Brown raisin bread with gleaming raisins but with no typical raisin bread texture. Everyone who has eaten raisin bread knows that the raisins produce steam when the bread is baked, and this steam produces the distinctive texture of the loaf. But no, the rough texture was not appetizing. "Let us proceed with the picture before the raisins lose their shine."

Though I could hardly keep from laughing, I made the photographs with quite a few variations of light intensity in relation to the background and a few lens changes. The pictures turned out well technically, the clients were pleased, and I was generously paid, including the leftover, delicious loaves of both raisin and sandwich bread. Most astonishing was that the picture was to be reproduced in an advertisement in a national bakers' journal, and any baker would know that the texture of this idealized loaf was impossible. Who was fooling whom?

I found working in the field a great contrast and relief to the necessary studio work. However, as in the studio, I found coping with problems to be a constant. *Fortune* magazine asked me to make a survey of Los Angeles in about 1945. They wanted pictures of the exotic indigenous architecture such as the Brown Derby Restaurant in Hollywood. There were many such awful examples around Los Angeles, and I drove hundreds of miles in pursuit of them. I was completely frustrated by a continuous drizzle; no shaft of southern California sun ever touched the difficult scene. The deadline was in three short weeks.

I phoned *Fortune* and said, "Conditions are awful, time is wasting, what do you want me to do?"

They replied, "Just keep making pictures and put the drinks on the expense account."

Early every morning I drove out onto the wet streets, trying my best to find and capture the architectural obscenities that loomed through the drizzle; but even these objects needed sunlight. I had

supper at dusk, then a two-hour drive to the airport to ship any expo-
sures to New York. *Fortune* wanted to see any results as soon as possible.

Three days before the deadline I called in and said, "What now? I
am not happy with my work."

They replied, "We do not have enough for the story, but it's not
your fault. Better luck next time! Send in your bill right away and don't
forget to add the drinks. You deserve them!" I always appreciated *For-
tune* as a client.

When working in the field, professional assignments can be very
difficult, because the requirements of the client can dominate personal
interpretation. Architectural photography may be a case in point. Fine
architecture almost makes its own pictures. However, with inferior
architecture, the architect or contractor wants it to be enhanced by
photography. If the photographer aids and abets obvious exaggeration
or concealment, he is guilty of deceit. Too often this is not realized
until the job is finished and his work published — then comes creep-
ing the painful question, "Why did I do this assignment?" Usually the
answer is, "Well, that's business. I have to make a living and compete
with other photographers. Did my work harm anyone?" The long
view is, of course, that to compromise truth harms everyone. I admit
doing a lot of professional work that disturbed my aesthetic integrity;
none was intentionally dishonest.

One axiom I discovered proved to be of great value: the client sel-
dom, if ever, knows exactly what he wants from the photographer.
However, his pride does not allow him to give any such ridiculous
impression. The desire and need for interpretative work is usually un-
formed and the client often looks to the professional for guidance in
this respect.

A case in point was my assignment to photograph the Mark Hop-
kins Hotel. Before San Francisco was "Manhattanized," the Mark re-
ally dominated the skyline. The owner's instructions to me were to
"make the hotel tower rise high above everything and in the corner
have a seagull as big as hell." I chose a telephoto lens and set my 8x10
view camera and tripod in the center of the lower California Street
traffic. I lived through it without being run over, he liked the picture,
and, happily, we both forgot all about the seagull.

Working on commercial projects with very short deadlines, I
quickly found an assistant to be absolutely necessary. Over the years I
have had numerous photographic assistants. I learned that there is a
great difference between having a person work *for* you or *with* you —

the latter being my preference. I have been blessed to work with many fine, young photographers.

Often an assistant has gotten me out of seemingly unsolvable situations. I recall one assignment from *Fortune* on the Pacific Gas and Electric Company. It was requested that I do some portraits of the executives, among them the president, James B. Black. Mr. Black was a dignified, reserved gentleman and cooperated as best he could, but he was incredibly stiff before the camera and I was concerned. My assistant Ron Partridge was helping with the setup and lights. I asked him to talk with Mr. Black, say anything to relax his masklike expression.

The pixyish Ron, dressed in old dungarees, sat crosslegged on the floor in front of Black's desk and said, "Mr. Black, I would like to work for your company."

A startled Mr. Black, half smiling, replied, "That is quite interesting; what would you like to do?"

Ron said, with deadpan seriousness, "Mr. Black, I would like to be a vice president."

Mr. Black, completely amazed, actually smiled — CLICK! — I had a good journalistic portrait, thanks to Ron.

As I became better known, I was offered jobs across the country. A major assignment was for the American Telephone and Telegraph Company. The first conference about this job was in New York City, with approximately fifteen company and advertising executives.

The Project: pictures of various employees of the telephone company at their appointed tasks.

The Subject: employees selected for their contributions to the neighborhoods or towns in which they worked.

The Message: readers were to see that telephone employees are kind, cheerful, and helpful with their clients' problems apart from assuring good telephone service.

The research division had picked out about twenty locations as possibilities, among them a town in northern Indiana, the city of Minneapolis, a suburb of Los Angeles, a small town on the Ohio River, and a village somewhere in Appalachia. Three weeks were allowed for this odyssey. Between travel arrangements and weather delays, the time available for the actual photographing was about two days per subject.

A cable splicer in Indiana raised ducks for the hunting season; AT&T felt he represented conservation. He was a nice guy and very

helpful. I photographed him in a cold underground tunnel through which a myriad of cables passed. He had one cable thoroughly gutted and was joining what seemed to be several dozen strands. All I had to work with were the ordinary ceiling lamps in the tunnel. We gathered several powerful electric torches to supplement the illumination. I made about thirty exposures before I was satisfied I had something that would not show motion. One down, five to go.

In Minneapolis a young lady who worked with the Yellow Pages was chosen. She and her husband were very active in their church and assorted community charities. She was quite attractive and evidenced enthusiasm, especially for the modeling fee. Because her complexion was rather sallow, I suggested a bit of makeup, something to darken the lips and give tonal values to the cheeks.

"Oh NO," she said. "Our religion does not allow any makeup."

I tried to explain that, as this was a black and white photograph, no makeup color would be obvious. Her husband was called in and he was equally obdurate. The prospect looked grim indeed until the manager of the Yellow Pages came on the scene and, with a very serious mien, described how essential it was she cooperate. It was agreed we would make the picture after the other employees left. To help the model he would hire a woman who understood makeup and it would be removed immediately after the pictures were made. The modeling fee was doubled and all seemed serene.

When a very discreet amount of makeup was applied and I began to work on the picture, she started to weep, asking her husband to assure her she was not committing a sin. Of course, her face became streaked. The husband, doubtful but encouraged toward a little bit of sin by the increased money, persuaded her to be dried, powdered, and made up again.

I worked until nearly midnight and the pictures turned out better than I had hoped. Our model rushed to the ladies room for removal of the makeup, after which she and her husband vanished from the scene. The local advertising executive, the manager, and I went home for a few welcome bourbons.

I was in Los Angeles the following night and on the job the next morning in Anaheim. I never saw the telephone employee I was supposed to photograph; on checking with New York I was told that it would be all right just to photograph his children, because they represented the activities he was interested in. They dressed up as wild Indians and turned the modest little home into bedlam. My pictures

were lousy. I happily left Los Angeles and exchanged smog for the then–clear San Francisco air.

The most rewarding situation was in a small town on a remote bank of the Ohio River. The telephone company representative had installed a small water system for the inhabitants; heretofore they had all trekked to the village pump for their water, summer and winter. I arrived the day the project was completed, and my camera witnessed a dear old lady turning on the single cold-water tap in her kitchen sink with an expression of long-awaited satisfaction. Present was the telephone man, bearing a similar expression, plus that of "job well done."

The one truly disturbing event on this assignment occurred in a small town in Virginia. The representative employee was a lineman, a technician who checked lines for nitrogen-gas pressure. He was also a valued member of the community, assisting underprivileged people with legal and personal problems. My work with him was delightful, if rather arduous. I was provided with a contraption that elevated me to the level of the pole top from where I could photograph his work in close-up.

We spent a day touring the countryside to find an appropriate pole in an agreeable setting. The next morning was cloudy. When we reached the site, it began to snow. I did not have a warm coat, but at first I did not notice the cold because of my concentration on the picture. The advertising people who were with me were ecstatic over the weather, "GREAT! It will show how telephone people work in storms to keep the service going!"

I climbed on the truck, then into the bin, and up I went with clanks and sways and freezing snow. I kept my 35mm camera under my jacket to protect it from the snow; at least it was warm. After every two or three pictures I had to wipe off the lens. When finished, I descended to the relatively warm cab and thawed out. Everybody seemed happy and the pictures were good.

But in this town I was joined by a regional telephone executive and also the advertising account executive from New York. From the start almost every other utterance was some snide remark about the "Nigras," and they ogled every black girl. At one point we stopped to investigate a possible location and I saw two black men working on fence repair along the road. They were dressed in rags and had the defeated appearance of physical and mental depression. They stared at us without apparent curiosity.

One of our party said, rather loudly, "Just look at those goddam

lazy Niggers; we're feeding them for nothing." I was getting madder and madder but I kept in control.

I was cheered when the lineman gave me a confident wink and said, "All our employees are not like the bastards we got with us here, thank God."

My professional assignments took me to places I otherwise would not have visited and gave me some awareness of the situation of so many citizens of our country. I sadly remember a few hours spent in Savannah, Georgia, awaiting the northbound Seaboard train. I went out for a stroll about town. I noticed a dignified, well-dressed black couple slowing their walk as a miserable little white man, in a soiled shirt and suspenders holding up baggy and greasy pants, strode directly toward them, forcing them off the pavement into the gutter. As he passed I heard him mutter, "Goddam dirty Niggers." The couple returned to the sidewalk and continued down the street. I honestly wanted to destroy that man, who for me was a symbol of evil. It was frightening to realize he was but one of millions, and his demented spirit still stalks the land and promises disaster. While we have made tremendous gains since then, racism is still very evident in our country, including the quiet and insidious racism that destroys from within.

In contrast I am thankful that some of my assignments had an abounding humor that was shared by all involved. *Life* asked me to participate in a story on "Mad Scientists" and selected the Varian brothers of Palo Alto as prime examples. They were remarkable men and, among many achievements, were noted for their invention and development of the Klystron tube, an energy-producing device essential to radar. Sigurd and Russell Varian were both large, charmingly homely men who cheerfully agreed to cooperate. They were not mad, but they had the potential for looking mad, and we attacked the problem with enthusiasm.

The brothers put together a rather awesome assortment of unrelated parts, such as wave-guides and resonators, and I photographed them standing on each side of this device with expressions of devilish ferocity, intently staring into my lens. It was pure fun and *Life* was enchanted, but what followed was hilarious, and quite unexpected. On publication, letters poured in from all over the world, addressed to both *Life* and the Varians. What was this invention? Respected colleagues would discreetly inquire, "If it's not restricted, my department would like to know what you boys are up to. We are all perplexed and cannot determine what it does. Is it an amplifying microwave detector? We are stumped!"

The Varians' replies were as funny as the inquiries: obscure descriptions of impossible creations, set forth with tongue-in-cheek seriousness. When the truth was revealed, the hoax was enjoyed by all — well, not all in fact, as there were some sour comments from dour personalities.

Another humorous experience took place in 1954 while I was on an assignment for the American Trust Company. They had contracted me to produce a photographic book, to be titled *The Pageant of History in Northern California,* that they would give to their most valued customers. In making the photographs I traveled all about the northern part of our state. One day I found myself at a large turkey farm. What appeared to be acres of turkeys, crowded together (perhaps with anxiety over the forthcoming Thanksgiving season), seemed to me to present an exciting pattern of heads, extended necks, and restless textures.

I set up my 5x7-inch Linhof on the metal platform on the top of my car; this gave an extended view over the swarm of birds. I made one exposure, then dropped the film holder on the aluminum flooring. It must have been a startling sound, because all the turkeys extended their necks at about a fifty-five-degree angle and chorused, "Gobble, gobble, gobble!"

I had a hilarious thought. I raised my right arm in the Hitler salute while shouting, "HEIL!"

The birds responded by raising their necks, every one of them, and joining in a loud, "Goebbels, Goebbels, Goebbels!!" I did my Hitler imitation several times, enjoying my own performance immensely, then made an effort to continue with my work.

As I reached around to reset the shutter, I saw, leaning on the fence to my left, an elderly, mustachioed gentleman chewing tobacco. He chewed reflectively, staring at me for a while and saying nothing.

Grasping for some way out of the ridiculous situation of being apprehended in an apparently incomprehensible act, I remarked, "I am photographing turkeys for the American Trust Company." Not a word, only slow, continual chewing and the glassy stare.

I continued, "Turkeys are funny critters, aren't they?" He responded with determined silence, continued chewing, and the same stare.

I turned to finish my pictures. When I dared look again, he was gone. I noisily gathered together my equipment (to a renewed chorus of "Goebbels") and climbed off the car, sure that he had gone to the sheriff to report the whereabouts of a Nazi.

Shortly thereafter, I was approached by a California winery of small

reputation that wanted to hire me to produce general advertising pictures as well as a new corporate brochure. They presented an outline of what was wanted and said, "Figure out what this will cost us." The arithmetic of mileage, materials, etc., was carefully reviewed and what I thought would be a proper percentage for effort included. It totaled, as I recall, four hundred and fifty-eight dollars.

I mentioned this to an advertising friend and he said it should have been half-again as much and cautioned me, "Be *very* careful when you go to the confirmation appointment, because they will give you some of their good brandy before lunch to weaken your resistance." He continued, "I know these people. They always do this and usually succeed in getting a lower fee." I took his advice seriously; at eleven-thirty A.M. I stopped at a lunch counter and had a double hamburger, drenched with butter, and followed by a glass of milk.

I arrived at the winery offices precisely at noon. I was greeted with, "Let's get the business over with first; we can describe the location and other details later. Let's begin with a sip of our brandy." We all had an ample slug of quite good brandy.

"How about a refill?" We all had a refill.

Then, "We have your estimate of what this job will cost us and it is much too high for us." Sinking feeling.

"Let's have another snort." Rising feeling because I knew their technique and I was still doing fine.

"Look, Adams, let's get this settled before we go to lunch, have another sip and we'll sign on the dotted line." I had another sip and was feeling quite serene — they were a bit woozy. Praise the Lord for the buttery hamburgers!

I said, "Look, I figured this to the bone and I cannot cut it one dollar."

As they refilled the glasses, they said, "Let's get this settled right now. We will be late (hic!) for lunch." No, they needed all the listed pictures made. No, they did not question my honesty. No, the budget would not allow that much money to be spent on pictures (another refill).

"Can't you listen to reason?" they said.

"No, it's the best I can do for you!"

"Oh, well. Let's sign the damn thing and have lunch. I'm starved (hic!)." Agreement thereupon signed, then one more snifter of brandy and we all went out to a fine lunch. I remained as cool as the proverbial cucumber while my clients gracefully accepted defeat.

News of my capacity quickly went around town. I had put away a

tremendous amount of brandy and had not batted an eye. While this strategy worked well, I do not advise it as a regular approach. Happily, the job was very successful, and considerably more work was requested, but without the brandy tactic.

My old friend George Waters, Jr., an excellent engraver and printer, deserves a place in photographic history because of his valiant struggle to bring creative photography to the attention of that monolithic corporation Eastman Kodak. In the 1940s Kodak was supreme in phototechnology and dominated the market even more than it does today. In the area of aesthetics they were sorely lacking, as are too many corporations. They were devout in the chapel of sales; advertising was their Holy Spirit.

George Eastman, the founder of Eastman Kodak (who died by his own hand, leaving the message, "My work is done; why wait?"), was a remarkable and difficult person. Completely honest, he applied his great wealth to charitable and educational purposes. Although he could not tolerate Bach, he endowed the Eastman School of Music. He installed a fine concert organ in his palatial home and employed a personal organist, who performed light popular classics as requested. The story goes that the organist became ill and delegated his best student to appear for the routine breakfast concert. Eastman had a pressure switch installed under the carpet near the top of the staircase; as he came down the stairs to the dining room, the organist was automatically signaled to begin. This student, fired with the responsibility of performing before the great Rochester tycoon and patron of the arts, began with a Bach aria and continued on with a fugue. Eastman sat at his table, obviously distressed and rattling his newspaper, but endured the ordeal and later sent a command to his organist never again to play Bach in his home. I mention this because it suggests the limitations of his taste in art, and he set the style for the company.

George Waters was employed in the photo-illustrations department of Eastman Kodak and was charged with providing photographs for the general advertising programs of the company. Disturbed by the routine, commonplace qualities of the pictures demanded by the advertising and sales executives, he ventured to invite such photographers as Edward Weston, Paul Strand, Charles Sheeler, and me to produce some photographs for possible use in their advertising program. I received color sheet film from George in 1947 to use on my first Alaskan trip and again on my trip to Hawaii in 1950. Some of the work was accepted.

Paul Strand was less fortunate; he followed the exposure suggested

by his Weston light meter and used a lens mounted in a new shutter with incorrect lens-stop indications on its dial. Most of his work was underexposed, and Paul became terminally disenchanted with color photography.

Edward Weston did some magnificent photographs, following his usual creative approach to his subjects. Fortunately he was successful in adapting his intuitive technique to the color process, and some were purchased for use by Kodak.

The primary film was Ektachrome. It is a great loss to photography that Kodak did not make separations (archival black and white negatives of each prime color image) of these handsome 8x10-inch transparencies by these great artists, for many have faded ruinously. If separations had been made, fine color prints and color press reproductions could be made at any time, and this important work would have been secured for the future. My early Kodachromes have lasted fairly well; the Kodacolor and Ektachrome colors have proved fleeting.

In 1948 the concept of the Colorama for Grand Central Station in New York City was developed and George Waters invited me to participate in the making of some color photographs for it. The Colorama was a giant transparency, eighteen feet high and sixty feet long. It dominated one end of the vast concourse of Grand Central Station with impressive effect. Prepared in Rochester, it was composed of twenty-inch strips of positive color film, enlarged from the original with extreme accuracy, taped together with transparent tape, rolled as a large rug, and transported to New York where it was installed in front of a huge bank of fluorescent tubes, properly diffused and filtered for optimum effect. Over the years Colorama images have been seen by uncounted millions of commuters and tourists.

For the Colorama assignments, I first used one 8x10-inch and two 5x7-inch color transparencies, properly proportioned in the camera to comprise a triptych. Later I used two 8x10 overlapping transparencies that were properly joined and proportioned. I had a device called a "breadboard" that attached to the tripod and supported the camera so that the center of the lens remained over the tripod socket when the camera was swung from one position to the other, thereby assuring no displacement of near objects in the subject. For my last Coloramas I used a 7x17-inch banquet camera with my 13-inch Zeiss Protar lens. The actual film format used in the camera was 4¾x16½ inches, and the Protar lens covered this area perfectly. The severe proportions of the format made it rather difficult to find appropriate subjects, especially in a location such as Yosemite.

The Coloramas became something of a landmark in Grand Central Station, and I happily made quite a number of them. They were aesthetically inconsequential but technically remarkable. In a sense they presented the "real" world but with commercial motivation; there were usually two figures, one photographing the scene with a Kodak camera and the other giving eager attention to the subject or to her companion. The figures were small and the message conceived to create interest in color photography rather than stress a particular camera. I am sure that if George Waters had had his way, the pictures would have been more imaginative.

Don Worth and Gerry Sharpe were my assistants at this time. When in the field they would set up my camera and attend to the many details of each assignment, which included acting as models when necessary. An excellent photographer, Don is also a very fine pianist and composer. While a graduate music student he became interested in photography: a life pattern similar to my own. Our paths crossed in Yosemite, and he assisted me from 1956 to 1960. In 1958, he composed the music for the documentary film *Ansel Adams, Photographer.* He continues to work intensely in his own creative photography and has produced a very beautiful body of photographs that places him in the front rank of American artists. Gerry Sharpe was truly gifted; her photographs were of highly imaginative quality. After working at Best's Studio for Virginia and on occasion for me, she received a Guggenheim and traveled to Ghana with high ideals and enthusiasm, producing some superb images. Gerry died tragically in 1968.

One of my memories of both Don and Gerry involves a trying time in 1958. We had spent nearly a month attempting a Colorama in Monument Valley, waiting patiently for the necessary dramatic clouds that never materialized. The hired professional models finally had to return home and I simply gave up, deciding to travel on to Santa Fe. In the hills outside of Santa Fe we happened upon a grove of aspens that immediately captured my imagination. Gerry, Don, and I quickly set up our cameras, and all three of us went to work. We found both Eliot Porter and Laura Gilpin photographing in the same grove at the same time. My creative results made me forget the unobtained Colorama — two photographs, both titled *Aspens, Northern New Mexico* — one horizontal and one vertical, each different in image and mood, though the groupings of trees were within feet of each other.

Following his term with Kodak, George Waters set up a printing business in San Francisco with considerable success. He engraved and printed a book that I was very pleased with, the large-format *Images,*

1923–1974. This project also benefited greatly from the elegant design created by my dear friend Adrian Wilson. In the face of growing competition from big printing firms it became financially impossible to operate a one-man plant, and George closed shop after the production of the remarkable facsimile edition of *Taos Pueblo* in 1976 and the first edition of *Photographs of the Southwest*. Happily he agreed to assist me with the printing of *Yosemite and the Range of Light* in 1979.

I struggled with a great variety of assignments through the years. Some I enjoyed and some I detested, but I learned from all of them. The professional is subject to pressures and adjustments that sometimes seem impossible. But learning how to complete just such impossible assignments on time is rewarding, because it develops discipline and a reputation for dependability. I have little use for students or artists who, from their particular plastic towers, scorn commercial photography as a form of prostitution. I grant that it is not difficult to make it so, but I learned greatly from commercial photography and in no way resent the time and effort devoted to it.

Of my last commercial jobs, two have strange links to one of my dearest friends, Imogen Cunningham. I was first introduced to Imogen at about the same time I met Dorothea Lange and many of the other Bay Area photographers in the late 1920s. Imogen's husband was the etcher Roi Partridge whom I had already met at Albert Bender's. Roi was a good artist, a solid craftsman, and a fine teacher. Imogen and Roi raised three sons of force and character. But Roi became more alkaline and Imogen more acid and, in human chemistry, one condition did not neutralize the other and they separated.

Imogen was from Seattle, well educated and had studied basic photographic procedure in Germany. From our first acquaintance I was aware of the immense versatility of her talent. I did not especially warm to her early work, such as her nudes of Roi in the mountains of the Northwest, romantic with glooming mist and appropriate diffusion. They seemed to me to be a combination of sincere personal expression and pictorial mannerism. I have never trusted art that seemed "arty," but in the first years of the century when she began photographing, straight photography was shunned as a matter of principle. To me the first of many important photographs were her remarkable compositions of plant forms, beautifully seen and executed.

Imogen supported herself as a commercial photographer, working with an arduous professional schedule: architecture, portraits, advertisements, and such projects as serving as photographer for Mills College in Oakland, where Roi was professor of art. My first contact with

Imogen's wrath was when Albert Bender, with enthusiasm for his newly discovered protégé Adams, secured me an assignment to do a small catalog for Mills. Little did I realize that I had trod upon very sensitive toes; I had violated territory sacred to Imogen, who left no bones unpicked about it. I declined the college catalog and the fires died down in time. We became good friends and mutual admirers and soon were cofounders of Group $f/64$.

Imogen was fearless, acrid, opinionated, capable, and, in her particular way, affectionate and loyal. She had an enormous roster of friends, personal and professional, throughout the country, if not the world. On her famed trip to the East Coast to photograph personages for *Vanity Fair,* she made a magnificent portrait of Alfred Stieglitz, one of the best ever done of that difficult subject. Classic Imogen: she borrowed his camera to take it! Stieglitz liked her work immensely but admitted he had difficulties with what he considered her astringent personality.

Once Imogen and I met at the Newhalls' in Rochester, New York. I was driving to an assignment in Pittsburgh and offered her a ride; from there she was to take the train back to San Francisco. She reconsidered the situation and decided to take the bus, enabling her to stop off at various cities and towns to see friends and clients. I understood she made more than a dozen stops on the return trip and arrived in San Francisco with more energy than she had on leaving. She must have been at least seventy-five at the time.

Imogen was warmly attracted to young people and sympathetic to their problems and uncertainties. She became closely associated with the flower children of the Haight-Ashbury district of San Francisco but turned away when drugs took over. She loved to go on camping-photographic excursions with her young friends in her Volkswagen camper, roughing it at eighty with enviable energy and enthusiasm. She proudly wore a peace symbol pendant and fended off with stubborn humor the protests of conservative friends that it was Communist propaganda. She had no use for dictatorships of any variety.

In 1969, for one of my last commercial jobs, I selected a photograph, *Yosemite Valley, Winter, Yosemite National Park,* for reproduction on a Hills Brothers coffee can. The idea was to produce something of lasting attractiveness after the original contents of the can had been consumed. The type on the can did not intrude on the picture and the image had a certain dignity. Potentially corny: actually reasonable. There were thousands of three-pound cans filled with coffee sold nationwide in grocery stores for $2.35 each.

Imogen thought I had sold out to Mammon in a big way. To point up her scorn, she asked a young friend who was driving south from San Francisco to deliver me a marijuana plant in one of the cans. She called it "pot in a pot." It arrived in good condition without being apprehended by the law. I enjoyed Imogen's joke, but when my good friend and fellow photographer Henry Gilpin, then deputy sheriff of Monterey County, dropped by and spotted the plant he quietly suggested that I destroy it. I did.

Imogen took me to task again in 1973 when I participated in a project for the Nissan Motor Corporation in U.S.A. I was to do a television commercial for them: the theme was "Drive a Datsun, Plant a Tree." If a person test-drove a Datsun, the company would pay the U.S. Forest Service to plant a tree. Each person also received a poster of one of my photographs. In the commercial I worked with my camera near a Datsun car parked on a forest road and stated:

A forest *can* rebuild itself, but the same type of trees may not grow back. And it takes a long time . . . sometimes as long as eighty years. When man gets involved, nature needs a helping hand. . . . Companies like Datsun, the car company, are paying for thousands of seedlings to be planted in National Forests throughout our country.

Through programs like this, we can help nature rebuild. . . .

I am told that more than one hundred and sixty thousand seedlings were planted. Imogen was quite vocal when she saw this television ad: "Adams, you've sold out again!" There was no escape from her righteous judgments!

After fifty years I cannot recall all my experiences with this extraordinary woman. Although she was frequently entertained, she returned each night to her solitary little house on Green Street, set amid a charming garden that seemed to prosper and flower just for her. I think it was then that she came face to face with herself and her health and what the coming years had in store. I talked with her shortly before she died: grim at first, she brightened into brilliant and penetrating conversation. Then she went to the hospital for a checkup. In a few days her son Ron phoned to tell me she had "flown the coop."

I took this to mean she had simply walked out of the hospital and I said, "Ron, you should have used stronger chicken wire." In fact he meant that the impossible had happened; Imogen had died.

It is difficult for me to think of photography without continuing reference to Imogen and the vitality she spread around her. At eighty, I do not consider myself as young as Imogen at ninety. Her last book, *After Ninety,* was a challenge to the future. She will remain a patron saint of photography for as long as the history of our era endures.

13.

YPCCO

YOSEMITE'S AHWAHNEE HOTEL, COMPLETED IN 1926, IS a vast pile of steel and granite with huge concrete beams simulating timbers. Reflecting typical national park tastes, the architect had tried to compete with the environment. He lost. One of the directors of Yosemite Park and Curry Company (YPCCO), the business that runs the public concessions within Yosemite National Park, visited the completed structure and was appalled by the plans for the yet unfinished interior decoration. The main hall was to be furnished with black leather-covered sofas and buffalo heads were to be hung on the expansive walls. In dismay he turned to Albert Bender for advice. "Whom do you know who could save this mess in Yosemite?" Albert recommended Dr. Arthur Pope, an expert in Persian arts, and his wife, Phyllis Ackerman, a tapestry authority. They accepted the challenge and prepared colorful and highly imaginative plans for the salvation of the Ahwahnee interior.

In search of capable assistants, Phyllis was referred to Jeannette and Ted Spencer. The Spencers were architects, though Jeannette concentrated on interior decoration and stained glass. First trained in Berkeley at the University of California, they went to Paris in 1921, he to the École des Beaux Arts and she to the École du Louvre. Jeannette's research for her thesis on the stained glass at Sainte-Chapelle in Paris dated the glass, and her definitive findings were published by the French Archeological Society.

From their first meeting Phyllis and Jeannette worked together with great effectiveness; Jeannette did most of the detail design and the stained-glass windows as well as painting the charming abstraction of American Indian basketry in the foyer. Arthur Pope successfully

combined Indian and Persian rugs of exceptional quality. While the exterior of the Ahwahnee remained "in the megalithic mode" (as Jeannette described it), the interiors acquired an extraordinary beauty, a rare example of tasteful and functional design.

When the Popes completed their assignment and departed, they recommended that the Spencers be retained by YPCCO as architectural and design consultants. This was a fortunate decision for Yosemite; the architecture and planning were in Ted's most excellent hands for several decades. He designed the Ahwahnee bungalows and a new dining pavilion for Camp Curry, as well as many other structures throughout the park. Jeannette did the interiors. Together they brought fine artists to Yosemite, among them Robert Boardman Howard, who did the peint-toile in the writing room of the hotel, the stylized prehistoric painting on the rock fireplace in the Camp Curry dining pavilion, and the sculptured metal fireplace hood at the Badger Pass Ski Center. No other national park, before or since, presented such fine examples of art and architecture.

The winter season was always slow for the concessionaires; tourists were almost nonexistent. To increase visitation Don Tresidder, the president of YPCCO, began a program of winter sports, opening a ski area and providing opportunities for skating, sleighing, and dog sledding. He also suggested a theatrical Christmas dinner at the Ahwahnee as a key focus for family winter vacations. In 1927, Jeannette worked on the settings and costumes, and Tresidder's Bohemian Club friends put on a pageant-dinner performance with a chorus, processions, and presentations of the conventional courses of an English Yuletide.

By 1928 I was a definite character about Yosemite, reasonably appreciated for my music and early efforts in photography. The Christmas dinner's director asked me to play the Jester, to which I agreed. I arrived before the performance and was jovially entertained at the singers' party with bourbon and water, chilled by icicles from the shingled roofs of the Camp Curry bungalows. I recall the definite turpentine taste this ice imparted to the drinks. We were transported in a state of convivial bliss to the hotel, where we were put in costume. The singers had had one rehearsal; I had had none. I was simply told, "Go in there and act like a jester; I don't have to tell you what to do! Just keep quiet when you hear singing." After a few more drinks we began the performance. It was imprecise, but lively and entertaining from the start. I do not recall all I did but I certainly made a prime fool of myself in the Ahwahnee's huge main dining room. Apparently, I climbed the forty-foot-tall stone pillars with abandon, to the gasps and

cheers of the diners below. My exploits were discussed for years afterwards.

In 1929 Tresidder asked Jeannette and me if we would direct the Christmas dinner and we said we would, provided we could make it professional in concept and performance. Tresidder agreed, and Jeannette and I plowed energetically into a new field. I was always amazed by both the research and ingenuity Jeannette applied to such events. With her very scholarly mind she chose to base the affair on *Christmas Dinner at Bracebridge Hall* by Washington Irving, an account of an English squire's Christmas entertainment.

My task was to arrange the music and organize the choir and soloists, as well as write the lines the characters would speak. I conceived of everything in a four-beat rhythm. The lines were to be rendered with stylistic severity, relating them to the music of the processionals. I was careful to include only fine music, avoiding the soupy and the banal. Among those I included were "The Coventry Carol," "O Jesu So Sweet," "O Holy Night," "Joy to the World," and "Green Groweth the Holly," a lovely song attributed to King Henry the Eighth. Don Tresidder performed quite well as the Squire; Virginia, who was in fine singing form, was the Housekeeper; Herman Hoss as the Parson was exceptional; and I directed the flow in my part as the Majordomo.

Our staging was constructed of simplest illusionary material, with a minimum budget and unlimited imagination. With appropriate artistic freedom Jeannette designed a handsome stained-glass window in parchment that was hung at the end of the dining hall above the large and handsomely decorated buffet. Before this was set the Squire's table: a glorious display of candelabra, pewter trays and goblets, and cornucopias of vegetables and luscious fruits. Stained-glass (again parchment) rondels were set at the window tops, and large banners hung out from both sides of the hall. It was an impressive setting for the colorful action during the dinner. Jeannette was wonderful to work with, holding everything together with great competence.

Horns throughout the hotel called the hundreds of dinner guests to the feast. And then, as written in my script, *The Bracebridge Dinner:*

The Parson then proceeds to the pulpit and says,

> *O welcome all!*
> *Our honored Squire*
> *Begs ye fulfill his high desire*

That Lord and Lady, Youth and Maid
Give rein to mirth and let not fade
The tumult of unceasing joy.
Nourish laughter. Gloom destroy.
Bright pleasure to this feast is bidden
He with frown best keep it hidden.

Course after course of grand foods, introduced through song and verse, were served to the guests: relishes, soup, fish, peacock pie, boar's head, baron of beef, salad, and finally the pudding and wassail.

The Squire places holly on the pudding, pours spirits thereupon and lights it with a four-beat motion, while he says,

Fragrant Pudding, crowned with Holly
Wreathed with flame — thou the jolly
King of Confects, Hail we all!
O thou regal spicy sphere
Most easily thou shalt endear
Every heart in Bracebridge Hall!

The Spencers and Adamses collaborated on the Bracebridge Dinner from 1929 to 1975. I always enjoyed these extroverted experiences, but arthritis takes its toll and the twelve long processionals became too much for me to lead, especially when it had become so popular that three performances had to be given in two days. The Bracebridge continues, more popular than ever, with tickets distributed through a lottery system. Virginia and I have since visited as guests and we were pleased to note that the quality of the affair has been maintained at a high level by YPCCO. I feel a certain pride about the Bracebridge; its aesthetics and style directly relate to the emotional potential of the natural scene. In Yosemite there is that certain grandeur and beauty which fine art and music enhance and inferior human endeavors denigrate.

Because of strict adherence to prohibition in Yosemite in those early years, the rather righteous National Park Service suggested we do something for New Year's Eve to divert the guests' attention from illegal liquid celebrations in their rooms. Jeannette and I put on several "Earth's Birthday Party" events that were rather spectacular; we once included the Adolf Boehm Ballet performing to a fine recording of

Stravinsky's *La Noce*. These were enjoyed by the guests, although it did not diminish the drinking before, after, or under the table.

In San Francisco, Ted and Jeannette staged another remarkable event, the Parilia (artists' ball), as a benefit for the San Francisco Art Association. Three huge areas of the Palace Hotel were involved: fanciful, exotic sets, elaborate processions, performing artists and dancers, considerable flow of spirits, and a pervading euphoria.

I was asked to compose the music for three "orchestras" of five percussionists each. The scores were difficult rhythmically, and in fact, there were only two tympanists in San Francisco who could handle them. I now admit I went a bit wild in what I expected any tympanist could do. These two had to move from group to group to take charge of the more complex parts. One of the frazzled musicians said to me, "Adams, I think you know what *you* are doing, but *I* don't!" It was a great imaginative success.

After the enthusiastic reception of the Bracebridge in 1929, Tresidder recognized I was also a photographer and asked if I would make some photographs of the outdoor winter activities in Yosemite that YPCCO could use for publicity purposes. I began photographing the winter sports, but also traveled into the High Sierra above the valley to show other more isolated areas of the park that could be enjoyed year-round.

My first trip for YPCCO was made in 1929 and a second in 1930. The second trip had purposes beyond my photographing; my traveling companions and I packed snow into the double-walled log cabins sprinkled about the Sierra, which could then be used as cool storage for food during the summer. As we skied we were also on the lookout for potential winter sports areas.

In 1931 I wrote about this trip for the *Sierra Club Bulletin* in an article profusely illustrated with photographs from the same trip.

> The familiar and intimate aspects of the Sierra that one has learned to love during the long summer days are not obscured by winter snows. Rather the grand contours and profiles of the range are clarified and embellished under the white splendor; the mountains are possessed of a new majesty and peace. There is no sound of streams in the valleys; in place of the far-off sigh of waters is heard the thunder-roar of avalanches, and the wind makes only faint and brittle whisper through the snowy forests. . . .

Fritsch (the Yosemite ski instructor) whips his skis on the snow and leaps down the long billowy slope; a cloud of powdery snow gleams in his wake. We follow; long spacious curves and direct plunges into the depths that take our breath with sheer speed and joy. Down and down through the crisp singing air, riding the white snow as birds ride on the wind, conscious of only my free unhampered motion. Soon we are at the borders of icy Tenaya Lake — two thousand feet of altitude have vanished in a few moments of thrilling delight.

. . . At Tuolumne Pass we find true alpine conditions — supremely fine snow, swift and dry; grand open areas above the last timber, undulating for miles under cobalt skies; peaks and crags flaunting long banners of wind-driven snow. A world of surpassing beauty, so perfect and intense that we cannot imagine the return of summer and the fading of the crystalline splendor encompassing our gaze.

YPCCO became my most important client for many years. I was paid expenses plus ten dollars per day, which was reduced to five dollars per day during the Depression. Considering the times, my minimal reputation, and the opportunity to photograph in Yosemite, I could not complain. My photographs adorned the covers of Ahwahnee dining room menus and beckoned from pages of magazines extolling the virtues of Yosemite through every season. A typical communication from YPCCO's advertising department would be:

October 3, 1934

Dear Ansel:

Enclosed display has dignity and class but it needs one thing to make it follow-through on a selling job — it needs a brief message to get the idea into people's minds: "Enjoy the glory of Autumn in Yosemite. There's a paved highway all the way. Rates to suit every purse."

Without something of this nature, it's just a couple of lovely pictures without any prompting toward action. (After they say, "Isn't that beautiful!" we've got to ask 'em whatthahell they're going to do about it?)

It was difficult for me to observe the mental processes of the advertising world in relation to Yosemite; their work was directed toward

only one objective: bringing people to Yosemite, rather than Yosemite to the people. The Yosemite ideals were cosmeticized to a conventional standard of use and enjoyment. From the beginnings of my active association with both the National Park people and the YPCCO staff, few really understood anything beyond their narrow borders of taste and awareness. I am not saying they did not react to Yosemite in some visceral way — its immensity and majesty are powerful. But very few added anything to its interpretation or its protection; they were simply there, tended their jobs, church and social functions, raised their children, and were perfectly content with postcard imagery, popular music, and the paternal leadership of government and corporate establishment.

Several advertising executives came and went before a man, whom I will refer to as Mr. Smith, took over advertising and sales for YPCCO. He was helpful in many ways and expanded my field of activity.

Our Mr. Smith would lead trips into the High Sierra, chiefly for publicity photographs. I found him to be reasonable, cordial, all business, and without a trace of conservation interest. His principal pleasure in the mountains came from the "simple life" — a passion for fishing and a bourbon before dinner. Nothing wrong with these dedications, but the essential ingredient was lacking: the love and understanding of wilderness and its importance to society. Keep it pretty, see that people enjoy fishing, riding, and the amenities, and be sure to make money in the process. Smith once asked for some pictures of the Sequoias, but gently admonished me, "Do not make them too ektetik." To the majority of business people of the time the term *aesthetic* was a foreign word. Fortunately, Tresidder, who later became the president of Stanford University, was sensitive to the natural scene and the need for quality in Yosemite.

In 1935, YPCCO commissioned me to make large murals (prints up to forty by sixty inches) for display at the upcoming San Diego Fair. I was fascinated with the challenge of making a photographic print in grand scale; many of my large-format Yosemite negatives took on a new resonance in mural-sized proportions. Soon after this project, Ted Spencer designed YPCCO's new San Francisco offices and specified a very large mural, twelve feet long by nine feet high. The subject I chose was a Yosemite winter landscape: Half Dome showing over the snow-laden orchard near Camp Curry. The mural was formed of eight panels, carefully matched and separated by a quarter-inch gray molding. The effect was of a delicate screen, and I was very

proud of it. In later years, when the office was moved, it was carelessly ripped from the wall by the demolition contractor. I had made a duplicate mural print that was sent around to various travel conventions on behalf of YPCCO until it finally died from dents and tatters.

The large screenlike mural had been so visually successful that I went one step further to apply a mural to a folding screen. When I had a solo show in 1936 at the Katherine Kuh Gallery in Chicago, as an experiment I included a 73x77½-inch three-panel screen of a detail, *Leaves, Mills College, 1932*. That screen was sold to Secretary of the Interior Ickes and it resided in his office for many years. I have made only a few other screens, some for good friends, one as an aesthetic shield hiding the stairs at Best's Studio.

I wrestled with the technical and creative problems of very large prints for many years, writing this in 1940 for *U.S. Camera:*

Photo-murals . . . enlargements with a vengeance. . . .

Apart from optical and technical considerations, the size of the photograph has an expressive relationship with the subject — no matter under what conditions of display it is seen. The subject itself is not an important factor in the determination of the best size of print, although we usually think of small objects requiring more intimate treatment than large, inclusive subjects would demand. It is, rather, the textural and compositional aspects of the photograph that determine the scale of the finished print.

Another highly functional form of the big enlargement is the screen. Perhaps the most satisfactory form is the three-panel; this combines interesting design possibilities and is self-supporting and adaptable to various spaces. Herein we have an augmented problem of pattern and design; the photograph is seen not as a flat surface, but as a combination of surfaces, each set at a different angle to the others. This produces effects not only of altered perspective and scale, but, on account of reflective properties of the panels, of light intensity as well. Obviously, the more abstract the subject, the better the result. A literal subject can suffer severely when broken up into two or more sections placed at various angles, but an all-over pattern, or a semi-abstract arrangement, can be most favorably accented thereby.

I know I was a source of annoyance to some of the executives of YPCCO because of my ardor for nature and conservation. I have a strong feeling that the Spencers often interceded for me with assur-

ances that I had something important to offer if I were given relatively
free rein to express it. My quasi–idyllic relations with YPCCO came to
an end over a most unfortunate situation, one that altered my sense of
trust but opened my eyes to the realities of life in the world of business.
The same Mr. Smith asked me to put together a brochure that would
present Yosemite as a year-round place to visit. My formal work agree-
ment with YPCCO applied to such a project, but if anything I worked
on was to be a retail sale, a separate royalty arrangement was to be
made. This was clearly stated in an exchange of letters between Tres-
idder, Smith, and me. The prints for reproduction were assembled and
delivered; after several months I saw a copy of the *Four Seasons in Yo-
semite Valley* with photographs by yours truly, for sale in gift shops.
Shocked, I approached Tresidder and reminded him of our
agreement.

He said, "That's Smith's department."

I protested to Smith and he said, "Talk to Tresidder about it."

I went to Tresidder yet once more and he simply said, "That's
Smith's department."

"But Don, we signed a letter about any of my work to be published
for sale."

The reply was, "Sorry, talk to Smith."

I was astounded and distressed. What could I do? If I let it pass, a
precedent would be established and, just as importantly, I needed the
money. Although my attorney friends advised me to do so, I was fi-
nancially unable to press suit. I called on YPCCO's legal vice president
and demanded something be done.

He said, "Come see me tomorrow."

I did and I quickly observed his great nervousness. He gave me a
document with one hand which I signed while he held a check at a
safe distance in his other hand. The document was severely composed
and stated that I, Ansel Adams, for the sum of seven hundred and fifty
dollars, release YPCCO of all obligations "from the beginning of the
world" in reference to the use of my photographs in that book. In
other words I was paid off on their terms. Actually, the amount of
money was much less than the probable royalties from the sale of a
popular book of this type.

I have been the victim of a few other questionable ventures. I
learned a bit too late of the importance of fine legal advice in such
matters and much too late was I brought to realize the need for con-
stant alertness. On the whole, however, I have been more free of such

troubles than most photographers I know. When we signed the con-
tract for *Taos Pueblo,* Mary Austin remarked, "This must be carefully
checked by both our lawyers; agreements between friends must be
perfectly clear."

Though I have often clashed with the corporate philosophy that
governs YPCCO, Yosemite has become, in my estimation, the best
managed national park. Led by the dedicated efforts of such men as
the present president of YPCCO, Edward C. Hardy, and our excellent
National Park Service superintendent, Robert O. Binnewies, Yosem-
ite is more sensitively alive for the visitor than it was during my first
visits nearly seventy years ago. I must caution that there are many im-
portant changes to be made in the future as the demands on the very
small area of the valley itself increase and as the High Sierra's charms
are discovered by new generations. But as we progress to even better
solutions, Yosemite remains in safe and caring hands.

The years of working for YPCCO had brought the great friendship of
the Spencers, and Ted and Jeannette grew constantly in our estimation
and affection. Secure in their knowledge and ability, they contributed
in endless ways to the improvement of the cultural condition. They
were consistent in demanding the highest in expression and execution
and in professional ethics. With them I felt the warmest relationship
of true comrades.

They both held important jobs in many areas of the country besides
Yosemite, comprising architecture, planning, and decoration. Ted was
the supervising architect for all building projects at Stanford from 1946
to 1960. Among other projects, he also designed the convention cen-
ter at Williamsburg, Virginia, and the Lawrence Radiation Laboratory
for the University of California, Berkeley.

We often talked of art, aesthetics, architecture and the world, and
on and on we shared our ideas over the decades. I wrote to Ted on
February 8, 1947:

> *I have been thinking a lot of late of that thing called Art, and my
> thoughts in the main have not been too pleasant. Sometimes I think I
> have a prophet complex, because I am constantly looking for the quality
> of prophecy in art. That thing which is concerned more with life and the
> world in both now and in the time to come — not just in the now. I
> guess I get that to a certain extent from Stieglitz. Most of what I see
> seems more mere decoration than profound expression — and directed
> towards the most artificial and fragile elements of our culture. What I call*

the Natural Scene — just nature — is a symbol of many things to me, a never-ending potential. I have associated the quality of health (not merely in the physiological or psychological sense) with the quality and moods of sun and earth and vital, normal people. The face of most art reminds me of a human face, bewildered, wide-eyed, with a skin of pallor and pimples. The relatively few authentic creators of our time possess a resonance with eternity. I think this resonance is something to fight for — and it takes tremendous energy and sacrifice.

14.

The Newhalls

MY FIRST CONTACT WITH BEAUMONT NEWHALL WAS reading his stringent review of my introduction to *The Studio Annual of Camera* 1934–35 in the January 1935 *American Magazine of Art*. I was a young and unsophisticated critic with only a novice's experience in the complex world of art, photography, and museums. Newhall took me to task for my failure to be sufficiently objective in my expressed opinions. His criticism was valuable to me, because he taught me the difference between aggressive personal opinion and logical presentation of facts. Of course, at this time the Group *f*/64 manifesto was still fresh in my mind and my criticism strongly reflected this bias. In retrospect our philosophy seems a little rigid, but I doubt it would have been as effective had we softened its objectives or been gentle in its promotion.

I found it difficult to understand the great patience of the art historian, such as Beaumont, to study, annotate, and write so carefully, slowly, and precisely upon the multiple concerns of that field. It is a form of creative architecture: designing and structuring edifices of information and interpretation. I began to see how the reconstruction of a work of art in terms of its time, its development and function, and its relationship to the history of art became, in a very positive way, a creative expression in itself.

My first technical book, *Making a Photograph,* was published in 1935. I soon received a letter from the same Mr. Newhall, now writing heartwarming comments on my new book. He had a strong interest in photography, and this book apparently reaffirmed his opinion that it was an art form. I still get great satisfaction that the book stressed straight photography, incorporated Group *f*/64 philosophy,

and, despite the date of publication and the dominance of the picto-
rialists, was very successful. The photographic reproductions are so
good that, a few years ago, a bookstore advertised *Making a Photograph*
as containing original prints and priced it at thirty-five hundred dol-
lars! I immediately advised them of their mistake.

Edward Weston wrote in his foreword to this book:

> In the last analysis, man himself is seen as the actual medium of
> expression. Guiding the camera, as well as the painter's brush,
> there must be a directing intelligence — the creative force.

I wrote in the introduction:

> David Octavius Hill and Robert Adamson succeeded both in
> making remarkable photographs and in demonstrating one of
> the basic principles of art: complete expression within the limi-
> tations of the medium . . . we can trace the development of
> photography as an art through a multitude of individuals, move-
> ments, and methods down to the present day. This development,
> however, is not entirely one of progress.
>
> The flood of pictorialism did not obliterate the slender thread
> of communication between the integrity of the earlier years and
> its hopeful reanimation in the present. This thread, which con-
> tinued the true identity of the art, was maintained with heroic
> devotion by Alfred Stieglitz more than by any other individual.
> Through his life-long efforts, photography has been vastly aided
> in the reassertion of its real quality and purpose. The photo-
> graphic renaissance, anticipated by Stieglitz, has become a vital
> actuality in the last two decades.

Following Beaumont's letter to me regarding *Making a Photograph,*
we began corresponding, and in 1939, while in New York, I met both
Beaumont and his wife, Nancy, for the first time. We were to rendez-
vous in front of the Museum of Modern Art (MOMA) and proceed to
lunch. I was a bit nonplussed to read an unpublished account of how
Nancy described this event — my western exuberance contrasted
sharply with New York conventions:

> In the sunlight before the curving, shimmering entrance cove,
> there was something that looked like a stroboscopic photograph.
> Bright whirls of metal slowed into a tripod, the dark blur re-
> solved itself into a tall, thin man in a wide black hat, turning the
> tripod head this way and that, as if a camera were fastened there.

Then he condensed the tripod, tossed it up in the air, and tested its weight. He saw us approaching with amusement — thus every photographer with a new device, even Ansel Adams, and we all began to laugh. Introductions over, he put the tripod through its paces again. "See — it goes up to twelve feet!" It shot up glittering, he settled it on its legs and shook it. "Steady as a rock!" Seeing us looking up — "Don't worry! I always carry a fireladder!" — and brought it down again. Tenderly turning and tilting the head again, he slid out the bed and screwed the invisible camera firmly thereon. "It'll hold an eight by ten!"

We were watching the man more than his demonstration. What an extraordinary, mercurial, multiple being! A lion, when you looked into that ardent countenance — the warm brown eyes brilliant under black lashes and flaring, quizzical brows, eyes set wide and deep under the wide, smooth dome, dimmed only by a few wisps of fine black hair, the broken eagle beak of the nose and the unconquerable chin (no beard in those days). An ape, when you considered the delicate ears forever pricked forward as though to catch the furthest whisper, the short, strong neck sunk into the hunch stance of the heavy-pack-carrying mountaineer, the long arms with the thick wrists and powerful tapering fingers. The whole man was radiant; he was like the sun. Yet you waited for the shadow, I don't know why.

Now, black hat tugged firmly down, with his mountaineer's loping stride, he was clunking the tripod along the pavement. At the corner of Fifth Avenue we waited for the light to change. People stopped to look at him better: some tittered. For a moment he looked sad and a little severe, then he lifted his chin, smiled and we went clunk! clunk! across Fifth Avenue to our favorite Cafe St. Denis.

The three of us hit it off immediately, bursting with stories and jokes throughout the meal. I contributed my poem:

> *Lines to a Waitress*
> * on being advised that there is only Swiss Cheese left . . .*
>
> *When hair grows on the Camembert*
> *And bugs infest the Brie*
> * When Edam dries*
> * And Roquefort dies*
> *Dear Miss, it's Swiss for me.*

Nancy followed with this story. She and her mother were having lunch at the same elegant restaurant we were in when her mother observed a cockroach on the back of her seat. She quickly called the waiter, who deftly entrapped the insect and exclaimed, "*Mon Dieu!* How did *that* get out of the Stork Club?"

The Newhalls and I shared a New England ancestry. I shall never be sure if this was an advantage or not: such background measures freedom, partitions enjoyment, and creates ideals that are often impossible to realize. We had our private heroes, saints, and creeds as well as our devils, purgatories, and hells.

Beaumont was trained as an art historian at Harvard and, after a short period as an assistant in the Department of Decorative Arts of the Metropolitan Museum of Art, in 1935 he was appointed librarian at MOMA. His fine scholarship was evident in the quality of the library that grew rapidly under his direction.

Nancy Parker graduated from Smith College in 1930, where she had majored in creative writing, drama, and painting. She also studied at the Art Students League in New York. She and Beaumont married in 1936, and their mutual passion for photography and its aesthetic, expressive, and social potentials flourished simultaneously. They became leaders in the world of photography — its history and interpretation.

Nancy Newhall had in every respect as fine a mind as Beaumont, though she was far more extroverted and had strong, passionately stated opinions; she brought intensity to every situation. Nancy had enormous creative energy: it was difficult for anyone to keep pace with her. Inspirations came with astonishing frequency. She would create problems for the sheer delight in solving them. Many women disliked her incisiveness and courage, and many men resented her capabilities.

Beaumont, on the other hand, is always calm and in perfect control of events, no matter how exasperating. He is extremely intelligent and patient, with an inherited New England rectitude that suggests an austerity that belies his sparkling wit. He is dedicated to photography in all its aspects. Originally published in 1937 as a catalog for a MOMA exhibition, his *History of Photography* is the prime work in the field, keeping pace through several editions with new discoveries and cogent clarifications.

Beaumont is also a photographer with a discerning eye. I saw a few of his pictures as early as the 1950s, but found him reticent to show or discuss them. He was finally prevailed upon to put together a show

that surprised and vastly pleased his friends. His portrait of Cartier-Bresson is remarkable and haunting in its qualities of personality and space. His architectural series of Leopoldskron in Salzburg, Austria, is a stunning example of perception and photographic facility. In recent years his photographs have gained recognition to a gratifying degree.

In 1940 I was asked to curate a major exhibition, "A Pageant of Photography," for the Golden Gate Exposition. I decided to exhibit a rich diversity of photographs: from the beginnings to the present, from Timothy O'Sullivan landscapes to Man Ray "Rayographs." The catalog was large, with handsome reproductions and short essays by Beaumont Newhall, Edward Weston, Moholy-Nagy, Dorothea Lange, N. U. Mayall (Lick Observatory), Grace Morley (director of the San Francisco Museum of Modern Art), and Paul Outerbridge. I was proud of the exhibition.

Diego Rivera, the great Mexican painter, was also employed at the Golden Gate Exposition. Rivera was invited to paint murals in front of the public, in a project titled, "Art in Action." Albert Bender, a patron of Rivera, was instrumental in arranging this project. I remember a meeting in Rivera's rooms at the St. Francis Hotel; he was quite rotund, sporting a broad, friendly grin and dressed in a colorful Mexican costume. I was impressed by his steady attention to what people were saying. I felt he knew what we were thinking as well — he anticipated several things I had to say seconds before I had summoned the bravery to say them.

After an hour's discussion about problems related to the exposition, a bellboy brought a telegram to his room. Rivera opened it and, after a glance, went into obvious distress, saying "I am next! I am next!" The message was that Leon Trotsky, who was living in Rivera's Mexico City home, had just been assassinated. Rivera was a Communist but at odds with the Leninist regime. He immediately asked for police protection, and the leaders of the exposition promptly arranged for it. Thankfully, no violence marred the visit of this great artist to our city.

Rivera had many friends in San Francisco. One of the most devoted was Emily Joseph. They enjoyed mutual bright conversation and banter. One day she visited him while he was at work on the large fresco at the California School of Fine Arts (now the San Francisco Art Institute). Diego was artist-in-residence and was having a deep effect upon the students. The fresco was in typical and topical Rivera style; prominent San Franciscans were depicted in appropriate environments and activities, and Diego himself was painted sitting on a sturdy plank, working on the mural. Emily visited him when he was working

on an area adjacent to his own rear-view self-portrait. She called to him, saying, "Diego, there is no doubt you are painting this for posteriority." It became the bon mot of the season.

During the whirl of the exposition, the Newhalls announced that they would visit San Francisco with the prime objective of seeing me and "A Pageant of Photography." I was understandably nervous about their reaction to my first attempt as the curator of a major show.

I decided they must see the sights, and we had a grand time. Upon arrival, I took them to the Top of the Mark to have a drink and watch the fog sweep in. The next day we drove along the shores of the marvelous bay itself and to Treasure Island, the site of the exposition. Nancy later wrote in the same unpublished manuscript:

> It was indeed huge and comprehensive, immaculate in installation, perfectly lighted, though to us the design was monotonous, with the endless successions of black and white rectangles on pallid walls. The photomurals he had made from astronomical negatives, especially the Pleiades and the corona of the sun during a total eclipse were breathtaking. And what a survey of the work of Western photographers, both early and contemporary; there were many we did not know and were rejoiced to see. Group $f/64$ had certainly established high standards of vision and technique. The show as a whole, we thought, represented a breadth of mind and heart unusual among creative artists with such strong personal dedications as Adams. By far the finest art we saw in the West was in photography, not in painting, nor sculpture, not even in architecture. Beyond question, photography was the art of the West — "A new art in a new land."

The Newhalls were overcome by their experiences on this first trip to California. One day I drove them north over the Golden Gate Bridge and along the Marin County coast. We had Benny Bufano with us, a fine sculptor, a true San Francisco character, and a warm friend. His prime subject, Saint Francis of Assisi (patron saint of San Francisco), was portrayed in various media: drawings, painting, mosaics, and sculpture. The cowled figure with wide-stretched arms was repetitively stylized but impressive. He had an extraordinary ability to create in his sculpture almost invisible edges that could be felt as sharp, defining transitions of form.

Benny loved hiking as much as I. Once we were in Yosemite and had climbed the steep slopes to the base of the cliffs under Taft Point

on the south side of the valley. Benny was talking about the local Sierra granite, how rich it was in structure and consistent in body. I noticed him staring across the valley to the huge soaring mass of El Capitan.

I jokingly said, "Now, Benny, don't get any ideas of carving F.D.R.'s head on that cliff!"

To my horror Benny replied, "That's just what I was thinking about; as soon as we get home I'll call my friend Eleanor." I honestly feared he might attempt to set such a concept in motion. He was a short man, compactly muscled, and wielded a mighty chisel.

I also drove the Newhalls to Carmel where I introduced them to Edward Weston. They visited his home and went with him to Point Lobos, where they experienced the wonders of his work and environment. Thus began a close association culminating in Nancy's editing of Edward's *Daybooks,* the very personal journals of his life and philosophy finally published in 1961 (*Volume I: Mexico*) and 1966 (*Volume II: California*).

We were all visually invigorated after our time spent with Edward, and we stopped frequently to photograph on the trip back to San Francisco. At one place along the Highway One roadside, I photographed from a cliff top, directing my camera almost straight down to the surf patterns washing upon the beach below in a continuing sequence of beautiful images. As I became aware of the relations between the changing light and surf, I began making exposure after exposure. Though each photograph can be shown separately, a group of five displayed together has the greatest effect. *Surf Sequence* is one of my most successful photographic expressions.

Soon after Beaumont and Nancy returned to New York, we began the enormous parade of photographic projects that the three of us concocted over the next few decades. While all could not be implemented, for want of energy and time, the seeds of many important projects and books had been sown during their San Francisco visit. We composed a productive and vibrant association. These were indeed golden days: everything exuded energy and friendship.

Beaumont's interest in photography as his specialty in art history had grown, and soon after his return to New York, he developed the concept of the Department of Photography at MOMA. The museum had already expressed some interest in photography. There had been "Murals by American Painters and Photographers" in 1932; a large retrospective exhibit that Beaumont curated in 1937, "Photography 1839–1937"; "American Photographs by Walker Evans" in 1938; and in 1940, "War Comes to the People, A Story Written with the Lens

by Therese Bonney." But a permanent Department of Photography would mean the very first long-term commitment to photography as a fine art by a major museum.

With the intelligent benefaction of David McAlpin and the guidance of Beaumont, the fledgling department was successful from the start. David Hunter McAlpin is one of those rare beacons and anchors who make things possible for other human beings: personally in friendship and encouragement, but also with his years of leadership and financial support of the arts and the humanities. He is a true philanthropist, functioning in an aura of personal modesty and simplicity. Without Dave, the Department of Photography at MOMA might not have been achieved for decades.

Dave wrote to me on September 7, 1940:

Dear Adams,

Newhall and I both feel it essential for you to be here for six months to a year as a member of the committee and special advisor in launching the Photo Dept.

The catch of course about getting it started is to raise the cash. The trustees have asked me to be chairman of the committee. We can hardly go out to solicit funds till we have something tangible. So I have suggested that we make a group. The expenses of a six months organization period would not be great. Perhaps we can then have something to go and launch a full fledged plan and sell it to the trustees — their attitude is receptive.

I have accepted the chairmanship provided you would come and stay here and devote as much time as necessary and serve as advisor, organizer and policy director. And I have offered to underwrite your retainer. So it's in the bag if you can be induced. And I don't know what "if" or "no" means! I realize it's a big thing to ask but there would be many pleasant sides to it — Stieglitz and O'Keeffe. A real visit to N.Y.C. New faces — a bit of opera and music on the side. New scenes to interpret, etc.

This letter was followed closely by one ten days later from Beaumont:

Dear Ansel:

Things have been happening during the last few days! The creation of a Department of Photography is a fact; the Trustees have approved of

the plans I submitted to them last July, and have appointed me Curator.
Dave McA has accepted chairmanship of the Committee, and last night
he and I met with John Abbott (Executive Director) for a long discussion.
The Trustees have not been able to give any money for the project at the
present time, although they have allowed me to spend more time on
photography. Our plan is to spend some time in developing the depart-
ment up to a point where we can interest outside money sources —
foundations, interested millionaires, commercial firms.

We are very excited that you are able to come on. Dave gave me the
facts in your letter, and it seems to us ideal to have you come on for the
six weeks beginning October 15. That will give you a chance to become
acquainted with the setup here, and it will give the Museum a chance to
get acquainted with you. We'd rather like to decide about the rest of the
schedule after you get here. There are a lot of things to be worked out, as
you can well imagine. In the meanwhile Dave and I will be sounding
out various committee members, and getting things lined up for an inten-
sive campaign. We were delighted with your cooperative and enthusiastic
attitude as outlined in your letter to Dave, and await your arrival eagerly.
It seems hardly worthwhile going into all the details of what we can do
in this letter — I think that you have a good idea of my attitude from
our California conversations, and I hope that you have the same of mine.
Isn't it swell of Dave to get the thing started?

PS I have written Stieglitz about the plans in general, and have appealed
to him for advice and counsel — I want him to feel that he is in on the
work from the very foundation.

We all felt it extremely important that Stieglitz be involved in the
formation of the new Department of Photography. Beaumont, Dave,
and I saw him as the leader of the photographic arts in the first half of
the twentieth century. However, Stieglitz acted the curmudgeon to
the end and on April 8, 1938, he wrote:

My Dear Adams:

I have nothing against the Museum of Modern Art except one thing &
that is that politics & the social set-up come before all else. It may have
to be that way in order to run an institution. But I refuse to believe
it. . . . In short the Museum has really no standard whatever. No integ-
rity of any kind. Of course there is always a well meaning — "the best
we could do under the circumstances." Newhall did come to me for some

*of my prints. I again tried to make clear to him why I couldn't join up
with the undertaking. Something happened here while he was present
which I think was an eye opener to him. As he left I told him that as an
individual I was interested in him. I'd look at his work at any time he
chose — but as an official of the Modern Museum I feared I could be of
no use as I felt that in spite of its good intentions the Museum was doing
more harm than good. The American idea that always something must
be better than nothing I disagree with absolutely. Quality throughout
does play a role. Well, the world is in quite a mess so why expect its
institutions to be otherwise. As a worker — a workman — one can keep
one's integrity in spite of all pitfalls & indifference on part of the over-
whelming majority of people who don't give a damn one way or
another. . . . I can imagine how driven & how tired you are. But it's
good for me to know that there is Ansel Adams loose somewhere in this
world of ours. . . .*

My love to you & again deepest thanks.

Stieglitz

Beaumont and I curated the first exhibit of the new Department of
Photography at MOMA, "Sixty Photographs." It opened on December
31, 1940, and was an unqualified success. It comprised a vigorous sur-
vey of photography from the 1840s Calotypes of David Octavius Hill
and Robert Adamson to 1938 photographs by Edward Weston and
myself. Stieglitz relented just enough to let us include his work.

I recall the challenging experience I had with Arnold Genthe in
obtaining his photographs for that exhibition. I knew Genthe slightly;
he was a bit before my time, and I did not have many opportunities to
meet with him except in New York when he was of advanced age. He
was a brilliant and courteous man and a leading portrait photographer
of his time. Beaumont and I very much wanted Genthe represented,
yet we could find no print that was good enough for display. Because
I had met him, it was suggested I visit and express the desire that he
be included in the exhibit, but, as no adequate prints could be found,
would he permit me to make exhibition prints from two negatives?
Naturally, he would see the prints and reject or approve them before
they were hung.

I was quite apprehensive approaching a famous man with a possibly
infamous request, but I plumbed my well of courage and called on
him in his downtown studio. He graciously received me, introduced

me to a pair of elderly ladies who were assisting him in the compilation of his work, and asked me the purpose of the visit. I explained the best I could, literally stammering with embarrassment.

He agreed with enthusiasm to my printing *The Street of the Gamblers* (1904) and *View Down Clay Street, San Francisco* (April 1906), the latter the world-famous image of the great fire that followed the earthquake of April 18. These were beautiful photographs; *The Street of the Gamblers,* made with postcard-size Kodak roll film, anticipated Cartier-Bresson in its amazing immediacy of the moment and the clear spacing of the several men walking in the Chinatown street. Genthe found the negatives and gave them to me, saying, "I know your work and I am indeed happy you are to make prints from them." I was quite overcome.

I did not wish to imitate his style (he used greenish, textured papers and a warm-tone print developer), so I decided I would make them in the modern mode: glossy paper toned in selenium. The negatives were very difficult, but I finally achieved what I considered fine prints. I mounted one of each and took them to him. He looked at them carefully, while I trembled in my newly shined shoes, then said, "Why didn't I print them that way in the first place?" I almost fainted with relief, expressed my pleasure that he was pleased, and returned to the museum.

I find it interesting to see the list of photographers whom we selected in 1940 to represent all of creative photography since its beginnings: Berenice Abbott, Ansel Adams, Eugene Atget, Ruth Bernhard, Mathew Brady, Henri Cartier-Bresson, Harold Edgerton, P. H. Emerson, Walker Evans, Arnold Genthe, David Octavius Hill and Robert Adamson, Dorothea Lange, Henry LeSecq, Helen Levitt, Lisette Model, Moholy-Nagy, anonymous news photographs, Dorothy Norman, T. H. O'Sullivan, Eliot Porter, Man Ray, Henwar Rodakiewicz, Charles Sheeler, Edward Steichen, Alfred Stieglitz, Paul Strand, Luke Swank, Brett Weston, Edward Weston, and Clarence White.

When World War II arrived, Beaumont enlisted with the air corps and gave distinguished service as a photo-interpreter in the Mediterranean theater. Much of the escalating work load at MOMA during the war years fell on Nancy's shoulders, as acting curator, and on mine, as vice president of the photography committee.

Because of these responsibilities, I spent a number of weeks each year in New York. I still tried to practice the piano daily, and so I had a grand piano installed at the Newhall apartment on 53rd Street. The

apartment agent made it very clear that there could be no music after ten P.M. The routine was fairly consistent: we would finish our tasks at the museum about seven, then have dinner. We both carried on a lively correspondence with Beaumont, and if a letter had arrived that day we would read it aloud and Beaumont would seem to be with us.

Italy, 27 February, 1944

Dean Ansel,

I was very pleased with your letter of 5 February. Yes, the more I think of creative photography, the more I realize how true it is that what counts in art is what is inside of us. That is what separates the artist from the layman — the ability to recognize and the skill to transmit to others those observations and feelings. How much we have to do when all of this is over! A fight for the real recognition of photography, not the intellectual acceptance of it which, I am afraid, is as far as we have gotten.

After washing the dishes, writing letters, and maybe an hour of piano, at ten I walked from their 53rd Street apartment to the Algonquin Hotel at 44th Street. Even though I had what undoubtedly was the smallest bedroom in the establishment, I found the Algonquin a most agreeable hotel; its enduring charm still exists.

The impact of New York City was for me one of expanding waves of contacts and events, washing an endless shore of personalities and activities. I remember a bright New York day: spring, flowers, a bit of snap in the morning stride of pedestrians. Nancy and I had been invited to the home of Charles and Musya Sheeler. Under light clouds and a gentle sky we drove to Irvington along the Hudson River. At about five we arrived at the Sheeler home, a beautiful, small granite structure, formerly the gate house of a large Hudson River estate. Musya greeted us with warmth and Charles with his usual austere admission of pleasure to see us. He was a deceptively shy man, firm and quiet, and a great artist. I admire his photography but believe he was even more impressive as a painter. Musya was a vibrant Russian: a former ballet dancer who had an abundance of affection for their friends.

Many Sunday afternoons were spent at the Sheelers'. On this particular day with Nancy and I visiting the Sheelers, there was a light, fragrant breeze, more friends arriving, more tea and vodka dispensed.

Musya was queenly in her dispensation of the vodka and cookies. The euphoria expanded while the mind vacated the cranium. Sheeler and I reminisced about an amusing incident at a recent photographic opening. After viewing the exhibition and both needing a cigarette, we had stepped outside. After a few minutes he had reflected, "Adams, isn't it remarkable how photography has advanced without improving?" I consider this a prophetic statement.

Realizing I had a MOMA meeting at nine the next morning, I reestablished myself to a certain extent with very strong coffee, but it took an hour to convince Nancy that Manhattan beckoned. The drive back to Gotham was not the pliant and delicate journey of the earlier hours; people were roaring about in their cars: honking, passing, crowding, scaring, but we did make it to West 53rd Street.

We had to face some kind of a dinner, because the Sheelers entertained with a maximum of alcohol and a minimum of solid gastronomic support. A close-by eatery provided some essential greasy protein and some unneeded bourbon. I drifted into the Algonquin about midnight. At eight Monday morning I wafted myself out of bed, into a shower, then to breakfast seen through a fog of repentance, then to the meeting, which, by the grace of God, had been postponed.

That Monday was not a bright day. The springtime of yesterday was only a memory. The sparkle in the stride of the multitude was now a drag. MOMA seemed like a columbarium, and I had no flowers to put into the appropriate urnal niches. Another week in New York had begun. My inner vision sought the Sierra and the Pacific shores.

"What in hell am I doing here, far from home and family and Yosemite?"

Time and again I would come to New York, excited with professional and social ambitions and promises, only to be physically frayed and spiritually disemboweled within a few weeks. In that penitentiary environment, most of the museums and galleries seem to exist in a kind of purgatory, either to accept the fluorescent heaven of a final resting place or the hell of obscurity. I have yet to understand the harmony of magnificent apartments, hideous ghettos, industrial deserts, furs, rags, Tiffany's and Joe's curio shop, beautiful women (virtue unclassified), unbeautiful women (virtue assured), and the people of strangeness everywhere. Yet, for a time all this appeals in some curious and compelling way. It represents a conflict of many decades: what charm, what grace, what culture — and what horror!

As wonderful as my good friends were, the city would finally defeat

me and I would flee west. For me the western border of beauty and wonder was roughly marked by Denver: west of Denver promised home, east of Denver was an alien world.

While Beaumont was in Italy during the war, Edward Steichen began to muscle past Nancy and me, intruding himself on the MOMA photography department scene. Steichen did not like Nancy as much as she detested him. As a friend said, "He has the ability to make women cry and he revels in it." I rarely saw Nancy cry, but almost every time I did it was after she had had a meeting with Steichen.

Steichen had been appointed a captain in the navy, in charge of the program to photographically document the Pacific war. There is no doubt of the importance of this project or of his military service. He also arranged for the production of gargantuan exhibits that were displayed at MOMA, such as "Power in the Pacific" and "The Road to Victory." These shows had nothing to do with the creative and aesthetic aspects of photography, the true province of a museum of art. They were patriotic and inspiring in the tempo and timbre of blatant wartime propaganda. It would have been much more appropriate to have presented them in Madison Square Garden, where they would have commanded an even greater audience. Beaumont returned on leave and was properly disturbed.

Edward Steichen and I were at swords' points from the moment we met in 1933. On the same trip when I first met Stieglitz, I was eager to meet all of the leading photographic lights. I phoned for a possible appointment with Steichen, and his secretary set ten the following morning, saying, "I am sure Mr. Steichen would love to see you!" I arrived at ten and waited. The great man appeared in a flurry of preoccupation and said, "I can't see you now; come back sometime, maybe next week," and then disappeared through a door with the obvious hint that I was quite unnecessary to him and to the world. I was naturally a bit miffed, but I thought that he must be busy and harassed. I returned but never obtained a meeting during that visit to New York. I felt his arrogance, not because he was too busy to see me, but because of his manner of disdain and his abiding sense of power and prestige.

Stieglitz reacted to my impressions by saying, "That's Steichen. Keep your distance and you will be happier." Steichen had been one of Stieglitz's greatest supporters in the early days of his first gallery called Little Galleries of the Photo Secession, at 291 Fifth Avenue in New York. Steichen genuinely helped increase American understanding of modern art by finding important avant-garde work in Europe

that he recommended to Stieglitz in the first decade of this century. They were very close for many years until Steichen drew away from the more subtle world of art and concentrated on advertising photography. Stieglitz felt that Steichen had sold out.

At the time he assumed the naval position in World War II, Steichen telephoned me in Yosemite, saying in a hearty voice, "Adams, I want you to run my laboratory in Washington." As I was desperately trying to find some possible niche in the war effort, this seemed to be an excellent opportunity and I put aside Steichen for country. Assured that I would soon hear from him, I waited for the promised call of the what, when, and where of my military future. After another month I read in a photographic magazine that Steichen had appointed someone else.

World War II ended; Beaumont returned to the museum and found that many of the trustees and other powers swore allegiance to Steichen's ideas about photography and exhibitions. On February 23, 1946, Beaumont wrote to me:

> . . . As near as I can make out I'm being screwed. A memorandum was drawn up by the subcommittee for presentation to Steichen . . . and it was a complete rolling out of the red carpet to Steichen. Stuck down in the memorandum was a statement that, "It is your expressed desire (i.e. Steichen's) that Mr. Newhall continue his position as Curator of Photography." I felt that this was not an adequate guarantee that I could continue to do work of importance in the museum.
>
> Steichen came to the Museum last Tuesday to see the show (Edward Weston retrospective). He told Edward that he was "taking over here." Dave McAlpin called me later to say that O'Keeffe had told him that Steichen had told her that he had accepted the job and was going to start as soon as he found a place to live in New York. So that is how things stand.

I immediately telegrammed Beaumont:

LETTER RECEIVED TONIGHT FEEL YOU MUST MAKE DEFINITE STAND NO COMPROMISE REMEMBER YOU BROUGHT PHOTOGRAPHY TO MUSEUM PHOTOGRAPHY IS MORE IMPORTANT STARTING WHEELS TURNING OUT HERE AM SPOILING FOR FIGHT AM WRITING.
LOVE TO EVERYBODY.

<div align="right">

7 March, 1946

</div>

Dear Ansel:

The Rubicon is passed. The die is cast. I enclose a copy of my letter of resignation. . . . After these months of indecision, after Nancy and I had talked ourselves out about the whole matter, I have at last come to a final and irrevocable decision. The Museum cannot have me if they have Steichen.

<div align="right">

Yours as ever,
Beau

</div>

The Newhalls left, and a few months later I notified them in pseudo-telegram style:

<div align="right">

THURSDAY, JULY 17

</div>

BEAUMONT AND NANCY:

FLASH!!!
EDWARD STEICHEN APPOINTED HEAD OF PHOTOGRAPHY AT MUSEUM OF MODERN ART. APPOINTMENT BECOMES EF-FECTIVE IMMEDIATELY. ROCKEFELLER SAYS, "MUSEUM EX-HIBITIONS WHERE PHOTOGRAPHY IS NOT THE THEME BUT THE MEDIUM THROUGH WHICH GREAT ACHIEVEMENTS AND GREAT MOMENTS ARE GRAPHICALLY PRESENTED." IN SHORT, EVERYTHING THAT WE FEARED * * * THE COM-PLETE ENGULFING OF PHOTOGRAPHY AS YOU AND I AND N SEE IT AND FEEL IT INTO A VAST PICTURE ARCHIVE OF SUBJECTS.

<div align="right">

ANSEL

</div>

I knew with the departure of both Newhalls there would now be capitulation to the common and the popular. I truly detested Stei-chen's large exhibits primarily because they were completely subject-oriented. I refused to participate in them for many years. His "The Family of Man" that opened in late 1955 was a tremendous hit with the public. Some of the images were magnificent, but Steichen had

many enlarged way beyond the point where there was any print beauty remaining.

He requested the use of my negative, *Mount Williamson, Sierra Nevada, From Manzanar, California, 1944.* I urged Steichen to let me make the huge mural he envisioned for this image, but he replied that mine then would be inconsistent with the quality of the other prints in the exhibit. I refused to part with the negative, sending him a copy negative instead. In my printing instructions (that I was very uncertain anyone would even read) I wrote on December 17, 1954:

> The negative was loaded in a small, stuffy room at Manzanar during the war and there is a damp fingermark in the sky which does not show in the small print but comes through like the fingerprint of Gawd in big enlargements.

I became ill when I saw the finished mural. He had transformed *Mt. Williamson* from one of my strongest statements into expensive wallpaper. "The Family of Man" would have been ideal under the auspices of the United Nations but not at the Museum of Modern Art. I lost interest in MOMA for many years.

When John Szarkowski took over as director of the Department of Photography in 1962, creative photography was offered another chance. MOMA, always a focal point in the world of art, for better or for worse, finally and unequivocally recognized photography for what it is and might be: a creative art, not a sociopolitical platform.

After his separation from MOMA, Beaumont was appointed the first curator of George Eastman House in Rochester, New York, in 1948. During the next two decades Beaumont developed the International Museum of Photography at George Eastman House into the greatest collection of creative photographs in the world. During these years Nancy, Beaumont, and I continued to collaborate on many books and exhibitions, enjoying frequent visits and work sessions together.

The Rochester experience with the Newhalls was important to me in many ways. Rochester is known as the photographic capital of the universe because of the presence of the Great Yellow Father, the Eastman Kodak Company. I found the town itself dismal, with a climate that was difficult, to say the least. I cannot imagine anyone willfully living there. The chief urban voices of Rochester are the police and fire sirens, practicing their wailings at all hours of night and day. San

Francisco has its foghorns, Rochester its sirens. But the creative spirit thrived somehow in spite of the environment. The University of Rochester is excellent, the Eastman School of Music a justifiably re-nowned institution, and the Rochester Institute of Technology a leader in the education of professional photographers.

The Newhalls acquired a small wooden house, and Nancy turned it into a beautiful home-salon, certainly one of the most charming residences in the area. Beaumont, a fine chef and food critic, produced an array of great meals from his kitchen. The house, built on Rundel Park, looked out on a central area of trees that was rewarding at all times of the year.

One time I house-sat for them while they were in Europe and I worked on a project for the University of Rochester. It was pleasant living in their home, but a bit lonesome, although I was surrounded by their cats. The cats disliked me; I do not know the reason, as I liked them. They remained very unfriendly until the Newhalls returned, then were all over me with affectionate climbings and cuddlings pe-culiar to sophisticated cats. There was a little swinging cat-door built into the base of the front window, which the cats were constantly passing through. Occasionally a neighbor dog would chase the cats right up to the door. There would be a bang and swish as a cat came through, usually followed by a dull thud as the dog hit the door frame.

I well remember the time that the three of us visited one of our heroes, John Marin, at his home in Cliffside, New Jersey. After my experiences with that sensitive man in the beauty of the Southwest landscape, I was astonished to find him living in a drab little house in a depressed neighborhood just west of the Palisades. I recall gray, stuffed furniture, curio ashtrays from Atlantic City, and a tiny, bleak fireplace over which hung, in an assertive way, an empty picture frame.

We all went out to lunch. First we took a breezy drive along the Palisades Parkway in Marin's Packard. He sat hunched low and far to the left in the driver's seat, almost obscured with a broad-brimmed hat, swirling around the curves with abandon. We stopped at an Italian restaurant of Mafia-mood, overlooking the Hudson, with barren booths and jukebox decor. The lunch was good for that part of the country and the Old-Fashioneds very good indeed.

We returned at a somewhat slower pace to his studio, where we were deeply moved by his magnificent paintings. The studio was a jumble as was the house, but nevertheless vibrated with his personality

and the strength of his work. I made a few casual portraits of Marin with my 35mm camera to show the spirit of the man and his environment. We returned to New York, sober and thoughtful. John Marin was a tremendous artist.

I first met Marin in Taos, New Mexico, in 1930 at Mabel Luhan's home, the same time I met Paul Strand. We shared an evening of music. I remember playing a lot of Bach, to Marin's delight. We discussed phrasing and the production of "clear notes." It was difficult for me to explain to him that a single note on the piano could not be modulated other than being struck with varying degrees of intensity, soft to loud. Marin said, "Now see here, Adams, a note is a single critter and can be changed a million ways." I could not persuade him that it was the sequence of notes that mattered: the quality of one note relating to the next and the one before and the space between (legato, portamento, staccato) and the relative intensities of the notes, to say nothing of the shapes of the phrasing. But he insisted that the "single critter" had great expressive qualities in itself. Marin loved to spin carefully detailed fables and once recounted the following:

One day I was cleaning my furnace over in New Jersey and there I was on my back digging the clinkers out of the grate when one fell on the concrete below and made the most beautiful tinkling sound! I made up my mind that if I ever got rich I was going to rent Carnegie Hall and invite everybody I knew and a lot I didn't know, including the stupid critics. I was going to have a smooth concrete platform in the middle of the stage. Whenever the people stopped chattering I would slowly dim the lights except for one gorgeous soft golden spotlight on the platform. I would then come to the platform, stand by it for maybe ten minutes — everything would get very quiet and still — and then I would drop *one* clinker — just one — on the concrete. There would be one *beautiful* sound — just *one* — and after several minutes of darkness, to let people think about what they heard, I would turn up the lights and let them go home. It could be the most wonderful concert they ever heard: one clear and brittle singing clinker note. Don't give me any more of that marmalade about your not being able to make a single beautiful note!

I convinced Beaumont and Nancy to join me on a trip through the Southwest. We moved from Zion to Bryce to the Grand Canyon and

many other areas of this astonishing country. One evening, after a grueling day of photographing and driving over miles of beautiful desolation, we came at evening to the brink of Bryce Canyon. Before we prepared a supper-in-the-dark, I begged them to walk to the edge of the great vista that was slowly yielding to twilight. Beaumont, tired, dusty, and hungry, waited for Nancy's glowing response to the scene and then said quietly, "Oh Gawd, more Nature." At first startled, I became sympathetic; I recalled how he had described New England, rhapsodizing on the tranquil scenes of villages and farms nestled dozing in the blankets of flaming autumn. He loved his land just as I do mine.

In 1949 the Newhalls insisted upon showing me a little of their country: the state of Maine. I chose late October over their protests that it would be severely cold. I wanted to photograph storms and great waves along the Atlantic shore. Neither cooperated during our trip; the autumn leaves had turned and mostly fallen, the air was keen, and the vistas sharp and a bit forbidding.

One of our first stops was to be for a promised Maine lobster. Before dinner we walked about the place and I noted a large pool of a gruesome green color. On inquiry I learned that it was a lobster pound where many thousands of lobsters were stored for the New York market. It looked like liquid mold, opaque and sinister with only an occasional ripple suggesting lobster-life. At dinner we each had a large lobster, poised upright and waiting for the inevitable. It tasted like penicillin, and I had trouble consuming even a part of it. The Newhalls thought it was ambrosial; I think it was the only disagreement I ever had with them over food.

We went on to Acadia National Park. It was cold and bleak, but I became aware of the essential beauty of the Maine coast. Mount Cadillac is a high dome of stone, almost Arctic in mood, rising with hoary patience above a restless ocean. Lichens, moss, scrub vegetation, and the eastern October wind: a situation I had never experienced before. I included one of the photographs I made that trip, *The Atlantic, Schoodic Point, Acadia National Park,* in my *Portfolio II,* published in 1950.

We stopped for gas, and while waiting for the slow pump to deliver the fuel I noticed a tumor about the size of a lemon on a front tire. I looked at the other tires and saw another growth on the inner side of a rear tire. The treads were worn smooth, too.

I said to Beaumont, "We have to get new tires. These are dangerous."

Beaumont protested, "The tires are perfectly all right!"

I replied, "I will not ride on those tires another mile — the casings have failed and anything could happen!" I knew an impasse was hovering, so I said, "Look, I will get you four tires for a Christmas present and we will put them on right now. A bubbled tire can be lethal." Beaumont had to give in; the new tires were installed and off we went to Boston.

While an excellent driver, Beaumont does not worry about the mechanics of a car until it stops. He is always concerned that I give too much thought to machinery. Perhaps I do, but I have had very few breakdowns on the road in over a million miles of driving. With my heavy 1946 Cadillac in rough country I would sometimes lose a rear axle. I always carried two or three extra axles, to the astonishment of desert repair shops. I would be towed in to some little desert conglomerate of service—repair shop—hamburger—beer counter and say, "I lost my axle."

They would respond, "Gee, that's too bad. It will take three or four days to get one out of Los Angeles."

I would reply, "I have an axle with me." They would always be incredulous, but I would present the axle, neatly swathed in greasy paper, and in an hour or so I was back on the road.

Projects with the Newhalls grew like Topsy. There are too many to describe, but all were exciting and worthwhile. Nancy and I produced seven books together: *Death Valley* (1954), *Mission San Xavier del Bac* (1954), *The Pageant of History in Northern California* (1954), *Yosemite Valley* (1959), *This Is the American Earth* (1960), *Fiat Lux* (1967), *The Tetons and the Yellowstone* (1970).

Always a pleasure to work with, Nancy possessed the ability of structured anticipation to a remarkable degree: projects from their inception would be beautifully conceived in their entirety. If we discussed a book or article, she could visualize the completed work with precision in content, format, and design. In laying out an exhibit or a book, I wondered how she could memorize the various placements and sequences without notes or apparent effort. She had a permanent visual memory for what she saw in the world, in a work of art, or on a page of type.

Nancy could also thoroughly research a subject, study maps and pictures, listen to verbal descriptions, and then produce an article that had the intensity and accuracy one would expect from a direct experience with the subject. One example was an article she wrote for *Arizona Highways* on the Canyon de Chelly National Monument in

Arizona. Our first collaboration was a series of articles for them on the Southwest, and we visited and photographed many places together except one, the Canyon de Chelly. However, after seeing early photographs plus the ones that I had made, and reading up on the area, she produced an article that was both fully accurate and emotionally valid. It was difficult to believe she had not physically experienced this marvelous place and absorbed its spiritual qualities.

One of her finest literary efforts was organizing *Time in New England,* combining the photographs of Paul Strand with selections from the writing of preachers, poets, and politicians that reflect the life-quality and spirit of the enduring early American culture. All went well with *Time in New England* until Paul stated he would not enter Boston, which he considered to be the seat of American Imperialism. How to do a book on New England without including Boston? Texts posed no difficulty, but the lack of photographs presented a problem. Nancy solved this dilemma by selecting some of Strand's most sensitive and expressive images of New England people and close-up objects that were used as symbolic statements of the Boston spirit.

This was probably the first book of its kind where photographs and text maintain a synergistic relationship; the pictures do not illustrate the text, nor does the text describe the pictures. I prefer the term "synaesthetic," as two creative elements join to produce a third form of communication. Wright Morris's pictures among his text in the books *The Home Place* and *God's Country and My People* are not truly synergistic, as they replace verbal descriptions. More recently, *Picture America* with photographs by Jim Alinder and words by Wright Morris is a rare book of synaesthetic quality; the pictures animate the short texts and the words heighten sensitivity to the photographs.

Possibly the most worthwhile of my projects with Nancy was the exhibition and accompanying book *This Is the American Earth*. In 1955 the Sierra Club still had the LeConte Memorial as its headquarters in Yosemite, but the National Park Service requested that it be put to better use for the public good. I suggested that the Sierra Club mount a magnificent exhibit of photographs related to our environment and install it at the Memorial. This idea met with great enthusiasm from the other Sierra Club trustees. I asked Nancy to help in the design of the show and to provide literary material. We gathered the work of thirty-two photographers, myself included, and assembled it with Nancy's poetic text. Nancy, assisted by Dave Brower, also designed the exhibition into a book, the first of the Sierra Club's exhibit format series. The devoted conservationist Supreme Court Justice Wil-

liam O. Douglas described it as "one of the great statements in the history of conservation."

A strange anachronism persists in most conservation literature. I do not understand how such a fundamentally emotional subject — our natural world — can be so bleakly interpreted and discussed. I have read few conservation books that gave me an honest thrill. Whenever I wish to refer to a brilliant stylist, I think of Wallace Stegner. The photography of such fine artists as Eliot Porter and Philip Hyde are all too often submerged in the weight of indifferent texts. The facts may all be there, but the spirit wanders forlorn.

Typical of such writing is, "The writer ascended the northwest ridge to an altitude of 8760 feet. He then traversed the gully to the west ridge and continued to an altitude of 9500 feet. He then attacked the southwest face and reached the 11,740 foot summit at 2:45 P.M. The view was extensive. He returned to his camp by the southeast slope." I am sure the experience was far more luminous than the remarks that I doubt would stir the spirits of even the most devoted mountaineers.

Nancy's text for *This Is the American Earth* is, for me, a sublime poem, paeonic and evocative. She illuminated profound thoughts with explicit and miraculous words and phrases. Her lines should be read as though they were parts of Genesis, each word for the words that live around it, each thought for the other thoughts comprising its matrix, in a structure of imagery, history, and prophecy.

> *You shall know the night — its space, its light, its music.*
> *You shall see earth sink in darkness and the universe appear.*
> *No roof shall shut you from the presence of the moon.*
> *You shall see mountains rise in the transparent shadow before dawn.*
> *You shall see — and feel! — first light, and hear a ripple in the*
> * stillness.*
>
> *You shall enter the living shelter of the forest.*
> *You shall walk where only the wind has walked before.*
>
> *You shall know immensity,*
> * and see continuing the primeval forces of the world.*
> *You shall know not one small segment but the whole of life, strange,*
> * miraculous, living, dying, changing.*
>
> *You shall face immortal challenges; you shall dare,*
> * delighting, to pit your skill, courage, and wisdom*
> * against colossal facts*

You shall live lifted up in light;
* you shall move among clouds.*
You shall see storms arise, and, drenched and deafened,
* shall exult in them.*
You shall top a rise and behold creation.
And you shall need the tongues of angels
* to tell what you have seen.*

Were all learning lost, all music stilled,
Man, if these resources still remained to him,
could again hear singing in himself
and rebuild anew the habitations of his thought.

Tenderly now
* let all men*
* turn to the earth.*

Among the most rewarding exhibits of my career, and one of the most creative experiences with Nancy as well, was the huge show of my work she designed for the de Young Museum in 1963, bearing the same name as her biography of my early years, *The Eloquent Light.* Nine galleries were filled with over five hundred items, painstakingly gathered and organized in Nancy's inimitable style: photographs, books, mementos, and typographic keepsakes I had produced or collaborated on from 1927 to the year of the exhibit. She introduced objects from Virginia's and my personal collection — Indian pottery, Spanish American santos, old gravestones from abandoned San Francisco cemeteries — as well as natural objects from the Sierra — rocks, lightning-blasted stumps, lichened branches, and living trees.

Nancy made subtle color changes throughout the galleries, allowed ample space for prints and groups of prints to breathe and, above all, kept me out of the final decision-making process. She left out quite a few pictures that I considered favorites. No amount of pleading on my part would affect her decisive design intentions. I was a bit ruffled until after the exhibit was fully installed, then I understood what she was striving for and I fully agreed with the brilliance of her decisions.

In 1971 the Newhalls moved to Albuquerque where Beaumont began teaching the history of photography at the University of New Mexico, lending his great talents to an already distinguished faculty in photography as a fine art. Nancy and I continued to collaborate,

though not as often as in the past. After smoking for a number of years, I developed a nicotine allergy that not only made smoking impossible but enhanced my sensitivity to the point where I could not tolerate the tobacco smoke of anyone else. While I was forced to break the cigarette habit, both Newhalls continued to smoke heavily, and this created a problem. While they understood, it was nevertheless an uncomfortable situation: having to keep a certain distance from two of my oldest and best-loved friends! My reaction to smoking is not a fanciful psychologic quirk: it is a very strong and very unpleasant physical experience.

One afternoon in 1974 I had a call from Beaumont and Nancy, who were in the Tetons having a short vacation. They had taken raft trips on the Snake River, which they greatly enjoyed, and had told me on the phone that they were taking another river trip on the morning of the next day, and if time permitted they would try still another in the afternoon.

The next evening Beaumont called and told me of Nancy's accident. It was during the last afternoon trip; they were gliding along the south bank of the river (the area can be seen in my photograph *The Tetons and the Snake River*). A large tree, its roots weakened by severe winter storms, fell without warning into the river, directly on the inflated raft, striking Nancy. They had lost their guide and had no radio communication. It was hours before a helicopter could be summoned for transport to the Jackson Hole hospital. I called the next day only to be advised that she was in stable condition. On July 7, 1974, Beaumont called to tell me Nancy had died. I felt very badly that I had not flown down to be with Beaumont, but her injuries had not appeared life-threatening. She had seemed to be recovering, and the night before she and Beaumont had toasted their thirty-eighth anniversary.

Her death was a blow to us all and took quite some time to comprehend. There were so many projects and ideas awaiting study, planning, and completion that it was hard for us to accept the fact that the days of a creative genius were finished. Beaumont arranged for memorial concerts in Albuquerque and here in our Carmel home; friends came and listened to music and thought of Nancy. No service could have been more fitting for such a spirit.

Beaumont brought Nancy's ashes down to a little beach near us, walked out into the water and cast them upon the restless Pacific Ocean. Edward Weston was also very much with us that afternoon. There was nothing to say, but everything to be felt and something to

do. I believe in the tradition of the American West to "pass it on." In that spirit Virginia and I in 1977 created and endowed the Beaumont and Nancy Newhall Curatorial Fellowship in Photography at MOMA.

It is difficult to understand the extraordinary coincidence of time and place; a tree, standing perhaps for centuries, weakens and falls at the precise moment the raft glides beneath it. The physical event is disturbing in itself, but the fact that Nancy Newhall, a dedicated writer and scholar, devoted to the wilderness, should have been the victim of this fearful moment in time is hard to accept without questioning the decisions of the gods in time and space.

David McAlpin

ONE EVENING IN 1936, DURING A VISIT TO NEW YORK to see my exhibition at An American Place, I encountered Georgia O'Keeffe and her friend David Hunter McAlpin as we all exited from a movie theater. O'Keeffe introduced Dave, and we immediately resonated as friends.

Dave was a Rockefeller by birth, a banker by profession, and entranced by the world of art and collecting. O'Keeffe was his pilot through the confusing corridors of modern art; for him she was a kind of Pallas Athene and guided him as he established his abiding interest in art.

Dave was in awe of Stieglitz, who for several years refused to sell him an O'Keeffe painting, saying, "You're not ready for it." Many would resent this highhanded attitude, but Dave understood and admired Stieglitz all the more. Several years later he finally obtained his O'Keeffe.

When I first met Dave, he had recently separated from his first wife and he gave me the impression of being a rather lonely man. One day in 1941, I received a breezy letter from him, filled with happy thoughts and news: he was to marry Sally Sage, "the most marvelous girl in the world — she's a dream and divine." They honeymooned in Santa Fe where I had the pleasure of meeting Sally, and it was obvious that an ideal association had been established. She is a remarkably wise and kind woman and the perfect companion for Dave. Over the years I cannot think of them separately.

During my frequent trips to New York, Dave had often invited me to visit him at his Princeton, New Jersey, home. A stately structure in

the American Colonial mode, it was surrounded by forest and bordered by a charming brook. There was a fine library and his grandfather's excellent collection of Chinese bronze vases. I met many of his Princeton University friends and had generous tours of that great institution.

During one such visit he decided I should be initiated into the rituals of eastern equestrianism. I had brought only the suit I wore. He had an extra pair of riding breeches that were far too tight for me, but found no riding boots that fit; I wore my oxfords.

We drove to the stables where Dave kept his two magnificent and well-bred horses. I had never used an English saddle before, as my riding experience was limited to the western mountains with a few plugging trail horses whose saddles had a pommel to hang on to. Whenever possible I preferred to walk both up and down trails and could keep ahead of most horses and pack mules.

My freedom of movement in those borrowed breeches was so limited that I could not mount the horse, and so the groom, suppressing hysterics, brought me a ladder. The horse did not like the ladder at all, but I finally was perched on a very active and alarmed creature who distrusted me from the start.

Off we went with gusto through woods and fields in the bright morning air. I had no idea how to steer an eastern horse. I had always pulled the reins to the right or left and western animals obligingly responded. But I discovered, after some dismaying reactions of the horse, that one pressed the rein on the neck to suggest the direction of travel. My horse was rolling its eyes and frothing and prancing about while an amused Dave tried to instruct me, chiefly by example.

Dave then decided to do a little jumping. We leaped a small creek and I instinctively grabbed for the nonexistent pommel. I thought the horse and I were to part company; only my strong piano-trained fingers holding on to the front edge of the saddle prevented that disaster. Then to my terror Dave headed for a low hedge with all the abandon of the Charge of the Light Brigade; my horse followed him, in spite of my yells and yanks on the reins. I saw only catastrophe ahead. At the last moment, Dave turned his horse aside and mine came to a sweaty, trembling halt. Dave, observing the condition of his other horse and its rider, decided to return to the stables. On arrival, the ladder was brought for my descent, but it took two men to control the terrified animal. I was embarrassed, Dave obviously relieved, and the horse seemed to be nearing a nervous breakdown.

Dave never again suggested riding with me across the dewy fields of Princeton.

Some years later, Dave had the Newhalls and me down for a Princeton November weekend. He discovered that we had had little or no understanding of football and he was determined to rectify this gap in our cultural experience. We tried to describe our dislike for spectator sports, but Dave was adamant. In one phone call, he miraculously secured three seats for the Princeton-Yale game that afternoon. We accepted defeat and repaired after lunch to the large outdoor stadium where we found our places on the cold concrete steps that passed for seats. Dave went to his reserved seat in another part of the stadium. The Newhalls were warmly dressed, but I had only my thin California raincoat. A bit of sleet intensified our misery. I recall a large, chilled crowd and a muddy field, with a couple of ambulances awaiting possible business near the entrance.

Finally the game began. Knowing nothing about football, I concluded that it seemed principally to be conducted by rather futile rushes of a lot of men from one place in the field to another, ending in a scrambled pile of bodies that untangled and prepared for another rush and pileup. I finally noticed a man, carrying a ball, darting with wild energy through other men who were trying to catch him. He made it to the end of the field in a sliding splash; this resulted in a mighty surge of shrieks and yells from the audience. I was perplexed.

At this moment an elderly lady directly in front of me passed out. Her companion donated his overcoat to protect her, and in a moment of charitable carelessness I gave mine, such as it was, to the emergency. I sat in a condition of increasing frigidity while the stretcher men were called; I barely retrieved my coat as they carried her off. I have no idea what happened to her; I hoped, at least, that she was warm and cozy in the ambulance. Again huddled in my feeble coat, I endured the long remainder of the game: my first and last experience with the great American tradition of football.

When we rejoined Dave outside the stadium, he was beaming (Princeton, I think, had won) and said, "Wasn't that a marvelous game?" Our rejoinders were most insincerely agreeable. We could not tell this wonderful friend that the experience was sleet on earth.

In the autumn of 1937, O'Keeffe invited Dave and me to visit at her home and studio, the Ghost Ranch, near Abiquiu, New Mexico. I wrote to Virginia, who was trapped with managing the studio in Yosemite.

My Dearest,

Things are going very well indeed. I think I have made some fine pho-
tographs, and the best of the trip is to come.

Thanks so much for the lens board and the Kodachrome. The mail
comes in rather infrequently and goes out when it feels like it. Hence the
lack of letters from you. They tell us when the mail is going out and then
we write. It is amusing to see O'Keeffe get a dozen air mail letters from
Stieglitz all at once. She is doing some extraordinary painting. We have
good times together; I actually enjoy riding here. I have borrowed her car
— she has two — and I scoot all over the country — on and off the
roads. It's a grand place.

O'Keeffe would drive for miles over the desert seeking visual ex-
citements and fresh subjects to consider, usually returning to her stu-
dio after a period of contemplation to begin the actual painting. One
day as I was driving around, captivated by the great landscape, I hap-
pened upon her as she was painting in her station wagon, protected
from the hot summer sun. She had folded down the back seats and
was comfortably seated before an easel, working away at a luminous
painting of fantastic cliffs and a beautifully gestured dead piñon tree. I
had recently acquired my first 35mm camera, a Zeiss Contax, and
she allowed me to photograph her as she painted: a unique situation
because she seldom welcomed people around her when she was
working.

Dave, O'Keeffe, and I traveled on from the Ghost Ranch to explore
parts of New Mexico, Arizona, and Colorado with Orville Cox as our
guide. Orville was head wrangler at the Ghost Ranch. He knew both
New Mexico and Arizona very well and could also speak a number of
the Indian languages.

I am deeply attached to the high desert regions of the American
Southwest. Despite its seeming intrinsic ruggedness, the land is unusu-
ally fragile; roads and other developments appear as highly damaging
and permanent intrusions. Here, no forests clothe in time the inequi-
ties of man's destructive tendencies. No water soothes the persistent
surface desiccation. Dust storms move sand and pebbles about, but do
not really change the general aspect of the land. Occasional flash floods
but slightly alter in man's time the basic configurations of watercourses
and alluvial fans.

Canyon de Chelly National Monument in northeast Arizona is an
extraordinary experience, made more intense by the presence of its

Navajo residents, who demonstrate that man can live with nature and sometimes enhance it. The Canyon de Chelly is geologically impressive. Its stone is largely solidified sand dunes, which accounts for the beautiful, flowing patterns revealed on the eroded cliffs. The floor of the canyon is almost entirely a sandy riverbed that in times of rain becomes of quicksand instability. In autumn, the cottonwoods take on a vibrant hue that blends with the warm colors of the cliffs.

Some of my best photographs have been made in and on the rim of the canyon. A favorite photograph from this trip was the one I made there with my Contax of O'Keeffe and Cox. The charm of O'Keeffe's expression is arresting, most obviously not posed, a true "candid." This was one special moment requiring the spontaneous capability of my 35mm camera, not the cumbersome and time-consuming setting up of my view camera.

Even in the Southwest, my enthusiasm for Yosemite and the High Sierra was frequently expressed, and finally Dave and O'Keeffe agreed to come. With his usual organizational ability, Dave planned a trip for September 1938, also including his cousin Godfrey Rockefeller and Godfrey's wife, Helen. Unfortunately, again Virginia would have to stay in Yosemite and keep Best's Studio open.

I enthusiastically wrote to Dave on July 11, 1938.

Dear Dave,

September 4th is not so far off. I can't help shouting for joy that you will be here. WHOOPEE!!! whoopee (echo) . . . I really think the Sierra will be a revelation for you. And, if O'Keeffe comes the party will be extraordinary — never was there such a collection of personalities in the Sierra all at once! Please don't think that I mean that the party would only be extraordinary if O'Keeffe were along — but there is something about the lady that is dynamic, to say the least. . . .

Tell O'Keeffe that I will do everything I can to assure safe and convenient transportation of her sketching and painting materials. I plan to keep you all several days in camp in various places, and she will have a multitude of subjects that will excite her. During those stay-overs the photographers will go berserk — why not O'Keeffe?

Impress on O'Keeffe that she will see things she has never seen before, and see them under conditions that are rare. This is really important. There is no human element in the High Sierra — nothing like New Mexico. But there is an extraordinary and sculptural natural beauty that is unexcelled anywhere in the world.

On September 10 I wrote to Stieglitz:

Dear Stieglitz,

The gang is here! — O'Keeffe, Dave, the Rockefellers. We leave to-morrow morning for the high mountains, about fourteen mules, guide, packer, cook, much food, warm bedding, photographic equipment, and great expectations in general.

I met O'Keeffe at Merced and drove her into Yosemite Tuesday. She likes our country, and immediately began picking out white barns, golden hills, oak trees. As we climbed through the mountains the scene rapidly changed and as we entered Yosemite she was practically raving, "Well, really, this is too wonderful!" We came into Yosemite at dusk, a very favorable hour, and the first impression will not be forgotten.

The only regrettable thing is that you are not out here seeing all this with us. I know you would like many of our places, not the kind of place you have to ride a mule to, but just warm, rich places along the road, or as seen from the porch chair.

To see O'Keeffe in Yosemite is a revelation; for a while I was in a daze. Her mood and the mood of the place, not a conflict, but a strange, new mixture for me. She actually stirred me up to photograph Yosemite all over again, to cut all the advertising rot and see things for myself once more.

That first afternoon in Yosemite, I drove everyone to Glacier Point, where I pointed out some of the areas we would visit. It was a cold day and the mountains looked very bleak and forbidding. In fact, I think the party was a bit discouraged by the barren aspect of the scene. We were looking up at higher terrain and could not see the more inviting valleys and forests hidden in the mass of rocky ridges and peaks.

The morning of departure found us on the Snow Creek Trail, climbing out of Yosemite Valley from the Tenaya Creek Canyon. The first stage, about three thousand feet of zigzag trail, brought us to Snow Creek Valley. As we ascended, the vistas of Half Dome and Clouds Rest increased in magnificence: five- and six-thousand-foot slopes and cliffs rising before us. They were impressed. Continuing, we turned eastward and crossed Mount Watkins Ridge, the trail leading on past Tenaya Lake and the ice-sculptured valley beyond, and to our first camp at Budd Creek in Tuolumne Meadows, eighty-five hundred feet elevation and decidedly chilly on our hour of arrival. It

was a very long day, and I confess I rode a horse a good many of the miles.

The next morning we traveled to Cathedral Lake, where we camped for two nights and had a fine day scrambling among the delicate crags of the region. We did not get into any really perilous situations. I was a "fourth-classer" (rope, but without pitons), and fortunately I knew my limits, further restricted by the fact that we did not anticipate climbing and thus had no rope with us. Two of the party wanted to crawl out on Matthes Crest but I did not allow that; without a rope it presented what I considered a very real hazard. It takes a little experience, such as my close call with William Zorach years before, to realize what dangers may exist in seemingly simple and safe situations.

Our next stop was at Fletcher Lake, en route to the valley of the Lyell Fork of the Merced River, a tributary rising at the south base of Mount Lyell. Photographing was very much in order. I was disappointed that O'Keeffe did not bring any painting materials or make any sketches. Her work remained centered in her beloved New Mexico and this was a true vacation, a change in visual experience.

Camping at ten thousand feet near Tuolumne Pass was more than cold, but we all considered it a prime adventure. The next morning, with an early start, we crossed Vogelsang Pass into the Maclure Fork of the Merced and branched eastward on the Isberg Pass Trail, leading along the high bench between Mount Florence and the cliffs of the Merced Canyon above Washburn Lake. Above, to the south, the necklace of peaks of the Merced Range encircled the view. These mountains were quite different from what the other members of the group had experienced, and all responded to the clean, crisp air and the sense of remoteness and quietness. The silence of the Sierra in late fall is unforgettable; all streams are low, and insect hum is gone for the year. Only the wind makes its secretive sounds through the conifers.

I well remember a late October day in 1924 as Uncle Frank and I prodded a weary donkey down the Isberg Trail to Merced Lake and on home to Yosemite Valley. A storm was in the making, with gathering gray clouds and a rising wind that mourned in the forest while the air turned icy cold. A mood of calamity grew upon us. We did not have adequate clothing for the occasion and feared frostbite. We managed to survive by crawling into our sleeping bags as soon as we found a campsite near Merced Lake. This 1938 trip with McAlpin and company was almost tropical compared to that 1924 experience.

In midafternoon we reached the Lyell Fork of the Merced River

and turned left for a mile of cross-country wilderness travel through lodgepole and hemlock pines to the meadows where we were to set up camp. We were ringed to the east and south with rugged peaks: the less severe slopes were to the north and, beyond the forest to the west, a valley opened yielding an expansive view of the encircling Merced Range.

Dave asked me to name the peaks we were seeing to the east; Rodgers Peak was hidden by a ridge, the summit of Elektra Peak and the north flank of Foerster Peak could be seen. A rock tower, actually the end of a metamorphic ridge, rose before the background summits. I casually remarked that the Sierra Club had named this little peak after me during a trip in 1934 when I introduced the annual High Sierra outing party to this area. I hastened to add that a natural feature cannot be named for a living person; their kind gesture was really a friendly nomination. O'Keeffe needled me for days on this admission. "Oh, *now* I see why you brought us here, just to show off your mountain!" I vigorously denied such intentions. She admitted that it *was* a nice little mountain and, "You should be proud of it."

O'Keeffe loved campfires and would stand close to them in her voluminous black cape, her remarkable features and her dark hair gleaming in the flickering light. She never seemed bored or tired and enjoyed every moment of the trip. The tree and rock shapes entranced her, especially the bright smooth polish on the granite of the high elevations. She would often say, "I must come back here some day; I may find something to paint. I guess it's too far, but maybe not!"

There were many unforgettable experiences during that trip: the glacial lakes in the upper valley, well above treeline, with the looming shapes of Rodgers Peak and the south cliffs of Mount Lyell, the ascent to Isberg Pass from where the grand view of the Ritter Range towered to the east and the southern Sierra stretched for two hundred miles under the bright, clear sky.

We reluctantly broke camp and descended to Washburn Lake which rests two thousand feet deep in a bowl of granite. The forests at this elevation of about seventy-five hundred feet were of lodgepole pine, fir, and aspen, lush in comparison with the stark growth of the higher altitudes. We then pressed on, down past Nevada and Vernal Falls to the civilization of Yosemite Valley with hot showers and well-prepared food. Virginia is a superb cook, and we quickly regained what weight the trip had cost us. Dave and the others stayed at the Ahwahnee and I was happy to be home in our own small but com-

fortable house behind Best's Studio. After a day or so we drove to San Francisco and had a final fling at the Fairmont Hotel before the group returned to the East and I back to Yosemite.

As the friendship between Dave and me grew, so did his interest in photography; as his acquaintance with the Newhalls also blossomed, Dave became a committed soldier in the fight for the recognition of photography as a fine art.

Besides our years of work together at the Museum of Modern Art in New York, Dave and Sally enjoyed a warm correspondence with Virginia and me and, whenever possible, we would get together. In 1972 I began receiving letters from Dave insisting that I make my photographs available for a major exhibition at the Metropolitan Museum of Art in New York. I had yet to have a major solo show in a New York City museum (Stieglitz's An American Place had been a private gallery), and Dave was convinced that the time had come. He was a trustee of the Metropolitan, and I was soon invited to have a show of one hundred and fifty prints in the spring of 1974.

On January 16, 1972, Dave wrote:

Dear Ansel,

I've given a lot of thought to the 1974 show. Adams is universally known as a Pioneer Conservationist, an enthusiast for the National Parks and open space, so this phase does not need to be overemphasized. Adams, the Humanist, is not known and this should be emphasized: — the Nisei, the Indians, even including the cook and wranglers on our wonderful pack trip in 1937 — as many pictures of people as possible, Stieglitz and O'Keeffe, etc. etc.

I had been frustrated for many years with the selection of my work for museum exhibitions. Curator after curator had chosen the same small group of landscapes, though I have thousands of other good negatives to draw from. I wanted this show to have a broader perspective, to show some of my many portraits and a sizable excerpt of my work with Polaroid Land materials, a project that I had followed for over twenty years.

For much of the next year, I printed the show and worked closely with the magnificent staff of the Met. Andrea Gray was the curatorial assistant in the Department of Prints, Drawings, and Photographs, and her energies and imagination were indispensable. I was so impressed

that when she left the museum I employed her as my assistant, a position she held for the next six years. Andrea balances incredible efficiency with one of the bounciest personalities alive. She brought a new sense of organization to my archive as well as my life. After leaving Carmel, she established herself as an art adviser of note in New York City. Her clients are lucky people. Andrea also possesses a superior intellect. After years of research, she was able to locate many of the original prints and reconstruct fully my 1936 exhibition at An American Place. The Center for Creative Photography sponsored this exhibition and accompanying catalog.

The Met exhibition gave me a certain nervousness about how the photographs would be received by the urban, sophisticated audience. Their world often seemed so cold and remote from my western roots, and I was very conscious of the potential resistance by urbanites to the other great world of nature.

On April 7, 1973, I wrote to Dave and Sally:

Nothing could be worse than a funny situation which is misunderstood, so I shall describe again my nightmare; I have a recurrent dream that is hair-raising. It is simply this: I am in some town and am picked up by a cab; signboards and posters say that Ansel Adams will play some concerto with a great orchestra tonight; I don't know the concerto and could not strike the first note. In any event, I am taken to the auditorium backstage; I meet the conductor and the orchestra members. The orchestra goes out on stage (the house is packed!). Then the conductor gestures me to proceed on stage, with him following me. The audience gives a great ovation as I move to the piano. I am seated at the piano, awaiting the start of the introductory notes. I am PETRIFIED; I do not know the concerto at all, not even the first notes. At that moment I usually awake with loud noises and gasps. It takes quite a little time to get this awful situation out of mind.

What was funny with the dream a few nights ago was this: the concert was sponsored by Dave and Sally McAlpin and your names were larger than Beethoven's on the posters. You both were backstage with the conductor and were beaming with cordial anticipation when I arrived. I was touched and scared to death. I never got to the piano in this dream, just part way on stage. I woke up with a mingled sense of terror and chagrin at having let you down.

In the midst of preparations for the exhibition the Met experienced large budgetary cutbacks. Dave provided the necessary funds so that

the show could go on, including new electrical wiring in one gallery that previously was so dimly lit that Zone III did not appear much different from Zone VI.

Since I had a number of books of photographs in print or soon to be published, Dave and I agreed that the catalog would be exclusively Polaroid photographs. The catalog grew into a book, *Singular Images,* with an introduction by Dr. Edwin Land and a closing essay by Dave, "Photographic Experiences with Ansel Adams." I was very happy with the entire exhibition and the very handsome catalog in the form of a small fine book.

I was honored to be asked to give two lectures at the Met during the opening week of the show. A few nights before the second lecture I was asked to speak to a group of students who called themselves "The Concerned Photographers." The talk was held just down the street from the Met at the International Center of Photography. I arrived and found myself among a hostile group, but I was fully armed with heavy rejoinders. The students didn't want to listen because they felt, as many others felt over the years, that my photography was not relevant in today's world. I began my talk by stating that I was concerned about photography as well as about the human condition. The response to that remark was *not* favorable!

It is interesting how my photographs have been in and out of vogue over the years. Both Edward Weston and I were accused of being irresponsible during the late 1930s as threats of world war grew, because we made photographs of aesthetic content and were not documenting the world's social condition. We were concerned with the world we knew and its future and were not belaboring the obvious. In the 1960s and '70s, our country was again troubled by grave problems — Vietnam, racism, Nixon, drugs, and so forth — but creative interpretation of the world and humanity had greater acceptance, and expressive photography could be practiced and experienced without serious attack.

Both lectures at the Met were warmly received. Following one lecture, during the question and answer period, a man rose and asked, "In the progress of your work have you ever been aware of achieving a new state of consciousness?" That provoked a moment of thought and I replied, "I practice Zone not Zen." My rejoinder was successful as humor, but the question required a considerably more involved answer. I believe the artist does enhance his state of consciousness as he progresses in his work. He achieves not so much a new state of awareness as he does a continuously expanding awareness of the world about him and of himself and his perceptive vision.

In a catalog for my exhibition "The Unknown Ansel Adams" at The Friends of Photography in 1982 I attempted to define my personal photographic credo.

A great photograph is one that fully expresses what one feels, in the deepest sense, about what is being photographed, and is, thereby, a true manifestation of what one feels about life in its entirety. This visual expression of feeling should be set forth in terms of a simple devotion to the medium. It should be a statement of the greatest clarity and perfection possible under the conditions of its creation and production.

My approach to photography is based on my belief in the vigor and values of the world of nature, in aspects of grandeur and minutiae all about us. I believe in people, in the simpler aspects of human life, in the relation of man to nature. I believe man must be free, both in spirit and society, that he must build strength into himself, affirming the enormous beauty of the world and acquiring the confidence to see and to express his vision. And I believe in photography as one means of expressing this affirmation and of achieving an ultimate happiness and faith.

16.

Edward Weston

ALBERT BENDER ATTRACTED ALMOST EVERYONE OF CUL-
tural consequence at one time or another to his frequent
soirees. On an afternoon in 1928 he called me, as he so often
did, saying, "Come for supper. There is a good photographer in town
and you should meet him." I arrived at Albert's and was introduced
to a slight of figure, thoughtful, and reserved Edward Weston, sur-
rounded by his four young sons: Chandler, Brett, Neil, and Cole.

Weston had made his living as a respected photographic portraitist
in the Los Angeles suburb of Glendale. Acting on the overpowering
conviction that a major change was necessary for his creative life, in
1923 he left a nest of growing reputation and income for several years
in Mexico — a voyage to unimagined lands of creative, inner-directed
achievement in his chosen medium. At the same time he permanently
separated from his wife and the mother of his sons, Flora Chandler
Weston.

At our first meeting Edward's attention was quietly focused on his
sons. They were becoming reacquainted after his amorous and ad-
venturous Mexican sojourn. Edward's second son, seventeen-year-old
Brett, had already made some remarkable photographs; most of them
showed an unavoidable parental derivation that, in time, he overcame
with his own powerful concepts and graphic qualities.

I am sure Edward was as poor as a churchmouse at that time. All
five of the Westons wore old, though very clean clothes. Edward was
impressed by Bender and his warmth, ebullience, and intelligence. Al-
bert became one of his earliest patrons, purchasing, and urging his
friends to acquire, Weston's photographs when few evidenced interest
in the fine print aspect of the art.

After dinner, Albert asked Edward to show his prints. They were the first work of such serious quality I had ever seen, but surprisingly I did not immediately understand or even like them; I thought them hard and mannered. Edward never gave the impression that he expected anyone to like his work. His prints were what they were. He gave no explanations; in creating them his obligation to the viewer was completed.

Later that evening, Albert showed Edward some of my prints from his collection. Edward made no comment. Albert insisted I play the piano; my playing at that time was quite acceptable and was far more accomplished than my photographs. To this day Brett will say, "We heard you play at Albert's; we liked your music but did not think much of your photographs." I fully agree with this comment; ten years later the opposite was true.

In 1931 I began writing a column on creative photography for *The Fortnightly,* an independent, San Francisco–based journal for the arts, now long defunct. My debut review was of Edward's first one-man show in 1931 at the de Young Museum in San Francisco. In the intervening three years I had become very responsive to his work — you could say that I grew into it.

Weston is a genius in his perception of simple, essential form. . . . In the main, his rocks are supremely successful, his vegetables less so, and the cross-sections of the latter I find least interesting of all. But I return with ever-growing delight to his rocks and tree details, and to his superb conceptions of simple household utensils. . . . I feel that photography will find itself in the not too distant future reverting to the simplicity of style that distinguishes the historic work of Atget. I also feel that Weston's work is tending in that direction . . . there is an essential relation (not necessarily physical) in the form and structure of all natural objects. The very complexity of the natural world obviously implies coincidence of form and function through our imagination. In certain aspects a pepper may easily suggest the curved lines of a human torso, even though the presentation of a pepper in this aspect was not intended by the artist.

It is a pleasure to observe in Weston's work the lack of affectation in his use of simple, almost frugal, materials. His attachment to objects of nature rather than to the sophisticated subjects of modern life is in accord with his frankness and simplicity. The progress of Weston's work to date is rapid and significant, and his

development in the future promises to be an important strengthening element in the complete establishment of photography as a fine art.

Edward responded in a letter dated January 28, 1932:

Your article I appreciated fully, it was an intelligent consideration, by far more so than most I get because it was a subject close to your own heart.

No painter or sculptor can be wholly abstract. We cannot imagine forms not already existing in nature — we know nothing else. Take the extreme abstractions of Brancusi: they are all based upon natural forms. I have often been accused of imitating his work — and I most assuredly admire, and may have been inspired by it — which really means I have the same kind of (inner) eye, otherwise Rodin or Paul Manship might have influenced me! Actually, I have proved, through photography, that Nature has all the "abstract" (simplified) forms Brancusi or any other artist can imagine. With my camera I go direct to Brancusi's source. I find ready to use, select and isolate, what he has to "create."

In 1929, Edward moved to the artists' colony of Carmel, where he opened a small portrait studio. He traveled on occasion to San Francisco and Los Angeles for portrait assignments and to keep in touch with friends and fellow photographers. In 1932 Edward and I joined in the Group $f/64$ effort and became devoted friends. We had both come to be sympathetic to each other's work, though we were never on an identical wavelength.

Edward distrusted science and technology. I would ask him, "Edward, *how* can you deprecate science in general and technology in particular; you use lenses (they certainly do not grow on trees) and photographic film and paper products of scientific research and high technology. You have electric lights and power, running water and a telephone. Please explain."

The question would never be answered, but responded to by, "Don't you see how much death and destruction through war and pollution science has brought us?"

In 1942 Edward had an exhibition at the Santa Barbara Museum of Art. He could not drive a car, so Virginia and I went to Carmel and drove him to Santa Barbara for the opening. It was a happy affair, with some of Edward's best work displayed to a half-adoring, half-perplexed audience.

On the drive home, we passed a large field, on whose distant edge was an interesting assemblage of weather-beaten planks and posts. I saw it out of the corner of my eye and continued driving. In a few minutes an image of what I had seen disturbed me; I had a growing sense of the importance of a potential photograph.

I said to Edward, "I saw something back there that bugs me. Do you mind if I turn back?"

"Not at all," he replied, "I think I saw the same thing."

We retraced more than a mile, parked the car, and carried our cameras across the wide field. The object turned out to be a pigsty with one embarrassed pig. We both made pictures; mine, *Boards, Farm near Santa Barbara,* is shown here for the first time. I never saw Edward's results.

This was one of the not too frequent occasions where a transient image makes an impression on the mind, though the photographer is not aware of it at the time. It seems to digest; the subconscious mind develops the impression into a quasi-visualization, then the conscience moves in and, with insistent pressure, makes the photographer feel quite troubled unless he returns to the source. On every occasion that this has happened to me, the subject was worthy of renewed attention. When I have not returned I am gently haunted with a sense of loss.

I was always a bit astonished (and perhaps a little envious) at Edward's achievements with the female of the species. The residue of New England mores in my genes inhibited my approval of his leaving home and family and resolutely entering a new world. I knew his first wife, Flora, but slightly. She seemed cheerful and wholesome. I am sure she had no easy time of it, although I felt she accepted life as it turned out to be. Regardless of Edward's deviations from conventionality, there seemed to be an aura of affection and understanding among the entire family. Edward equated gentle license with creativity; he could not imagine art without sex. Others I have known who exhibited intense activity "with the skirts" (as Francis Holman would say) left trails of wrath, disillusionment, and remorse, usually with psychopathic overtones. Not Edward. He blithely moved from one affair to another, leaving behind compassionate Minervas rather than furious harpies. His sons emulated him to a degree — with the exception of Neil, who has had a long and happy marriage — and ventured to the altar several times, carrying on with macho enthusiasm.

Edward's second marriage was a remarkable success. Charis Wilson is a gifted and beautiful person with great charm and intellect. For

years, both before and during their marriage, it was a most sympathetic and rewarding association. Charis was his wife, model, editor, co-worker, and best friend. When Edward received his Guggenheim Fellowships, the first ever awarded to a photographer, in 1937 and 1938, he and Charis traveled and photographed. Their book from these years, with his photographs and her text, is the classic *California and the West.*

During the winter of 1936, Edward and Charis came to Yosemite for the first time. It was a wonderfully snowy winter and the day after they arrived we had a fine snowstorm. I took great pleasure in driving Edward about the valley. I had some concern that he would not react photographically to Yosemite. He feared beautiful "postcard scenery" — but if the world before him contained shapes and qualities that he could realize as an image, he would respond, be it mountains, relics of barns, rocks, surf, seaweed, or people. I dedicated myself to being his guide and chauffeur, though I still wistfully think of the opportunities I missed by not having my camera with me. When I saw his results, I felt the sacrifice was worthwhile.

There were to be hundreds of spectacular Yosemite snowstorms for me in the years to come, though time and circumstance made me treat each great weather event as the one-of-a-kind situation it was. I had visualized for many years an image of Yosemite Valley from Inspiration Point and exposed many sheets of film in an effort to achieve that visualization. Finally, in 1944, a sudden heavy rainstorm hit, which at midday changed to wet snow. I drove to my chosen site and quickly set up my 8x10 camera to capture the marvelous vista spread before me. The clouds were moving rapidly and I waited until the valley was revealed under a mixture of snow and clouds with a silver light gilding Bridal Veil Fall, realizing the photograph *Clearing Winter Storm.* While nature had not provided a drama this remarkable during Edward's winter visit, he made many effective photographs in and about the valley and seemed content.

Edward and Charis had been living in a rented apartment in Carmel. In 1937 his son Neil built them a simple house and studio on Wildcat Hill in the Carmel Highlands. Edward loved nearby Point Lobos; it was a very fertile source for his work and is still considered a mecca for photographers from all over the world.

Charis and Edward had no children; they had cats. Over the years these cats multiplied until Edward's sons would say, "They infest the place!" Each cat was a named and cherished individual. Unfortunately,

most of them were half-wild and sick. This was a strange dedication, a mad family of creatures that Virginia and I could not understand.

I invited Edward and Charis to join me in the summer of 1937 on a short excursion to the spectacular Minaret country southeast of Yosemite. This was to be their first trip into the High Sierra. I received a letter in May of that year from Edward shortly after I proposed our trip. We corresponded throughout the years, and many of the letters were similar to this one, with a request for technical advice.

Dear Ansel —

No word as to your proposed Sierra trip. Is it off, or still too early?

I have made the last desert expedition of the year, or season. Getting too warm. We went across the Colorado Desert taking the old stage route from near Julian to near Coyote Wells. A very exciting adventure too long to be written. Will tell you. Got a beautiful negative of a fresh corpse. Part of the tale.

One reason I write you at this time is for opinions and information on lenses. I'm sure you have 10 times my knowledge at your fingertips.

My Turner-Reich, 12-21-28, which I bought because it was a good bargain, has proved quite satisfactory under most conditions. I had the diaphragm fixed so that it stops down 3 extra notches after the f /64 it came with. The single elements have all the definition I demand when used with the smallest apertures except when I use the 21 inch with bellows completely extended. I can't work close, of course, with 28 inch. 90% of my present work is done with 21 inch. I could swear that I focus carefully, but when I develop find that I'm off. This only happens when I get beyond f /64 or so. I tried a newspaper in brilliant sun to see if focus changed, and I tried light bulbs placed so I would have to use swings, but discovered nothing. I must admit my eyes are not what they were but I can't believe I'm so far off.

All this has led me to believe that I would like a doublet of not less than 19 in. nor more than 22 in; 20 or 21 would be perfect. I would want up to date color correction. I would prefer a slow lens because I don't want to pay too much and because it would be lighter, less bulky.

But what do you say? Have you any ideas knowing my needs? . . . Thanks!

Afectuosamente (and to V —)
Edward —

I replied on June 3:

Dear Edward,

It was swell to hear from you — and I look forward to the picture of the corpse. My only regret is that the identity of said corpse is not our Laguna Beach colleague [William Mortensen]. I am convinced there are several stages of decay.

By no means is the Sierra trip off. Only — what with mosquitoes and high water — the season is not just right for a high country trip.

As for the lens trouble you write about. . . . Any good modern lens is corrected for maximum definition at the larger stops. Using a small stop only increases depth; beyond a certain point definition is actually impaired.

I think what you want for your best solution to the problem is a Zeiss Protar No. 6, 19 in. . . . This lens is quite light in weight. You could always add the second element to it (or have a set of elements to use singly or in combination). The Protar gives the most beautiful "breathing" image of all lenses — you cannot enlarge as many times as you can with the Dagor, but for contact work and moderate enlargement it cannot be excelled. I would like to show you some of the stuff I have made with my 5½-inch Protar.

I am feeling much better. We look forward to seeing you very soon. Let me know what I can do for you — if anything. I hope you are getting some swell stuff.

We waited for late July and less annoyance from mosquitoes. Edward and Charis joined me in Yosemite Valley. We then proceeded in my Oldsmobile over the Tioga Road to Tenaya Lake, then Tioga Pass and on to Mammoth, Minaret Summit, and Agnew Meadows in the Middle Fork of the San Joaquin River. I had made plans in advance for a packer to get our equipment and supplies to Lake Ediza, leave us there for several days, then pick us up for the return trip to Agnew Meadows.

Edward had never been in such a surround of mountain magnificence, and at first he seemed quite unsettled. He soon began to see pictures and make exposures, exploring a good part of the region with obvious enthusiasm. He made many 8x10 negatives and exhausted the forty-eight sheets of film (in twenty-four loaded film holders) that he had carried with him — and the trip was only half over.

Then came the problem of reloading film. There were no conve-
niences such as a motel bathroom that could be made into a darkroom
at night. We were in true mountain wilderness with sleeping bags, one
small tent, and a very bright moon. I had some 8x10-inch sheet film
and a changing bag with me.

I said, "Edward, it will be okay. You can use my film and bag."

With a very serious expression Edward said, "I don't know how to
use a changing bag."

It takes a little practice to unload and reload sheet films success-
fully in a changing bag, keeping the film, film boxes, separating sheets,
holders, and slides in working positions, while not scratching or
touching the emulsion side of the films with inevitably sweaty fingers.
If Edward had never used a bag, this was *not* the first time to try it. I
gallantly assured him, "I will change the films for you."

He showed a combination of relief, gratitude, and concern. These
were *his* films and would I handle them carefully enough? I under-
stood his position; I would not appreciate others loading my film, but
there was nothing else to do. After changing films scores of times in
the wilds, I felt I had sufficient experience.

We set up the little tent and Charis promised to keep the mosqui-
toes off my neck while my hands were trapped in the bag by the elastic
sleeves. Our resident mosquitoes were augmented with additional
hordes as dusk approached. When darkness was sufficient, Edward
crept into the tent to join us and perched on a folded jacket. He
handed me six holders at a time; when one set was done we unzipped
the bag and exchanged for a fresh set of holders. My bag was designed
for 4x5 holders; 8x10 holders were difficult to manipulate, but I did
manage; all the while Edward, fearful of light leaks, draped a dark
sweater over the bag, and Charis, behind me, swatted and swished
heroically with a bandanna while the murderous mosquitoes, un-
daunted, devoured us.

About two hours later we finished the entire job. Edward expressed
his undying gratitude, which I accepted as justified. While it was a
fearfully uncomfortable undertaking, it made possible the exposure of
forty-eight more Weston negatives.

I have a favorite photograph from this trip that I made of Edward
photographing Charis, who was swaddled with layered oddments of
clothing and her head turbaned with an old sweater as a desperate
barrier against those mosquitoes. I had promised her that if we went
high enough there wouldn't be any of those savage mosquitoes. We

unfortunately proved that they thrive on the blood of photographers even at the ten-thousand-foot level.

In a few days, tired, dirty, and happy, we were back in Yosemite Valley, enjoying a fine dinner Virginia had prepared for us. Suddenly a salesgirl from Best's Studio pounded on the window, yelling, "The darkroom's on fire!" The fire had proceeded rapidly, destroying many of my negatives before it was put out. Edward and Charis more than amply repaid my work in the changing bag with their own hard work as we fought, with partial success, to save, rewash, and dry my negatives. I estimate I lost about one-third of my life's work that night.

As I brought Edward to the Sierra, he introduced me to Death Valley. Since photographing there in 1937 with Willard Van Dyke, Edward produced a major revelation of the area through his creative eye. Photographs by other photographers gave an impression of dull and depressing vistas. When I first traveled to Death Valley in 1941, my vision was encouraged by Weston's photographs, and successive excursions convinced me of the area's grandeur and beauty; its vast desert wildness is unmatched in North America. The Mineral Rights Act of 1872 intrudes on many dreams of preservation and protection by allowing for unacceptable mining exploitation of this and other fragile areas throughout the country.

Death Valley is very difficult to photograph: a few obvious opportunities and a vast number of recalcitrant situations that try the photographer's patience and craft. Contrary to the universally accepted opinion that Death Valley is good for pictures only in early morning or late afternoon, Weston demonstrated that fine images could be made at high noon. While he reveled in brilliant values of light and shadow, he also perceived the aesthetic possibilities in the play of subtle values in flat light. For many photographers he achieved the impossible.

Nancy Newhall and I collaborated on the book *Death Valley* in 1954. In our advice to photographers we wrote:

> The journey down to Badwater or up to Dante's View, or the tramp across the dunes themselves is worth getting up in the black of night to know. The deep glitter of night pales, slowly the mountains rise, the salt flats glimmer. In transparent shadow you set up cameras and wait for a Dantean vision of sunrise.

I remember many sunrises in Death Valley, especially one near Stovepipe Wells in 1948. After sleeping on the camera platform atop

my car, I woke before dawn, made some coffee and stoked my stomach with beans reheated from last night's supper. I then perched my camera and tripod across my shoulders and plodded heavily through the shifting sand dunes, attempting to find just the right light upon just the right dune. The sun floated above the margins of the Funeral Range, promising a very hot day. Just then, almost magically, I saw an image become substance: the light of sunrise traced a perfect line down a dune that alternately glowed with the light and receded in shadow. The result is *Sand Dunes, Sunrise, Death Valley National Monument.*

I frequently visited Edward and Charis; when I was near Carmel I would stop for a day or two, bunking on the couch or floor. Edward's home was his studio, and he continued to earn his small living from occasional sales of his photographs and infrequent portrait assignments. I was present for a number of Edward's private showings of his photographs, something of a ritual. Friends assembled, the print easel was set up, and the viewing light adjusted. When all were seated, Edward would wipe his glasses, take a print from the top of the set he intended to show, place it reverently on the easel, step back, and we would all look at it for a minute or more. Print after print would follow until the set had been displayed. Throughout this performance there was usually complete silence; an occasional appreciative grunt would be heard, but the general attention was rapt and still. When the viewing was over, conversation would break out. All sensed that something magical had occurred, an event they would not forget.

Edward had great faith in the potentials of creative people and he would enter into the exchange of ideas with a positive gusto. However, he was quick to recognize the lack of creativity in any person and had little patience with them. The person so identified received no mistreatment in any way, only total neglect. When such persons came unannounced to Edward's home, he would greet them at the door and simply stand quietly before them, initiating no conversation and answering questions with minimal words. They would soon catch on and depart.

In 1945 I received a short postcard from Edward.

Dear Ansel,

Charis and I are no longer one.

Edward

I dashed off a note of concern that was soon followed by another postcard from Edward dated November 17th:

Dear Ansel,

Thanks for writing. And I will be here for at least a while. You will never see Charis and Edward together on Wildcat Hill. Divorce.

— E —

And I quickly responded:

Dear Edward,

Am hearing some Wagner on the radio; tremendous shapes and tone. Can't help thinking of you at this time. Appreciate your letter; don't expect you to write. Just want you to know that I am here on earth and sympathetic.

I am saying this in all sincerity — not just because I want to speak platitudes. I just thought about some people I know who string platitudes in a glittering chain on the harlot bosom of convention. People who can "feel sorry," or who (with internal moral effort) are "sympathetic." Frankly, I don't feel sorry for you or Charis at all in the deepest sense. I have complete faith that you both would take the appropriate action for the particular circumstance, and who could feel really sorry for that? I do regret the surface effects — Carmel, the sea, rocks, the little house with the big mood. But I know that there will be other and more wonderful things and moods — that's why I don't feel basically too bad.

I believe you to be one of the greatest artists of our time — certainly the top man in photography. I mean that in every way. I am proud to know you, to know you are my friend. I am doing what I can in photography; I am doing some real good in my way. But you, in the production of your photographs, your statement of the real, vital world, do a hundred times as much as I can ever do. You have been going through a relatively thin phase; I have the feeling now that a new world is opening up for you; a new vision. Hope you understand my temerity to talk about you to you this way. Please get in physical good shape without delay. The sun is shining on all sorts of wonderful things. I wish I could go with you out into the world just as we went to Tenaya. Wonderful for me. See, I'm selfish after all! Luck to you, and a real glory.

As ever,
Ansel

On December 1st, Edward wrote:

Dear Ansel,

I have read your letter over and over. It moved me deeply. Men should retain the right to weep when occasion demands.

I will not protest your appraisal of me, my work; I want to believe everything you say! — even though I don't think there is ever a "greatest."

You are right, neither Charis nor I want or need sympathy. We remain to each other best friends.

A good Mex. Abrazo —
Edward

In 1949 *My Camera in Yosemite Valley* was published and it was a great success. The letterpress plates by the Walter Mann Company were superb, the printing excellent, and the reviews rewarding. Houghton Mifflin Company, the long-established Boston publishing firm, joined as co-publisher with Virginia, who actually financed the book, using the bit of money she had left from her inheritance. Houghton Mifflin was the national distributor. Virginia received ten thousand dollars therefrom, which almost paid for the production of the book, and she retained direct sales rights. All concerned did quite well with this production.

I had felt that Edward had not been treated fairly by those who had promoted and published his work in the past. I believed his most recent book, *Fifty Photographs,* published in 1947, was pretentious, presenting Edward's prints with heavily inked reproductions and some rhetorically florid texts. Merle Armitage, the Los Angeles cultural entrepreneur, had designed and produced it; he never forgave me for my criticisms, public and private. In all fairness, this book did bring Edward's work to an important audience. However, Edward told me he never received a penny for this project.

By this same time, Edward's health had begun a long, slow disintegration. It finally became apparent that he suffered from Parkinson's disease, a tragic life-conclusion. Parkinson's made him very unsteady; his last negatives were made in 1948. Virginia and I were deeply impressed by his great body of Point Lobos work. I suggested to the director of the California State Parks that he consider some arrangement with Edward on the production of a well-designed booklet on

Point Lobos. He turned the idea down with scorn. "All his photo-graphs are of rocks and dead trees." I had overestimated this man's taste, but I can agree that Edward's photographs were not of conventional guidebook character.

The success of *My Camera in Yosemite Valley* prompted Virginia and me to suggest cooperation with Edward on a book to be titled *My Camera on Point Lobos*. Edward appreciated the idea, which he approached with caution, not certain of the subject domination such a book might imply. I argued it was essential that the content be his Point Lobos work: a few of his great landscapes as well as the classic details of tree and stone for which he was garnering worldwide acclaim. Dody Warren, his capable assistant who wrote the accompanying text for the book and became Brett's wife for a time, was very protective of Edward, but we all finally agreed on a balanced content that in no way compromised his creative directions. There are about six images that may be considered land- and seascapes; nineteen represent details of shapes and textures; all in all, a remarkable presentation of the magical quality of Point Lobos by the master photographer.

Edward selected a few excerpts from his old daybooks to end the book.

5-14-30: Point Lobos yesterday.

How many times the last year or so have I written this line! I never tire of that wonder spot, nor could I ever forget it, no matter where I go from here.

It was a perfect day of brilliant sun, and the laziest sea I have yet seen in the North. I decided to work with cypress for the first time in months: the sun on their weather-polished trunks reveals every tiny line, etched black on a surface glistening as ivory.

Harder to isolate details of a cypress than to work with rocks. And I have done so many that to find new forms was not easy. I worked with but two trees all day: but these two were so difficult, my hazard so great, that I returned home exhausted.

The second was a marvelous old root. I had found it long ago, and it was difficult to reach without a camera: but the 8x10, its weight and worse unwieldiness, made my task as dangerous -- no, more dangerous than any I have faced in photography.

The tree hung over a cliff, above a sheer drop to the ocean, with only a couple of possible ledges to hold the camera. I planned carefully every step down, removed all loose rocks and branches, before making the descent. One misstep as I stood

there focusing, and I never would have focused again. I was never so limited in viewpoint or so fixed in position, but from that one available spot, which did not allow me to move six inches in any direction, I found a very fine combination of roots.

I have a hard earned negative.

Mindful of Edward's needs and remembering the scant returns he had received from previous efforts, Virginia insisted on advancing him one thousand dollars, saying, "Edward, this is all you might receive if the book is not appreciated. We want to be sure you will get something." It was all we could afford at the time.

Our production of this book was an intensely serious effort to do justice to Edward's photographs by achieving maximum image quality; we all worked with greatest care and devotion. I recall one especially interesting experience with Dody and Raymond Peterson, our excellent engraver. We were studying the proof of Plate #19 (*Eroded Rocks, South Shore, 1948*) at the engraver's shop. This particular image was the quietest of all in the book: an expanse of smooth, gray sand, punctuated with a few emerging rock shapes in sunlight.

Dody said with honest exasperation, "Pete, this is the only one you have missed; it's dull and flat! Look at the quiet brilliance of the original print. How come?"

Peterson said, "Dody, that's the *original* you are looking at!" It was true; Peterson had etched the copper plate just enough to enhance the qualities of the original when it would appear on the printed page.

The chief concern with reproduction techniques lies not in duplication, but simulation of the value-effects of the original prints. Even the most advanced laser-scanning technology of the present time cannot duplicate the silver print image, but they can give magnificent simulations. In the hands of a fine printer the laser-scanner process can exquisitely enhance value separation, and I now insist upon its use whenever possible for reproductions of my black and white work.

Sad to relate, *My Camera on Point Lobos* was ahead of its time and was a commercial failure. As with *My Camera in Yosemite Valley,* Houghton Mifflin took half of the edition (the other half going to Virginia). This covered about half the costs. The direct mail sales were dismal. The book was remaindered for $2.95; today copies bring hundreds of dollars.

In 1955, Edwin and Terre Land came to San Francisco for a visit. Land, always with great interest in art and creative people, wanted very much to meet Edward, and when I told him of Edward's precarious

health Land asked, "Why not drive to Carmel tomorrow?" I telephoned and arranged for a convenient meeting time.

It was a memorable day; the Lands quickly appreciated the magic of Edward's work and his environment. They viewed many prints and purchased quite a few. They may never know how important this acquisition was to Edward's practical condition and how much it meant to him to have their warm presence enrich the spirit of the house on Wildcat Hill.

Before we left, Land asked if he could see where Edward kept his negatives. They were stored in a tiny structure about fifty feet from the house, raised above the ground on concrete blocks, fairly well ventilated but without humidity control and definitely not fireproof. It is foggy a good part of the summer in the Carmel Highlands, and the few hot days that occurred during the year were not enough to dry things out. Edward used simple manila envelopes for his negatives; some of these were joined with a central line of adhesive down the backs, and the dampness caused some chemical transfer therefrom to the backs of the negatives in the form of a thin, blue line. These lines were later removed with difficulty and some very valuable negatives preserved.

We found the key to the storage shed and proceeded to its door. Edward gestured and said, "There they are." Because of the advance of Parkinson's, he was unable to use the key. We entered the musty space and looked at the neatly ordered filing cases of negatives. Land was obviously moved by this forlorn gathering of a great man's life work. Later he asked me about the suitable storage of these negatives and I was able to say that the Weston sons were planning to build a concrete, air-conditioned vault near the house.

As we returned to the house, Edward remained facing the shed. I realized that he could not even turn around without assistance. I helped him face the house and we proceeded slowly down the sloping path. Once back in his chair by the fireplace he thanked us for coming and bade us good-bye in a voice both forceful in effect and quavering in tone.

We entered my car and drove up the coast, each deep in thought. I could sense that Land was contemplating the experience. He asked some questions about Edward's life history and made some meaningful comments on the solidity of his work and the touching simplicity of his studio home.

I, too, had been thinking of his simplistic life-style and his dedication. I said, "Din [Land's name to his friends], Edward has said to me

any times that I am too involved in external problems such as con-
vation, museums, teaching, and photography in general, and that I
should make my life simpler and concentrate on my creative work.
Whenever I visit him and see his work, I am led to believe he might
be right."

Land turned to me and said, "I disagree. Weston lives in a shrine;
you live in the world." I have always been thankful to Land for this
remark. I admit that I have been, from time to time, on the brink of
embracing escapist simplicity. However, the die was cast many decades
ago and the attempt to change a basic life-pattern would have been a
disaster. For Edward, such dedicated simplicity was a life-goal and it
served his creativity very well.

With great affection and devotion, Edward's sons cared for him
during his last years. Brett became head nurse, for there were many
times when Edward could not be left unattended. As his condition
became grave, friends offered support of medical and surgical atten-
tion, but he resisted such treatment, saying, "No one is going to touch
my brain!" We all knew that Margaret Bourke-White had undergone
an operation for Parkinson's without significant success. When I re-
ceived news of his passing on New Year's Day of 1958, I was saddened
but frankly relieved, as were his family and wide circle of friends. Al-
though he was debilitated and in pain, I never heard him complain.
He did not deserve the final years of progressive dependence, discom-
fort, and depression for which little could be done.

In 1983 I saw an exhibit of Edward's work in San Francisco. Old
and new prints from the same negative, silver prints in contrast to early
platinums, some prints made by Brett and some by Cole, all set on the
walls along with prints made by Edward himself. There were "project
prints," proof prints, reproduction prints, original fine prints, and
modern interpretations. There was no respect for the importance of
printmaking by the artist, thus no decisive message, "This is Edward
Weston's creative intention." I was dismayed and bewildered. Prints
from Edward's negatives made by Brett or by Cole are very fine and I
enjoy them too. Yet Edward's prints proclaim the artist in their own
inimitable way. It is the comparative display, without even informing
the audience that the negatives were performed by several individuals,
that disturbed me. Hearing Bach played on the instruments of his time
has a certain magic; hearing him played on the noble grand pianos of
our time is an altogether different experience. I prefer the latter, but I
must respect the former. I would not want to hear them both at the
same concert.

In an exhibit of this type, the museum becomes the laboratory or the autopsy room; the viewer receives less of the aesthetic and personal experience and is exposed to an analytical display of erudition and evaluation. The art historian may need this kind of dissection, but not those who seek the personal and aesthetic intention of the artist. The artist who has left the world is helpless to control the vagaries of curators and historians. In the zeal to show all sides of the artist's creativity, it is not infrequent that an exhibit is presented that is more concerned with facts, comparisons, and the curator's fancies than the qualities of the work as a whole. In Edward's case, the scraps of production, the reject, the prints that did not quite meet the creative intentions were gathered along with some of his most beautiful work, in a thoughtless mélange for all to see. This exhibition was unjust to a dead and defenseless great artist. Fortunately, Edward has had many sensitive and beautiful exhibitions.

Brett still lives near Carmel and our friendship continues. He calls me "Pasha" and I call him the "Silver-Halide Siegfried." His greetings are clavicle-cracking bearhugs, delivered with enormously hearty gusto. Brett is only nine years younger than I, but he still goes on strenuous photographic trips with his friends, often to the desert country east of the Sierra, working out of his well-stocked campervan.

Brett has lived a full life. He loves fast cars and fine women and uses the best photographic equipment. He has amazing creative energy and has published more portfolios of his work than any other photographer. His photographs have always been vivid and vigorous and, in recent years, very successful in gallery sales. Edward had the greatest admiration for Brett's photography and chose Brett to print his own negatives when Parkinson's made it impossible for him. After a time, Brett passed the printing on to brother Cole, because he needed all his time for his own work.

Brett believes most strongly in himself and in his creative objectives. He admires those who work in similar directions and does not pretend to be objective in his critical judgments. He lives in an intuitive world, distrusting techniques that he does not understand, preaching the "triumph of instinct." His instincts have treated him very well indeed.

Experience enhances intuition, and if the intuition is strong and bravely realized, the artist is in a most favorable situation. The price of trial-and-error training is high in time and energy. In my own experience I worked on an uncertain empirical basis until I began teaching and developed the Zone System. But Stieglitz, Edward Weston, Brett

Weston, and most of the photographers in history progressed most handsomely without the system. I am convinced that if such a technical approach had been available in their time, their craft problems would have been simplified. No one will ever know. As Brett states, "I am a primitive. Ansel is a scientist." This is an overgeneralization. I am *not* a scientist. I consider myself an artist who employs certain techniques to free my vision.

In retrospect, Edward was a great artist, worthy of all the devotion the world of art and creative photography holds for him. He was one of my dearest friends, a man of genius and compassion. Like the music of Bach, Weston's images well define the perceptions and sensibilities of the art and artists of his time: wonderfully organized shells or peppers, in contrast with highly personalized images of landscapes or fragments of the world about him, compelling portraits and nudes as wonderful as any ever made.

Immediately after Edward's death, I wrote to Edwin Land:

January 5, 1958

Dear Din,

Edward Weston's passing evokes a number of thoughts about photography. I find myself questioning a lot of directions and situations, and Weston's death closes an era and makes these questions pointed, and sometimes disturbing.

Edward represented the artist, and there have been very few indeed in the domain of photography. His technique was about as empirical as anything could be. His equipment severely simple. He rarely photographed anything he did not find interest in; his pictures were reflections of his inner spiritual and unconscious drive. Many events conspired in his favor, and yet — without conviction and energy, and an almost monk-like existence, he could not have produced the vast body of work which places him at the apex of his art.

Edward's work remains an example of achievement, of purpose, and as a standard of expressive quality in photography.

17.

Documentary Photography

THOUGH A PACIFIST AT HEART, I BECAME OUTRAGED over the deeds of the hideous Hitler regime and attempted to enlist to participate in its demise. While I was turned down because I was a married forty-year-old with dependents, I volunteered for any war-related job I could find. My civilian assignments included escorting American troops around Yosemite Valley. Often hundreds at a time visited as companies of heavy artillery made long practice treks to Yosemite, towing columns of large field cannons. I felt this contribution to the war effort was inconsequential, and I was restless to be of greater help.

The colonel in charge of the 1604th Company at Fort Ord brought his men several times. He invited me to come to the base and teach some of his men practical photography; because his group was an artillery repair and maintenance outfit and because he claimed he could not get satisfactory pictures from the Signal Corps, he wanted his own men to provide them.

Several times I was driven from Yosemite in his command car. These trips were also practice assignments for the colonel's drivers; they would be expected to find the shortest ways to and from Yosemite and to compete for the fastest time. They seemed to use only two speeds: stop and race. Twice on hot days the car's motor burned out. These trips were planned on maps, not in reality; I traveled over more unsurfaced back roads in the San Joaquin Valley than I thought existed.

This job led to one at the San Francisco Presidio, printing some top-secret negatives of Japanese military installations in the Aleutians.

During this session, I slept at home but was under constant armed guard.

One day in the late summer of 1943, an old Sierra Club friend, Ralph Merritt, visited me in Yosemite. I discussed with him my frustration in not being able to find appropriate use of my energies during these war years. He suggested that the best I could do was to take advantage of my situation and continue photographing the natural scene, saying, "I feel that when the war is over, these will be useful to our country."

When I replied that I felt the present human obligations to be of supreme importance, he rejoined, "I do have a project that might interest you." Whereupon he told me he had just been appointed director of the Manzanar War Relocation Camp north of the small town of Lone Pine in the Owens Valley. He described in detail the plight of the Nisei, American citizens born here of Japanese descent, who were suddenly uprooted from their homes, farms, industries, and offices after the attack on Pearl Harbor. Under the shock of this terrible event, the military had panicked at the possibility of an invasion from the Pacific by the Japanese and recommended the removal of all West Coast Nisei, "for their mutual safety." With the military's advice, President Roosevelt signed Executive Order 9066. I am sure he had no realization of its tragic implications; thousands of loyal Japanese-American citizens were denied their basic civil rights. Unfortunately, this decision had the support of a great number of Caucasian citizens throughout the West, who racially disliked the Japanese-Americans as social and economic competitors.

Executive Order 9066 was swiftly executed. The War Relocation Authority was formed, and several camps in isolated areas in western states were hastily constructed. Operated at first by the U.S. Army, civilian directors and staff were duly appointed, although the camps continued to be "protected" by the military.

The great documentary photographer Dorothea Lange made some moving photographs that reveal the despair, bewilderment, and misery of the thousands of American citizens as they were apprehended and isolated almost as prisoners of war. While the first months at the camps were bleak and severe, there was none of the neglect and brutality we associate with European and Asiatic concentration and POW camps.

When Ralph Merritt became director of Manzanar, he found the occupants restless and uncertain, yet striving to turn the camp into a little island of civilization for themselves. He governed with fairness

and frankness, stressing the principles of democracy and freely admitting the error of the relocation decision. "As nothing can be done, we must make the best of it and I shall help you all I can." His attitude revived community spirit and made life more bearable for all.

He proposed a photographic project where I would interpret the camp and its people, their daily life, and their relationship to their community and their environment. He said, "I cannot pay you a cent, but I can put you up and feed you." I immediately accepted the challenge and first visited Manzanar in the late fall of 1943.

The gasoline ration board in Yosemite was very cooperative, providing ample fuel and adequate tires for the hundreds of miles of driving between Yosemite and Manzanar: about one hundred sixty miles over Tioga Pass in summer but four hundred miles in winter via Bakersfield and the southern passes.

The Owens Valley was once a very beautiful agricultural area. Bountiful streams flowing from the High Sierra provided life for the soil. In the early 1900s, rapidly expanding Los Angeles, about three hundred miles to the south, usurped the water rights to practically all of the bounty of the snows, as well as the water from the streams that flow into Mono Lake at the north end of the valley. All waters were channeled through the Los Angeles Aqueduct, an engineering wonder at the time, to the burgeoning urban sprawl of the thirsty city. Before this environmental disaster, the valley was green, the air pure, and the community of farmers was in economic balance.

My first impression of Manzanar was of a dry plain on which appeared a flat rectangular layout of shacks, ringed with towering mountains. These shacks created a mood that was not relieved by the entrance gate and its military guards. Arriving at the administration building, I was met by Ralph and his staff, led to my quarters, and then given a cursory tour of the camp. Under a low overhang of gray clouds, the row upon row of black tar-paper shacks were only somewhat softened by occasional greenery. However, the interiors of the shacks, most softened with flowers and the inimitable taste of the Japanese for simple decoration, revealed not only the family living spaces but all manner of small enterprises: a printing press that issued the *Manzanar Free Press,* music and art studios, a library, several churches (Christian, Buddhist, and Shinto), a clinic-hospital, business offices, and so on.

Everyone seemed constructively occupied, alert, and cheerful. Surrounding the housing area were extensive farms, literally carved out of the desert through backbreaking work. Sufficient water had been

obtained for irrigation, and the camp was agriculturally self-sustaining. Under surveillance, a few Nisei were allowed to go into the mountains and find appropriate stones to build a charming Japanese garden in the camp center.

I was profoundly affected by Manzanar. As my work progressed, I began to grasp the problems of the relocation and the remarkable adjustment these people had made. It was obvious to me that the project could not be one of heavy reportage with repeated description of the obviously oppressive situation. With admirable strength of spirit, the Nisei rose above despondency and made a life for themselves, a unique micro-civilization under difficult conditions. This was the mood and character I determined to apply to the project.

At first I was shy, conscious of my intrusion into their privacy. I found the people generous, warm, and cooperative, anxious to talk about the outside world and their own situation. I was amazed at their patient acceptance of their life; they showed surprisingly little animosity and evidenced a sustaining philosophic attitude, awaiting the day when they would be allowed to return to their homes.

It was very disturbing to witness the arrival of the young army-uniformed Nisei when on leave for a visit with their families. It must have been most difficult for them to be confronted by their parents, incarcerated American citizens — a severe contradiction of the principles for which they were fighting the war. Germans and Italians of American descent were not impounded, nor was the large population of Nisei in Hawaii. It was a nightmare situation.

While the floor of the Owens Valley is desolate, very hot in summer and very cold in winter, the surrounding mountains are spectacular, especially the Sierra Nevada on the west, culminating in Mount Whitney rising fourteen thousand five hundred feet above the valley floor. The Inyo Range to the east is more of desert character and of lower elevation but is very beautiful in its own way. I have been accused of sentimental conjecture when I suggest that the beauty of the natural scene stimulated the people in the camp. No other relocation center could match Manzanar in this respect, and many of the people spoke to me of these qualities and their thankfulness for them.

The grand view of the Sierra from Manzanar visually excited me, and I knew I must make some inner-assigned photographs, though it took an extensive search to find the image that clearly communicated what I saw and felt. Behind and to the west of the camp was a huge field of boulders, extending several miles to the base of Mount Wil-

liamson. One day I sensed the conditions to be right: there was a glorious storm playing across the crest of the Sierra and I watched as it approached the peak of Mount Williamson. I drove out to the boulders and set up my 8x10 camera on the car's rooftop platform. This perspective allowed me to compose the photograph with the boulders in the foreground, progressing to Mount Williamson in the midst of a dramatic mix of shafts of sunlight and storm clouds.

Another of my best-known photographs was made while I worked at Manzanar — *Winter, Sunrise, The Sierra Nevada, From Lone Pine, California*. I had come to know the Owens Valley well and felt there was a photograph of the Sierra and Mount Whitney to be made near the little town of Lone Pine, some fifteen miles south of Manzanar. I made a number of efforts at different times of the day, but did not achieve the desired image, deciding it must be made at sunrise.

One very cold and very early morning in December of 1943, Virginia and I arose before dawn and drove to Lone Pine. I selected a spot not far from the main highway, parked the car, and set up my camera on the platform. We then huddled together in the car, gratefully sipping from a thermos of steaming coffee that Virginia had prepared. Soon, the sun rose above the Inyo Range behind us, glowing pinkly upon the Sierra summits. I scrambled up to my camera, knowing the time was close but feeling it was not quite right. Beams of light began highlighting the brushy trees in the foreground of my composition; they also illuminated the rear end of a horse as it calmly grazed in front of the trees. Frustrated, I watched as the light appeared, just as I had hoped. Serendipitously, the horse momentarily turned to profile and I made the exposure. Within seconds, the tonal variety that created the mood of the scene was destroyed by a flood of even sunlight.

Nancy Newhall, acting curator of the Photography Department at MOMA while Beaumont was in the army, insisted upon an exhibition at the museum of the Manzanar photographs. Because of scheduling beyond our control, the Manzanar exhibit was not installed in a regular gallery but relegated to display space in the first basement area. Nevertheless, it created much attention and varying comment.

At the suggestion of Tom Maloney, publisher of *U.S. Camera,* that the Manzanar project become a book, I assembled photographs from the camp with some of those from the Owens Valley, and also wrote appropriate accompanying text. The book, *Born Free and Equal,* was published late in 1944. It was poorly printed, publicized, and distributed, perhaps to be expected in wartime. Although the motive of the

book was clearly presented in pictures and text, it met with some distressing resistance and was rejected by many as disloyal. I could tolerate the narrow opinions expressed verbally or in the press, but it was painful to receive a few letters from families who had lost men in the conflict; they were bitter and incapable of making objective distinctions between the Nisei and Japanese nationals. How can you adequately reply to a couple who lost their three sons in the Pacific war?

I wrote in *Born Free and Equal:*

> You have now met some of the people at Manzanar, seen a small part of their daily life and work. I hope you have become aware of their tragic problem.
>
> As I write this men are dying and destruction roars in almost every part of the globe. The end is not yet in sight.
>
> What is the true enemy the democratic peoples are fighting? Collectively, the enemy is every nation and every individual of predatory instincts and actions. We fight to assure a cooperative civilization in opposition to the predatory Nazi-Fascist-Militarist methods and ideologies of government. We must prosecute this war with all the ruthless efficiency, stern realism, and clarity of purpose that is at our command. We must not compromise or appease. We must assure our people that there will be no further human catastrophes such as the destruction of Rotterdam, the annihilation of Lidice, the rape of Nanking, or the decimation of the Jews.
>
> We must be certain that, as the rights of the individual are the most sacred elements of our society, we will not allow passion, vengeance, hatred, and racial antagonism to cloud the principles of universal justice and mercy. We may well close with these words of Dillon S. Myer: "If we are to succumb to the flames of race hate, which spread with fury to every markedly different group within a nation, we will be destroyed spiritually as a democracy, and lose the war even though we win every battle."

Born Free and Equal was but the first of my attempts at the photographic essay, a form that I found to be the most complex task in my professional career. The allowed time was usually too short, the writer too busy to talk coherently about his part of the project, and the weather often belligerent.

While documentary photography was a major concern of European photographers, it was not recognized as such in America (with a

few exceptions, such as Lewis Hine and Jacob Riis) until the 1930s with the advent of both the Farm Security Administration and *Life* magazine. Rumors to the contrary, I never discounted the importance of the documentary vision in social and historical applications, though I resented the many implications and statements that it was the *only* important form of serious photography.

In 1931, in a review for *The Fortnightly* of an exhibit of work by the great French photographer Eugene Atget, who over many years photographed the city of Paris, I wrote:

> The charm of Atget lies not in his mastery of the plates and papers of his time, nor in the quaintness of costume, architecture, and humanity as revealed in his pictures, but in his equitable and intimate point of view. It is a point of view which we are pleased to call "modern" and which is essentially *timeless*. His work is a revelation of the simplest aspects of his environment. There is no superimposed symbolic motive, no tortured application of design, no intellectual axe to grind. The Atget prints are direct and emotionally clean records of a rare and subtle perception. . . .

Life magazine helped expand the photograph as document into full visual essays with heart and social intention, nourishing the new American photo-journalist. One of the most successful *Life* photographers was Margaret Bourke-White, whom I first met in 1934. She had just moved into her studio on one of the top floors of the Chrysler Building and I recall a giant aluminum gargoyle clearly visible through the large window. Her assistant, a nervous young man, said, "Please be seated," but there was nothing to sit on. Bourke-White entered the room briskly and cordially greeted me. She was dressed with great chic, on the edge of flamboyancy, and moved and talked with marvelous vitality. She explained that she was preparing for an assignment and could give me but a few moments — "My helper is checking my cameras right now." At that moment a loud crash came from the adjacent room; the camera and tripod on which the young man was working had suddenly collapsed and were severely damaged. Bourke-White reacted with composure, saying to him, "Please call for another Speed Graphic right away." Stating she would pick up the camera on the way to the airport, she gave me a warm adieu, abandoning me in her pristine office with the broken camera still lying on the floor.

Bourke-White, constantly on assignment, flew everywhere, in all types of planes, often under perilous conditions. Her stamina and

courage brought forth astonishing photographs, expressing a high level of photojournalism. In late 1947, following my Guggenheim-funded trip to Alaska we met again as seat-mates on a plane from Chicago to New York and had a lively conversation. I had recently enjoyed her book, published in 1937, *You Have Seen Their Faces,* with text by Erskine Caldwell, her husband at that time. I told her I found it a moving and deeply observed portrait of the South and its racial blight.

As we chatted, Meg told me that her working method, whenever possible, was to set the shutter at 1/100 second and make exposures with every lens stop from $f/4.5$ to $f/22$; one was certain to be perfect! We continued discussing technical shoptalk, though her experience was with the camera, not in the darkroom. Photojournalists rarely do their own negative processing or printing. They are field people, and their basic craft is concentrated on mastering their subjects and applying the sharp, visual, reporter's eye. For them, photographic image content is the dominant consideration, print quality a distant second.

As we approached New York, deep in bourbon and professional discussion, it was obvious there was a weather problem. The plane circled for more than an hour, mostly in thick clouds, and Meg became visibly nervous. When the pilot announced, "I am instructed to make a fast descent to three thousand feet [from twenty-four thousand feet]," she grasped my hand in a viselike grip, releasing it only as we came out of the dive over Brooklyn.

She said, "You know, I have flown zillions of miles but I am always nervous about anything unusual." I admitted I had also been worried during the steep, swift dive.

Every few months our lives briefly touched without intention. One day in 1948, I was in the office of the picture editor of *Fortune* discussing a possible assignment, when Meg barged in, an astonishing vision in a full, white Astrakhan coat and cap.

"Hi! I'm just back from Gandhi's funeral!" We assembled to hear her describe the turmoil of the preceding weeks. She spoke with riveting energy, and if she was fatigued she certainly did not show it.

Though we never shared an assignment, we would meet often in New York, and once she joined our family in Yosemite for Christmas. I had a moving last visit with her in her home in Darien, Connecticut, when she was suffering during her final years with Parkinson's disease. I photographed her with my Polaroid camera, and she took the camera from me and returned the gesture. She was bravely active and outgoing until near the end.

As with Bourke-White, most of my journalistic assignments came from *Life* and *Fortune*. During the 1950s Dorothea Lange and I became partners for a number of stories. Dorothea, who also lived in the Bay Area, had established her fine reputation while working as one of the photographers in the Farm Security Administration (FSA) project during the Depression.

In 1935 President Roosevelt established the Resettlement Administration, to aid the thousands of farmworkers unemployed because of the great quantities of land that had become a dust bowl, unable to produce crops. Within this organization was the FSA, led by Roy Stryker, which assembled photographers to record American rural life. Dorothea was, in my opinion, the superior artist in that group. Her great photograph, *Migrant Mother, Nipomo, California, 1938,* is as compelling aesthetically as it is as a document.

My associations with Dorothea were both rewarding and perplexing. No one could dispute her gifts and her extraordinary energy. Her political/social views were quite definite, yet discreetly restrained in her professional and public contacts. I recall many discussions among our close friends and colleagues as to whether she leaned to Leninism or Trotskyism and whether she was a Communist Party member or not. She implied her sympathies in her work, but usually did not make obvious images or pronouncements along any party line. There was great integrity in her beliefs and opinions, and great skepticism about the complacent society around her and the avowed "Good Old Boy" attitudes of industry as well as the general machinations of politics.

Dorothea's first husband was the painter Maynard Dixon. He was very creative and, to say the least, individualistic. The West was his spiritual domain. He loved the Indians and the cattlemen and, above all, the country. He painted simple, stylized, and heroic images of the West, some of which have great beauty and power. He did not receive the support due him from the intelligentsia of San Francisco, who were then following the shimmering mirage of modern art. What bothered Dixon was not the qualities of good modern art, but the assumption that all avant-garde art was de facto superior.

I had been introduced to many of the artists of San Francisco in 1926, as Albert Bender took me under his wing. This was an extraordinary community; there were no giants of art, but the creative ambience was positive and reasonably healthy. Modern art came late to the American West; late-nineteenth-century modes slowly gave way to expressionism, but the conservative painters fought it tooth and nail.

While Maynard achieved less acclaim, Dorothea became recognized as a powerful and perceptive artist, one of the great photographers of our time. During the 1920s, she had been a professional portraitist and did quite well, but when the Great Depression began, Dorothea turned her convictions and her eye to the problems of society. Her photographic studies of farmworkers came to the attention of Dr. Paul Taylor of the University of California, an authority on agricultural labor problems. From the start it was obvious they made a most effective team; Dorothea left Maynard for Paul. It was a sad situation for Maynard, but he managed it well, as he did many other shattering problems throughout his life, eventually finding a happy marriage to Edith Hamlin, an excellent San Francisco painter.

I recall one joint assignment with Dorothea for *Fortune:* a story on the agricultural situation in the San Joaquin Valley of California. Dorothea and I were instructed to stress agribusiness, because, after all, *Fortune* was a business magazine. She stoutly protested; she wanted to depict the far less privileged small farmer, many of whom had been absorbed by the huge corporate farms. Those who remained were having increasingly difficult times; rising costs, strong competition, and the problems of selling their produce presented a dim future. Paul Taylor was a staunch supporter of the Federal Water Project by which each member of a farmer's bona fide family was entitled to enough free water for one hundred sixty acres of land. The huge corporate farms claimed the same advantage, and that battle continued for years. The *Fortune* project was resolved by Dorothea's working with the small farmers and their farm-labor problems while I was left with the large farms and the corporate spirit. She was capable of making one feel a bit conscience-ridden, and this adventure in partnership offered no exception. After this session with agribusiness, I had a clearer vision of what the struggle was all about: overexploitation will exhaust our soil and water and is certain to impoverish California within foreseeable time.

Another joint project was an article for *Life* on the Mormons in Utah. I had suggested this story to Dorothea as one she would revel in, and she eagerly pursued it with the insistence that I collaborate with her. We agreed to produce also an exhibition of our photographs.

Utah is a unique area of America, both in scenic and human terms. It is disarmingly beautiful country, possessed by a strangely conservative population. The Mormon religion is a strict dogma that binds the people together as no other group in our land. The Mormons have an

exemplary family life, their honesty is proverbial, there is little or no crime, they take care of their aged and indigent. They are also an intensely private people.

Dorothea and Paul went to Salt Lake City to obtain permission for our project from a suspicious Board of Elders of the Mormon Church. Apparently, Dorothea and Paul only spoke of the exhibition and not a word about the *Life* magazine story. I discovered this unfortunate circumstance at the close of the project, and I confess to a real sense of guilt at what I considered our betrayal of their trust.

Although the *Life* article turned out to be quite short because of the demands of fastbreaking war stories, we felt that the exhibit could tell the story of the three towns we photographed and their people. The exhibit started as a beautiful concept, and the first picture selection was stunning. Then, Dorothea applied her doctrinaire attitudes, which sucked dry the potential spirit. The exhibition garnered little interest and was displayed only briefly.

In spite of the occasional difficulties I had while working with her, I wish to affirm Dorothea's extraordinary qualities as a photographer. I learned much from her devotion to the art and the severe application of discipline and effort in everything she did. I used one of her photographs, *White Angel, Bread Line, San Francisco,* in *Making a Photograph* as an example of powerful creative photography applied to a social situation.

Dorothea and I had a lively correspondence, freely expressing our philosophical disagreements about photography and life in general. This letter, written in 1962, can stand for many.

Dear Dorothea,

Photography, when it tells the truth, is magnificent, but it can be twisted, deformed, restricted, and compromised more than any other art. Because what is before the lens always has the illusion of reality; but what is selected and put before the lens can be as false as any totalitarian lie. While it is true that we get from pictures pretty much what we bring to them in our minds and hearts, we are still restricted by the content and the connotations of the image before us. If the picture is of a clam I don't think about flamingos! The connotations of much of documentary photography are — to me — quite rigid. . . .

I resent being told that certain things have significance; that is for me, as spectator, to discover. I resent being manipulated into a politico-social formula of thought and existence. I resent the implications that unless

photography has a politico-social function it is not of value to people at large. I resent the very obvious dislike of elements of beauty; our friend Steichen has shocked me time and again by a self-conscious fear of the beautiful. Does he feel that way about a painting, about sculpture, architecture, literature and just plain nature? He does not. I am not afraid of beauty, of poetry, of sentiment. I think it is just as important to bring to people the evidence of the beauty of the world of nature and of man as it is to give them a document of ugliness, squalor and despair. . . .

Is there no way photography can be used to suggest a better life — not just to stress the unfortunate aspects of existence or the tragic / satirical viewpoint of the photographer? There must be. . . .

You happen to be one of the very few who has brought enough deeply human emotion into your work to make it bearable for me. I wish you would try and think of yourself as a fine artist — which you are; that is a damn sight more important to the world than being merely an extension of a sociological movement.

Love,
Ansel

18.

National Parks

WHILE I HAVE SPENT CONSIDERABLY MORE TIME IN Yosemite National Park than in any of the others, my devotion to the natural scene has drawn me to the parks and monuments of nearly every state. I have traveled from Acadia National Park in Maine to Hawaii National Park, from Denali National Park in Alaska to Big Bend National Park in Texas. I consider myself to be supremely fortunate to have had this opportunity. The photographic potentials were magnificent and the sources literally inexhaustible.

I had photographed in Yosemite and the surrounding Sierra Nevada for two decades before I applied my photography to the country beyond. In 1941, I received a letter from Harold Ickes requesting that I photograph the national parks under the aegis of his Department of the Interior. It sounded perfect to me — one of the best ideas ever to come out of Washington. My pictures would be reviewed by Ickes, and together we would select a reasonable number of images for enlargement to mural size; these would be hung in the corridors and principal offices of the Interior Department building in Washington. The ownership of the negatives was to remain with me, and there would be no restrictions on the future prints I could make from them.

I was appointed at the maximum annual salary then allowed for any position not subject to congressional approval: twenty-two dollars and twenty-two cents a day for no more than one hundred eighty days' work a year, plus five dollars per diem expenses and a reasonable amount of travel vouchers. This excellent arrangement would allow me the remaining one hundred eighty-five days each year for other photographic endeavors.

My travels on behalf of the mural project began in October 1941, and I was accompanied by my eight-year-old son, Michael, and Cedric Wright. I planned to work on two other projects at different times during this trip: a commercial assignment for the U.S. Potash Company in Carlsbad, New Mexico, and some inner assignments for myself in the stimulating landscape of the Southwest.

I wrote to Beaumont and Nancy:

<div style="text-align:right">

Mesa Verde National Park, Colorado
October 26, 1941

</div>

Dear Beaumont and Nancy,

We have had a spectacular and dangerous trip. All went well through Death Valley, Boulder Dam, Zion, North Rim, South Rim. Then we spent the night on Walpi Mesa, proceeded to Chinle and had two spectacular, stormy days at Canyon de Chelly. I photographed the White House Ruins from almost the identical spot and time of the O'Sullivan picture! Can't wait until I see what I got. Then our troubles began. They have had the worst rainy season in 25 years and the roads through the Indian Country are unbelievable! The road from Chinle to Kayenta was so terrible that it took us fifteen hours to go sixty miles; then we ended up at midnight flat on our chassis in the worst mud hole you ever saw — with lightning and thunder and rain roaring on us. We slept in the car that night and worked from 5 A.M. till noon getting the old bus rolling again.

[In Utah we] encountered the Butler Wash. It was running 15 inches deep, so we thought it was safe. I set the car in low and proceeded to barge through as I have many such affairs. When the front wheels touched the far bank the motor stopped — water was thrown on the block by the fan belt. I should have removed it first. Well, there we were with the backside of the car actually under water. In a moment of panic I decided to reverse and get out of it all; I could not budge the car ahead after getting it started because the rear wheels had found a hole and no advance was possible. I put it in reverse, gunned it, got half-way across, and the entire ignition passed out. Here I was, with the muddy water running over the floor board and within two inches of cameras and films in the back. A storm was coming up; things looked black indeed because those washes can rise five feet in fifteen minutes. We stripped and moved everything out of the car onto a high bank. [With the help of a large state truck] we just did get the car out; the storm broke and the wash went up.

We were so completely lucky — timed almost to ten minutes! . . .
Breathed a vast sigh of relief when we struck the pavement in Colorado.
Never such a trip! We have only 4000 more miles to go!!

<div align="right">

Affectionately yours,
Ansel A.

</div>

Happily, our journey proceeded without calamity from there on, and we arrived in northern New Mexico on our way to Carlsbad, the next national park and the site of my commercial job with the U.S. Potash Company. I decided to stay in the Santa Fe area for a few days in search of personal photographs. One bright autumn afternoon found us in the Chama River Valley. Cedric was not too fond of arid landscapes, and that day he was frustrated and weary. I struggled with several obdurate subjects, losing in battle to a stump that refused visualization, and decided it was just one of those unproductive days. We unanimously agreed to call it quits and return to Santa Fe.

Driving south along the highway, I observed a fantastic scene as we approached the village of Hernandez. In the east, the moon was rising over distant clouds and snowpeaks, and in the west, the late afternoon sun glanced over a south-flowing cloud bank and blazed a brilliant white upon the crosses in the church cemetery. I steered the station wagon into the deep shoulder along the road and jumped out, scrambling to get my equipment together, yelling at Michael and Cedric to "Get this! Get, that, for God's sake! We don't have much time!" With the camera assembled and the image composed and focused, I could not find my Weston exposure meter! Behind me the sun was about to disappear behind the clouds, and I was desperate. I suddenly recalled that the luminance of the moon was 250 candles per square foot. I placed this value on Zone VII of the exposure scale; with the Wratten G (No. 15) deep yellow filter, the exposure was one second at $f/32$. I had no accurate reading of the shadow foreground values. After the first exposure I quickly reversed the 8x10 film holder to make a duplicate negative, for I instinctively knew I had visualized one of those very important images that seem prone to accident or physical defect, but as I pulled out the slide the sunlight left the crosses and the magical moment was gone forever.

I knew it was special when I released the shutter, but I never anticipated what its reception would be over the decades. *Moonrise, Hernandez, New Mexico* is my most well known photograph. I have received more letters about this picture than any other I have made,

and I must repeat that *Moonrise* is most certainly not a double exposure.

During my first years of printing the *Moonrise* negative, I allowed some random clouds in the upper sky area to show, although I had visualized the sky in very deep values and almost cloudless. It was not until the 1970s that I achieved a print equal to the original visualization that I still vividly recall.

To the despair of biographers and historians, and with my usual mistreatment of chronology, I misdated the making of *Moonrise* for many years, variously labeling it 1941, 1942, 1943, and 1944. The true date was recently discovered because Beaumont Newhall had been more bothered than I by my lack of precise dating. He asked a friend and astronomer, Dr. David Elmore, if a computer could be used to solve the mystery of *Moonrise*. Elmore welcomed the opportunity to apply celestial mechanics and computer technology to a problem in the photographic world. Using geological survey maps, he determined the elevation and azimuth, entering these facts into his computer along with a drawing of the basic components of *Moonrise*. The computer graphics program worked minute by minute through the possible years before its screen finally showed the moon arching toward the position in the photograph. Elmore said, "When it lined up it was like bang, bang, bang. Lights went off in my head. Everybody looking on cheered." *Moonrise* had been made at between 4:00 and 4:05 P.M., October 31, 1941. It is too bad I can never date so exactly my thousands of moonless pictures!

After the experience in Hernandez, Cedric, Michael, and I rested in Santa Fe where I developed my negatives in a borrowed darkroom. We were invited to several memorable evenings. Michael would have a juice or cola drink and go to sleep in an Indian blanket while the less sensible adults engaged in high jinks and endless talk. On an afternoon that I knew was going to be a real bash, I said to Cedric, "There is going to be a lot of imbibing tonight and I think we should protect ourselves." Accordingly I bought a small bottle of olive oil and we swallowed several gulps just before we left for the party. This action was based on the legend that olive oil would coat our innards and prevent absorption of alcohol. Michael was both perplexed and amused at this ritual, and I explained to him why the unappetizing intake would prevent the effects of coming liquids. It did work surprisingly well — we had a grand party and then we were up at dawn, our heads clear as a bell.

The next evening we arrived at another party and were immedi-

ately confronted with a large tray of martinis. Michael piped up with alarm, "Look out, Daddy! You haven't had your olive oil!" This remark had to be fully explained to everyone, and for several years a party never began without "Have you taken your olive oil tonight?"

After leaving Cedric in Albuquerque for a bus ride back to Berkeley, Michael and I continued our trip, driving south. We arrived in Carlsbad, where Michael had an attack of appendicitis, but was well taken care of at the local hospital while I photographed for the U.S. Potash Company. I worked long and hard in the depths of the potash mines with my 5x7-inch Linhof camera, Kodachrome sheet film, and a large supply of foil flashlamps — a technically and physically difficult job. When finished, I mailed the film off for processing and entered Carlsbad Caverns National Park to size up the situation for a possible Interior Department mural.

The caverns did not prove successful for the mural project, however. Obviously, there is no natural light in caves. At Carlsbad, their illumination by the National Park Service was for theatrical, not cave effect. I decided I would need much more artificial lighting than I had brought to achieve a sense of the immense caves, and I resolved to return at a later date.

The processed films for the Potash Company arrived; I opened the package with trembling fingers and found the pictures highly successful. I proudly carried them to the manager's office and presented them with unabashed pride.

He looked at some and said, "Wonderful! Congratulations!" then got to the largest and most important group of pictures, those of the miners on their platforms drilling into the beautiful crystalline rock. The color was gorgeous, the exposures perfect.

He stared at them and then said, "What in hell were you doing putting those men on wooden planks instead of the mandatory metal supports? This violates government and company regulations; we'd lose our ass if we released these pictures!"

I was in despair. I was obligated to redo the job, and this would mean ordering more film and flashlamps and about a week's delay. I reminded him I had the assistant superintendent of the mines with me at all times because I wanted the pictures to be correct in all particulars.

He called the unhappy man to his office and spared no words. He telephoned the head office in New York and repeated the outrage while glaring at the assistant whose only defense was, "I didn't think they would show in the photographs."

The manager turned to me and said, "Do them over, double the bill, it's not your fault." I repeated the particular picture session with success. This was another learning experience — check everything possible well in advance.

In 1942 I continued my national park travels, describing them to Nancy:

En Route, Wyoming, June 11th, 1942

Dear Nancy,

Wish you were right here on this train going north through a very beautiful, but very arid country. Will arrive at Billings, Montana, tonight, then to Yellowstone, then to Glacier, then on west to Rainier and Crater Lake, then home. Have been getting some perfectly swell negatives; developing them in National Park Service darkrooms and am immensely pleased. Got a superb picture of the Never Summer Range west of Rocky Mountain National Park — great snow-covered mountains with shaded, snow-covered hills in the foreground and a very nostalgic sky — well, wait and see, I will send some on.

We are roughing it through a deep canyon; can just see the tops of the walls from the Pullman window. Green, grassy slopes, yellow-cream rocks, sagebrush. Just passed about fifty miles of snowy mountains — so many mountains here there is no chance to remember what they are.

. . . I'll take a government car to Yellowstone. Tell old Jackson I will be thinking of him. [Note: The great expedition photographer of the American West, William Henry Jackson, was living in New York City at the age of ninety-nine. He died later that same year.] He might have had a portable darkroom and a 20x24-inch camera, but I got 280 pounds of baggage and cameras and tripods and typewriters and am having a hell of a time without the old station wagon!!

Just passed an acre of blue lupine with snow peaks in the distance . . . it's almost too much.

If your old man has come back from feeding the cat (or worse) give him my best. Same to you.

Yours ever,
Ansel

Next address: c/o Superintendent, Glacier National Park

I quickly became enamored of the geysers of Yellowstone. It is difficult to conceive of any substance in nature more impressively brilliant than the spurting plumes of white waters in sunlight against a deep blue sky. I was delighted photographically with the geysers at dawn, as well as at sunset. The subject matter of Mount Rainier did not lend itself to murals, but rather to photographic interpretations of nature in intimate contact with the world. I was pleased with my quiet studies of leaves and ferns.

Exciting as the mural project was, I soon regretted that I had no prior experience in programs supervised by a bureaucracy. I kept all receipts and submitted a diary describing each day in the field with every hour accounted for, carefully excluding time spent on other projects. I traveled by rail to the parks outside California, and this demanded careful routing simply to be sure I was moving about with minimum mileage and expense to the government. As it was, every one of my travel vouchers was routinely inspected and compared to railroad timetables. All were cleared but one. When I left Rocky Mountain National Park for Glacier National Park, I discovered the shortest bus trip to the next railroad station had been discontinued and I had to take a longer route. A few months later a man with a bulky briefcase visited me in my San Francisco studio with a claim against me for three dollars and eighty cents that represented an over-minimum cost for the bus trip. I explained the situation. It was apparent that his office worked from an out-of-date timetable and did not know of the cancellation. He looked most disconsolate and, pointing to his inch-thick file, said, "Look what we went through for three dollars and eighty cents!" In the spirit of patriotic generosity I wrote him a check for the full amount. He said, "Washington thanks you," and departed.

Unfortunately the mural project was terminated on July 1, 1942, because of the pressures of World War II. It was not renewed after the war, and the murals for the Interior Department were never made.

In 1945 I submitted an application to the John Simon Guggenheim Foundation for a fellowship to allow my return to photograph the national parks and monuments. I was determined to continue the project that I had begun only four years earlier, not now with the intent of making murals for government walls, but as my own personal creative project. I was granted a Guggenheim in 1946, and it was renewed in 1948. The book *My Camera in the National Parks* and my second portfolio, *The National Parks and Monuments,* both appeared in 1950, projects directly related to my Guggenheim Fellowships.

Upon receiving the Guggenheim, I decided to travel to Glacier Bay and Mount McKinley (now called Denali) National Parks in Alaska. Since a trip to the state of Washington in 1942, I had sensed that this northwest country was only the threshold of a certain mystery: the dark evergreens, the northern haze, the shining summits of the Olympic Mountains to the west, and the soaring cone of Mount Rainier below the rising sun suggested further grandeurs to the north. Imaginatively inclined, I felt Alaska might be close to the wilderness perfection I continuously sought.

Michael, now fourteen, accompanied me to Alaska in 1947. Planning our travels I faced a difficult decision. I preferred travel by car, accepted the train, but was frankly scared of flying. Several friends had experienced terminal misfortune in airplanes, and I rationalized that the air was a very unnatural environment for man. Even Edward Weston, the great distruster of technology, flew long before I did, and loved it. I knew when we reached Alaska we had to fly; it was the only practical way to visit many of the areas I wanted to photograph.

Michael and I transferred from train to ship in Seattle for the gorgeous voyage through the Inland Passage and along the Canadian coast to southeast Alaska. I was deeply affected by my first glimpse of the northern coasts and mountains. The rain did not depress me; it was clean and invigorating, and the occasional glimpses of far-off summits gave promise of marvels to come.

Ketchikan, Alaska's southernmost town, was our first stop. At a distance it reminded me of a New England settlement. As we came closer, an appalling array of junk and disorder was revealed. The tide was low and the shoreline was a hideous gathering of filth of all description. The architecture of the town was "shackesque."

We progressed up the Inland Passage to Juneau, Alaska's capital, which was superior to the other towns of the region in its advanced "shackesque" character. Juneau's setting is spectacular, crowded upon the narrow strip of land between Douglas Sound and the precipitous mountains that rise above the last streets and footpaths of civilization.

At that time Alaska was a territory whose governor was appointed by the Secretary of the Interior. Ickes had written on my behalf to Alaskan Governor Ernest Gruening. We contacted him upon our arrival and on his warm invitation arrived at the governor's mansion to meet a charming, informal man who quickly became a friend. He and his wife could not have been more helpful to us; we were many times at the mansion, where I met some fine and imaginative people. Alaska

was not exactly an Athens, but many citizens were dedicated to it and its future.

Governor Gruening kindly arranged for us to go on the first wild-life and fishing patrol flight of the season; we were to see a good part of southeast Alaska from the air. The wildlife officer, his deputy, Michael, and I gathered at the dock at four in the morning to board the amphibious Grumman Goose. I was shaking, but Michael was ecstatic. We entered what at first looked like a tool shed, a completely noncosmeticized seaplane.

"Ever been on this plane before, mister?" asked the pilot. "Some call it the Flying Coffin, but it's really a safe kite. We got new engines but the insides are a little crummy. As this is the first day of the fishing season, we check a lot of boats for licenses and catch. Just belt in and relax."

The two engines were started, wheezing and rumbling from the wings above us, and then revved up with a horrendous roar. The plane had little sound insulation. It started out over slightly choppy water and at full throttle bounced up and away over the mountains. Michael's eyes were popping out at the terrific noise and the mighty lurching of the old plane; I was transfixed with fear in a hard bucket seat with picks and shovels on one side and burlap and boxes on the other.

We first zoomed over a high meadow and could clearly see some large bears wandering about. Crossing the summit, we dropped swiftly to an inlet and taxied up to a fishing boat and checked on names and licenses. All was well, and we took off again to the south.

After hours of flying, landing, checking fishing boats, occasionally issuing citations, and taking off — all in the midst of incredible scenery and unusually good weather — we landed at Ketchikan. The pilot decided to use the wheels instead of the floats, and we headed for the airport. The plane came in gracefully enough, but it became obvious to the pilot that the right landing wheel was not holding its extension. He yelled for all of us to get over to the left side of the plane and belt up tightly. He brought the plane in on one wheel, balancing for as long as he could. The plane settled down on its wingtip tank and scraped along intermittently until we finally stopped. The only damage was a little paint scraped off the tank. Though nerve-racking, it was an example of excellent piloting.

After a late lunch, the pilot and his deputy had business to conduct, and we were turned loose on the town. I made a few pictures and

Michael browsed through the fishing tackle shops. In the meantime the plane's wheel-plunger was supposedly being serviced, but we found that the proper equipment was not available in Ketchikan. After expressing a few unprintable definitions of the state of the Alaskan airline industry, the pilot said, "Don't worry, we can get off on one wheel. Just hug the left side." We put all the movable weight on the left side and plastered ourselves against the frame. The pilot got help to turn the plane in the right direction. The motors roared, and we took off with the right wingtip lightly bouncing a few times on the runway — we were off into the wild blue yonder!

This unsettling adventure was soon forgotten as we flew over the sea and then turned east to the mountains. The pilot said, "I think we should see some nice country on the way home." We crisscrossed the Coast Range many times, exploring deep valleys, lakes, passes, and peaks. The shadows lengthened and the golden light on the snowy mountains intensified. The pilot told us to crowd up front so that we could better see what was unfolding around us. It was a fantastic experience as we flew over the glaciers and among the craggy masses of mountains. I had no desire to photograph because I did not want to divert my passionate attention from the incredible sights developing around us. We landed in Juneau harbor on the pontoons. After locking up the plane, the pilot and I had a few drinks. A superb day!

The next evening the governor drove us to his cabin northwest of Juneau at Eagle Bay. On the way, being conversationally excited by a political opinion while rounding a sharp curve, we met head-on, though at slow speed, a large government truck. I was sitting in the passenger seat and my skull plowed into the windshield, causing me to see more stars than I would at a planetarium. It was a good bump but I quickly recovered. The two young men in the truck were terrified when they saw that they had collided with license plate "Alaska 1," but the governor put them at ease, saying, "Nobody's fault, boys — just an Alaskan event." We arrived at the cabin and had a happy evening (the governor had no objection to a good party) and we returned to Juneau about midnight.

Our next flight was by scheduled plane from Juneau to Anchorage. The governor had asked the pilot to fly as close to Mounts St. Elias and Logan as regulations permitted. A gloriously clear day revealed a remarkable mountain vista; flying at ten thousand feet we were about midway between the glistening summits and the glaciers entering the sea. I suffered a disturbing headache en route, very unusual for me.

At Anchorage we were met by two representatives of the Alaskan

Railway and driven to the yards where I was introduced to a motor-driven rail car by which we would travel to McKinley Park Station. This conveyance was an old stripped-down Plymouth with flanged railroad wheels. The steering wheel was removed but the post remained, a marvelous instrument for impalement.

Our companions were an official of the railroad, who served as our driver, and the railroad's medical chief. As we headed east the doctor noted my forehead bump and asked, "What happened to you?" I told him about the car-truck encounter the previous evening. I said that I felt fine but that I had suffered a bad headache during the morning flight. He glared at me and said, "Don't you know it could be fatal to fly after suffering a concussion?" I said I didn't even know I had a concussion. He admonished me to take it very easy for the next few days. Of course, that was impossible.

The trip to Mount McKinley National Park was memorable. It rained most of the time and the driver of our makeshift rail car discovered that someone had failed to fill the brake sandboxes; applying the brakes without sand on the wet rails had very little effect. We saw a moose ahead and it was a miracle that we avoided him; he ambled off the track just in time! The driver, a bit shaken, decided he should look up the trains scheduled for the day, which might be coming our way on the single track. There were a few sidings we could turn off on, if we could stop. We slowed down to twenty miles per hour.

The driver said, "If you see a train coming, jump!" Then he announced, "In fact, we should be meeting a freight train in a few minutes." When we saw a siding sign, the driver down-geared the car and it gradually slowed. The driver and the doctor nimbly jumped off and grabbed each side of the car, with considerable effort bringing it to a squeaking stop a few feet from the siding switch. We all then pushed the car off the main track. In about ten minutes the freight passed, our car was pushed back on the rails, and we were on our way. It was raining heavily. The rear wheels spun on the wet rails, but we finally achieved about thirty miles an hour. Fortunately, no other train coming toward us was scheduled for that day, though there was no published schedule for moose traffic.

The rain finally stopped, the rails dried, and the brakes worked. We passed several busy repair crews; the melting permafrost frequently causes the rails to sag, creating a continuous maintenance problem.

We arrived rather late at McKinley Station for a dull dinner and a night plagued with mosquitoes. The next morning we were driven by regular automobile the ninety varied and beautiful miles of park road

to the ranger cabin at Wonder Lake, where we stayed for several days. We were near the land of the midnight sun, where it is no longer darker at midnight than early twilight in San Francisco. This region is quite colorful; the mountains to the north reminded me of those in Death Valley.

I was stunned by the vision of Mount McKinley, which rises eighteen thousand feet above its immediate base to its summit of twenty thousand six hundred feet. It is a vast, magnificent mountain, presenting complex challenges to the photographer. Upon arrival, I photographed it, wreathed in clouds and with a glorious full moon setting behind its snowy peak. At about one-thirty A.M. the next morning, as the sun rose, the clouds lifted and the mountain glowed an incredible shade of pink. Laid out in front of Mount McKinley, Wonder Lake was pearlescent against the dark embracing arms of the shoreline. I made what I visualized as an inevitable image. The scale of this great mountain is hard to believe — the camera and I were thirty miles from McKinley's base.

The weather did not continue to cooperate; it was most discouraging photographically. There were constant clouds about the summits, though we did not suffer the persistent drizzle of the coast. After several days we moved on to Fairbanks, where Michael and I found ourselves in a dust storm with temperatures of ninety-five degrees in the shade. I had always thought of Fairbanks as a below-zero town. In the northern summer, with many extra hours of sun, it can be a very hot place indeed. We returned to Juneau by air, with a stop at Whitehorse in the Yukon Territory. We crossed the famous Chilkoot Pass at an alarmingly low altitude. A heart patient had been put aboard at Whitehorse, and the pilot was asked to fly at as low an altitude as possible. He maneuvered the old DC-4 dexterously through the pass; I could see every blade of grass and wildflower. As we approached the coast, great panoramas of mountains and distant sea were revealed. We circled over the jagged, ice-thorned Mendenhall Glacier and made a safe landing at the airport northwest of Juneau.

While we awaited a trip to Glacier Bay National Monument on a National Park Service launch, I explored Juneau without much photographic success. A portion of the trip to Glacier Bay was rough and rain was continuous. Once there, I made few photographs, mostly details of grass, leaves, and rock. More distant views were hampered by the weather. One wonderful morning the clouds lifted and we could see Mount Fairweather rising fifteen thousand feet above us, a white glory in a slate-blue sky. Before I could get my camera on the

tripod, clouds and mist obliterated the peak and I did not see the mountain again.

The National Park Service launch took us into several inlets, one close to the Marjorie Glacier. This location yielded a few gray negatives, for the wet weather persisted to the point of exasperation. I found the most extraordinary natural details in the interstadial forest, where a large stand of cedars, leeward of a rock ledge, had been sheared off a few feet above their bases by a recent advance of a glacier. The stumps were impregnated with glacial silt and stood firmly on the sharp rock of the shore. They were gray-white, ghostly, and of varied shape and surface, enhanced by the overcast light.

The stone of the area is hard and fresh; it shatters into clean-edged geometric shapes, which I have seen before only in the highest altitudes of the Sierra Nevada. The ice withdrew from Glacier Bay only a few thousand years ago; the Muir Glacier had receded seventeen miles since John Muir first camped near its base in 1879. This harsh land is blessed by the beautiful northern light and the constant, cleansing rain. Where there is vegetation, it is of lush, cool green; grasses and leaves glisten under rain in the soft, but revealing light. The waters of Glacier Bay are very transparent, and I could see far into their rocky depths.

My National Park Service companions had further work to do in the field; before leaving Juneau on this last and momentous excursion to Glacier Bay, I had made arrangements for a seaplane to pick up Michael and me near Bartlett Cove and bring us to Juneau where we were to board the ship for Skagway. The seaplane arrived through the overcast and we hurried to load our gear. The case holding my film of the entire Alaskan trip fell into the shallow water of the landing dock. It was quickly retrieved from two or three feet of very cold water, opened, and the water that had seeped in, was drained. There was nothing more to be done until I reached Seattle and could airmail the film to my superb assistant Pirkle Jones in San Francisco, who I knew would instantly do the best possible job of developing them. The films were packed in separate boxes for normal, normal-minus-one, and normal-plus-one development. I was naturally quite worried about them, but thanks to Pirkle's care only a few were irreparably damaged; my prized Mount McKinley negatives were perfect.

In 1948, my Guggenheim Fellowship was renewed and I returned to Alaska, without Michael but with Glacier Bay in mind. Again, the weather was consistently hopeless for photography; only four clear days in the whole month of July! Under constant drizzle and heavy

clouds, I made appropriately gray studies of leaves along the trailsides of the park, water glazing every surface. I longed for open skies. Fortunately, I became friends with the glacier study party of the U.S. Geological Survey and made two flights with them over the Juneau ice field. The first trip with the pilot was marvelous. While sitting beside him I saw much of the Coast Range, as we circled peaks and domes that rose above vast expanses of ice and snow.

Walking, we see much of the detail around us, the endless progression of the small patterns of the earth as well as the associated distant vistas. Riding a horse, we see less of the immediate detail but perhaps gain in the vistas. Driving an automobile, we see little, if any, of the detail and are confronted with unfolding vistas though with little time for appreciation. From an airplane the world recedes into unfamiliar patterns and shapes. We seldom see the shapes of the earth aesthetically interpreted with subtlety and fine craft, such as the achievements of the great aerial photographer, Bill Garnett.

On the second trip over the ice fields, I was tied to the plane with ropes in the cargo section of the Grumman Goose from which the door had been removed. I wore all the clothes I had and borrowed a heavy overcoat. It was extremely cold; I worried about how to complete the trip unfrozen and had no way to communicate with the pilot. I attempted a few photographs in spite of the cold and the buffeting slipstream. The pilot wheeled about and returned to Juneau and I was untied, unbundled, and removed from the plane in a semi-cryogenic condition. I was thawed in civilized tradition with a hot toddy or two. The pilot admitted he had not given thought to how cold it might be for me. Live and learn!

The same group flew me in the Grumman to their camp at Bartlett Cove in Glacier Bay. They were to fly me by helicopter to the summit of Mount Wright, leave me there for the day with my camera, and pick me up at dusk. The next day and for two days thereafter we were rained in. I photographed a few details about the camp but was getting restless. Each morning the geologists went off in little outboard motorboats on their appointed rounds, but there was no room for me.

On the third morning, at about two A.M., the skies were clear and crisp and the helicopter was made ready. It revved up a bit, then shut down and the pilot and copilot examined the engine. They reported that a bearing had burned out and it would take days to get a replacement from Seattle. The flight was off and I was stranded at the end of an isolated inlet, frustrated but pondering my good fortune that the bearing did not fail in flight or after I had been stranded on the top of

the mountain. I could see beautiful clouds in the distance and could imagine the glitter and clarity of the high peaks; there was no way to move into photographically favorable territory.

The next day it was decided that I was not being treated well, and the leader said, "You and Harry and I will take one of the boats for a trip up the coast." We started out with good weather and renewed expectations. The Evinrude motor performed well for about ten miles, then failed completely. With two pairs of oars we undertook to row south back to camp; the wind and current were against us, and though rowing arduously, we lost more ground than we gained. The only thing to do was beach the boat on the rocky shore and await rescue. We had no radio, but I was assured that "the boys will find us in good time." It began to rain and continued into the next day. It was a long and dismal time under the persistent drizzle on that barren beach. As high tide can be twenty feet or more above low tide, we would pull the boat farther on shore every few hours. There was nothing to secure it to but hard, sharp-edged, and heavy rocks. There was nothing to sit on, or lie on but those unforgiving rocks, anatomically nonconforming and wet with rain. As expected, around ten o'clock the next morning a rescue boat appeared and we were towed back to camp, a long, choppy trip under increasing rain.

After two more gray, rainy days, we flew back to Juneau. A few days in Juneau — a bit lonely, because the governor and his wife were in Washington — I gave up and flew directly to San Francisco. Such may be the experiences of summer weather in Alaska.

During that wet and quiet month I had a lot of time to think and to consider fully my beliefs about conservation and the environment, prompted by the great problems facing Alaska. While Alaska's population was only a few hundred thousand people, the land area was immense and its potential wealth enormous. Governor Gruening was aware of the dangers of uncontrolled exploitation and wisely balanced the pressures. I agreed with his position that Alaska must not stagnate; its development should be carefully regulated; its wildness and beauty preserved and its principal assets and resources utilized with great care.

William Colby felt that those who loved the land should be able to enjoy it in appropriate ways and that such lands should be increased in number and area throughout the country. He was not averse to service facilities in national and state parks provided they did not impose activities and ambience foreign to the spirit and intention of the reserved areas. I remember Colby describing a talk with John Muir at Glacier Point in Yosemite in about 1908. It was a glorious day, and Muir said

to Colby, "Bill, won't it be wonderful when a million people can see what we are seeing?" Since then many millions have stood at Glacier Point and experienced the vast view of Yosemite Valley that remains nearly free of evidence of human presence.

As I spent the quiet days in the wild regions of Alaska, I clarified my own concepts of re-creation versus recreation. I saw more clearly the value of true wilderness and the dangers of diluting its finest areas with the imposed accessories of civilization. In Alaska I felt the full force of vast space and wildness. In contrast, the wild areas of our other national parks in the Lower Forty-eight are relatively confined and threatened with increasing accessibility and overstressed facilities. With the usual bureaucratic opacity, national park trails are valued in relation to their degree of use. Little stakes are driven into the ground, usually in the middle of a fine vista, with names or numbers of "educational" value, shattering the moods of simple reaction and contemplation. Roads had been built across the center of some meadows in Yosemite Valley so that the public could see more of the cliffs with less interruption of the forest upon the views. Not only did these roads damage the drainage and ecology of the meadows but they imposed an artificially managed and measured experience upon the public. In Alaska, the little towns were ugly but minuscule in relation to the wilderness around them. Occasional mines and timber cutting were worrisome only when I thought of their possible expansion. The full impact of industrial development introduced by the oil pipeline across Alaska had not yet appeared.

The quality of place, the reaction to immediate contact with earth and growing things that have a fugal relationship with mountains and sky, is essential to the integrity of our existence on this planet. On this rainy trip to Glacier Bay, I realized the magnitude of the problem and resolved to dedicate as much of my time and energy to it as I could. I regret that my accomplishments could not equal my intentions.

In 1950 in *My Camera in the National Parks,* I set down my beliefs:

We have been given the earth to live upon and enjoy. We have come up from the caves; predatory and primitive ages drift behind us. With almost the suddenness of a nova's burst to glory we have entered a new dimension of thought and awareness of Nature. The earth promises to be more than a battlefield or hunting ground; we dream of the time when it shall house one great family of cooperative beings. At least we have the promise of such a world even if the events of our immediate time suggest

a return to tooth and claw. We hold the future in a delicate and precarious grasp, as one might draw a shimmering ephemerid from the clutches of a web. The heritage of the earth, direct or synthetic, provides us with physical life. . . .

One hundred years ago the larger part of our nonagrarian land was a complete wilderness. Miners were just penetrating the foothills of the Sierra Nevada; hunters, trappers, and explorers had combed the mountains, plains, and backwoods of the continent but had left little permanent impression on the more comely features of the land. True, vast forests had fallen before the axe and plough, and wildlife was sorely depleted. Myriads of buffalo bones bleached on the great plains, hides and pelts piled into the millions, the oceans were drained of the leviathans. These human invasions were as a great wind, wreaking certain havoc, but permitting certain revivals. Machines had but slightly supplemented hands. Man lived close to Nature — a raw and uncompromising Nature — and he was a part of the great pageant of sun, storms, and disasters. By the turn of the century the Nation came into its adult strength, industrialization had launched its triumphant final campaign, and men turned upon the land and its resources with blind disregard for the logic of ordered use, or for the obligations of an ordered future. The evidence is painfully clear; entire domains of the Pacific Northwest — once glorious forests — are now desolate brushy slopes. Thousands of square miles of the Southwest, once laced with green-bordered streams prudently secured by the groundcover of ample grass, are now a dusty phalanx of desert hills, starving the pitiful sheep and their shepherds that wander over them. We all know the tragedy of the dustbowls, the cruel unforgivable erosions of the soil, the depletion of fish and game, and the shrinking of the noble forests. And we know that such catastrophes shrivel the spirit of the people.

Possessions, both material and spiritual, are appreciated most when we find ourselves in peril of losing them. The National Forests were established just in time to prevent unimaginable disaster. Through the far-seeing efforts of men such as John Muir and Stephen Mather the concept of the National Parks was solidified and vast areas set aside *in perpetuum* against the ravages of diverse forms of exploitation. Then, through the device of Presidential Proclamation authorized by the Antiquities Act, many National Monuments of exceptional worth and interest were

added to the growing system of conserved areas. Add to this the belated controls of other natural resources, and we cannot feel altogether planless and drifting — although almost every protective regulation was effected too late to achieve the ideal measure of success. . . .

The National Parks represent those intangible values which cannot be turned directly to profit or material advantage, and it requires integrity of vision and purpose to consider such impalpable qualities on the same effective level as material resources. Yet everyone must realize that the continued existence of the National Parks and all they represent depends upon awareness of the importance of these basic values. The pressures of a growing population, self-interest, and shortness of vision are now the greatest enemies of the National Park idea. The perspectives of history are discounted and the wilderness coveted and invaded to provide more water, more grazing land, more minerals, and more inappropriate recreation. These invasions are rationalized on the basis of "necessity."

And this necessity may appear quite plausible on casual examination. People must have land, and land must have water. Cattle and sheep must have forage. With the establishment of reservoirs — great man-made lakes often reaching far into the wilderness domain — come diverse human enterprises, roads, resorts, settlements. The wilderness is pushed back; man is everywhere. Solitude, so vital to the individual man, is almost nowhere. Certain values are realized; others destroyed. . . .

The dawn wind in the High Sierra is not just a passage of cool air through forest conifers, but within the labyrinth of human consciousness becomes a stirring of some world-magic of most delicate persuasion. The grand lift of the Tetons is more than a mechanistic fold and faulting of the earth's crust; it becomes a primal gesture of the earth beneath a greater sky. And on the ancient Acadian coast an even more ancient Atlantic surge disputes the granite headlands with more than the slow, crumbling erosion of the sea. Here are forces familiar with the aeons of creation, and with the aeons of the ending of the world.

19.

Edwin Land

I FIRST MET EDWIN LAND IN 1948 AT A PARTY AT HIS HOME in Cambridge, Massachusetts, soon after his announcement of his Polaroid Land instant photographic process. The next day, as I visited him in his laboratory, the brilliant scientist made a portrait of me with his prototype camera. As it was peeled from its negative after just sixty seconds, the sepia-colored print had great clarity and luminosity. We were both beaming with the satisfaction of witnessing a photographic breakthrough come alive before our eyes. For Land it represented confirmation of a dream; for me it was a thrilling experience relating to the future of my craft and my first adventure with instant photography.

From our first meeting, I responded warmly to Land's intellect and personality; we seemed intuitively to understand each other. Land has an extraordinary curiosity about everything and the discipline to satisfy it. I am not a scientific genius as is he, but I have a compelling interest in the developments of science and technology.

I soon wrote to him, expressing my reactions to what I had witnessed in Cambridge:

February 5, 1948

Dear Dr. Land,

My interest in the new camera and its aesthetic potentials is, as you know, considerable. I have a few questions to ask which will have practical benefit to me in the future — provided you choose to give the

answers at this time. I will thoroughly understand if you feel certain aspects of the process cannot, or should not, be discussed at this time. My questions are:

1. Permanency. Are the prints, as they are now produced, permanent? Would some metallic toning treatment (of the gold-protective bath Kodak GP-1) be advisable — whether or not the print is to be toned in selenium or by the Nelson Gold-toning Process? Will the prints also stand the heat of dry-mounting?

2. Considering normal use of the materials as being a Weston speed of 125° F and a processing time of 1 minute, what may one say the difference in effect will be with more-or-less exposure, and / or more-or-less processing time?

I would, of course, make for myself a series of practical tests placing various brightnesses on different zones of the exposure scale; I believe I could determine simple working effects that way. But, of course, I realize there may be chemical and physical effects involved in changes of processing time that might have serious effects on the quality, color, and permanence of the image.

3. Being orthochromatic, I presume the emulsion will respond to the usual filters employed with that type of emulsion. And will it also respond to Polaroid filters?

4. Have you any idea of the reciprocity departure of the emulsion? That is, have you found a low point in image-brightness in which the characteristics of the emulsion are appreciably changed?

Cordially,
Ansel Adams

Land and his wife Terre responded with interest in my work, and the next year they purchased my *Portfolio I.* I received a most encouraging letter.

February 1, 1949

Dear Mr. Adams:

Your Portfolio has been a continuous source of satisfaction to our family and our friends. My own admiration for your combination of aesthetic and technical competence is complete. As a small indication of this I should like to send you a camera and associated equipment and film as a personal gift. Since I am always a little puzzled about where you are,

*will you let me know where it should be sent, or best of all, is there any
chance that you might visit us and pick it up here?*

With kind regards, I am sincerely yours,
Edwin Land

Thus began my experimentation with the Polaroid camera and
film, soon followed by an invitation to become a consultant, a profes-
sional association that has continued to today. I believe my services
were helpful to Land in several ways. His aim was to produce the most
perfect picture-making process, and he felt that I, an exacting photog-
rapher, could provide important feedback. Since I balanced creative
ideals with a practical approach, were I pleased with his product, so
too might other creative and professional photographers.

January 10, 1950

Dear Dr. Land,

*This is just a short report relating to the use of the Land Camera on a
field trip with students from the Art Center School here in Los Angeles.
I hasten to get it to you while the ideas are warm.*

*I used the camera to very good advantage in demonstrating some prac-
tical sensitometry;*

We used the camera in demonstrating the limits of range of color film.

*We used the camera to demonstrate composition, arrangement, and
relative scale.*

*We used the camera to demonstrate various expressions and postures
in making portraits.*

Significance:

*It is obvious to me that the value of the Land Camera in teaching
various aspects of photography is extraordinary. This is the first chance I
have had to use it in this regard.*

*I suggest that your sales division further explore the use of the camera
by photographic and art schools; I am sure there is a rather large potential
market there.*

Negative Comments:

These related to:

*Color of image. All students objected to the brown tone. They are
taught to work for much colder values in regular work.*

Lack of stop and shutter speed indications. The students all made this objection, but were somewhat calmed down when I told them that the Land shutter numbers related to definite stop and speed values.

Shutter speeds thought not adequate for sports and ordinary street action.

Sincerely,
Ansel Adams

Land had at his command many people talented in the fields of physics, chemistry, and optics; in addition he brought people of imagination and aesthetic training into his research groups. One was the art historian Clarence Kennedy, a wiry little man with great intelligence and spirit. He had worked with Land on the development of the original polarizing plastic, a tremendous contribution to the science of optics and to the world at large, primarily as the famed Polaroid sunglasses whose lenses reduce or remove the glare from water, glass, and other reflecting surfaces.

In the late 1930s, Land designed an 11x14-inch stereo camera for Kennedy with which he made photographs of classical and Renaissance sculpture that revealed not only his perception of the varied subjects but his extraordinary ability to record the glow of marble and the sheen of bronze in breathtakingly beautiful prints. His photographs of paintings produced images of super-realistic quality complete with a sense of depth of paint.

When the great collection of Italian masterworks (including Botticelli's *Birth of Venus* and some della Robbia terra-cottas) was sent to the 1940 Golden Gate Exposition in San Francisco, Kennedy was invited to direct their installation and lighting. I saw much of him, because the photography galleries that I was in charge of were in the same building, the Palace of Fine Arts.

Kennedy's experience at the exposition was harrowing. The huge packing cases containing the Italian masterpieces were picked up at the dock by heavily guarded trucks and, with a motorcycle escort, hauled to the exposition grounds. Before unloading commenced, however, the public relations department appeared with some bathing beauties who were draped on and about the cases for publicity pictures. Little did they realize the glories the cases contained. Kennedy was beside himself; we all agreed it was a rather inappropriate combination, but publicity, then and now, invites the ridiculous. I shall never forget the goose pimples on the girls, posing in enticing positions un-

der a cold, foggy sky. While it was in pre-bikini days, there was still a lot of epidermis exposed to the elements.

It was a mystery to everyone why the Italian government allowed the export of many of the greatest art treasures of the Western World. Kennedy, of course, was gravely concerned about their safety. It was promised that the temperature and humidity controls would be installed and working before the exhibit arrived. They were not! An anxious Kennedy spent a worrisome night on an army cot in the galleries, surrounded by what he says must have been the sound of the frames cracking in their crates. But the tardy equipment finally arrived, was properly ensconced and working the next day, and the exhibition opened to incredible success.

Edwin Land was able to assemble such diverse and brilliant working groups that included the oddities Clarence Kennedy, an art historian, and Ansel Adams, a practicing photographer. He nurtured participation and praised any breakthrough his groups might accomplish. This attitude stimulated all who worked with him.

As a Polaroid consultant, I was primarily involved with the qualities and performance of materials in reference to my professional and creative approach. The Polaroid Land process is of great technical complexity, and the delicate variations and balances of the physical qualities were kept meaningful and clear by a high order of technical and aesthetic direction.

It is unfortunate that most photographic manufacturers know or care little about creative photography. They have a vast knowledge of advertising and sales, some of engineering, optics, physics, or chemistry, but none of aesthetics. Everything must relate to the marketplace; if sales are not adequate, the corporation will find it difficult to continue, certainly unable to spend funds on exotic indulgences such as fine printing papers. This is true from a simplistic, economic viewpoint, but Land believed that if the manufacturer includes objectives of highest quality in the social and aesthetic sense, all of his products should benefit. I learned very important lessons in this regard; I became more resolute to the challenges of quality, yet more understanding of the realities of the marketplace.

Land was not an easy boss. He had tremendous energy, often arriving at his laboratory by eight A.M., returning home sometimes by seven P.M., though often after midnight; he expected his group to do likewise. They thought nothing of a weekend call to come to the laboratory and help him complete a task. I recall one time Land and I were working late on a project; at midnight I was bushed and could

no longer think straight. I was staying with the Lands, so leaving was difficult, but I did. Land did not leave until three in the morning, tired but satisfied that the experiment had been finally and favorably completed. I think he was a bit disappointed in me for not sticking it out, but I was so sleepy I might have done more harm than good.

Underlying his monumental scientific achievements, Din Land's prime objective relates to communication between people. He is convinced that images can be as effective as words and that every person has a latent ability to make effective contact with another through visual statements. He felt that with the Polaroid process, "Everyone can be an artist." I had a friendly disagreement with him about the definition of artist, but I knew what he intended by that statement — that everyone can become visually expressive and a fresh order of communication could assert itself. I do think that visual sensitivity and expression can be developed to a high degree of subtlety and accuracy. I have dreamed of an experiment in which a group of men and women would be isolated for several months under strict prohibition of using the spoken word. They would communicate only by "instant" images.

Land is especially concerned with the potential of young children to observe and capture the unfolding wonders of the world around them. He is critical of conventional educational methods and systems, trusting in the basic abilities of the mind to create a better world before the suffocating intrusion of irrelevant facts and ideas saturates the potential intellect, curiosity, and receptivity of youth.

Din, Terre, and their two daughters grew to become close personal friends of ours. My first excited letter on an important event was written to the Lands on April 10, 1959.

Dear Din and Terre,

I want you to be among the first to know that I have been awarded my third Guggenheim Fellowship!

This relates to the summation of my work; the making of definitive prints — mostly of negatives heretofore not adequately printed. This is very important to me, as the body of my work has never been adequately printed or presented. I have always been too busy doing professional work to find the time to make really fine prints. It has been a constant cause of concern, as some of my best work has never been on paper!

The grant is not large financially — $3,000 a year for two years —

*but it will make possible my rejection of some dismal bread and butter
assignments which I have to do in the portion of time not devoted to
Polaroid projects. Another grant through the Sierra Club is making pos-
sible* Portfolio III *(Yosemite Valley), and the returns from the sale of
this portfolio will accrue to the Club and permit the printing of more
images of the Natural Scene.*

*If all goes well I will find myself completely occupied with creative
work and that will be good. Anyway, I wanted to keep you advised of
the Beard's progress.*

Lots of love from us all — as ever,

Ansel

I was very surprised to find a very thoughtful friend in this man
whose genius often isolated him from others. I took our daughter
Anne east with me on one winter trip and on our final day in Cam-
bridge we were at a party at the Lands'. It was a happy affair, with
many people of varied interests. The social exchanges bristled with
ideas and serious, but never stuffy, conversation. We were to take the
night train to New York at about ten P.M. and Anne became very
sleepy so I thought it best to leave for the train. As Land bundled us
into our taxi, he gave directions to the driver and his taxi charge num-
ber and off we went through an incredibly heavy and dangerous Atlan-
tic snowstorm.

As we were walking into the station I heard a voice behind me,
"Carry your bag, mister?" I was counting my pennies so I declined.
The voice persisted, "Glad to carry your bag, mister."

I looked around and there was Din. Bewildered, I asked, "What in
the world are you doing out here in this blizzard?"

"Just wanted to be sure you and Anne made it safely. Have a good
trip." As our taxi left his home, Din had gotten his car out of the
garage and followed us, through a heavy storm, to the station.

I saw that Anne was secure in the Pullman lower berth and I
climbed into the upper. We were asleep about an hour before the
scheduled departure. I cannot remember a more restful night in a Pull-
man. When I awoke, the train was still; I poked my head out of the
curtains and asked the passing porter, "Are we in Grand Central?"

He sharply replied, "Goodness no, we are still in Boston!"

On pulling out of Boston an icy switch derailed the engine, and we
were stuck there until nine A.M. We arrived in New York late in the

afternoon, with snow and ice to excess everywhere. I telephoned the Lands to tell them we were safe, and Land remarked, "If I had known it was going to be like that, I would have gone with you!"

The San Francisco earthquake of 1957 was severely exaggerated in the news reports that reached Cambridge. Land phoned and asked, with real concern in his voice, "Are you all right?"

I replied, "All okay, a little damage to the house, no fire."

He rejoined, "Did the quake bend your nose back in shape?" How he had remembered the story told to him years before of the small disaster about Adams and his nose from the 1906 earthquake was beyond me. I treasured this thoughtfulness.

It is little known that Din Land is a benign prankster, performing unexpected little turns of fun, seasoned with witty remarks. Years ago, I arrived at the Land home for an early Sunday supper. I saw a most unpleasant-looking man slouching at the entrance, with coarse features and a large cigar in his mouth. He glared at me as I approached, and I thought, "The Boston Mafia!" Then Did said, "Hello," and took off the mask and cigar. I am sure he noted my first expression of alarm, followed by one of great relief, and ending with a thorough enjoyment of his visual joke.

Once Din and I went to Dr. Harold Edgerton's laboratory at Massachusetts Institute of Technology to observe the making of a strobe flash picture of a bullet piercing a balloon, recorded on a new Polaroid transparency material. The extremely short electronic flash was fired by microphone. We stood around, expectantly waiting for the firing, fully briefed on what was to occur and how safe it was. The revolver was securely lashed to a firm support, and there was an efficient sand trap to catch the bullet. The balloon was filled with talcum powder, inflated, and properly placed in the line of fire. The camera was focused upon it, all ready to go. At the moment of firing, one of Edgerton's assistants struck a large segment of rail with a heavy metal mallet. The sound was terrific, and all but Edgerton and Land hit the floor. Great hilarity ensued. The photograph came out perfectly, with the bullet clearly emerging in a cloud of talcum from the still-tense surface of the balloon; at the moment of exposure the balloon had not had time to think about collapsing.

In the early days of Polaroid, I found that the majority of professional and creative photographers dismissed the process as a gimmick. I was considered by my colleagues a bit eccentric because of my enthusiasm and championing of what they considered a beguiling toy. Aware of the resistance by professional photographers to the available

roll-film product, I urged development of a 4x5-inch film-pack system. I helped put the research and development into motion, but I wish to make it clear that I did not invent the Polaroid film-pack. To function in the new and larger format, the Polaroid process had to be adjusted, which involved sophisticated technology and design. I received the prototype materials and immediately began to experiment with them and to render reports. Most of the results of my work were communicated through correspondence as I continued to test products in Yosemite, San Francisco, and Carmel. To date, my files hold over three thousand memos to Polaroid, some of them up to eight pages long.

The 4x5-inch film-pack adapter, containing the processing rollers, dependable pack insertion and withdrawal mechanisms, and well-engineered design, appeared in 1958. Sophisticated improvements have evolved packs of eight films each in both 3¼x4¼-inch and 4x5-inch sizes, using both positive print and positive-negative (P/N) materials as well as Polacolor film.

I believed the best way to win converts to Polaroid was to provide my fellow professionals with boxes of the film to experiment with. I had some sent courtesy of the company to Imogen Cunningham and received this letter in reply:

February 10th, 1964

Dear Ansel,

Herewith I am giving you notice that I am practically dropping dead from overexposure to POLAROID. Quite a number of people have seen my tries and quite a few people like them, so I have decided that I will make you a visit with a pocket full of them. I have used mostly 52 but seem to do as well on 57. I have done very few 55 P/N because I have only one box. I found out that what you said about the negative and the positive is true but I did do one from which both were useable — that is by printing from the negative on Varigam and using a No. 10 filter. Anyway it is a challenge and I would like to work more on this. I find it so fascinating with people that I run myself ragged and make a shot or two of everyone who comes within my gate. I confess that I cannot run around with a 4x5 camera and keep wondering if the new little camera gives one more flexibility. I went to the Polaroid demonstration at the St. Francis but the gal who showed this camera off was so besieged by young men who wanted her to photograph them, that I didn't get beyond the

edge of the crowd. Besides they had a set up. Bound to come out all right
if you have a measured strobe.

> *Affectionately,*
> *Imogen*

Many of my most successful photographs from the 1950s onward have been made on Polaroid film. A favorite image is *El Capitan, Winter, Sunrise,* made in 1968 with Polaroid Type 55 P/N material. The greatest glory of Yosemite is witnessed during the dawn following a snowstorm. On this snowy morning, I urgently searched the valley for a photograph, for soon after sunrise the trees and valley walls lose their white frosting of snow in the growing warmth of the day. I found El Capitan, the largest single piece of granite in the world, heroically revealed as the clouds and mist flowed about its huge form in wreaths and ribbons. One look at the tonal quality of the print I achieved should convince the uninitiated of the truly superior quality of Polaroid film.

My association with Land provided me access to some of the many theories he has developed. His retinex theory has been of immense importance to me. In this theory he states that the level of the environmental light modifies the appearance of anything seen under it. Black and white photographic prints average twenty percent reflectance; that is, they reflect twenty percent, plus or minus, of the light falling upon them. Placing such prints on light walls merely serves to lower them in value. Land suggests that we reduce the reflectance of the walls to approximately twenty percent in any of a wide range of colors to maintain the proper print values. With these deeper hues the photographs come alive on the wall, and with the addition of light the print's values are emotionally enhanced. It is an interesting fact that color images, both paintings and photographs, are not so obviously affected by environmental reflective conditions.

This can be confirmed by looking at photographs in a lighted gallery through a black mailing tube, standing at a distance where the print area alone is observed and not the wall. The print is looked at through the tube for about ten seconds, then the tube is suddenly removed. The print will quickly drop in value, before the pupil of the eye is able to react.

For many years I have been annoyed by the constant and monotonous use of white or near-white walls in museum displays of photography. I have had several exhibits where the wall color was close to

ideal for my prints: a chocolate brown at the Victoria and Albert Museum in London, and a deep khaki-brown at the Academy of Sciences in San Francisco were two of the best. I chose a forest green for the color surrounding *Moonrise, Hernandez, New Mexico* on the cover of *Examples: The Making of 40 Photographs*. I find it very successful.

Continuously projecting concepts and methods into the future, the advent of the SX-70 camera and process in 1972 opened further worlds of visual exploration and communication. While it was truly a quality instant process for the millions, creative photographers also responded to this brilliant new system. The simplicity of operation and the handsome color print obtained encouraged new and experimental work. Among millions the brand name "Polaroid" is now a household word.

Land continued his commitment to the serious photographer with his creation of special film holders and an appropriate processing unit that produces 8x10-inch instant color prints of extraordinary quality and impact. The 20x24-inch camera followed, and he has also constructed a camera, actually an entire room in the Boston Museum of Fine Arts, with which 72x40-inch prints can be made of paintings and tapestries at a scale of approximately one-to-one. These photographs are extremely accurate in color and detail and compare rewardingly to the originals. The implications are obvious; faithful replicas of important paintings, and so forth, can be displayed in appropriate locations anywhere in the world, not as mediocre copies but as precise simulations, closely conveying the magic of the originals. Conventionally enlarged color prints do not possess the accuracy and conviction of these large contact-quality images.

In 1979 the National Portrait Gallery requested that I make the official portraits of President Carter and Vice President Mondale, the first by a photographer (to the dismay of many portrait painters). I had not done professional portrait work for years, and I agonized over the potential hazards of the assignment. From other photographs I had seen of Carter I was aware he might be a difficult subject. His smile was infectious but photographed like a lighthouse; on the other hand, I could not visualize him in facial repose. I also imagined taking his priceless time, with all the complex arrangements involved, and then having a streak of bad luck with equipment, circumstance, and imagination. To fail would be more than embarrassing.

I considered the problem for a few days and then had a fortunate glimmer of a solution. I telephoned my good friend John McCann at Polaroid and inquired if they would be interested in cooperating with

me in this complicated job. If so, I would at least have immediate feedback in terms of acceptable likeness on sheets of Polacolor material. They enthusiastically agreed; the 20x24-inch camera would be at my disposal with all the lighting equipment required and a staff of four to assist! Fortified with those happy answers and knowing I would have my own very capable assistant John Sexton with me, I accepted the assignment.

The White House is a beautiful expression of traditional American interior design. I observed that when you are in the White House you become part of the decor. I could not conceive of drawing up a chair or even sitting in many of them. I studied most of the White House spaces and considered several possible sites for the presidential portrait, finally selecting a spot by the marble fireplace in the private dining room. A dark-green Early American wallpaper with primitive scenes in unobtrusive design was appropriate to the close-up portrait that was desired.

The sitting was thoroughly rehearsed; one of the assistants who was physically about the same as the President was the stand-in. It was wonderful to have unlimited opportunity to check everything: lighting balance, focus, and composition. John Sexton made a careful notation of equipment position and then, as a luncheon was scheduled, the Polaroid people packed up and removed everything. We resumed refined testing in the afternoon. We then had to pack up and remove all the equipment from the White House as the next trials were to be in the Vice President's residence. I was to photograph the President the afternoon of the following day and was advised I had one hour, at most, for the job; and the day after I was to photograph the Vice President with an even shorter allotment of time.

The Vice President's residence was a far more attractive subject; thanks to Joan Mondale's taste, smooth light-valued walls supported a fine collection of contemporary art. My only problem was that, because of the rather small space, I had trouble with the shadows cast on the walls from the several lights. I finally determined an ideal location: the Vice President would stand on the stair landing with the stairwell receding in simple planes of value, accented by the corner of a vivid, crimson painting.

The next afternoon we were back at the White House, set up and ready to go. The President entered the room and fitted into the scenario perfectly. He was cordial and cooperative and quickly grasped my objectives. I made the first trial exposure. All appeared as hoped

for, but I had one problem: the President was so interested in the process that he would leave his position by the marble fireplace and come to the camera to observe the processing operations. The sandwiched negative and color print are laid on the floor until the seventy-second development time is complete. The negative is then peeled from the print, which in a minute or so acquires the set color, though it continues to improve subtly over the next few hours. It is quite an exciting experience to see this take place before one's eyes. The President had to be coaxed back to his critical position against the wallpaper on numerous occasions. In precise placement, his head related beautifully to the background detail; two inches to the right or left created confusion. The camera is not one with which I could follow the subject. At one point I was not succeeding verbally in correctly replacing the President, so I walked up to him and gently pressed his shoulders into a more agreeable angle to the camera. Suddenly, a firm, stern hand rested on my shoulder; I did not realize that it is taboo to touch the President, and the Secret Service man was very alert. While unsettling at the moment, it was cause for genial laughter from all, including the President.

President Carter's dignified and friendly face was handsomely recorded. Four good photographs were made; the Portrait Gallery got the best, President Carter received one, Polaroid chose one, and I have mine as a prized possession and evidence of an exciting and successful assignment. The 20x24 images are one of a kind.

My favorite photograph from the sitting was not the presidential portrait but the one I made with my 4x5-inch camera of President and Mrs. Carter standing in the doorway of the East Room, holding hands and smiling into my lens.

The same general procedure was followed for the Vice President's portrait. He was most cordial and patient; I could not have asked for better cooperation. We had a little difficulty adjusting the 30-inch lens, and the Vice President utilized the delay by working on papers on the dining room table. His limousine was waiting for him, but he evidenced no haste or concern. I developed great respect and a sense of friendship with the Mondales. Joan is outstanding in her gracious human qualities and her dedication to contemporary American arts. She is called "Joan of Art" for her enthusiastic backing of government support for the arts.

I give a good share of the credit for the success of this project to Edwin Land and Polaroid. Land's extremely active mind encompasses

the worlds of science, art, and human values. A mutual friend once said to me, "Land is not only one of the great minds of the age but he has also one of the great hearts." His prime concern rests in people and everything he has accomplished relates to ideals of civilized man. He truly believes that everyone possesses creative potentials and that in only a few rare instances of genius has this potential been partially revealed.

Few corporations have ever been run as Land ran his Polaroid Corporation. The reality of great success forced a huge increase in manufacturing capability and thus a much larger, internationally based company. Business could no longer be conducted quite the way he liked. He preferred a simpler and more creative pattern of research and production, and retired from Polaroid to create new laboratories dedicated to optical research.

Din has been closely associated with the American Academy of Arts and Sciences, serving as its president from 1951 to 1954 and supporting the building of the beautiful new headquarters in Cambridge, Massachusetts. His philosophy and humanity are revealed in the statement he made on April 2, 1979, on the occasion of the opening of the new home of the academy:

> Each stage of human civilization is defined by our mental structures: the concepts we create and then project upon the universe. They not only redescribe the universe but also in so doing modify it, both for our own time and for subsequent generations. This process — the revision of old cortical structures and the formulation of new cortical structures whereby the universe is defined — is carried on in science and art by the most creative and talented minds in each generation. For individuals to contribute to this constantly evolving projection of mental structures upon the universe, it is necessary for them to concentrate on one area of knowledge or experience, and thus they limit themselves by excluding many other areas. This Academy's function is to associate many specialized lines of concentration by gathering the individuals in whom they are embodied. Thus, while each person is narrowed by his own specialization, the group as a whole is enriched.
>
> The transfer of concepts as models from one field to another requires intimacy, informality and friendliness because the transfer usually is not a conscious process. Models for physics may come from music, for chemistry from physics, for art from

cosmology. . . . The great historic periods of spectacular human advance, within time spans of relatively few generations, may have been periods in which society made possible the concentrated interplay of the separate contributions of creative individuals. There is no way in which we can tell whether we are entering such a period of history, but whether or not we are, the role of the Academy seems clear.

20.

Teaching

RECENTLY, A YOUNG PHOTOGRAPHER BROUGHT HIS portfolio to me and asked for my comments. It was immediately apparent that he was attempting serious work. A few of his images were quite fine; all were refreshing because he was trying to establish a personal vision, to "see." Unfortunately, his craft varied in quality, and he often used two octaves of tonal value for six octaves of potential expression.

How could I communicate my thoughts to this young man without in any way dulling the bright edge of his enthusiasm? I refused to give insincere approval or captious disapproval. I attempted a rational discussion with the photographer on the problems and dedication involved, because I feel obligated to be frank. A critique is an evaluation of shades and levels of capability. What if Alfred Stieglitz in 1933 had dismissed my work with a shrug? It is easy to say that if I believed in myself I would not be swayed by the opinion of others. But the right word at the right time can have immense significance, and thus I explained to the young artist the excitement I felt in his attempt as well as the challenges ahead for him.

I gratefully remember the many helpful comments I received from various sources. Perhaps few were immediately applied, but continuing input from without surely helped progress within. John Marin was someone who took the time to pass on his thoughts to me. He had been generous with comments on art and on my photography since our meeting at Mabel Dodge Luhan's many years before. His watercolors, deceptively simple and broad in color, are disciplined works that clearly display brushstroke efficiency and space-controlled energy. One morning in Taos I watched him paint his *Taos Peaks* watercolor:

with his paint-tipped thumb he delineated the peaks with three sharp, swift gestures! It was an extraordinary example of intuition and complete command of the hand, mind, paint, and paper surface.

Marin would spend days wandering around the Taos country, sometimes painting but mostly looking about, watching cloud formations and, "Just sitting on a rock waiting for something to happen." He stored impressions in his mind, and when the creative pressures asserted themselves, he would work almost feverishly for hours, completing one watercolor after another with enormous energy and concentration. Then, after the production cycle was over, he would return to a passive, soaking-up period. Marin would make statements such as, "I am always exploring something — a rock, a tree, a face, or a cloud — the more I look, the more I see," and, "Keep the camera-eye going; it can't hurt you!"

Marin followed the great tradition of "pass it on": a tradition of sharing knowledge in which I had been raised. My father considered a profession an obligation to be practiced well and passed on to others through teaching and example. He taught that selfishness was a prime sin, and I suppose the sharing desire comes in part from his attitude. As a child, as soon as I understood anything I wanted to share it. Having found a moment of illumination and clarity, I had the urge to repeat the event for myself and bring others to the experience.

My piano teachers never demonstrated for me any music that I was studying. The Socratic method was applied, which ensured maximum individuality in each piano student. My teachers were severe in their technical standards and unforgiving of lazy and sloppy work. If I did not know my notes, I was sent home. If I persisted in errors, they would seldom be corrected by example but by comment, usually conscience-stirring. They stressed personal interpretation and listening to as much music as possible to clarify personal direction. Convinced of the results I enjoyed with the type of music teaching I was exposed to, I was determined to apply those teaching methods to photography.

Perhaps my negative experiences in school encouraged my own urge to teach, but to teach in a completely different way. While I taught music, I was concerned with passing on the inspiring instruction I had experienced from my own teachers. I never gained sufficient facility or experience in my own music to go much beyond the beginning stages of teaching piano. Probably because of my greater passion for photography, I was a far more effective teacher of that medium from the start.

Except for occasional workshops, my first photographic teaching experience was in 1940 at the Art Center School in Los Angeles. I agreed to teach there because I felt it had much to offer; the industrial design division remains without peer to this time. Their photography department, however, was limited, and I saw teaching there as an opportunity to improve photography in the functional as well as creative areas.

The director of the Art Center, Edward "Tink" Adams (no relation), had, by sheer willpower and aggressiveness, raised the school to the top level in its fields: commercial art, design, and advertising. Whenever Tink was mad, he had the habit of breaking pencils. On one occasion he broke several during a ten-minute discussion I had with him on the aesthetic-spiritual potentials of photography.

At the Art Center School, I quickly found I had little to teach but the way I did it. This was in opposition to my concept of instruction in music. The students copied everything I did (even the food I ordered for lunch) simply because I gave them no sensible alternative. That had to change.

With the cooperation of Fred Archer, instructor in photographic portraiture, I set out to plan a way by which the students would first learn their "scales and chords" to achieve technical command of the medium. It took several weeks in refinement before I could teach it to students. I called my codification of practical sensitometry the Zone System. In *Examples: The Making of 40 Photographs* I defined it as:

> ZONE SYSTEM. A framework for understanding exposure and development, and visualizing their effect in advance. Areas of different luminance in the subject are each related to exposure *zones* and these in turn to approximate *values* of gray in the final print. Thus careful exposure and development procedures permit the photographer to control the negative densities and corresponding print values that will represent specific subject areas, in accordance with the visualized final image.

The Zone System worked well, and the students progressed rapidly in their craft. What pleased me most was that they discovered their latent individuality; once they could visualize their images and apply their well-practiced craft, they were able to express themselves with conviction and enthusiasm. Craft facility liberates expression, and I am constantly amazed how many artists think the opposite to be true.

In photography it is vitally important to assume that the student wants to express something, vague as his ideas may be. It is the teacher's responsibility to discover what this expression may be. Many had personally important things to say, but only a few special teachers could help them. The teacher must guide the student carefully, asking if his image says what he wanted to say and what he tried to visualize as the completed print before the exposure was made. It must be the student's image, not one imposed upon him.

Edward Kaminski, a close friend and teacher at the Art Center School, was a remarkable and inspiring teacher with an enormous fecundity of ideas. Ed would take a group of beginning art students to the beach. From a well-worn sack he would extract a variety of objects — a faucet, a piece of broken glass, a sponge, a door knob, a tangle of wire — and would scatter them among rocks and seaweed, saying, "Now look; find things that seem to go together; think of the possible pictures." At first floundering, the students would gradually recognize relationships of shape, form, and values and would become really excited and enthusiastic. Ed also encouraged the students to peer through rectangular cut-out framing cards for ideas of optimum composition. This frame is a teaching tool I still use.

With my students I did not introduce artifacts into the scene as did Ed, preferring the naturally found object for all its promise to the inquiring eye. I took students to parks and beaches, homes and factories, vacant lots and car dumps. Here they were confronted with subjects that seemed hopeless. The students would stand around with quizzical looks on their faces, expressing "What in hell can anyone photograph here?" As in Yosemite, I looked for something as simple as a cluster of pine needles or a few pebbles, and instructed them to observe possible relationships of shapes and values. I had each student look at what I had put together on my ground glass. I always insisted that they could not use *my* subject and composition but must find rewarding organizations for themselves. In a short time, most all of the students would be producing perceptive results and become intensely excited over the art of seeing. Literally, flowers bloomed in the desert and the students entered an era of exploration.

At the Art Center we did extensive basic photographic training for the armed forces and for the photographic departments of the airplane factories. Working with students from the Signal Corps, I recall a typical exercise that I devised: the class was in the basement with cameras secured in their cases and I stood at the school entrance on 7th Street.

When I saw a streetcar coming, I bellowed, "ATTACK!" As the students rushed upstairs I yelled, "GET THAT STREETCAR AS IT HITS THE LINE-OF-SIGHT OF THE POWER POLE!" They yanked cameras from their cases, and attempted to set the focus by feel while they planned the exposure. The aperture click stops were also set by feel, shutter speeds by so many winds of the focal-plane shutter. The next task was to anticipate the right moment to make the picture. The average results were: one-third had streetcar touching the pole, one-third were late, and one-third early. As soon as the shutter clicked, the students dashed downstairs to develop the negatives for a minute in a highly concentrated solution. Fixed for thirty seconds, rinsed in water, then put through an alcohol bath for fast drying, they were then brought to me for evaluation. Some students accomplished the entire exercise in six minutes, including the up and down races on the stairs. The negatives were certainly not expressive images, but some were good solutions to the time problem common in a military situation. I found the project approach to be very effective: students should be given a reason for learning.

The city of Los Angeles had set up a civil defense program and the photography department of the center was asked to help. I worked out a system of corpse identification that could be very valuable in a civil disaster. A mirror was held close to the victim's head and a photograph made, showing both profile and approximate full-face. I took my students to the Los Angeles morgue to practice one night a week. The hard-boiled attendant greeted us with, "Good ev'n, people; you wanna gent or a dame? I got lots — wanna check first?" The desolation lay not with the bodies but in the totality of the bleakness of the basement room with its grim, white walls, its chilling temperature, the ghoulish mentality of the attendant, the cold fluorescent lights, and the acrid smell of formaldehyde. Fortunately, the dead were not aware of their immediate environment.

I remember one dignified-looking old man wheeled out as one of our models. I noted little beads of perspiration on his forehead; the attendant said, "Too much embalmin' pressure — that's formaldehyde comin' through." Whereupon he wiped it off with his sleeve.

The semester came to an end. On my last day in Los Angeles I packed my car with all my belongings and had a few farewell drinks with staff and students. Later I met with my last class at the morgue and worked until midnight. I then set forth for Carmel, arriving at Edward Weston's home after an early breakfast on the road. I was very

glad to see him. He looked at me and said, "Where in hell have you been? You smell like you've been embalmed!" I told the truth and was again scolded for getting too involved with the outside world.

Tom Maloney asked me to conduct *U.S. Camera* Forums in Yosemite that summer of 1940. I invited Edward to teach with me. He contributed greatly during this workshop, more by example than by critiquing student photographs. He would set up his camera, let the students scan the ground glass, and then answer questions. When he was asked to look into a student's camera, he gave recommendations and sometimes moved the camera a little to clarify the composition. Edward concisely defined photographic composition as "the strongest way of seeing."

We made many day-long trips to Mariposa, Hornitos, and Meyers Ranch, just west of Yosemite Valley. We also traveled east on the Tioga Road into the high country of Tenaya Lake and the Tuolumne Sierra. Edward was especially excited when he was surrounded by the granite landscape of Tenaya Lake: glaciated rock, erratic boulders brought thousands of years ago by the glaciers from the distant summit peaks, and the beautiful Sierra junipers growing in the bare native rock. Some of Edward's finest work was done in this area.

However, with all he had to offer, Edward did not really enjoy teaching, and our brief association was very much the exception, not the rule. This workshop was the beginning of what was to become my longest, ongoing teaching experience. I wrote about it in *U.S. Camera,* in 1941:

> The Forum definitely is not a school. It compares with no known undertaking in the photographic world. It offers opportunity for the exchange of ideas and for the observation of methods and procedures. It does not compete with institutions of instruction; rather, it is helpful to all of them, serving as a stimulator of ideas.
>
> Each day's program was somewhat as follows: the group assembled and drove to some spot relatively near at hand on the floor of Yosemite Valley. While assisting others to set-up and compose, and solve their technical problems, Weston and Adams would perhaps make a photograph, with full explanation, or work out problems of composition on the ground glass of their cameras for all to see. All this would be accompanied with a running discussion of pictures, points-of-view, ideas. The attitude

and viewpoint of the individual was always stressed; imitation of what Adams or Weston had done, or were doing, was never condoned. The visualization of the final photograph was paramount in all these discussions and demonstrations.

For that 1940 workshop we had twelve students with total receipts of five hundred and five dollars. I received two hundred as organizer, director and teacher, Edward one hundred fifty, our sponsor, Best's Studio, one hundred, and the remaining fifty-five dollars was applied to expenses. Fortunately, as the years increased, so did our income.

World War II and then my Guggenheim Fellowship years caused inevitable delays, but in June of 1955 I began annual Ansel Adams Workshops that continued in Yosemite through 1981. Thousands of students attended over the years, and I feel it provided an intense short-term learning experience that has been an important alternative in photographic education of the last several decades. Students have come from every state and many countries and such excellent photographer/teachers have joined with me as Arnold Newman, Mary Ellen Mark, Marion Patterson, Al Weber, Ruth Bernhard, and Morley Baer. Because of health, age, and the effects of heat and altitude, I transferred the workshop to Carmel in 1982, under the direction of The Friends of Photography, where we continue, with vigor and in the same tradition.

In 1945 Ted Spencer, then president of the San Francisco Art Association, knowing of my interest in photographic education, asked me to set up a Department of Photography at the California School of Fine Arts. I was most excited. Ted designated a large area in the basement of the main structure and also one of the spacious studios.

Building a darkroom was another matter. I worked for several days on sketches, trying to retain a long line of windows on the north wall; I thought they would prove an ideal illumination for a workbench for mounting, spotting, and other aspects of print preparation. I finally devised a plan comprising a group of darkrooms and a large central room as a demonstration space.

Ted took one look at my drawings and gently asked, "What about the circulation?" I said I honestly could think up no alternative plan that would keep the windows.

He then replied, "Why do you have to keep the windows?" as he quickly made a lucid sketch, which, by disregarding the windows entirely, vastly improved the circulation and even gave space for three additional darkrooms and a larger demonstration area. I heartily

agreed and admitted I had had an obsession about those windows because of my affinity for natural light. I also had overlooked the fact that night classes were planned and we would have to illuminate the workbench anyway. This problem, easily solved by an architect, was also a fine lesson in priority thinking.

The photography area was designed perfectly. The compartments were efficiently built with service station style construction. When the estimates came in I was a bit chilled — ninety-five hundred dollars, without equipment! Ted said, "It's your baby. See what you can do to raise the money." After a discouraging beginning, I finally obtained ten thousand dollars from the Columbia Foundation. I also raised an additional twenty-five hundred for equipment. The project today would cost many times that amount.

Then the unexpected occurred. The painters, sculptors, printmakers, and ceramicists arose in wrath and protest; photography is *not* an art, they claimed, and had no place in an art school. Besides, the other artists insisted they had insufficient space as it was. Ted was really provoked but he stood fast. He knew photography is an art form and he was determined that it become a part of the school curriculum. I was very unpopular around the school until it became obvious that my basic teaching in that medium, in both craft and aesthetic direction, was agreeable and progressive.

I wrote to Ted in 1947:

I think that the students do reflect my influence, and — joking aside — maybe I should stop fussing around and just be an influence! Actually what has happened is this — by some trick of fate I developed my work at the time of a general renaissance of straight photography, and I happened to be one of the very few who were articulate in writing, teaching, and lecturing. My rationale of the exposure-development procedures certainly struck a new note in mechanical approach. I did not invent anything — just restated facts in terms of practical use. I am sure anyone with normal intelligence could have accomplished as much — but it just happened to be me who walked into the arena at the right time.

While each situation is a singular event, there are three basic questions I ask my students to consider when evaluating their photographs: What is seen? How is it seen? How is it executed? What is seen is a matter of time and place and naturally leads to how it is seen, the visualization. Execution relates to craft and acceptable print quality.

For example, the subject might clearly suggest a certain quality of light — was this visualized and achieved in the finished print? Are the print values pleasing or are the high values depressed? If so, I try to help determine the cause. Did the photographer take full advantage of the near-far aspects of the subject? Perhaps moving closer to the subject would increase the sense of space and scale.

A helpful tool I developed was teaching students to "read photographs," that is, to attempt their own visualization from what they suppose the reality might have been while viewing a variety of images of ordinary subjects. I have found it most rewarding to study pictures of all kinds, trying to put myself in the position of the camera in relation to the subject and to visualize images I might find in the same situations. It becomes an interesting exploration, rather uncertain because I can only assume the reality from the image before me.

However, as much as I loved teaching, after a year at the School of Fine Arts I found myself in a struggle for enough time for my own work. Receiving the Guggenheim Fellowship in late 1946 tipped the balance; I could afford to use the next year to photograph for myself. My problem was to find another photography teacher to take my place. The Newhalls, knowing of my dilemma, wrote and suggested their friend Minor White. Minor had been photographing for over ten years, with his progress interrupted by service in World War II. He returned from the war to New York City, determined to discover what was happening in the world of creative photography. Visiting Stieglitz had been a profound experience for him, as it had been for me twelve years earlier. Minor told me that the concrete shell of his life was broken open by the remark from Stieglitz, "Have you ever been in love? Only then can you photograph."

Minor wrote of our first meeting in *Memorable Fancies:*

Ansel met me at the train yesterday. This morning in his class at the California School of Fine Arts the whole muddled business of exposure and development fell into place. This afternoon I started teaching his Zone System. Ansel did not know it, but his gift of photographic craftsmanship was the celebration of a birthday.

After seeing his photographs and observing his teaching of the students over the space of a few weeks, I quickly recognized that Minor was a remarkable photographer and a potentially great teacher. I recommended him as my replacement, and he swiftly established himself

as one of the most important teachers at the school and endeared himself to the art community.

Minor was a very different person and teacher from me. The best description I can give of his teaching is that it involved intense "verbalization" — the talking out of creative intentions, concepts, and directions. Minor required maximum quality and conviction of a photographer's images, all implying superior craft. However, it was the inner message of the photograph that most concerned him; he always wanted to know the thoughts, feelings, and reactions of the artist to his subject and his image.

Many were the vigorous yet friendly arguments we endured on this subject over the ensuing years. I remain convinced that the medium must explain itself in its own terms. I agreed with Edward Weston's frequently spoken Louis Armstrong quote, "Man, if you has to ask, 'What Is It?' you ain't never goin' to know." For me, a photograph begins as the visualization of the image which represents the excitement and the perception of that moment and situation. The print represents excitement, perception, and expression (performance). Meaning is found in the final print and only in terms of the print itself. For me, this meaning may vary a little over time and circumstance. For the viewer, the meaning of the print is his meaning. If I try to impose mine by intruding descriptive titles, I insult the viewer, the print, and myself. I hope to enhance, not destroy, that delicate imaginative quality that should be expected from any form of art.

I recall an excellent example of imposed meaning. I have a photograph of a cemetery statue, an "Angel of Sorrow," in front of a group of oil wells near Long Beach. When I came across this dichotomous scene I was excited by the intangible improbability of the juxtaposition of the objects and the almost sublime quality of light. I made the first print about 1939 and did not resuscitate the negative until about 1970, making a large print that gave me the same excitement I felt at the time of its exposure. A conservationist friend saw the print and became entranced with it as a symbol of pollution and death. I cannot deny him his meaning, although I did explain that it was very far from the original experience. When I encounter a work of art in any form, I make no effort to surmise what it signified to the artist; I can only accept or reject it on my own emotional-aesthetic terms.

Another aspect of Minor's philosophy that I disagreed with was that he believed that the critical attitude should always be with the artist: before, during, and after the creative act. I believe in the use of intuition before and during the creative act, with the critical attitude being

applied only after. Study, observe, practice, perfect the craft of the medium, and then go into the world with trust in your intuitive creative appreciations and ability to see. When a photograph is made, I consider it an accomplished fact. Then, I go on with the next creative effort. To brood over something irrevocably done is a waste of time. Work, of course, must be evaluated with honesty so that we can learn from our mistakes and progress. In expressive photographs, psychological and creative situations of the greatest complexity are revealed that are far beyond conscious awareness.

Minor became known for his mystical approach to photography. I could never establish an adequate definition of just what this approach was, most probably because I am definitely not attracted to those concepts nor to astrology, another favorite subject of his in his later years. Minor drew horoscopes of each applicant before deciding to take her or him on as a student. However, I have no question whatever of his dedicated sincerity. He stimulated students and associates to an astonishing degree, as their continued enthusiasm and productivity attest.

Minor and I strongly agreed that nothing takes the place of constant effort; the artist has no time or energy to waste. Bohemian indolence is the pastime of the inadequate. Whether I walk at Point Lobos, fly in an airplane, move in a new environment, or relax in my home, I am always seeking to relate one shape or value to another, seeing an image in my mind's eye. It is a glorious and rewarding exploration. If something moves me, I do not question what it is or why; I am content to be moved. If I am sufficiently moved and it has aesthetic potential, I will make a picture.

In retrospect, I feel that Minor was just the right foil for the slightly Calvinistic philosophy of the Group $f/64$ school that my friends and I professed. We stressed the basic craft as it has seldom been accented before or since. Minor taught a high order of craft as well as the introspective attitudes of personal psychology and, later, such Oriental philosophies as Zen. In a sense he added another dimension to the art of photography: perhaps controversial, but convincingly creative.

Minor eventually became professor of photography at Massachusetts Institute of Technology. At first it seemed anachronistic that a mystical and emotionally oriented individual found a place in that cool and awesome center of science and engineering. MIT's wisdom was revealed in their desire that the rigors of their basic programs be relieved by exposure to creative art. After all, they had Gyorgy Kepes directing the department of architecture, under whose enlightened aegis Minor functioned. Minor, through his teaching, exhibitions,

lecturing, and consulting, achieved remarkable and fully justified fame. His portfolios and books place him among the most important figures in twentieth-century photography.

Minor was the moving spirit in the founding of *Aperture,* a revered journal of creative photography. Since the days of Stieglitz's *Camera Work* in the early years of this century, there has been a conspicuous absence of publications presenting creative photography, especially its avant-garde directions. Most photography magazines are glorified camera sales catalogs. I wrote to Dorothea Lange, an early *Aperture* supporter, explaining:

March 28, 1954

Dear Dorothea,

Ever since the f /64 days I have preached the need for a truly creative journal of photography. I tried to incite interest in New York when I was at MoMA. I was and am quite unable to sponsor such a journal person- ally — both financially and in terms of time and energy. But the project was always lurking in the background and there were frequent nibbles and gusts of enthusiasm — but nothing happened.

Minor and I saw eye to eye on the need for a journal. I encouraged him to launch it; it seemed a natural for him, immersed as he was in teaching, writing, and photographing along the lines of his own particular direction. I encouraged him to undertake the project, and I assured him I would do everything I possibly could to help. We had a meeting; I got a lawyer out to listen in just to be sure that the plan being formulated did not contain legal bugs. I offered to give a fine print to everyone sending in a $25.00 subscription; I think the total number of prints was about 60.

Love,
aa

I have been often asked how we found the name *Aperture.* Pure luck of the draw. One day in February 1952, Minor and I were sitting in our home, talking about this future journal, when Minor said, "We have it all in the bag except the name." He listed some of the sugges- tions: *Exposure, Stop, Vision, Seeing, New Seeing, Visualization, Camera Vision, New Camera Vision, Photo Digest,* and *The Photographer,* and I replied I thought all of them dreary.

"What's your idea?" asked Minor.

I thought for a few minutes and came up with *Aperture*. It clicked and by spring, *Aperture* was on its way. It was the most imaginative journal of its day; some thought it far out, which, fortunately, it was. The reproductions were of the best quality and the texts kept pace with the imagery.

Over the years I disagreed with some of the content as being neo-scholastic and dominated by Minor's devotion to his mystical approach to photography. These differences were not important; no one could work with Minor without recognizing his genius and dedication. Through various tribulations of finance, format, and direction, *Aperture* continues to function.

My impulse to "pass it on" was further expressed in writing. My first book, *Making a Photograph,* had been a surprising success. Following my spell of teaching at the School of Fine Arts, I decided to write a series of basic photographic textbooks based on the techniques I had developed, including the Zone System. The first volume, *Camera and Lens,* appeared in 1948, quickly followed by *The Negative* (1948), *The Print* (1950), *Natural Light Photography* (1952), and *Artificial Light Photography* (1956). The dust jacket of the first edition of *Camera and Lens* explains the purpose of the series.

> The basic principle of Adams' forthright new approach to photography is startlingly direct and obvious. "Know what you're after," says Adams, "before you begin!" Then each step falls into its proper place and order, because you have the logic of photography as explained in this Basic Photo Series at your command.
>
> *Camera and Lens* and the other Adams books teach you to think "backwards" from the final print you desire, even before you open a shutter. With the print desired in mind, you pre-select the picture proportion, the degree of enlargement, the paper contrast, the handling of negative (development depends upon exposure), the lighting conditions, the arrangement, the film, the lens-stop, and the exposure. Production of fine photographs becomes a controlled process, not hit-and-miss.

Camera and Lens received a warm welcome. When *The Negative* appeared, however, there was a more varied response. There was criticism that the Zone System was too complex, technically erroneous, and unnecessary. I had done a considerable amount of practical research and had ample proof for myself that the Zone System worked

for professionals and students alike. For technical confirmation, I asked Dr. E. C. Kenneth Mees, director of the Kodak laboratories, and Dr. Walter "Nobby" Clark, his associate, to check the accuracy of the Zone System and its codification of the principles of applied sensitometry. Their favorable comments supported and encouraged me.

The publishers of my original *Basic Photo Series* were Willard and Barbara Morgan of the publishing house Morgan and Lester, which became Morgan and Morgan. Willard, affectionately called "Herc" because of his physical size — six feet, seven inches tall and of appropriate structure and strength — was a very active figure in photography in the 1930s and 1940s. He was one of the early supporters of the Photography Department at the Museum of Modern Art. Working with Willard Morgan was a strong confrontation with the journalistic emphasis on photography. Realism and impact were the dominant threads of his approach. Willard was tolerant of poetic aspirations, but he did not fully understand them.

Barbara Morgan is a highly imaginative and capable photographer. Many of her photographs — portraits, dance documentations, and combined-image prints — are a most estimable contribution to creative photography.

Willard's office was in a small building on Park Avenue South: a rather cluttered entrance, then a semi-tunnel to the elevator lobby. A few floors up, a crowded, colorless space looked out on the dreary concrete landscape, even more colorless; if you stretched your head around you might see some looming skyscrapers rising into pale blue or gray. The noise of the city filtered through the windows, and the occasional tragic grace-notes of sirens could be heard. I would arrive at their office to find Willard sitting at a cluttered desk, acting cheerful. I could not understand how anything creative could arise from that environment, and yet they were the leading publisher of photographic books for many years.

In the 1950s, Morgan and Morgan found itself in a difficult financial position. With the cooperation of most of his authors, who agreed to accept delayed royalties, they were able to survive. Upon Herc's retirement, his sons, Douglas and Lloyd, took over the business. Unexpectedly, Douglas personally benefited from our publishing relationship. In 1963 I found myself in real need of a good print spotter. I was completing my fourth portfolio, *What Majestic Word,* an edition of two hundred and sixty portfolios, each containing fifteen photographs for a grand total of thirty-nine hundred prints to spot! I called Brett

Weston to inquire if he knew of an experienced spotter. He replied that he sure did and that she was visiting from Los Angeles.

I said, "Bring her right over!" and he replied, "I know she is busy today but she will be there tomorrow." She was staying with Brett while seeking employment. The truth, I later learned, was that she had never done any spotting, but Brett gave her a twenty-four-hour crash course after I phoned.

The next day Liliane De Cock appeared and, although nervous, demonstrated expertness at spotting. I immediately hired her to complete the portfolios. She proved so capable and such a sensitive co-worker that she became my full-time assistant for the ensuing nine years. Liliane developed a passionate interest in photography and became a photographer of rare promise.

Liliane planned and edited my first general monograph, *Ansel Adams*, and designed *Singular Images*. She worked with our publisher Doug Morgan on these projects, romance bloomed, and they were married in our living room. She moved to the New York area where she is a proud mother, helps in the publishing business, and continues her photography.

Following an apogee of financial disappointments with Morgan and Morgan, my business manager Bill Turnage and I agreed it best to change publishers. In 1974 I happily became associated with New York Graphic Society, a division of Little, Brown and Company. With this change of publishers I felt it time to completely update and revise the *Basic Photo Series*. With the collaboration of Robert Baker, *The New Ansel Adams Photography Series* was created with *Polaroid Land Photography* (1978), then *The Camera* (1980), *The Negative* (1981), and *The Print* (1983).

My earlier books were not only written but edited by myself. I created unneeded embarrassment by not using professional editors and copy readers: every author needs a second opinion to inform him when he is not clear. When it came time to begin the complete revision of the technical series, I knew better what I wanted the series to be, and thus made a serious effort to get a good editor to assist me. Fortunately, Robert Baker turned out to be ideal. He is brilliant, precise, and thoughtful and did an excellent job with my various texts, bringing them together with coherence and taste and without altering my writing style.

High praise is also in order for my two photographic assistants during this period of time. Alan Ross performed the many tasks and tests

for *Polaroid Land Photography* and *The Camera,* and John Sexton did the same on *The Negative* and *The Print.* Without their dedication, imagination, exactitude, and exceedingly hard work such a technically complete revision of the series would have proved impossible.

My personal teaching must be limited, because of age and energy, to workshops for The Friends of Photography, but I am able to teach thousands through this series of books. I am often approached by readers brimming with questions that one of the texts has stimulated. In 1983, while on one of my frequent visits to Point Lobos, I was sitting at one of the picnic benches changing film in my Leica R-4. A middle-aged man, obviously a photographer, since he was festooned with several cameras, came and sat opposite me. He expressed astonishment that I was using a 35mm camera. I explained that I was not dedicated to any particular size and that I had used the 35mm extensively. I am often typed as a rigid large-format man in spite of the fact that I have done much work with smaller formats. With the new 35mm roll securely installed, I made a gesture of leaving when he said, "May I ask you a question?" I agreed to talk and relaxed for the inevitable.

His question was, "Mr. Adams, I've just read your book *The Negative.* You developed the Zone System over forty years ago. Do you think it is still effective?"

I replied that the function of the Zone System is to establish a working technique that enables the photographer better to manage creative visualizations. I do not think the Zone System is fully valid in creative photography without visualization of the expressive image before the exposure is made.

He asked, "But do you think the Zone System is necessary? Alfred Stieglitz and Edward Weston did not use it. Historically, the greater part of photographic work was accomplished without it. Why do you think it so important?"

My answer to this seemed simple. "I think it essential for the beginner and extremely helpful to the advanced worker. I have no doubt that Edward and all the others arrived by empirical experiments and practice to a near-perfect intuitive method of work. In a sense they were obliged to use some applications of the Zone System, whether they knew it or not, as you cannot practice photography without utilizing the principles of sensitometry."

He said, "I am not making myself clear. I look all around me and see hundreds of photographers relying on camera electronics or simply

exposing with random repetition, bracketing exposures to cover mistakes. If this seems to be the modern approach, do you feel your system continues to be relevant?"

I carefully considered my reply. I said, "Being trained in music, I was obliged to know my notes, to practice continuously so that the notes, phrase shapes, and dynamics would be securely established in my mind. My playing, therefore, was expressively intuitive, based on a thorough experience with the facts and structure of the scores.

"What you do not seem to understand is that after the Zone System is learned in detail, then it becomes an intuitive process in practice — a way of thinking and applying technical principles while visualization is taking place. If I had to work out the Zone System details from scratch with every photograph, I would fail as a photographer and artist. Visualization is in two principal steps:

"First, image management, which relates to the construction of the image as the lens delivers it to the film, and,

"Second, value management, which relates to exposure and development of the negative, thereby securing the information for the expressive print.

"With practice this becomes a rapid process, almost entirely intuitive and immediate. I note, with regret, that many of the photographers of the day are not concerned with basic technique. Their work clearly shows this sad fact. There have been many excellent ideas rendered in ineffective craft; the message simply does not come through."

He appeared thoughtful and I quickly added, "I note you have three different cameras around your neck. Do you really know what you are getting with any of them? Can you see the image in your mind's eye, so to speak, before you release the shutter? Do you function on a hit-or-miss basis, hoping that with luck something will turn up in the negative or through darkroom labor? If so, I feel sorry for you as this is not necessary if you acquired the knowledge of sensitometry as taught in the Zone System. Yes, I continue to believe the Zone System represents a very important introduction to a fluid craft approach."

He rose from the picnic table and said, "It's too late for me. I do not have the time to work it out." I found I had nothing to say in reply and I saw him walk off to the cliffs, stand for a few moments looking at the crashing surf, then walk on until he was out of view. I moved out on the trail with my spot meter in one hand, my camera set at manual in the other.

I wondered if I had started something in his mind that became a burden adding to the spirit of uncertainty so many of us have. I was telling him it would take a lot of hard work, from which there is no escape if one wishes to be an artist in any medium. Musicians practice constantly; most photographers do not practice enough. The siren-call of the hobby obscures the necessary exactions of art. It is easy to take a photograph, but it is harder to make a masterpiece in photography than in any other art medium.

21.

Carmel

SINCE 1928, VIRGINIA AND I HAD LIVED IN SAN FRAN-
cisco and Yosemite; by 1961, we felt the need for a change.
We thought seriously of moving to Santa Fe. Wisely, Virginia
pointed out that as much as we loved the Southwest, it was a long way
from our roots and professional resources — I continued to earn a
substantial portion of my living from commercial assignments and she
still managed Best's Studio. We were also reluctant to leave both Yo-
semite and the Pacific Ocean permanently.

The other possibility was Carmel. We had visited that small village
many times over the years and had a number of friends living there,
including Dick McGraw. One of my students when I taught at the Art
Center School in Los Angeles, Dick was serious about his study of
photography and produced some solid color work. Dick was very
well off, the son of the industrialist Max McGraw, president of the
McGraw Edison Company in Chicago.

Talking with Dick one day, I told him of our indecision about
where to move; he suggested we come to the Carmel Highlands, five
miles south of Carmel-by-the-Sea. Dick was living in a small A-frame
house he had built at the end of a road, just a mile south of Edward
Weston's home on Wildcat Hill. Dick awaited the day he could ac-
quire the central hill of the property. That day finally came; Dick had
Ted Spencer design a remarkably contemporary structure, as severe
and spacious as Dick wanted. It commands one of the best views of
the California coast, from Santa Cruz to Point Sur, with sun, vast sky,
and ocean panoramas that give the impression that the end of the con-
tinent is at one's feet.

Dick hoped to foster the development of a small creative community within the seven gorgeous acres he owned and offered us one of the lots. We accepted and found ourselves with a lovely property offering an expansive view of the Pacific Ocean. With some regret we sold my old family house on the dunes of San Francisco, where I had lived since it was built in 1903. We asked Ted to be our architect and drove him to Carmel to see the site. In the car on the way back to San Francisco, Ted asked me what was needed in the general plan. I told him I required a good darkroom space, an ample workroom, lots of pass-through storage, a section of the living space that could be used as a gallery, and fine view windows to the Pacific. On the backs of several envelopes he sketched out his ideas. "You will want a high ceiling, of course." Agreed. "As you are building on a slope, why not put the bedrooms downstairs?" Agreed. His concept was exciting, even in its rough form. The next day he drew out a more precise sketch, and many details were filled in.

Ted conceived a marvelous impression of space for the interior areas, yet the exterior is retiring, giving little suggestion of its content. He was very sensitive to the building site and suggested we move the location of the house about twenty-five feet down the slope for a more impressive view of the beautiful hill to the northwest. This decision also hides us from view and protects us from the traffic noise of California's famed coastal Highway One, about five hundred feet to the east. Only from the air does the extent of the roof reveal the size of the structure.

Ted employed old bridge timbers for the principal exterior supports and for the large fireplace mantel, over which we planned to have a handsome arrangement of bleached branches of *Pinus albicaulis* from the High Sierra timberline. But when I saw the mantel in place, I recovered the large fifteenth-century Chinese drum we had bought from William Colby years before. I had recently donated it to the California Academy of Sciences; because it was six feet in diameter, I had thought it would be far too large for our new home. The director had overlooked the formal acceptance and was pleased to listen to my frantic description of the situation. I hereby express my appreciation for their institutional generosity in the return of the drum; it adds its bit of splendor to the room, relating to the scale of the ocean view and the beautiful texture of the curving hill. Its sound is a pleasing low rumble, almost thunderlike, changing its timbre from day to day with the humidity.

We hear the insistent sound of the surf, rising from the ocean two hundred thirty feet below. Its crescendos deepen into a low roar during the winter gales. Our summers are chiefly foggy, tempering the climate to an agreeable degree. I am constantly aware of how fortunate we are in the perfection of our location and how deeply we are indebted to Dick McGraw and Ted Spencer for making it so beautifully come to pass. Completed in 1962, the house has proved a magnificent partner for my daily work and living as it mellows in its surround of garden and forest.

Dick had his difficulties, but he was never a boring neighbor. He owned a rare and handsome vintage BMW sports car that he called Beastie. He became its slave and overlooked the fact it cost a small fortune to support. One night both Beastie and another identical BMW were parked in front of our house and a wag said, "You should breed them." I brashly replied, "That would be misengination!" My one and only legitimate and original pun.

Among his friends, the "McGraw Syndrome" was a frequently observed phenomenon; if things could go wrong, they were certain to do so in Dick's presence. One day he had his priceless Beastie parked in front of the shop where it had just been repainted with meticulous care. People were stopping to view this undoubtedly beautiful automobile. A cheerful, blowsy drunk approached and stared open-mouthed at the dream before him. He then pounded with hammy fists on the car door, exclaiming, "Thish ish the most bootifull car I've sheen!" making tragic dents in the delicately formed aluminum. Because Dick was sure that after the dents were removed the special orange-yellow color of the repaired door could not be matched, he had the entire car repainted.

Days later, the shop called to advise him that the painting was complete and the car would be ready the following morning. Dick encouraged them to keep some overhead vents open for better air circulation during the night. Air certainly circulated, as did millions of gnats, which lit upon the sticky paint and looked like pepper scattered on fried eggs. The morning view of the car curdled Dick's soul; of course, Beastie had to be again completely repainted.

Records would be delivered warped, books damaged in transit; we would sometimes receive the same item and mine would be delivered in perfect shape. Endless miseries plagued him: digestive troubles, allergies, thoughtless friends, environmental insults, and so on. Perhaps there is some demon of fate that persistently transmits misfortune to certain individuals.

"Good morning, Dick!"

"What's good about it?" Alas and alack.

He sought a local psychiatrist's counsel, only to be told that he was beyond help.

Dick possessed great, but veiled capabilities and a touching generosity. No one truly knows the many kind gestures and how much financial support he gave to various artists and musicians, all the while insisting that his benefits remain secret. During Edward Weston's last years, Dick made possible the printing of one thousand of Edward's negatives by Brett, the sales of which were a major financial support for Edward.

All in all, Dick suffered a desolate and somewhat wasted life. Affluence often leads to disaster. I think we are built for work, and certain orders of physical and spiritual achievement succumb in the absence of effort and drive. Dick died in 1978, devastated by cancer. Toward the end, he refused all visitors and died alone.

Our move to Carmel Highlands brought the renewal of old friendships and the making of new ones. As my radar of memory explores the past, certain individuals emerge as guiding lights. Jehanne Salinger Carlson, living in nearby Pacific Grove, is one of these. We first met around 1930 in San Francisco; a strong rapport was established from the beginning. As Jehanne is very French and I am very Yankee, communications should have been difficult, but they were not. She is a very wise and imaginative woman, experienced in both art and politics. Widowed when her youngest boy was only eight, she raised four sons, two of whom are engaged in education, one in business, and the eldest, Pierre Salinger, is a respected journalist and former press secretary to President John F. Kennedy. A highlight of Jehanne's rich and varied career was her service on the official French translating team to the United Nations Charter Conference held in San Francisco in 1945. Now in her eighties, she continues to be a source of intellectual stimulation and inspiration to me.

Up the hill from us in the Highlands lived Rosario and Katie Clare Mazzeo; few people have had such a happy impact on my life. I met them first in Boston in 1951. Rosy was bass clarinettist and personnel manager of the Boston Symphony Orchestra and Katie Clare was accomplished on the piano and harpsichord. There were many gay parties at their apartment on the Fenway. A birdcage elevator brought the musical great, and the other greats as well, to their extraordinary top-floor abode. When Rosy retired from the orchestra, they recalled Carmel Highlands and acquired a large home that became a gathering

place for countless friends from all over the world. It is a beautiful house and holds treasures of music, photographs, and books. Rosy displays his extensive clarinet collection upright on several large tables in his studio — each standing like a tree in the forest, I call it Clarinet National Park. Apart from his undoubted genius as a musician and teacher, Rosy is deeply interested in photography. He has traveled over most of the world and has photographed extensively with a quick and discerning eye.

Indeed, it seemed that a prerequisite of Monterey Peninsula citizenship was being a photographer. Rosy, Wynn Bullock, Brett Weston, myself, and others dreamed of establishing a center where creative photography could flourish in Carmel. I have had a constant urge to do something to foster the creative photography movement: Group f/64, the Ansel Adams Gallery, the massive photographic exhibition at the 1940 San Francisco Golden Gate Exposition, the Department of Photography at the Museum of Modern Art, the Beaumont and Nancy Newhall Fellowship, and the Department of Photography at the San Francisco Art Institute.

Cole Weston, Edward's youngest son and a truly capable extrovert, was manager of the Sunset Center. A former school complex situated in the heart of Carmel, it had been purchased by the city to be developed as a cultural center, and Cole was active in assembling appropriate tenants. In late 1966 Cole called me and said, "You have been making noises about starting a creative photography group ever since you moved here. Now you better go out and start one, because I have a wonderful gallery space here in the center that would be just right for such an activity." This served as a trigger for action, and within a week or so the bones of The Friends of Photography were fleshed out with enthusiasm and energy, dressed in the proper legalisms of a not-for-profit endeavor.

After our first election, I became president of the board of trustees, Brett was vice president, Rosy, secretary, and Arthur Connell, treasurer. It was an entirely volunteer organization. I remain perplexed as to how we survived and why those many wonderful people gave so much of their time. Donations and dues helped keep us precariously afloat. We assembled a surprising roster of excellent exhibits over the first years, with a wide range of historical and contemporary photography.

As The Friends membership grew, the volunteer workload inflated. I felt The Friends to be an important concept, and a few of us doggedly held on. We employed a full-time professional staff, but

problems expanded as fast as programs. Needing better financial and managerial assistance, Bill Turnage and William Rusher entered the fray and calmed the storm. The trustees appointed the Committee on the Future of The Friends to study our ongoing role. Their determination was that there was an important need for this organization and they outlined a series of steps to begin the future.

The most exciting chapter in the history of The Friends of Photography began with the hiring of James Alinder as executive director in 1977. I had known Jim over the previous decade as a professor of photography, as an editor and chairman of the Society for Photographic Education, and as an important young photographer. Jim was the beacon, a dynamic leader who propelled The Friends into the forefront of active creative photography organizations. He has built The Friends into an internationally recognized institution. The largest and most effective of its kind in the world, we now have twelve thousand members, are financially sound, and have an impressive record of over two hundred exhibitions of serious photography, an award-winning publishing agenda, and each year we contribute importantly to the education of photographers through our workshop program.

In 1978, The Friends held an exhibition of my portraits and published the book *Ansel Adams: 50 Years of Portraits* as one of their *Untitled* series journal issues. It was very rewarding for me to have this rather unknown aspect of my photography seen for the first time. The publishing program of The Friends has done great service to the field by presenting books by many important photographers whose work greatly deserved public attention, such as the volumes on Roy De Carava, Marion Post Wolcott, Ruth Bernhard, and Carleton Watkins.

Alinder leads an excellent professional staff, with important editorial and curatorial contributions made by David Featherstone. The superb quality of The Friends workshop staff, including Mary Virginia Swanson and Claire Peeps, was a major reason why I transferred the administration of the Ansel Adams Workshop to The Friends. A growing grant and awards program provides worthy recognition to our finest photographers.

Under the guidance of an outstanding board of trustees, with Peter Bunnell as its very capable president, The Friends' purpose has continued to be to support and encourage creative photography. The Friends has given me the opportunity to understand my medium better in relation to the photographic community at large. It has been the most rewarding and important association during the Carmel chapter of my life.

Shanghai and San Francisco are sister cities, and after viewing a major San Francisco exhibition that Jim and Mary Alinder had curated, Mayor Dianne Feinstein requested a similar show of my photographs to be prepared for China. I was especially pleased because an exhibit of this kind may do something to help with international relations and soothe the saber-rattling of our current national defense posturing. The Friends constructed the exhibition, fully framed and ready to be pulled out of sturdy packing cases and hung. Pan American Airways donated the shipment of the prints. The BankAmerica Foundation generously funded the preparation of the exhibition as well as the accompanying American team: the Alinders and Robert Baker, all three of whom lectured on photography and critiqued the work of Chinese photographers. Accompanying them were Julia Siebel, an important Friends trustee, and the three Alinder children. I am told the exhibition was so popular in Shanghai that people began waiting in line at six each morning; five thousand people attended each day. It was then installed in Beijing at the National Museum of Art. From the photographs of the installations I could observe that the Chinese curators had done an admirable job; the photographs were hung spaciously on seemingly endless walls. I regret not traveling to China, but concerns of health were then dominant.

Because Virginia and I want The Friends to thrive through the years, we have pledged to give our Carmel home and studio to The Friends to become their property after our lifetimes. I have two ideas about its use. One is, in a limited way, to keep it a working studio. A master photographer would live and work there for six months or so, printing a portfolio or perhaps working with several students in the master class tradition. The darkroom would continue to be alive and a place of creation. A more probable and valid use of the house to sustain the growth of The Friends would be the passing on of the material wealth the house represents. I would encourage them to sell it, with the proceeds designated for a permanent home for The Friends. The construction of a new building on the Monterey Peninsula to serve as its national headquarters is one of my fondest dreams and one of my next projects.

I have never dictated to The Friends; rather, I believe it is its role to enlarge my experience of creative photography by presenting a wide variety of aesthetic possibilities. I attend as many photographic exhibits as I can; the current location of The Friends gallery in Carmel has been tremendously helpful in keeping me current.

I suppose I have seen hundreds of art exhibitions during my life-

time. Some exhibits speak to me and others do not; I cannot explain why I immediately feel positive or negative. I do not react negatively simply because the work is not similar to mine; I am not chauvinistic about my $f/64$ inclinations. I trust the first impression, the initial glance at an image seems to reveal its inherent qualities. I pass through a collection, or scan a wall quite swiftly in my initial viewing. It seems that the image is fixed in my memory as an overall experience. I then return to the prints with a more penetrating attitude and refine my first impressions. Usually I find little in an image beyond what my first glance offered. I am surprised how much of the image is grasped and evaluated by my cerebral computer: form and content, disturbing edge and corner intrusions, bad mergers of line and value, and general print quality.

When I am in the presence of a work of art I find myself in a particular state of mind that does not exist under normal conditions of environment. It is also different from my state of mind while visualizing a photograph. Some inner creative mechanism appears to take command in either case. The secret of art lies in the incomprehensible capability of mind and spirit to perceive and create.

It has occurred to me that art has progressed by a series of oppositions to an established earlier style. When sufficient time elapses there may be a return thereto, but such is classified and described in quite different terms. I strive to comprehend many of the philosophies that are belabored at their inception, and I do not mean to suggest that such are not valid. Certainly it is the privilege of the artist to express himself with total freedom. Exceptions would relate to any expression that would result in physical harm. The Constitution does not oblige me to observe anything against my will. It is my responsibility to provide the filtration of the hideous or the obscene if I believe such exists in any work of art. One man's grace may be another's obscenity.

I am weary with the multitude of styles and dominations of modern art, literature, and music. I am naïve enough to believe that art has a definite relation to what may be called beauty, rather than being limited to the fashionable or political. I wonder how many more semantic designations for art styles are available. The latest I know in photography is post-modernism. While it must be something more than that which follows modernism, exactly what has eluded me. Conceptual photography is another term for which I have no comprehensible definition, except possibly when the idea gets in the way of the image. Every photograph any serious photographer makes is based on some degree of concept. Hence, we are all conceptualists except those who

believe they have found a niche in the critical pantheons, bonding themselves to another particularly sacred word.

One summer I returned to Yosemite from Utah with a magnificent fossil of a shell: an ammonite attached to part of a sphere of rock. It is one of the most exciting objects I have ever seen. I placed it in the center of our dining room table. A young couple, a painter and a sculptor, came for lunch. They expressed amazement and delight over it, "Who did it?"

I said that, as it was fifty million years old, I had no idea who.

They immediately lost interest. "Oh, you mean it is just a natural object?" For them, art can physically be created only by an artist, not by the viewer's creative perceptions.

I confess to a limited appreciation of all art, even less the contemporary statements. In other words, I am limited and exclusive in my response to much of art, and I know it. To be fully committed, an artist has to believe so strongly in his own art that it is difficult to have strong affinities to other artists' production. If I truly believed in the art of another artist, I would be making it rather than what I am making. The few examples of art in any media that I respond to bear close relationship to the personalities that have produced them; this colors the levels of my appreciation. When I rashly express such thoughts, I feel as if I have questioned Scripture in the time of the Inquisition. I tread as softly as I can and carry a gentle twig.

However, these observations relate to my personal appreciation. I am perfectly aware that art, in all forms, is vastly greater than I am. While I may reject most of what I experience in the art world, I feel obligated to do what I am able to do to keep this world going. I know the pendulum will swing; but it does not have to swing precisely back to its original track. I believe it is the obligation of all creative people to keep creativity moving.

It is increasingly clear to me that my art relates more and more to a sublimation of my closeness to the natural world, its events, light itself, and the positive. What I do seems natural and simple to me; to others it may appear as a miraculous performance. It is neither simple nor miraculous; it is a personal expression based on observation and reaction that I am not able to define except in terms of the work itself. If mankind progresses, we are certain to attain heights undreamed of now. We might trust that we will become a mirror of the creative background of the Universe. For me, God is a three-letter word representing the goals of creation.

22.

Presidents & Politics

I HAVE BEEN LUCKY TO OBSERVE, IN SOME CASES AT CLOSE range, history in the making: political, photographic, and scientific. Since the 1920s I have met numerous government officials from Presidents to park rangers and have found that most are good human beings, dedicated to their work.

I respect the office of the President — a person selected by the citizen stockholders to serve as chairman of the board of the largest democratic corporation on our planet. The Presidency of the United States is an awesome job, requiring wisdom instead of cleverness and compassion above rigid objectivity. I stand when the position enters the room; I do not for the man. I would certainly stand for Einstein, Gandhi, Mother Teresa, Martin Luther King, and others who have brought such splendor and succor to mankind. I am intensely loyal to the earth and the constructive societies and movements that have flourished upon it.

My family was apolitical. I think my mother and aunt leaned to the right and my father and I teetered to the left. Aunt Mary considered William McKinley one of the greatest Americans; she had a lifelong crush on him. I admit he could have been a charming uncle and he was handsome, according to his photographs, but I never discovered what he accomplished other than having an Alaskan mountain and national park named after him. I was pleased when the park's name was recently changed to Denali, the original Indian name of the great Alaskan mountain, Mount McKinley.

I took very little interest in politics until the 1930s when I became involved with the Sierra Club. My political activity has continued to be related primarily to conservation problems.

To my regret I never met Franklin Delano Roosevelt. I photographed him at a distance in Yosemite and was nearly nailed by a Secret Service agent who mistook my Contax telephoto lens for something else. Once in New York City, I was given a front row seat when he spoke at the Museum of Natural History. I witnessed how difficult and painful it was for him to move across the stage on the arm of his son and how vigorous and forthright he appeared as he stood at the podium and delivered a strong plea for conservation in his inimitable voice. He was a wily and brilliant politician who made great cabinet appointments.

During the Great Depression, a vast number of American citizens turned toward leftist philosophy, and often with good reason. My friends and I signed numerous petitions on behalf of Jeffersonian Democracy, antifascist propaganda, and so on. In retrospect, many of these were undoubtedly Communist inspired. It soon became evident that the party was both determined and dumb; even the type used to print their widely distributed circulars was always the same — a giveaway of the source. The extreme right took advantage of this vibration of opinion, leading to the dreadful McCarthy period: the first time I doubted the integrity of the American system.

In the mid 1940s my old friend Bertha Pope Damon sold her beautiful Berkeley home to Dr. Robert Oppenheimer of Los Alamos fame. He was an extraordinarily intelligent and gentle man who did not allow the hysteria of the time to spoil friendships and scientific associations because of differences in political or social beliefs. At a transfer-of-house celebration, Bertha gave a lively party to which she invited both her friends and the Oppenheimers' friends. People of all description attended; I knew only a few and was casually introduced to many — names and faces that could never be remembered the next morning.

At this same time, McCarthy and his supporters were questioning Oppenheimer's loyalty. After the party, Bertha received visits from the FBI asking for the guest list. She provided her own, but the Oppenheimers had sent invitations to their choice of guests. Bertha could name only a few, who were established residents of Berkeley. The FBI interviewed party guests, including me, several times. The same questions were received with the same answers, "I honestly cannot remember." Even after Oppenheimer was relieved of security clearance, the search went on.

During the McCarthy era there was a sour taste of evil in the air, an unsettling distortion of our American principles of justice. The

rumblings that shuddered out of Washington were picked up in all parts of the country; friend turned against friend; reputations were destroyed; the Gestapo spirit was alive in all levels of society. Artists, writers, philosophers, and scientists were the prime targets. There was a conspiracy against freedom and imagination that was ruthlessly directed against liberal thought and belief.

On frequent trips to New York in the 1940s, I had become a member of the Photo League, a loose-knit organization of professional and amateur photographers. The Photo League held lively discussions, lectures, and exhibitions, published a newsletter, and ran a school of photography. Most of the New York photographers of consequence at that time were involved: the great documentary photographer W. Eugene Smith, Paul Strand, Philippe Halsman, Eliot Elisofon, the Newhalls.

Begun in 1936, the League sprang from the philosophy that art can and should be used to effect social change. Included among the diverse membership were people with ties to various socialist and Communist groups. By the late 1940s, however, the membership had expanded and the programs of the League embraced many aspects of photography, moving far beyond its use as a political tool.

In the McCarthy years, the League was placed on the Red List of the House Un-American Activities Committee (HUAC). At my last meeting I rose to beg the League to renounce all ties to Communism. To HUAC you were either a Commie or you were not. I pleaded that photography should be an instrument of expression, interpretation, and truth: for the Photo League to continue we would have to depoliticize, which certainly would not hurt photography. All I ever received in reply was a protest that our Bill of Rights was being threatened. I resigned from the League because I refused to be associated with Communism, even in the name of freedom of choice.

After my resignation, I received a letter from Gene Smith, which summed up my feelings as well as his.

December 22, 1951

Dear Ansel,

First, I do appreciate your note about Spanish Village, and am humbly grateful that you did like it, for in the respect I have for you, I value your opinion very highly. Thank you very much. It is a letter I shall keep.

Since the Photo League is no longer in existence, I see little need to go too deeply into it. There is no doubt some of the members were Communist, I do not believe this made it a subversive organization, nor do I believe its reason for existence was to serve the Communist party. While I was serving as president, during a meeting in which we were trying to determine, "what next program for the Photo League," a small group of extremists did try to take over. They did not succeed and all dropped out of the League. On the other hand, I believe that many young idealists went along with the Communist theory of government, with absolutely no desire or inclination to overthrow the government, and are excellent U.S. citizens.

Experiences like mine with the Nurse Midwife (recent LIFE) and an understanding of her situation, her medical problems, the failure, the lack of effort of the Medical Association to do anything to improve conditions, makes me realize more fully that in certain instances there has to be a great deal of change, and if the proper groups do not see to their own responsibilities, then the government, in spite of its waste motion and sometimes incompetence and sometimes graft, will have to take over the responsibility. . . . I would love to find a good "Smith" story to do in California, for I have never photographed there. I would also like to see you again.

Sincerely,
Gene Smith

Throughout the Eisenhower and Kennedy administrations, my political energies were centered upon Sierra Club concerns in California. I did become acquainted with Lyndon Johnson, an impressive figure. Twice I had good talks with him at the White House and found him to be sharply intelligent and concerned about our natural and human resources. When he pressed the flesh of the multitude, he looked each person squarely in the eye and held the proffered hand for a brief moment, giving an impression of personal concern and confidence.

In 1965 President and Mrs. Johnson asked Nancy Newhall and me to prepare a book, *A More Beautiful America*, that was to reflect his interest in the environment. Opposite my photographs, we printed excerpts that we had selected from his speeches, such as:

It is not just the classic conservation of protection and development, but a creative conservation of restoration and innovation. Its concern is not with nature alone, but with the total relation

between man and the world around him. Its object is not just man's welfare but the dignity of his spirit. Above all, we must maintain the chance for contact with beauty. When that chance dies, a light dies in all of us. It is our children who will bear the burden of our neglect. We owe it to them to keep that from happening. For once the battle is lost, once our natural splendor is destroyed, it can never be recaptured. And once man can no longer walk with beauty or wonder at nature, his spirit will wither and his sustenance be wasted.

Environmental concepts were not as sharply defined twenty-five years ago as now, and I am happy to add my praise for what both President and Mrs. Johnson accomplished for conservation. Although his presidency was tragically flawed by his decision to escalate dramatically our involvement in Vietnam, Johnson displayed genius in domestic policy through his landmark legislation of the Great Society.

In 1974 the important art dealer Harry Lunn, who had supported and promoted my work for many years, presented a copy of my new book, *Images 1923–1974*, to President and Mrs. Gerald Ford. The Fords loved the book and requested a print of their favorite photograph, *Clearing Winter Storm*, for display in the White House. Bill Turnage and I visited President Ford early in 1975 to present him with a print of this image. President Ford was most cordial and attentive, and he exuded a sense of trust and responsibility. I was deeply concerned with the deterioration of our national parks under the Nixon administration and so I presented the President with this memorandum.

NEW INITIATIVES
FOR THE NATIONAL PARKS

1. Redefinition of the meaning of parks, and the basic purposes of the system.

2. A Presidential Commission to thoroughly study and modernize the organization, personnel, and attitudes of the National Park System.

3. A major review of concessions policy and management, developing non-profit, public trustee foundations as the optimum approach to best serving the public and the parks.

4. Reduction of man's physical impact on prime areas such as Yosemite Valley and replacement of automobiles by alternative transportation systems in most parks and monuments.

5. New emphasis on preservation and environmental responsibilities. Improved park interpretation, stressing natural values and contemporary awareness.

6. Improved National Park Service performance in realizing and expanding compliance with the Wilderness Act.

7. Urgent Presidential intervention to prevent any Office of Management and Budget reductions in proposed Park Service Budget and staffing levels.

8. Presidential level review of all areas of future park or reserve potential. This generation may have the last chance to save essential lands for future generations.

After our discussions, we walked a bit beyond the Oval Office to the area of the swimming pool, paced by a large group of reporters and photographers who kept their distance. Betty Ford invited us to lunch and we had a sparkling informal visit as was reported by Marjorie Hunter in *The New York Times* on January 28, 1975.

After meeting with the President, Mr. Adams joined Mrs. Ford for a full tour of the White House, including the family's living quarters.

It was the kind of tour that few visitors get — and the kind of frankness that few guides display.

Escorting him into the private family dining room, Mrs. Ford eyed the wallpaper with its battle scenes and confessed, "I find it disquieting to eat in there. It's like watching a war going on all the time."

In a tiny sitting room adjoining the Lincoln bedroom, Mrs. Ford observed that this was the room where President Nixon often secluded himself to listen to music.

Opening a closet door, she said, "And here's where he played his tapes." Then, laughing, she corrected herself: "I mean his records."

Mrs. Ford also showed Mr. Adams a private family room where the President keeps his Exercycle and barbells for early morning workouts.

On top of a cabinet in one corner rested an old leather helmet that the President had worn as a football player at the University of Michigan in the early nineteen-thirties.

"Go on, Ansel, try it on," said David Hume Kennerly, the

President's personal photographer, who had arranged the meeting with the Fords.

"No, no," Mr. Adams replied, smiling. "You can't wear another man's crown."

In June 1977, the President phoned and asked if I had a place for his daughter, Susan, in my Ansel Adams Workshop, which was then still held in Yosemite. A photographer with a promising eye, she easily fit into the group, Secret Service and all.

I saw the Fords several more times and, after he left office, they came to lunch at our home. It was gratifying to observe how Americans in the highest posts can remain so warm and human even as the restrictions and responsibilities of office intrude upon them.

In 1980, I was surprised and delighted to hear that President Carter wished to present me the Presidential Medal of Freedom. It was a gala ceremony, conducted with superior taste and quality throughout. Practically all of the first floor of the White House was occupied with beautifully set circular tables, and the lunch and service were as fine as one could find anywhere. Earlier, the ceremony itself had been held outdoors before an audience of relatives and friends. Each recipient was escorted to the platform by a member of the armed forces, glistening in full-dress splendor. Seated on the platform, we awaited the President, who arrived, full of charm and vigor, made a few remarks, and then proceeded to bestow each medal. I was in interesting company, including Admiral Rickover, Tennessee Williams, Eudora Welty, and Beverly Sills. As the others before me, at the President's request I rose and walked to the podium to listen as the citation was read; then the President placed the medal about my neck and ended with a cordial handshake. It was all very exciting and euphoric. My citation reads:

At one with the power of the American landscape, and renowned for the patient skill and timeless beauty of his work, photographer Ansel Adams has been visionary in his efforts to preserve this country's wild and scenic areas, both on film and on Earth. Drawn to the beauty of nature's monuments, he is regarded by environmentalists as a monument himself, and by photographers as a national institution. It is through his foresight and fortitude that so much of America has been saved for future Americans.

Jimmy Carter

I feel Carter represented the presidency very well indeed. He was unfortunate with some of his appointees and had more than his share of bad luck. Carter was an honorable man, but proved no match for the Reagan Machine at reelection time.

My experience with Ronald Reagan was negative from the start. As I write, he is in the fourth year of his first and, hopefully, last term of office in the White House. This character has been a persistent source of concern for millions of Americans since he was elected governor of California. As governor he was remote, except to the favored few. I believe he did chiefly what he was advised or ordered to do by the wealthy ruling factions to which he was so beholden. Big Business is smugly in the saddle and the economy is fed all the oats. "Man does not live by bread alone" was not a part of Reagan's political stable. He has little or no personal interest in the environment or its protection. "If you have seen one redwood tree you have seen them all" has become a symbol of his basic attitude.

I have been outspoken in my opposition to Reagan and what he stands for and in my interview for *Playboy* magazine in their May 1983 issue, I pulled no punches. *Playboy* is a strange mixture of content that is unique and provocative. I debated very carefully their request for an interview, because the magazine as a whole is grossly sexist. However, its respected interviews touch varied facets of contemporary American life and reach an audience with whom I have rarely come in contact. Interviewers David and Vicki Sheff were well prepared and conducted nineteen hours of taped dialogue over a two-week period. At one point they asked:

PLAYBOY: You were instrumental in getting photography accepted as an art at museums and universities. Almost half a century later, do you think it is accepted as legitimate art?

ADAMS: For the most part, but there are still people who are hard to convince, I'm afraid. There is a peculiar animosity between painters and photographers. University budgets are being cut, so painters in an art department will argue that they deserve more than the photography department, on the grounds that photography is a lesser art. It's crazy. Well, that's a typical result of all the budget cuts, (Lifts his martini) Thank you, Mr. Reagan. (Under his breath) I'd like to drown him in here! (Laughs) Oh, my! That went on tape. To the FBI, if you're listening: That was only a figure of speech. He wouldn't fit into my martini.

Comments such as these apparently stirred the White House. In early June I received a telephone call from Reagan's assistant, Mike Deaver, who said, "The President would like to meet with you and discuss why you dislike him." My assistant, Mary Alinder, thought that the call must be a hoax and phoned the White House, where Deaver confirmed that the invitation was for real. I questioned whether it would be worth my while to meet with Reagan; I doubted if he would really listen. Why dispute with mosquitoes when the skies are filled with the angels of light? But I realized here was no mosquito, but a person who holds man's fate in his hands; and so I accepted and the appointment was made for one-fifteen P.M., June 30, at the President's Suite in the Beverly-Wilshire Hotel in Los Angeles.

Since assuming office, Reagan had not met with even one major environmental leader. I felt the meeting to be a huge responsibility, since I must represent the concerns of so very many people. Priorities were buzzing in my head; I had tried to bring myself up to date and had The Wilderness Society's *Watt Book* for reference. This four-inch-thick volume was composed of many authenticated documents, hearings, and addresses, and it served well in providing substance to my very strong antipathy to James Watt, then Secretary of the Interior and one of the most dangerous government officials in history.

The President was very cordial and made warm comments about my work (appreciated), then he said, "Mr. Adams, I feel we have a lot in common. I consider myself an environmentalist!" (not appreciated). He talked at considerable length about his accomplishments in conservation while governor of California. Part of my mind was absorbing this news and the other part was frantically trying to rearrange my priorities, because I had been told I could expect no more than fifteen minutes with him and he had already provided a monologue of that length. While I did have time to present my views, a tension persisted until the meeting's end, fifty-five minutes later!

Throughout that time, we agreed only on one thing: the value of nuclear power. As might be expected, we agreed for different reasons. Though I am totally opposed to the proliferation of nuclear weapons, I have been at odds for many years with those who are adamantly against nuclear power. I reminded President Reagan that the burning of fossil fuels pollutes water and air, reducing the ozone layer of the atmosphere and bringing acid rain. His curt reply was, "There is considerable scientific disagreement about the causes of acid rain."

Many of my friends are shocked by my support for nuclear power. I feel that unless we stop polluting our atmosphere we will poison

ourselves and be just as dead as the bomb would make us. Nuclear power is, of course, potentially dangerous if less than perfectly managed. If very carefully controlled in every respect, it should provide all the energy required until fusion power is fully developed. The problem lies largely in the modern demand for energy, the wasteful use of power, and the finite limit of natural resources. Hence, I favor what I consider to be the lesser of two evils and support nuclear power. I find that most opposition brings forth no constructive alternatives, no answers that provide for our future power needs.

Fusion power is the ideal solution to the energy problem, and its development should be given highest priority. In May 1983 we were invited to visit the Lawrence Livermore Laboratories to see the great installations in magnetic and laser fusion research. It was an enormously impressive experience, and, with the thought of what safe fusion power could contribute to the world's energy supply, I became more confident in the future. During my visit with President Reagan, I suggested that he take ten billion dollars from his defense program and apply it to a crash program for magnetic fusion development. Reagan raised an eyebrow at my temerity, but I believe it is obvious that once fusion power is achieved, the energy shortage will be past and we will be independent of foreign fuels. In 1902 the automobile was in its infancy and the airplane an insubstantial dream. From the two-cylinder gas buggy to magnetic fusion is a giant stride, but, incredibly it can be accomplished during one lifetime.

I was negatively impressed with Reagan's failure to discuss or challenge my opinions at every turn. When I attacked the environmental policies of James Watt, the President rejoined, "James Watt is a remarkable person; he is doing exactly what I want him to do." He then continued, "Anne Gorsuch Burford was shamefully railroaded out of her position. She was doing an excellent job." After I left the President, all I could think of as a suitably concise description of our meeting was "When the vacuum hit the fan!"

The flow of bilge from the Reagan administration is a blot upon our history of literacy. Reagan, with his smooth, unctuous repetitions, merely confirms our national style — which, of course, will not be remembered as one of our great historic legacies but may well be part of what brings us to our knees if our spirits fail and our resources fade. It is not good for the mind to rely upon the crutch of quotations, except when they are poignantly to the point. I thank Adlai Stevenson for the following, "Republicans stroke platitudes until they glow as epigrams." I believe I am completely justified in my very strong criti-

cism of the Reagan administration and most of the characters who inhabit it; but do I stroke accusations until they become mindless hostilities? I tried to keep this question in mind when I was interviewed by the *Washington Post* the morning after the Reagan-Adams meeting. I did fairly well with my recollections of the meeting. The interview was reproduced worldwide, not without effect.

While Reagan and I talked about many environmental issues, the time slipped by and was gone before I was able to cover the subject of urgent need for protection of California's Big Sur Coast. I first saw the whole length of the glorious Big Sur in the 1930s. Virginia and I accompanied William Colby on one of many trips we made with him all about California as he searched out appropriate scenic lands for preservation efforts. This excursion was a revelation. The coastal region beginning just south of Carmel to the borders of San Luis Obispo County, about ninety miles, is the most impressive landscape of its kind in the country. The Santa Lucia Mountains drop for thousands of feet to the sea, creating a complex of shore and surf that comprises an American treasure. The Big Sur Coast is truly of national importance and therefore deserves national protection; it is undoubtedly among the most beautiful of the untouched lands and certainly should be secured and protected for the future.

The two-lane road through Big Sur has bumper-to-bumper traffic much of the year. Millions of tourists traveling between Los Angeles and San Francisco use this scenic highway. Mountains would have to be destroyed to increase it to four lanes. Every time a house is built on top of a coastal mountain, the access road slashes a raw scar across its face, visible from land, air, and sea. Mining companies must be held in check as they hungrily await the chance to pulverize Big Sur mountains, such as Pico Blanco, into limestone ore. Proposals to build resort hotels and homes abound, with no understanding of the fragility of our splendid coast. I have seen the environmental devastation of the famed French Riviera. Buildings crowd one upon another, from water's edge to mountaintop. The subsequent air pollution produces thickly veiled views. It once had a very similar beauty to our Big Sur.

I believe that many of the residents of Big Sur deeply desire that the area be protected for the future; they vary in their philosophy of how this may be accomplished. Some claim that for more than fifty years they have protected the coast and there is no reason why they cannot continue to do so. Some wish to retain development rights. Some want to save the coast, but also desire to retain the right to develop their own property. Those who cultivate marijuana back in its hills

and valleys have been, of course, quite negative to the "Feds." Many Big Sur residents fear the government would move in and take over their land without due process and full value purchase. They are dangerously naïve: modern political and financial pressures for development and commercialism are much more sophisticated and powerful than those of the past. Individualism is commendable, but I believe the public good takes precedence over any private advantage. Due to these beliefs, I became the recipient of anonymous threats, such as, "The People of Big Sur Await Your Sudden Death!"

I had first thought of the National Park Service's entering the scene with a plan similar to the Cape Cod National Seashore, by which both the land and the life-style of the residents were protected from the ravages of exploitation. Later, because of the proximity along the entire eastern border of the area of the Los Padres National Forest and the Ventana Wilderness, it seemed logical that the control of the area should come under the United States Forest Service. Control was intended as appropriate management and protection of the area, including the right of first refusal of sale of land and the maintenance of the qualities of any improvements that were logical and helpful to the project as a whole.

A major political struggle began. The good functions of the Big Sur Land Trust in making possible considerable reserved areas, as well as the continuing acquisitions of state park lands, hold much promise for the future. The Big Sur Foundation, under the leadership of Will Shaw, a distinguished architect and planner, and the brilliant young attorney Saunders Hillyer, undertook serious study of the legal and political aspects of the project. I have served as vice president of that organization since its founding in 1977. We had good support from important politicians and organizations in Washington, notably California Senator Alan Cranston and Bill Turnage of The Wilderness Society. Big Sur became a leading project for the society and remains high on its agenda. Strangely enough, the Sierra Club has evidenced small interest in this project, although the local Ventana chapter members are supportive.

Senator Cranston and our very excellent Congressman Leon Panetta formulated a bill that cleared the House of Representatives and would have passed the Senate in the closing session of 1980 except for the delaying tactics of former Senator S. I. Hayakawa. Certainly the worst senator from California in history in the areas of conservation and the environment, Hayakawa denied the people of the United

States protection for the Big Sur Coast. I hope that history will not be kind to his type of conservatism and insensitivity. We continue the fight and are determined that the protection of Big Sur will be achieved.

When I say to a congressman or senator, "You know, I am really not a politician," they smile. It seems that when one gets passionate about a subject he becomes political. As a private citizen I can come forward with very strong concepts and opinions. To appease a diverse electorate the professional politician must understandably guard both tongue and pen; the doing is more vital than the talking.

In two recent, and typical, letters written to Senator Cranston shortly after the resignation of Secretary of the Interior James Watt, I stated:

March 20, 1983

Dear Alan,

I have been thinking of you daily! The situation in the domain of the "All Highest" seems to be deteriorating. One down, one to go! It is not a laughing matter!

I am trying to put together a letter which will express my convictions — I think all citizens should express themselves. I find it difficult to maintain objectivity in the face of both the ridiculous and the terrifying. I do not like to think we are coming apart at the seams. But when I see Falwell on TV and Reagan in action, I wonder if any man can carry the load of reconstruction over the years to come. . . .

As ever,
Ansel Adams

June 25, 1983

Dear Alan,

We need fire, not glowing embers! We do not need hyperbole or bantering. I am waiting for a bit of wrath and outrage, expressed in the consistent mood of dignity and concern, impact and compassion. Like a full orchestra, not just a string quartet!

A sense of compassion is extremely important. It's what Reagan ain't got! He has "jollyfication." When severe, he reminds me of a school teacher I had, or the leading man in a righteous play.

Especially of late, it seems obvious that he is reading his speeches; he has a gifted writer who can string words together with a melliferous intention — and not much else.

I wish I were forty again. I would respond with joy and energy to a "Let's Go" syndrome with all I've got. Maybe that would be a good punch line.

Virginia and I send our affectionate greetings to you and Norma. LET'S GO!!!

Ansel

I have known many great people in California's history, spanning my sixty active years. But I have never been in contact with a public official of such integrity, imagination, concern, and effectiveness as Alan Cranston. Based on personal contact and observation of results, I have found him to be a great leader, one who transcends party politics for causes of essential human importance. I first met Alan when we began working together for the protection of Big Sur. I particularly remember one conversation with him at Point Lobos, as we gazed out at the glorious ocean and its kelp beds, watching the sea otters play in the surf. Alan expressed his fears for the future of our land, sea, and air, and his concern for the devastation that is mindlessly wrought on our environment. He spoke of the near and far future of the world and of his staunch commitment to protect our planet for the generations to come. His leadership gives me hope.

I chide my Republican friends on their misinterpretation of the term "capital." They say they are concerned with security of property and money, collectively known as capital. "Capital" in this sense is actually the interest and dividends from exploitation of the earth and its manifold benefits. I reply that the only true capital is the resources of the earth, and misguided Republicans that they are, they are actually invading our basic capital at the expense of the future.

Nature is always better when left to itself — but for what purpose? The dichotomy between our need for minerals, timber, and pasture and the equally valid need for nonmaterial experiences has persistently disturbed me. While I have been verbally aggressive about park and wilderness concepts and values, I have never been opposed to the presence of man in considered and appropriate relationship to the world.

When I was young I traveled alone or with a friend or two of sympathetic outlook, wandering about the mountains for days or weeks without contact with the outside world. The wilderness became a pri-

vate domain and the unexpected appearance of strangers seemed an intrusion or even trespass. I outgrew this youthful assumption. Starry-eyed reaction to the splendors of nature is an invaluable experience for everyone, provided it is tempered in time with a realization that this reaction hopefully exists for the many rather than the few. We must seek the healing that peace on earth and the wise use of its bounty can bring to all of us. Plato wrote in *The Republic:*

> Until philosophers are kings, or the kings and princes of this world have the spirit and power of philosophy, and political greatness and wisdom meet in one . . . then only will this our State have a possibility of life and behold the light of day.

23.

Resolutions

I N THE 1970S, AS I ENTERED THE SEVENTH DECADE OF MY life, I decided to place my negatives, photographs, correspondence, photography collection, and memorabilia in an institution where it would always be available to serious scholars and students. I offered my archive to the University of California system, but was rebuffed; at that time they were unwilling to put even minimal funds into an archive of creative photography.

Following a 1973 solo exhibition at the Museum of Art at the University of Arizona, its president, Dr. John P. Schaefer, suggested I consider his university as the repository for my archive. In 1974 he visited me in Carmel. We spent quite a few wonderful hours together, wandering about Point Lobos, getting to know each other, and talking about photography. I found John to be a man of extraordinary energy and imagination. He stated that photographs as artistic and historical documents had been too long neglected by universities. I said that I wanted my archive to be part of a much larger entity containing the archives of several photographers. John's ideas meshed with mine, and during those walks the Center for Creative Photography was born, with my archive as the beginning. Through a gift/purchase agreement I have already sent a very large number of my original fine prints and much of my personal collection of work by other photographers. The Center for Creative Photography's holdings now include the archives of many photographers, including: Edward Weston, Sonia Noskowiak, W. Eugene Smith, Wynn Bullock, Fred Sommer, Harry Callahan, and Aaron Siskind.

When I depart this sphere, all my negatives will be housed at the Center. I have specified that my negatives may be printed *only* for

educational purposes by advanced students, faculty, and visiting schol-
ars under the supervision and control of a committee of experts se-
lected with the approval of the trustees of the Ansel Adams Publishing
Rights Trust. These prints will never leave the Center and will be
clearly stamped and labeled as *not* being an Ansel Adams print and
must *never* be sold.

Trained as a pianist, I am aware that I depended upon the music of
the past (Bach through Scriabin) as the source for my musical expres-
sion. As most musicians, I am not a composer. Photographers are, in
a sense, composers and the negatives are their scores. They first per-
form their own works, but I see no reason why they should not be
available for others to perform. In the electronic age, I am sure that
scanning techniques will be developed to achieve prints of extraordi-
nary subtlety from the original negative scores. If I could return in
twenty years or so I would hope to see astounding interpretations of
my most expressive images. It is true no one could print my negatives
as I did, but they might well get more out of them by electronic
means. Image quality is not the product of a machine, but of the per-
son who directs the machine, and there are no limits to imagination
and expression.

Before this resolution, I had considered following the practice of
etchers and lithographers, who destroy the plate after a specified num-
ber of impressions are made; in the medium of printmaking, the plate
or block allows for only a limited number of impressions before it
deteriorates. In photography the negative can be printed from indefi-
nitely without loss of quality, and thus the destruction of the negative
I believe to be an affectation, true to traditions of commerce, but not
true to the medium itself. In the 1930s, Edward Weston decided to
make small batches of prints, limiting the total to no more than fifty
of any one image. I do not think that any of his masterpieces came
even close to selling that many, and so he only made ten or so total
prints of each.

I had never made limited editions from my negatives, but was con-
vinced it was appropriate on one occasion. Robert Feldman's Parasol
Press published my fifth, sixth, and seventh and final portfolios. *Port-
folio V,* issued in 1970, moved rather slowly, but after several years it
did sell out. When it came to *Portfolio VI,* we agreed that limiting the
edition by canceling the negatives would favor the sale of the one hun-
dred copies. In keeping with this, and because of my uncertainty of
just what the future held for them, I took a Wells Fargo check canceler
and ran it across each negative surface. I know now that I was wrong

to mutilate them. Photography is a medium that theoretically allows unlimited printing from the negative; negatives should never be intentionally destroyed. I cannot accept the value of artificially produced scarcity as more important than the value of creative production.

The Center was very fortunate to attract James Enyeart as its director. Excellent as both an administrator and historian, Jim has expanded the sphere of activities with remarkable speed and uncompromising quality. He has recently undertaken a multimillion-dollar fund-raising campaign to construct a much needed building to appropriately house, in temperature- and humidity-controlled rooms, the rapidly growing photography archive. Exhibition galleries worthy of the work of the many great artists and the superb collection will also be included.

The future of my archive secured, I established two trusts in 1975 to further structure my life so that I would not have my energy sapped by uncertainty and details. One is the Ansel Adams Publishing Rights Trust. Besides me, the trustees are Bill Turnage, my attorney David Vena, and my publisher Arthur Thornhill, Jr. This trust controls all future publishing ventures and the reproduction rights to my photographs. Even after my death, I know that many projects that I may not have finished will be completed in the spirit and with the attention to quality I have tried always to require.

Since my participation in the Datsun advertisement over ten years ago, I have not allowed the association of my photographs with a commercial product. I have been offered extravagant sums of money with the intention that *Winter Sunrise* be splashed across magazine pages and billboards on behalf of a whiskey. I choose instead to have images reproduced on behalf of the causes I believe in: creative photography and environmental protection.

The Ansel Adams Family Trust is the recipient of the net proceeds from the Ansel Adams Publishing Rights Trust. Virginia and I are the sole trustees of the family trust. When we die, Michael and Anne will be the trustees.

As I was organizing my life, coincidentally there was an astronomical rise in the collecting of photography in general and my photographs in particular. The demand for prints grew until I spent most of my time in the darkroom, repeatedly printing the same few negatives: January — five prints of *Moonrise,* two of *Clearing Winter Storm,* three of *Monolith,* one of *Frozen Lake and Cliffs,* two of this, lots of ones of that, done! February — another similar order. I longed to get out with my camera, write new books, and make prints from my thousands of

neglected negatives. I had become a prisoner of photography's burgeoning popularity.

Bill Turnage suggested I set a final deadline for print orders. I agreed and publicly announced that I would not accept orders after December 31, 1975. When these orders were filled, I would make no further prints for public sale. The price would be eight hundred dollars per 16x20-inch print — a new high for my work. I expected to have a total order of fewer than a thousand prints, instead the total was over three thousand. I spent much of 1976, 1977, and 1978 filling these orders. Interestingly, the prices of my prints at auction and through dealer sales also began doubling and tripling. An order I accepted in 1975, when delivered could bring the dealer or private purchaser five thousand dollars or even more. I received only the originally agreed-upon sum. Prices hit absurd levels in 1981 when a mural-size print of *Moonrise* that I had sold for five hundred dollars only a decade earlier sold for seventy-one thousand five hundred dollars, the highest price ever paid for any photograph. This sale made the headlines, and it was assumed by many people and most charities that I was the recipient of the funds. Unfortunately, the photographer is paid only once for a print: at the time of the original sale.

I began to understand the whys and wherefores of art and its promoters. The direct artist-customer relationship is somewhat different from the artist-dealer-client complex. The sincere and successful dealer can be a boon to the creative artist in any medium. Both the artist and the client seek identity, and the good dealer acts as both psychiatrist and promoter. I have been very fortunate; for the past few years my primary dealer has been Maggi Weston of the Weston Gallery in Carmel. Maggi is a strikingly handsome redhead whose enthusiastic hugs I consider proper medicine for almost any ailment. She had just opened her gallery in 1975 when I announced finis to my print orders. A good friend for many years, throughout her marriage and subsequent divorce from Cole Weston, we talked of her future. Convinced that the photographic market was just beginning, she mortgaged her house to raise the funds to place one last, large print order with me. The potential risk in doing this scared her, but I had complete confidence in her future success. It was a pleasure for me, as Maggi's friend, to watch the escalating prices. The Weston Gallery was financially established and her house resecured.

Maggi, along with her very knowledgeable associate Russ Anderson, has educated great numbers of people with the grand spectrum of photographs that she exhibits and sells: from Fox Talbots made in

1842 to the work of Julia Margaret Cameron in the 1870s to Stieglitz, Strand, the Westons, myself, and then on to the younger generations: Olivia Parker, Jim Alinder, Jerry Uelsmann, Don Worth, Ralph Gibson, Paul Caponigro. The Weston Gallery provides one place where the entire history of photography can be viewed and may be purchased at prices that still seem most reasonable compared to the other art media. In these few short years, the Weston Gallery has become the largest photography gallery in volume of retail sales in the world. What Maggi, Russ, and their staff have accomplished is truly amazing.

In 1979 Maggi and fellow dealer Harry Lunn approached me with a new project. Public museums were only then beginning to collect photography seriously; many were disappointed that I had quit selling my work and that the specific images they wished were either not available or priced too severely. These two enterprising dealers suggested I print a limited number of representative sets of my photographs to be placed only in appropriate and scattered museums. I responded warmly to this suggestion. I wanted my work to be seen by many people, not just on the walls of the few who could afford it. Because of my Museum Set project, such institutions as the Stanford Art Museum, the Minneapolis Art Institute, the Australian National Museum, the Canton Art Center, the Los Angeles Museum of Contemporary Art, the Museum of New Mexico, Cornell University, and Boston University have a superior selection of my photographs in their permanent collections.

I believe there is a relationship between the experiences of art and of nature, in that both have definite functions at appropriate social and creative levels. Works of art, literature, or music have little value or human benefit if held available only to the few. If such is not of general human benefit what are its reasons for being? Comprehending the natural world is, in itself, an act of creation and should be universally shared.

I was also faced with mounting requests from hundreds of people who could not afford an original fine print but wanted one or more to hang in their own homes. Few can pay the thousands of dollars for an Adams fine photograph, and so I decided to issue a series of exquisitely reproduced posters. I had great confidence in Dave Gardner, the co-owner of Gardner/Fulmer Lithograph, who had printed the new edition of the book *The Portfolios of Ansel Adams,* where he had come extremely close to my own photographic values. Dave is the only

printer to translate my photographs into near-perfect reproduction form. He uses a combination of a laser-scanned negative, a very fine screen, two colors of ink (black and gray, and he is not afraid to use lots of black), and, most importantly, a sensitive eye. I chose three images, *Moonrise, Winter Sunrise,* and the vertical of *Aspens;* New York Graphic Society had them designed as posters. Mary Alinder and I supervised the first press runs (either one of my staff or I are on press to personally inspect the first press run of all new projects); the resultant posters were spectacular and, at twenty dollars apiece, affordable.

The posters met with such welcome that I also agreed to Ansel Adams calendars to begin in 1984. Each of these reproductions is beautifully reproduced by Gardner/Fulmer Lithograph. Printed inside is a full-page Adams editorial on my perceptions of the current grave threats to our environment, with the hope that:

> The photographs in this calendar may serve as reminders that something of the primal world endures, although physically and aesthetically endangered. What remains of the natural scene can be seen as symbolic of the original bounty of the earth. The natural beauty and wonder we now observe are a diminishing resource; substances vital to our physical and emotional survival are being critically depleted.

As I cleared the decks for future projects, I found an ever-present complicating factor: health. My mind is as active as ever, but my body is falling farther and farther behind. My adult physical problems seemed to have begun in Glacier Bay in 1948 when I was vigorously pulling on a hawser to bring a launch in to dock against a tidal current and choppy waters. My deck shoes slipped; I did not fall, but felt a strange tearing sensation under my breastbone. There was no pain. It was as if a piece of silk had ripped within. After the boat was secured, I went below deck, not feeling myself. A good platter of bacon and eggs seemed to remove my problems and the voyage proceeded on schedule.

In New York City several months later, I had an inappropriately hasty lunch at the Cafe St. Denis and hiked as fast as I could to the Newhall apartment to join them for a trip to Blue Mountain College in North Carolina, where a photography seminar was to be held. Just before I reached the apartment, I felt a violent pain in my chest, unlike anything I had previously experienced. As I was obviously in some

kind of trouble, Beaumont called his doctor. I was hospitalized with an assumed coronary attack. Considerably worried, I went through a number of tests. The cheerful diagnosis was that my heart was perfectly normal. The doctor thought that I might have a hiatal hernia and I was trundled off to X-ray for a barium picture. It was observed that I had a three-centimeter shift of the diaphragm, meaning that a meal, no matter how agreeable, could very effectively press my stomach up into the chest cavity. This can cause pain very closely simulating that of coronary insufficiency. Ever since, I have had frequent occurrences of this troublesome effect, mostly after eating.

Around 1970 the sensations increased and my good friend and excellent doctor, Mast Wolfson — still practicing medicine today at the age of ninety — determined that my heart was not behaving properly. Further consultations revealed that one of my heart's valves was damaged and that my coronary arteries were most likely clogged. After a needed weight loss of fifteen pounds, I entered Presbyterian Hospital in San Francisco for a valve replacement and triple coronary bypass to be performed on February 14, 1979.

I had always assumed that I would be fearful of such invasions of my system, but when the time came I was completely at ease; wheeled into the operating room, I was in a blissful, euphoric condition. Without surgery I was fast reaching an embarrassing state of inactivity; I could not walk a hundred feet without the crippling symptoms of chest pains and shortness of breath. I do not recall many of the events surrounding or following the surgery, save that a pig valve and other miscellaneous surgical additions had repaired my heart on Valentine's Day.

I had a favorable recovery and was soon moved from the hospital to the home of our dear friends Otto and Sue Meyer. I convalesced scarcely one hundred feet distant from our old home in San Francisco. The foghorns groaned, the waves on Baker Beach crashed slowly and decisively — all familiar sounds from the past. The Meyers gave me the attentions usually reserved for a potentate. Their royal treatment, I am sure, hastened my recovery.

We had met the Meyers when they moved into our neighborhood in the 1950s. A member of an important German family with major interests in the Rhine district wine industry, Otto had escaped the Nazis in the late 1930s. Eventually establishing himself in San Francisco, he brought great expertise and imagination to California winemaking, becoming the president of Paul Masson Vineyards, which he built into one of America's leading quality wine producers. Otto has

also become one of the most respected civic leaders of San Francisco. He is deeply concerned with the arts; he serves on the boards of The Friends of Photography, the San Francisco Opera, where he was the longtime chairman of the company's Spring Opera program, and also, from its earliest beginnings, the board of the Merola Opera Training Program.

Sue is equally remarkable. Sparkling, energetic, extremely capable, she is also one of the great supporters of the arts and charities in San Francisco. She was one of the founders of the innovative craft gallery, Meyer, Breier, Weiss. Sue entertains with great joy and open arms. We truly call their home the Hotel Meyer — the best in San Francisco!

I returned home to Carmel two weeks later. I could immediately walk farther than was possible before the surgery, and I felt as good as ever, with the sort of energy I had thirty years before and with a firm pulse and no chest sensations. My only complaint was a pestiferous vertigo: a side effect from the anesthesia. In two months the vertigo vanished and I was able to drive the late Congressman Philip Burton to Big Sur for his first view of that marvelous region; he soon became one of the leaders in the fight for its preservation.

My new pig valve functions splendidly: however, my bypasses became plugged up within a year. I now exist on collateral circulation to the heart and have a pacemaker that comes in at every lapsed beat like a small mouse working out with a tiny punching bag.

I consider myself fortunate; on several occasions I have faced extinction, only to be reestablished by the art and science of the medical profession. As if being my executive assistant and the head of my staff were not complex enough, Mary Alinder, who holds a degree in English, is also a registered nurse. Her personal intervention and quick actions have added years to my productive life. The Great God Photon was surely smiling on me when I was able to talk Mary into directing my activities — saving my life three times was a *very* important side benefit.

In my next life I might be an architect, photographer, doctor, or writer. "De Lawd" will decide on this for the sanity of the world to come. I may come back as a doorman at the Algonquin with a simple home in Queens, a wife who has my slippers ready along with a bit of the old martini, and an interest in nothing in particular and resentment of everything in general. De Lawd forbid!

As I grow older I become less interested in travel to other parts of the world. There is so much absolute beauty along the California coast

that I could work for a century, exploring with eye and lens. Photographers who frequently travel photograph with less than full knowledge of their subjects. I believe one must live in a region for a considerable time and absorb its character and spirit before the work can truly reflect the experience of the place. In my own case, hasty visits have usually resulted in inconsequential images; perhaps an occasional flash of insight, or a remembrance of an earlier place or time helped in visualizing a photograph. But most often I have grasped for some evanescent image only to find it a hollow recording of the subject because I really did not see or understand what was before me.

My experiences in Europe ran true to my visual prophecies. I did not care for what I saw of France, but I felt very much at home in England and Scotland. I have had many exhibits in foreign lands, but the only ones I have attended in person were those at the Arles Festival in 1974 and 1976 and at the Victoria and Albert Museum in London in 1976.

The Arles exhibits, organized by my good friend and photographic colleague Lucien Clergue, were beautifully hung in an elegant building in that ancient Roman town. The lighting was inferior, as is to be expected in old structures and unfortunately is still the case in many new ones. Happily, the human element was superb. I was able to meet many of the great French photographers, including Jacques Henri Lartigue and Henri Cartier-Bresson. Traveling twice to Arles, I did not respond to the southern landscape; the air was hot and thick with haze. When asked to return to Arles in 1982, I asked the Alinders to lecture on my behalf.

Of the sights I saw in France there was but one that thrilled me: Chartres Cathedral. I was greatly impressed with the rich, glowing colors of the stained-glass windows. They were of a soft and deep hue, in accord with the encompassing great poem of stone. I walked toward the altar, then turned to view the entire vault. To my shock and astonishment, a few windows in the entrance wall were harsh and bright, even garish. For the moment I wrongly assumed that they were replacements after World War II. I was told, "No, they have just been cleaned." When the glass was first installed, it was as bright as the laundered panes appeared. My romantic palette was shattered. The grime of centuries had created an illusion of frosty splendor and I had to adjust to a thirteenth century brighter than I had imagined it to be.

The exhibition at London's Victoria and Albert was one of the best installations of my work I have seen. Replying to some questions from their curator, I had requested they paint the walls to achieve the pre-

ferred twenty percent reflectance — and in any color except pink. When I arrived in London, the curator came to my room at the Connaught, looking very worried. He said that he hoped I would like the wall color when I saw it: chocolate brown. Then *I* was the concerned one. I entered the museum the next morning with heavy foreboding of the effect of my photographs on such a wall color. To my absolute delight, the color of the walls was just the right value and made the prints float in space. My London visit also personally introduced me to my respected European colleague Bill Brandt, who attended the opening along with my old friend Brassai. It was a joyful occasion.

The Connaught is a very British hotel: righteously stuffy, with everything and everyone impeccable. On this trip Virginia and I had quite an entourage: our granddaughter Sylvia, Bill Turnage, and Andrea Gray. I presented my American Express card to pay our considerable bill and was politely informed that the Connaught accepted no charge cards. This had happened to us a few days earlier at the Tour d'Argent restaurant in Paris. There we were forced to pass the hat, and everyone had to empty his pockets to cover the stupendous bill. We did not have enough cash left between us to pay for the Connaught, however, and since it was Sunday, all banks were closed. I stood in that fancy lobby, Stetson in hand, no resolution in sight, when the manager discreetly informed me that they would, of course, accept my personal check. I was duly impressed.

We drove out of London and up to Scotland. I photographed an old cemetery in Edinburgh, a city to which I would love to return. But even with those fine European experiences, I was glad to return home to Carmel.

In 1977 John Szarkowski proposed the organization of a large traveling show of my work to open at MOMA in the fall of 1979. John spent one week with us in Carmel, in a firsthand curatorial search through thousands of proof sheets as well as fine prints. Eventually he selected one hundred fifty-three photographs, limiting his choices to my western landscapes and thus titling the exhibition "Ansel Adams and the West."

John achieved a brilliant visual statement by his placement and proximity of the prints. The opening section of the exhibition was entirely of photographs made over many years of Yosemite Valley taken from one viewpoint. The series of five photographs that I call *Surf Sequence* was hung in almost a diamond shape of frames so that the viewer could wander through the sequence in any order. In a few instances he hung two prints of the same image made years apart, side

by side, to show my changing interpretations of the same negatives. John also searched far and wide to find vintage images — those prints made close in time to the negative. It was wonderful for me to revisit prints I had made up to five decades earlier.

The MOMA opening coincided with the publication of my book *Yosemite and the Range of Light*. I traveled to New York and, though just seven months had passed since my open heart surgery, thoroughly enjoyed all the hoopla, including a cover story in the September 3 issue of *Time* authored by the respected art critic Robert Hughes. One special evening was a dinner in my honor at the "21" Club hosted by Arthur Thornhill. Among the guests were my old friends Sally and Dave McAlpin and Beaumont Newhall: a nostalgic event for all.

Yosemite and the Range of Light has proved to be a phenomenon. I would estimate that before its publication I had sold a total of one million copies of my books. This single title has sold over a hundred thousand copies in hardback and another hundred thousand in a soft-cover edition. I am most definitely delighted with its popularity.

In 1980 I was warmed by the establishment of The Ansel Adams Conservation Award, the highest honor The Wilderness Society con-fers. Bill Turnage read the citation that named me the first awardee,

"Ansel Adams — for your deep devotion to preserving Ameri-ca's wild lands and to caring that future generations know a part of the world as it has been. . . ."

These words were especially moving to me. It is certainly good to hear such while one is still in this sphere.

Without my awareness, I became famous. I am enveloped in a shroud of notoriety, embalmed with praise and wondering if I shall rise again. Here I am with numerous honorary degrees, awards, and medals, the center of disputes and reputedly the fountain of all pho-tographic knowledge (which I certainly am not). Relatively few really know me, but millions know the folk hero they think is me. I have apparently touched many people through my work, and this gives me great satisfaction.

The billions of people who have preceded me were conscious en-tities; the lion, the man, and the mouse, little difference among them in the ancient procession of life on earth. I believe that the individual is but a cell in the larger body of the species; as the cerebral concentra-tions become more complex, the illusion of individuality develops. Superior minds and spirits emerge, yet who can deny that countless

others of equal stature might have been revealed had circumstances favored them or their destinies? The miracle of the accident may exceed that of the reality.

I will always embrace a credo of excellence in craft and vision; both are difficult to maintain. I have not intentionally warped my work into the patterns and patter of the times. My vision established its own groove, as I know I have been derivative of myself for fifty years. If I felt a compelling urge to change directions of vision and feeling, I would do so.

My years in Carmel have developed a fine rhythm. I awaken by seven and sit down to a healthy breakfast prepared by Virginia, of oatmeal with bran, toast and jam, juice, and decaffeinated coffee. While eating, I make my way through two papers: the *Monterey Herald* and the *San Francisco Chronicle*. I used to turn directly to "Doonesbury," the most significant cartoon in my memory: a form of philosophic social commentary that was far more than funny. I especially appreciated the environmental satires and the keen sense of human values Garry Trudeau expresses through such characters as Duke, B.J., and Zonker. Next, I jump over to Herb Caen's column and then have a quick look at the news. On Sundays, our fine friends Linda and Arno Hanel spoil us by dropping off hot croissants and the *New York Times*. It is soon back downstairs to enjoy a hot, pounding shower, get dressed, and then to work.

At the present time, I am working with my photographic assistant Chris Rainier, proofing for the first time all of my forty thousand negatives made over nearly seven decades. Chris's own photographs are quite beautiful. It is invigorating for me to be with a young person of such quality while he is maturing and acquiring craft and experience.

On occasion new reproduction prints still must be made, since most of my previous prints for this purpose have been dry-mounted on boards. My latest publishing projects have used the laser-scanner, and its circular drum requires unmounted prints — often made specifically for each project. If this is the case, Chris will pull the negative from the vault and set up the necessary chemistry. I don my *Washington Post* apron and disappear into the darkroom, reappearing to check the tonal quality of the first proofs, often by drying portions of the photograph in my microwave oven! It can take an hour or several days until I have achieved a print with which I am satisfied.

At eleven A.M. precisely, my stomach unfailingly says, "Feed me!" Though perpetually on a diet, I sneak into the kitchen for a bowl of

maple syrup beans or a few cookies and milk. Then it is back to the darkroom to be summoned for my real lunch at twelve-thirty. We are blessed with two fine chefs who cover lunch and dinner seven days a week: Fumiye Kodani has been conjuring kitchen magic for us for nearly fifteen years, and Bruce Witham, a young Culinary Arts Institute graduate, provides supreme fare in the new California mode. I insist that the entire staff eat lunch with Virginia and me as often as possible. It is companionable and relaxing to have that short social period in the middle of our working day and, of course, we spend most of lunch talking business.

Phyllis Donohue, one of the finest persons I have known, has served as my master print spotter and has cheerfully tackled many other tasks. For over a decade, Phyllis has been important to the production of my books and portfolios. Rod Dresser has been a tremendous recent addition to the staff. Besides backing Chris up in the darkroom, he is fluent in computerese and is in the process of cataloging all of those proofs that Chris and I are making. In the future I shall be able to summon up a negative, proof, or reproduction print in the flash of a microchip. Since one of my failings is worrying unnecessarily about financial realities, the calm presence of Judy Siria, our bookkeeper par excellence, is always welcome.

After lunch comes the second-best part of the day: mail! I subscribe to a goodly number of journals and magazines, and after every letter has been perused, I retire to my bed for a brief time of reading the new publications as well as from a ready stack of books. After an hour, I give Mary a call on the intercom and she comes down to take my pulse and blood pressure and to do a quick check on other necessary functions — lungs and circulation. She then unmercifully drums me out of the house on an enforced walk.

When Mary began working for me in 1979, the first task I gave her was to make me start writing this autobiography. I simply could not get going. We began by taking long walks, Mary with tape recorder in hand, questioning me about everyone from Charles Adams to William Zorach. She encouraged the purchase of an IBM Displaywriter, and I entered the computer age and actually began writing this book. Most afternoons I now spend writing into the machine, then Mary edits my text the next morning. As I sit down in front of my computer, I often find 3x5 cards written out by Mary, taped to the screen in front of my eyes: "AA, You need to write about Diego Rivera" or "AA, Here is what you've written about Imogen Cunning-

ham — what about the story you told me yesterday about her?" and her ubiquitous, "Walk for Health!"

After a couple of hours on the computer, I move to writing letters in response to a telephone call for help telling me that there is some emergency in the environmental scene and I must immediately write to Congressmen X, Y, and Z. To be effective, such letters must be composed with great care and this takes time and mental energy. But I am depended upon to write such letters and there goes an hour of intensive effort. I know it is a great cause, but it can also be quicksand to my time.

My staff has instructions to allow few phone calls to interrupt me as I write. There are only a handful of people I will let break my concentration. My old friends are sympathetic to this and gladly call again at a later time. One person I never put off is my attorney David Vena. Dave is the rare and happy combination of brilliant, hard-driving lawyer coupled with a rare sensitivity and commitment to the creative arts. His charming wife, Carol Vena-Mondt, has established herself as a painter of great promise, working in mixed media. They make a dynamic duo!

At four P.M. I often greet an interviewer or TV crew and sit in the living room, answering questions for an hour or so. At five o'clock Virginia sets out a bar, and several of the staff, visiting photographers, and friends sit down and join us in a drink. Cocktails at the Adamses' is a long-established tradition. I am partial to a very dry martini, lemon peel marinated in vermouth, over the rocks, and diluted with a lot of water so that I can enjoy more than one. Sunset is best when there is no trace of fog and everyone gathers in hope of witnessing the emeraldlike green flash as the sun is greeted by the Pacific. To all those nonbelievers in the existence of the green flash, *Webster's* properly defines it as "The momentary green appearance of the uppermost part of the sun's disk, due to atmospheric refraction, as it sinks below, or rises above, the horizon."

I prefer a simple and light supper: soup and crackers, then an early bedtime. I have always been an insomniac and leave a light on all night, moving in and out of sleep while reading and listening to the radio.

I continue to photograph, though not with the daily energy of decades past. In recent years Jim Alinder has been my companion during these sojourns. We have walked the forests of Pebble Beach, climbed the rocks of Point Lobos, inspected the great lasers of Lawrence Livermore Laboratories, scoured the old artillery emplacements in the

Marin hills, searched the back roads and farms of San Mateo, Santa Cruz, and Monterey counties, and are always captivated by the splendor of Yosemite Valley.

In our most recent trip to Yosemite, Chris Rainier joined us to be sure my film, filters, and lenses were always at hand. Since Jim and I were both using our Hasselblads, we could exchange equipment. He visualized an abstract waterfall detail necessitating the use of my long telephoto and I saw a tree detail that required the close-up capability of his new macro lens. We had a couple of beautiful days, tiring in their intensity, yet the thrill of making a new image was still with me. We ended the last day by photographing each other and then returned to enjoy the company of family and friends over cocktails at Michael and Jeanne's comfortable Yosemite West house.

The Hasselblad has been my camera of choice for the past twenty years. I thoroughly enjoy its superlative optical and mechanical precision. I met Dr. Victor Hasselblad in New York in 1950. On my return to San Francisco, I found one of his first cameras awaiting me: the 1600F model, with the request to try it out and send my comments to him in Sweden. I was to keep the camera with his compliments. As with any pilot model there were many things to write about, but the basic concept of the camera was magnificent. The maximum 1/1600 second shutter speed was, of course, realized more on the design board than in actuality. It tested out at about half that, but the slower speeds were quite accurate.

The next model, the Hasselblad 1000F, was much more satisfactory in all respects; the shutter speeds were more accurate throughout the range. However, the mechanical focal-plane shutter was a serious design problem and was abandoned for the 500C model, signifying a between-the-lens shutter of 1/500 second maximum speed. This camera appeared with a magnificent series of Zeiss lenses and numerous accessories and became tremendously successful. Then the 2000FC model appeared, with an electronically controlled focal-plane shutter of great accuracy at all speeds. With high ethical intention, this camera was designed to use both the old 500C lenses and the new lenses made especially for focal-plane shutter use. Because these superior lenses have become extremely costly, this feature was greatly appreciated.

I shall never forget the instructions I received from Victor himself, which accompanied that first camera. "When lens attached hold firmly, input lens on camera, press to side, stop turning at sound of click and camera is ready to take." His English improved over the years. A devoted amateur photographer specializing in birds, he warmly en-

couraged young photographers and sponsored excellence in many fields. When an astronaut apologized to him for losing a Hasselblad camera during an early space walk, Victor replied, "Think nothing of it. What other camera manufacturer has a little planet in space?"

I have made many of my well-known photographs with the Hasselblad, but to single one out, a favorite is *Moon and Half Dome, Yosemite National Park, 1960.* I was driving a bit aimlessly around the valley one winter afternoon, when I clearly saw an image in my mind's eye of Half Dome as the moon rose over its right shoulder. I parked my car and with my Hasselblad and tripod firmly positioned across my shoulder, I strode over the snowy field in front of the Ahwahnee until I found the place that best revealed the scene. The photograph shows Half Dome, surely the most distinctively shaped mountain in the world, partially darkened by late afternoon shadows with its seemingly smaller companion, the near-full moon. I used my 250mm telephoto to compress the space relationship, making the moon appear somewhat larger in relation to Half Dome than it was in reality.

After Victor's death, the Hasselblad Foundation established a gold medal award. In 1981, I was notified that King Carl XVI Gustaf of Sweden would present me with the second Hasselblad Medal. The first had been awarded to the great Swedish photographer Lennart Nilsson. The Hasselblad Gold Medal was a very special honor for me because of my deep respect for Victor and what he had accomplished. The ceremony took place at MOMA. It was quite an affair: the King and Queen, Blanchette Rockefeller, the superb director of MOMA Richard Oldenberg, and about four hundred guests and one hundred paparazzi. It has been, thankfully, my only experience with this form of the European press. All one hundred electronic flashes were fired simultaneously as King Gustaf presented me with the medal. The incredible light prepared one for the apocalypse. Throughout, I was impressed with the simplicity and graciousness of the Swedish royal couple.

Though I love a good party, I have never been much of a holiday person. Virginia's birthday has come and gone, forgotten by me, too many times. I cannot wait for the day after Christmas, when my staff returns to work. I personally do not recognize a day off — work is my greatest enjoyment. However, during the past half-dozen years, Virginia and I have spent many birthdays, Christmases, Easters, Fourths of Julys, and Pig Valve (Valentine's) Days, gathered about the Alinder table with our extended Carmel family including their children, lovely Jasmine, handsome Jesse, and gregarious Zachary.

Jim and Mary asked if The Friends could give my eightieth birthday

celebration in 1982. It was two nights I shall always remember. February 19, three exhibitions of my photographs opened simultaneously on the Monterey Peninsula: a large retrospective curated by Mary at the Monterey Peninsula Museum of Art, a show of unknown work curated by Jim at The Friends gallery, and an exhibit at the Weston Gallery. I made my way from opening to opening, driving up in my 1977 white Cadillac, license plate "Zone V," my arrival announced by the playing of the computer horn my staff presented me as a birthday gift. It plays seventy-two different tunes but I am partial to the "Marseillaise" and "I'm a Yankee Doodle Dandy." There were hundreds of people at each opening, spilling out into the streets, and I was greeted at each stop with cheering choruses of "Happy Birthday."

The following evening was a black-tie dinner for two hundred thirty-four people. Many of my oldest and dearest friends flew from all over the world to be with us. Mary directed the event with aplomb, and Jim was a dapper master of ceremonies. The food was superb, prepared by the incomparable Michael Jones and Valentine Fine of A Moveable Feast, including my favorite, "Ansel's Sorrel Soup." Incredibly, the birthday cake, shaped like Half Dome, was escorted in by an eighty-piece marching band.

Then the toasts began and I was surprised, delighted, and greatly honored to be presented with the Legion of Merit by the French cultural attaché and Lucien Clergue; it is the highest award that the French government can bestow on a non-French artist.

But I had yet to receive my gift from Virginia and Mary — a gift of music. Over the years my interest in music has continued, though not at the serious level of my youth. In earlier days I attended every concert that came to town. Later, I was much more selective and concentrated on piano and orchestral presentations. I have always found that string quartet concerts were the most difficult to sit through; the first half was usually wonderful, but the second section — no matter what the music — exhausted me. I assume that, not being a string man, I was wearied by the effort to hear and understand the music. I finally arrived at the point where I could not sit through a concert without worrying about my photographic problems. I reasoned, "Why should I be occupying a seat in a crowded hall, suffering with my divided attention, while denying serious music lovers a chance to benefit?" I enjoy my hi-fi when I want to listen. I cannot have music playing while I am working in the darkroom or while writing; I cannot help listening to the music and my mind wanders. It is a distraction of one form of art enveloping another.

The apex of my musical experience was the eightieth birthday concert in our home arranged by Virginia and Mary. I had given them instructions that when I die I do not want a funeral, but rather a small concert to be arranged for our friends. They decided to give me the concert while I was still alive. They chose my favorite, the sublime pianist Vladimir Ashkenazy, one of the greats of our time. Such an artist, when heard in a concert hall, is one thing; but when heard in the intimate surrounds of the home, it becomes a completely unforgettable experience. His interpretations of Chopin, Beethoven, and Ravel were colossal.

A year later Askhenazy returned and I photographed him as he practiced at the piano in our gallery, surrounded by my photographs. He liked the results so much that two of those portraits were used as album covers for his recordings of Mussorgsky's *Pictures at an Exhibition* and Beethoven's *Hammerklavier,* both on London Records. I was also able to achieve some successful portraits of Ashkenazy's lovely wife, Dody.

Over subsequent visits I continue to be impressed with Ashkenazy's quiet and modest personality, his twinkle of humor, and his incredible, architectural, and poetic approach to music. His performances, on record or in person, bring the keen realization of the almost infinite dimensions of great music, especially that of the abstract.

It occurred to me that this is what I want my photographs to accomplish in their own way. I know some photographs that are extraordinary in their power and conviction, but it is difficult in photography to overcome the superficial power of subject; the concept and statement must be quite convincing in themselves to win over a dramatic and compelling subject situation.

As I listen to great music — Bach and Beethoven to Stravinsky and Bartok — I am dominated by the music, but my mind seeks resolution to questions that have concerned me for most of my life. While I have never looked for literal or literary meanings in music or art, I have communicated critical thoughts, unwittingly, in those terms. For many years I have distrusted the dominance of words and believe communication can and will embrace other means of expression and description. The aural architecture of music is a particular pattern of perception and revelation. I believe that all art is a mystique and does not tolerate the dissections of cold critical analysis and aesthetic definitions.

24.

Harmony

D URING THE PROGRESS OF MY GENES IN THIS LIFETIME, I have come to realize the potential of greatness as well as the depths of depravity of the human species to which I belong: the beacons of civilization radiate hope and faith in the world, in contrast to the shadows of destruction and emptiness. Myths and creeds are heroic struggles to comprehend the truths of the world, though they are revealed as being timid and shallow as awareness of the universe expands.

I have known people of great wealth and compassion and others of equal wealth and power with no concept of the dedication to creative effort or the generosity of heart and spirit. I have known people of little means who have given so much to the world in the areas of art, science, and the simple situations of living, now and for the future. While only touching the fringes of environmental problems, I am happy to have been able to have had some small effect on the increasing awareness of the world situation through both my photographs and my vocal assertions. Far too many people think lightly of idealistic attitudes and do not understand that this idealism is not involuted, but directed outward for the benefit of the world and the people living upon it. I believe the ultimate objective of life lies in creative and productive work; devotion to business and money, as ends in themselves, are but phases of a developing civilization.

After living a long life, I am often asked what I think the future holds. I know little more about the future now than I did eighty years ago. What I *feel* about the future is another matter. The vast surge of population is certain to affect the environment and the essential resources, to say nothing of natural beauty and wilderness values. No

matter what we think about the tangible and intangible situations in the world about us, we cannot ignore that the fate of humanity must remain our prime consideration. The threat of nuclear war overshadows all aspects of life; should it occur, the problems of the environment would not exist — there would be no environment and few if any people to contemplate it and consider better paths for humanity to follow.

I know the arguments for capitalism and both the real and potential terror of right-wing brutality. The stock market soars while the desolation of unemployment and poverty increases. Give me all the slick economic and social theories you have; I shall trust none of them until I believe in my heart and see with my eyes that they serve mankind today and in the future.

While an autobiography must be in retrospect, it may also treat of dreams of what the years to come may promise. In wisdom gathered over time, I have found that every experience is a form of exploration. Wandering over the windy sand dunes as a child was a venture of wonder and discovery, all taking place in little more than a square mile of intricate beauty. I can still recall the feeling and sound of sand as I shuffled through it, and the dune grass, shrubs, and flowers, all displayed in inviting disorder. Near the cliffs west of Baker Beach lay exposed areas of clay on which the sand had once paused and moved on. In spring, after the showers, these depressions held still pools of shallow water alive with tiny larvae, insects, and green plants. Moving in circles about the dunes provided a journey without end, more mysterious when the fog billowed in from the sea. Late in the day the fog would thin; long streamers of mist would partially shield the sun; its veiled circle cast delicate shadows of the grasses upon the sand and edged the dune contours with pale light. In the early years I could only feel what I was experiencing. Later I could recall the visions and integrate them with daily life and events in the world of music and activity that were accumulating around me.

We all move on the fringes of eternity and are sometimes granted vistas through the fabric of illusion. Many refuse to admit it; some make mystical stews about it; I feel a mystery exists. There are certain times when, as on the whisper of wind, there comes the clear and quiet realization that there is indeed a presence in the world, a non-human entity that is not necessarily inhuman. I believe we are born with an incredible program for our life to be, tucked away in a small cranium and pressing to grow and function. I have often had a retrospective vision where everything in my past life seems to fall with

significance into logical sequence. Intuition, suspicion, or confidence in new ventures: there is a strange strain within me when advantage is not taken of some situation, the immediacy of recognition of the rightness or wrongness of a mood, a response, a decision — they are so often valid that I am increasingly convinced that we have yet to grasp the reality of existence.

I believe that whatever happens, such must be natural. It may be an occurrence beyond normal, rational explanation or it may simply be a construct of the mind. I have had some experiences that I cannot explain; I can only attest they are true and they baffle me. I sense a relationship between the inner-worldness of art and the outer-worldness of psychic experience.

I had acquired a new Pontiac station wagon one Saturday morning in the early 1940s and took father, mother, wife, aunt, and both children out for a first ride. I started down West Clay Park and had an overwhelming conviction that something was vitally wrong with the car, yet it seemed to be performing perfectly. I continued a few blocks out Clement Street to a mechanic I knew who was open on Saturdays. I explained my problem and lack of evidence and asked him to look over the front suspension, tires, and steering. He was skeptical but agreed to examine the car. Finally he crawled out from underneath and said, with an amazed expression, "You nearly lost your tie rod!" He showed me that the cotter pin had fallen out of a very important bolt that held the tie rod together; in a short distance the tie rod could have come apart and the steering capabilities failed, perhaps on one of those famous San Francisco hills. How did I know about the impending failure? There was no difference in the feel of the wheel, for as long as the bolt remained in place the tie rod was intact.

One day in San Francisco, I was walking down a street in the financial district when I received a distinct order to stop. People coming toward me looked at me in surprise as I was transfixed in mid-step. Suddenly a piece of concrete, a foot square, crashed on the sidewalk a few feet in front of me. Workmen on the roof above must have dislodged the deadly missile, but there had been no cry of warning that I could have heard.

Once, Beaumont, Nancy, and I were driving to Yosemite. At that time the Altamont Pass was a climb up a road over a rounded ridge with no visibility around the other side. The car took the easy grade at forty miles per hour; when about a thousand feet from the top, I was overpowered by an urge to drive off the road. Without any warning to the Newhalls, I quickly pulled over onto the rough shoulder.

We were all perplexed at the maneuver. In a few seconds two racing trucks appeared abreast at the top of the hill, completely filling both lanes of the road. We were driving with the wind and in a closed car; we had not heard those trucks.

The enormous complexity of the world leaves me little peace — curiosity kills complacency. If the sun is represented by a ball eight inches in diameter, the Earth (proportionately eight-hundredths of one inch in diameter) would be about seventy-six feet distant. The nearest star would be thirty miles away. To read that the universe contains approximately ten to the one hundred sixtieth power particles is both exciting and completely beyond my comprehension. A rock, a plant, or a man may be considered an entity. The rock changes shape and structure over long periods of time, the plant can grow and flower within days or weeks, and man thinks he is an eternal species.

While watching nasturtiums grow in a redwood box outside our dining alcove, I thought of the complex instructions the cells were receiving from some parent impulse. The tall stalks matured over a few days, with the flowers emerging from the pointed tips. Flowers and leaves turned toward the sun. The nasturtiums grew copiously, creating a miniature green forest, a great cool jungle for ants to explore. Within a week I observed wormholes in some of the leaves. Close examination found small green caterpillars munching away on the undersides; so close in color were they to the leaves that I could see them only when they moved. A progression of bees and Monarch butterflies enjoyed the open blossoms in what appeared to be a routine visitation pattern.

I was looking at many millions of cells and trillions of molecules following instructions from a compelling source in some framework of space and time. Each of the countless instructions came from a DNA continuum; genes were at work as they are in our own bodies. Perhaps, the reality of life exists in this continuum and the physical bodies of plants, insects, man, and all life are but refueling stations of existence. The pollen of these flowers was carried off into the world by the bees and the wind; the plants died but their life is ever renewed.

My private glimpses of some ideal reality create a lasting mood that has often been recalled in some of my photographs. I remember the sound of a particular registration of the organ in Saint Paul's Cathedral in London, the voicing of one chord in a Bach Partita I had once achieved and never again could duplicate, and the timbre of a certain voice I heard only once from an adjacent room. The subtle changes of light across a waterfall moved me as did a singular vista of a far-off

mountain under a leaden sky. Others might well have not responded at all. Deep resonances of spirit exist, giving us glimpses of a reality far beyond our general appreciation and knowledge.

The gigantic scale of the universe was just being revealed when I was a youth and I knew a little about what I was seeing in the crisp Sierra nights. One cold, moonless summer evening I was camped out at ten thousand feet elevation at Fletcher Lake. From my sleeping bag I witnessed an enormous glitter that was overpowering in majesty and mystery. The greater information we have today would only intensify the questions and the humility that the presence of innumerable worlds evoke. No matter how many stars we see in a clear mountain sky, we know now that they are but a minuscule fragment of the total population of suns and planets in the billions of galaxies out there in the incomprehensible void.

The only things in my life that compatibly exist with this grand universe are the creative works of the human spirit. After eighty years, I scan a long perspective. I think of a mantra of Gaelic origin given me fifty years ago by Ella Young. It echos everything I believe:

> I know that I am one with beauty
> And that my comrades are one.
> Let our souls be mountains,
> Let our spirits be stars,
> Let our hearts be worlds.

ACKNOWLEDGMENTS

SOURCES

Ansel Adams. Advertisement. *U.S. Camera,* volume 12 (November 1940), p. 15.

———— (unacknowledged). "Christmas Comes But Once a Year." *Life,* volume 5, no. 26 (December 26, 1938), cover and p. 16.

————. *Making a Photograph.* London and New York: The Studio Publications, 1935, pp. 13–14.

————. "The New Photography." *Modern Photography 1934–5.* London and New York: The Studio Publications, 1935, p. 14.

————. "Photography" (on Eugene Atget). *The Fortnightly* (November 6, 1931), p. 25.

————. "Photography" (on Edward Weston). *The Fortnightly* (December 4, 1931), p. 25.

————. "Photo-Murals." *U.S. Camera,* volume 12 (1940), pp. 52–53.

————. "Retrospect: Nineteen-Thirty-One." *Sierra Club Bulletin,* volume XVII, no. 1 (February 1932), pp. 1, 2, 4, 9, 10.

————. *Sierra Nevada: The John Muir Trail.* Berkeley: The Archetype Press, 1938, from unnumbered foreword.

————. "Ski-Experience." *Sierra Club Bulletin,* volume XVI, no. 1 (February 1931), pp. 44–45.

————. "U.S. Camera Yosemite Photo Forum 1941." *U.S. Camera,* volume 15 (March 1941), pp. 56–57.

———— (unacknowledged). "Wizards of the Coming Wonders." *Life,* volume 36, no. 1 (January 4, 1954), pp. 93–94.

———— and Mary Austin. *Taos Pueblo.* Copyright © 1930, Ansel Easton Adams, unnumbered. Facsimile reprint, Boston: New York Graphic Society, 1977, unnumbered. (Originally published 1930.)

James Alinder. *The Unknown Ansel Adams.* Carmel: The Friends of Photography, 1982.

———— and Wright Morris. *Picture America*. Boston: New York Graphic Society, 1982.

Mary Alinder. *Ansel Adams: The Eightieth Birthday Retrospective, Monterey.* The Monterey Peninsula Museum of Art, 1982.

Margaret Bourke-White and Erskine Caldwell. *You Have Seen Their Faces.* New York: Viking, 1937. Reprint, New York: Arno, 1975.

Witter Bynner. "To a Guest Named Ansel." By permission of the Houghton Library.

Robert Cahn. "Ansel Adams, Environmentalist." *Sierra,* volume 64, no. 3 (May/June 1979), pp. 31, 33–49.

Sean Callahan. "Countdown to Moonrise." *American Photographer,* volume V, no. 1 (January 1981), pp. 30–31.

Imogen Cunningham. *After Ninety.* Introduction by Margaretta Mitchell. Seattle: University of Washington Press, 1977.

————. Letter written to Ansel Adams dated February 10, 1964. Copyright © 1978 by the Imogen Cunningham Trust.

John Paul Edwards. "Group F:64." *Camera Craft* (March 1935), pp. 107–110, 112–113.

Andrea Gray. *Ansel Adams An American Place, 1936.* Tucson: Center for Creative Photography, University of Arizona, 1982.

Robert Hughes. "Master of the Yosemite" (cover story). *Time,* volume 114, no. 10 (September 3, 1979), pp. 3, 36–44.

Marjorie Hunter. "An Ex-Ranger Gets a Personal Plea to Help the National Parks." *The New York Times* (January 28, 1975). Copyright © 1975 by The New York Times Company. Reprinted by permission.

J. M. Hutchings. *In the Heart of the Sierras.* Yosemite Valley: The Old Cabin, 1886, pp. 56–57.

Robinson Jeffers. "Night" and "To the Rock That Will Be a Cornerstone of the House." Copyright © 1924, 1925 and renewed 1952, 1953 by Robinson Jeffers. Reprinted from *The Selected Poetry of Robinson Jeffers,* by permission of Random House, Inc.

Edwin H. Land. Letter written to Ansel Adams dated February 1, 1949. Copyright © 1985 Edwin H. Land. All Rights Reserved.

————. Statement for American Academy of Arts and Sciences, April 2, 1979, as it appears on a carved tablet in the Academy building. Copyright © 1979 Edwin H. Land. All Rights Reserved.

David H. McAlpin. Letters/excerpts written to Ansel Adams dated September 7, 1940, and January 16, 1972. Copyright © 1985 David H. McAlpin. All Rights Reserved.

Wright Morris. *The Home Place.* New York: Scribner, 1948. Reprint, Lincoln: University of Nebraska Press, 1968.

Beaumont Newhall. *The History of Photography.* New York: Museum of Modern Art, 1982.

————. Letters/excerpts written to Ansel Adams dated September 17, 1940; February 27, 1944;

February 23, 1946; and March 7, 1946. Copyright © 1985 by Beaumont Newhall.

Nancy Newhall. Two excerpts from the unpublished manuscript *The Enduring Moment*. Copyright © 1985 by the Estate of Nancy Newhall.

———. *This Is the American Earth*. San Francisco: The Sierra Club, 1960, pp. 78, 80, 83–84, 86, 88. Copyright © 1960 by the Sierra Club. Courtesy of the Estate of Nancy Newhall.

Nissan Motor Corporation in U.S.A., "Drive a Datsun—Plant a Tree," 1973. Use of the excerpt of this advertisement which appears on page 148 is by permission of Nissan Motor Corporation in U.S.A.

Dale Russakoff. "The Critique, Ansel Adams Takes Environmental Challenge to Reagan." *The Washington Post* (July 3, 1983), pp. A1, A6.

David and Victoria Sheff. "Playboy Interview: Ansel Adams." *Playboy*, volume 30, no. 5 (May 1983), pp. 5–6, 67–73, 76, 81–82, 84, 86, 87, 222, 224, 226.

William Siri and Ansel Adams. "In Defense of a Victory: Nipomo Dunes." *Sierra Club Bulletin* (February 1967), pp. 4–5.

W. Eugene Smith. Excerpt from letter to Ansel Adams dated December 22, 1951. Reproduced through the courtesy of the W. Eugene Smith Estate. Copyright © 1985 by the W. Eugene Smith Estate. All Rights Reserved.

Alfred Stieglitz. Letter to Ansel Adams dated December 21, 1938, and excerpt from letter to Ansel Adams dated April 8, 1938. Correspondence reproduced through the courtesy of Miss Georgia O'Keeffe. Copyright © 1985 by Miss Georgia O'Keeffe. All Rights Reserved.

Paul Strand. Excerpt from letter written to Ansel Adams dated October 14, 1933. Paul Strand letter reproduced through the courtesy of the Paul Strand Archive and Library, Silver Mountain Foundation. All rights reserved.

———. *Time in New England* (with Nancy Newhall). New York: Oxford University Press, 1950.

Robert Turnage. "Ansel Adams, The Role of the Artist in the Environmental Movement." *The Living Wilderness*, volume 43, no. 148 (March 1980), pp. 4–31.

Charis Wilson Weston and Edward Weston. *The Cats of Wildcat Hill*. New York: Duell, Sloan and Pearce, 1947.

Edward Weston. *California and the West* (text by C. W. Weston). New York: Duell, Sloan and Pearce, 1940. Rev. ed., Millerton, New York: Aperture, 1978.

———. *The Daybooks of Edward Weston*, Volume I: *Mexico* (introduction by Beaumont Newhall, Foreword and technical note by Nancy Newhall). Rochester, New York: George Eastman House, 1961. Volume II: *California 1927–1934* (introduction by Nancy Newhall). New York: Horizon Press and Rochester, New York: George Eastman House, 1966. Reprint (both vol-

umes), Millerton, New York: Aperture, 1971.

———. *Fifty Photographs: Edward Weston* (edited and designed by Merle Armitage). New York: Duell, Sloan and Pearce, 1947.

———. Letters/excerpts written to Ansel Adams dated January 22, 1932; May 1937; postcard 1945; November 17, 1945; and December 1, 1945. Copyright © 1985 by The Center for Creative Photography on behalf of the Edward Weston estate.

———. "Foreword." *Making a Photograph,* by Ansel Adams. London and New York: The Studio Publications, 1935, p. 11.

———. *My Camera on Point Lobos* (edited by Ansel Adams). Yosemite: Virginia Adams, and Boston: Houghton Mifflin, 1950.

Minor White. Excerpt from "Memorable Fancies" 9 [10] July 1946. Courtesy the Minor White Archive, Princeton University. Copyright © 1985 by The Trustees of Princeton University.

Walt Whitman. "Miracles." *Leaves of Grass.* Philadelphia: David McKay, 1900.

Cedric Wright. From *Words of the Earth,* pp. 66, 68. Copyright © 1960 by the Sierra Club. Reprinted by permission of Sierra Club Books.

INDEX